Singular Images

Failed Copies

*William Henry Fox Talbot
and the Early Photograph*

Vered Maimon

UNIVERSITY OF MINNESOTA PRESS

Minneapolis • London

Publication of this book has been aided by a grant from the Millard Meiss Publication Fund of the College Art Association.

Portions of chapter 2 were previously published as "Talbot's Art of Discovery," in *William Henry Fox Talbot: Beyond Photography,* ed. Mirjam Brusius, Katrina Dean, and Chitra Ramalingam (New Haven: Yale Center for British Art, 2013). An earlier version of chapter 2 was also previously published as "On the Singularity of Early Photography: William Henry Fox Talbot's Botanical Images," *Art History* 34, no. 5 (November 2011); reprinted with permission of the Association of Art Historians. An earlier version of chapter 4 was previously published as "'Displaced Origins': William Henry Fox Talbot's *The Pencil of Nature,*" *History of Photography* 32, no. 4 (Winter 2008).

Published by the University of Minnesota Press
111 Third Avenue South, Suite 290
Minneapolis, MN 55401-2520
http://www.upress.umn.edu

Library of Congress Cataloging-in-Publication Data
Maimon, Vered.
 Singular images, failed copies : William Henry Fox Talbot and the early photograph / Vered Maimon.
 Includes bibliographical references and index.
 ISBN 978-0-8166-9471-6 (hc)—ISBN 978-0-8166-9472-3 (pb)
 1. Photography—Philosophy. 2. Talbot, William Henry Fox, 1800–1877. I. Title.
 TR183.M336 2015
 770.1—dc23 2015017705

Printed in the United States of America on acid-free paper

The University of Minnesota is an equal-opportunity educator and employer.

20 19 18 17 16 15 10 9 8 7 6 5 4 3 2 1

In memory of my parents,
SARAH *and* DAVID MAIMON

Contents

Introduction: The Photographic Imagination / ix

Part I British Science and the Conception of Photography

1 Scientific Method *The Engine of Knowledge* / 3

2 Imagination *The Art of Discovery* / 39

Part II Botanical Images and Historical Documents:
The First Applications of Photography

3 Time *Singular Images, Failed Copies* / 113

4 History *Displaced Origins and* The Pencil
of Nature / 175

Acknowledgments / 199

Appendixes / 201

Notes / 219

Index / 247

Introduction

The Photographic Imagination

THIS BOOK HISTORICIZES the conception of photography in the early nineteenth century in England as part of an epistemological shift in which new systems and methods of knowledge were constituted after the collapse of natural philosophy as a viable framework for the study of nature. It locates the conditions for the conceptualization of photography within the legacy of British empiricism and the introduction of time into formations of knowledge. By addressing photography not merely as a medium or a system of representation but also as a specific epistemological figure, this book emphasizes historical discontinuity in order to challenge the prevalent association of the early photograph with the camera obscura. Instead, it points to the material, formal, and conceptual differences between the photographic image and the camera-obscura image by analyzing the philosophical and aesthetic premises that were associated with early photography.[1] Thus it argues that the emphasis in early accounts on the removal of the "artist's hand" in favor of "the pencil of nature" did not mark a shift from manual to "mechanical" and more accurate or "objective" systems of representation. In the 1830s and 1840s, the photographic image, unlike the camera-obscura image, was seen neither as an emblem of mechanical copying nor as one of visual verisimilitude. In fact, its conception was symptomatic of a crisis in the epistemological ground that informed philosophical, scientific, and aesthetic thought in the seventeenth and eighteenth centuries.

Rather than attributing a "fixed" epistemological status to early photography, this book outlines a different genealogy from the one that dominates historical accounts that often address the early image as an emblem

of visual, empirical, or positivistic "truth." Canonical histories of photography, for example, those by Helmut Gernsheim and Beaumont Newhall, are often linear and teleological, because they describe the invention of photography as an inevitable "historical necessity." Thus, Gernsheim states that "the photographic camera derives directly from the camera obscura" and that "in 1685 the camera was absolutely ready and waiting for photography."[2] In a similar manner, Newhall argues that "[t]he physical aid of camera obscura and camera lucida had drawn men so near to an exact copying of nature and to the satisfaction of the current craving for reality that they could not abide the intrusion of the pencil of man to close the gap. Only the pencil of nature would do."[3] These accounts enforce the idea that photography was born out of a continuous Western quest for visual resemblance and verisimilitude in representation, as Martin Kemp strongly affirms when he states that photography is "a logical (if not inevitable) outcome" of the long-term "ambition to invent a machine or device for the 'perfect' imitation of nature."[4] This teleological and ahistorical idea is a highly prevalent one within histories of photography, not only in canonical ones but also in more recent ones; consider, for example, Mary Warner Marien's statement that in the early nineteenth century the "camera image was thought to be an analogue of the picture on the human retina. As such the medium was understood as material confirmation of the Enlightenment proposition that the image on the human retina is independent of the subject's thoughts and feelings. The photograph was externalized, ideal human vision."[5] Lately, philosophers reinforce these positions as part of a "defense" of the "kinship" between photography and "truth" against the digital transformation of the medium, for example, in the recent edited collection of essays by Scott Walden significantly titled *Photography and Philosophy: Essays on the Pencil of Nature.* Walden argues that photography, because it "excludes the image-maker's mental states from the process that maps features of the original scene onto features of the image, is an objective process."[6] He thus emphasizes the "epistemic advantages" of photography over other forms of representation, based on new ideas within the philosophy of the mind.

Contrary to the emphasis on historical continuity and necessity in these accounts and the assumption that in the early nineteenth century photography represented impartiality and epistemological "neutrality," this study emphasizes historical discontinuity. It argues that history presents different regimes of "truth" and forms of visual intelligibility in which the status of the photographic image can be highly specific and inconsistent. In

England, as opposed to France, photography was conceived within a primarily scientific context in which the question of "truth" not only was related to problems of visual representation but also had significant epistemological and ontological implications. Thus the early image was often associated with the inductive method of science; yet at this historical juncture *induction* was a controversial term open to epistemologically incompatible definitions. This book thus reconsiders the relations between early photography and knowledge, in particular empiricism, by emphasizing the inseparability, during the 1830s, of scientific forms of inquiry from religious and metaphysical concerns that had much more to do with belief than with any modern notion of scientific "impartiality" and "objectivity."[7] Within the specific genealogy I analyze, the major question with regard to the early image was not simply whether it was "true" or "false" but also whether it could further promote the religious and philosophical convictions of Victorian science and culture, which could never be "proved" but nonetheless had to be accepted as given.

Within the legacy of British empiricism, questions of belief and habit were haunted by the specter of skepticism, in particular after David Hume's attack on causality. The indispensable, yet also highly suspicious, role of the imagination in fostering beliefs, as Hume showed, becomes a source for epistemological instability that constantly holds the possibility to insert doubt and "error" into scientific and philosophical forms of validation. And although, with the changing role of the imagination from a reproductive faculty to a creative one in Immanuel Kant's transcendental philosophy, it becomes celebrated as an emblem of creativity and genius in romanticism, in particular within Samuel Taylor Coleridge's aesthetic theory, it is also what manifests more than any other faculty the philosophical and epistemological precariousness of what Michel Foucault calls the "modern episteme" of knowledge. As Foucault shows, for Kant, the imagination is a synthetic faculty whose primary function is to link the transcendental categories of understanding to empirical sense impressions, but whose very existence marks the impossibility of an epistemological synthesis of knowledge outside the circular theological and metaphysical premises of the "classical episteme." With the emergence of the modern episteme, it becomes clear that although the imagination undermines the validity and universality of knowledge, it is also a necessary condition for it. It is in relation to the necessary "fictions" of the imagination and the "deceptions" of experience and habit, rather than the claims of reason, that the epistemological status of early photography is analyzed in

this book. Its conception, I argue, marks not the "birth" of a modern figure of "proof," "testimony," and "evidence" but the inherent opacity and indeterminacy of the new conditions of knowledge as these emerged in the early nineteenth century.

This study focuses primarily on William Henry Fox Talbot's texts and images, and to a lesser extent on other practitioners and writers, such as John Herschel, Robert Hunt, and Antoine Claudet, as well as on early reviews and publications on photography. Talbot is a very important figure within the history of photography as the inventor of paper photography and the negative/positive process, which enables the production of multiple copies from a single negative. In this regard it is Talbot's conceptualization of photography as a copying method, rather than Nicéphore Niépce and Louis Jacques Mandé Daguerre's invention of the daguerreotype as a single irreproducible object, that is often seen as continuous with the modern notion of photography as a medium and system of representation.

Talbot was an English gentleman and an amateur "man of science" with many scholarly interests, including mathematics, optics, botany, philology, etymology, and Assyriology. He was born in 1800, entered Trinity College at Cambridge University in 1817, and was made a fellow of the Royal Society, Britain's primary scientific institution, in 1831. Based on Talbot's own discovery account, the idea of fixing the images of the camera obscura came to him unexpectedly in 1833 during his honeymoon at Lake Como in Italy after failed attempts to draw the landscape using the camera lucida and the camera obscura. He started his photographic experiments in 1834, and his earliest images date from 1835. Yet eventually Talbot deserted these efforts in favor of his mathematical and optical studies and the publications of his classical antiquarian researches. He returned to his photographic experiments in 1838 and then heard that Daguerre had found a way of fixing the images of the camera obscura. He quickly assembled the results of his fixing and copying experiments and presented his first photographic process, named photogenic drawing, to the Royal Society on January 31, 1839. Talbot's first photographic process, as Larry Schaaf explains, was a "print-out" process that fully depended on solar energy for the complete formation of an image. His early images, though relatively "fixed," required long exposure times and were mostly produced through contact printing without the camera obscura. It was only with his second photographic process, the calotype (from the Greek word *kalos,* meaning "beautiful"), discovered in 1840, that Talbot introduced the notion of "latency" to paper photography, the

idea that the image "develops" after a short exposure time during which an invisible image is formed and later developed in the darkroom. This "developed-out" process greatly facilitated the use of the camera obscura for the production of photographic images.[8] In 1844 Talbot published *The Pencil of Nature,* a book illustrated with photographs in six separate installments, in order to promote his discovery of the calotype by proposing different applications for this process that lay behind the daguerreotype in terms of popularity and economic success.

Talbot's images, in particular those of his country estate, Lacock Abbey in Wiltshire, and accounts of his discovery are foundational within the history of photography. His statements are quoted again and again by scholars and historians as encapsulating the "essence" of photography as a "natural magic" and a highly accurate form of representation because it is, as Talbot often stated, made by nature alone without the aid of the artist's hand. Thus Talbot is often presented as a "monumental" figure, a "genius," because he was able at such an early stage in the history of photography not only to conceptualize the uniqueness of photography as a visual medium but also to predict what it would become, its future uses and cultural value. For example, Schaaf, Talbot's primary historian, starts his book on Talbot's photographs with the question "What defines a great and original mind? What is creativity?"[9] Consequently, the most comprehensive studies on Talbot by Schaaf and H. J. P. Arnold are conceived as monographs that carefully trace his scientific and intellectual biography and the different stages of his photographic experiments that led to the discovery first of photogenic drawing and later of the calotype.[10] These studies rely on original sources, mostly Talbot's notebooks and his rich correspondence with major scientific figures such as John Herschel, Charles Babbage, and David Brewster, as well as family members.[11] At the same time, alongside the emphasis on Talbot's originality as an inventor or discoverer, Schaaf in particular insists on outlining the progress of Talbot as a photographer and artist and the development of his "personal vision." He therefore analyzes Talbot's images as proving his growing mastery of his art.[12]

This book, although focusing on Talbot, is not conceived or written as a monographic study. Its scholarly aim is not to present a comprehensive and accumulative study on the progressive way in which ideas developed in Talbot's "mind" or to evaluate his artistic talent. Rather, it moves away from the focus on Talbot the "individual" and instead centers on Talbot the "subject" and on the historical and epistemological conditions within

which his discovery accounts and images were made. By employing Foucault's archeological and genealogical methods of analysis, it emphasizes not Talbot's family background and the different influences on his life but the way terms and concepts he used and mobilized were far from unique or original but quite the opposite, prevalent in the milieus in which they circulated because they were subject to what Foucault calls historically specific "discursive rules of formation."[13] That is, the precise usage and meanings of these concepts cannot be elucidated by relying exclusively on Talbot's correspondence and notebooks but must be analyzed in relation to much broader yet specific scientific, philosophical, institutional, and cultural discourses and practices within which, I argue, Talbot's conceptualization of photography became possible. By the same token, although this study addresses many of Talbot's images, their analysis is meant not to point to the development of Talbot's talent as a photographer or artist but to show how their material mode of production and composition embody the specificity of early photographs and their difference from the camera-obscura images and conventional genres such as the picturesque.

I therefore analyze Talbot's discovery accounts not as exemplifying his creativity and originality but as manifesting the complex set of philosophical and methodological commitments of the English scientific establishment in a very precarious moment in its history. These accounts, to employ a Foucauldian terminology, are addressed not as "monuments" of a continuous general human consciousness but as "documents" whose analysis consists in defining discursive elements, series, and relations that mark "epistemological thresholds" and discontinuities.[14] Correspondingly, this book is conceived not as a continuous biographical study but as a historically informed critical reconsideration of some of the "foundational" accounts of the history of photography and Talbot's status within them. Of course, as Foucault points out, "the notion of discontinuity is a paradoxical one: because it is both an instrument and an object of research; because it divides up the field of which it is the effect."[15] That is, discontinuity is a concept that comes out of the historian form of analysis as its condition, and one that is simultaneously "found" or "discovered" in the historical materials themselves. In this regard, the difference that this book points to, that between modern and contemporary forms of conceptualizations of photography and earlier ones, is inseparably historical *and* theoretical.

This reading of Talbot's discovery accounts and images in relation to broad formations of knowledge rather than biography joins scholarly

efforts, in particular Geoffrey Batchen's *Burning with Desire: The Conception of Photography*, to locate the conditions for the conception of photography within what he calls the "undecided folding" of the classical and modern epistemes of knowledge. Batchen analyzes the metaphorical language and rhetoric of Talbot's discovery texts, as well as those by other inventors, in order to point to a "reflexive movement" between polar terms such as *nature* and *culture, reflection* and *projection*. He thus points to a historical shift in the meaning of the camera obscura and in the prevalent terms *nature* and *landscape* during the time photography was conceived. And although Batchen attributes these shifts to the changing conditions of knowledge, his primary concern is with the effects this shift had on problems of representation, in particular the picturesque, as part of an effort to reconcile binary terms in the picturing of nature such as transience and fixity.[16] This study significantly expands Batchen's scope of analysis by examining the shifts within the conditions of knowledge in the early nineteenth century, not just in relation to problems of pictorial representation and the history of art but also in relation to the history and philosophy of science and the major scientific institutions of Victorian England, as well as its literary and antiquarian traditions. It aims to show how Talbot's diverse scholarly concerns, in particular his researches in mathematics, optics, botany, and philology, informed his conceptualization of photography. That is, it shows that the way Talbot conceptualized photography and the inconsistent epistemological value he attributed to it hinged, to a large extent, both on the general methodological and philosophical premises underlining these fields of inquiry and on specific practices through which knowledge was produced and disseminated within Victorian science and culture.[17] As recent studies have shown, Talbot's achievements within these scholarly fields were minor, but addressing them is important for understanding the forms of investigation, observation, and experimentation which underlined his photographic experiments and the models of discovery through which he came to conceptualize photography.[18]

Another significant difference between this book and Batchen's work is that whereas he focuses on the "idea of photography," the desire to fix the transient images of the camera obscura, this study argues that the early photograph was an "image without a concept." That is, what was emphasized in Talbot's different accounts of his discovery, as well as in accounts by other practitioners, was the irreducible difference between the camera-obscura image and the photographic image because of the

latter, inherently temporal, mode of formation, which prevented it from adhering to pictorial and conceptual forms of identity and sameness as these pertained to other systems of representation. I therefore show how rich and complex the field of photographic experimentation was in the 1830s and 1840s as part of an effort to reconsider the suggestion that there was one "idea" of photography or that photographic experimentation was guided by a well-defined end.[19] It was not until the mid-1850s that a defined concept was formed and the photographic image entered a different discursive order.

This book is thus interdisciplinary, as it relies on a number of scholarly disciplines, including the history and philosophy of science, philosophy, art history, and literary theory, in order to emphasize the historical specificity of early photography. Through Foucault's historical and epistemological analysis of knowledge in *The Order of Things* and Gilles Deleuze's philosophical criticism of representation in *Difference and Repetition*,[20] I show that whereas the camera-obscura image manifested the philosophical premises of "representation" as a form of knowledge, the photographic image came to embody the idea of "history" as an underlying condition of the modern episteme.

The introduction of time into formations of knowledge resulted in a radical reconfiguration of the relations between thought and being and therefore also in a new conception of the empirical and of nature itself. Consequently, the early association of the early image with nature during the 1830s and 1840s actually marked its *difference* from the camera-obscura image and the philosophical and epistemological premises that informed it. On the one hand, in this period new mechanical physical theories emerged, like the wave theory of light, in which the conceptual focus was on continuous processes of motion rather than on substances and matter; thus, explanatory models of natural systems were no longer representational or causal but mathematical and abstract. On the other hand, within romanticism, and in particular *Naturphilosophie*, nature became a dynamic organic whole composed of conflicting invisible potential forces rather than isolated atoms. Living beings were now seen as animated by the internal powers of life, which emerge outside the order of representation that can no longer provide a foundation for knowledge, because the mode of being of things is not reducible to their descriptability or visibility. Thus in each case nature ceases to form a part of the atemporal table and fixed image of representation characterizing the classical episteme of knowledge. Whereas in the seventeenth and eighteenth

centuries representation organized knowledge based on the metaphysical transparency of discourse and the necessary continuity of nature and human nature, in the modern episteme being and thought inhabit their own separate and distinct spaces that unfold in time. In its inherent opacity and temporal uncontrollability, nature came to mark the irreducibility of being to representation. This book thus locates the specificity of the early image within this shift in the status of the empirical through which empiricism (as both a theory and a method of knowledge) becomes part of the investigation of "organic" and dynamic temporal forces of life and thought.

My work on early photography is partly inspired by Carol Armstrong's writings on cameraless photographs of botanical specimens, where she strongly argues against the prevalent association of the early photograph with the camera-obscura image. In a catalog essay for an exhibition she curated on the subject, Armstrong insists that rather than looking for the essential photograph,

> [the exhibition] will seek to define anew what differentiates the early photograph from what came before it and what came after it. Rather than looking, as mainstream histories of photography often do, for the ways in which the destiny of the photograph is inscribed in its beginning—for photography's teleology . . . , [it will] show instead that photography was different at its outset than it is now, that what it has become was never a matter of technological predestiny, that it has had many strange and surprising shapes that may not be immediately recognizable from the normalized point of view.[21]

Yet, as part of her efforts to point to historical difference and specificity, Armstrong attributes an essential ontology to the photograph as an indexical sign. In her book *Scenes in a Library: Reading the Photograph in the Book, 1843–1875,* Ronald Barthes's theory of photography becomes the ground upon which historical difference is outlined between a nineteenth-century preindustrial and "auratic" discourse of photography that is based on notions of presence, and twentieth-century discourse that emphasizes resemblance and legibility. For Armstrong, nineteenth-century photography "proves" and reinforces Barthes's essentialist theory of photography.[22] I, by contrast, point to the theoretical limitations of the index as a historical tool of analysis. I show that the postmodern epistemological premises that informed Barthes's formulation of the index are incompatible with

the philosophical and epistemological convictions of the nineteenth-century natural philosopher. For Talbot and other practitioners, the early image did not offer a unique "irrefutable proof" that something "has been," but presented a "wonder," that is, another manifestation, similar to other natural and scientific phenomena, of the metaphysical continuity and regularity of nature. Moreover, by insisting on the temporal aspects of Talbot's botanical images, I reconsider the exclusively structural and "spatial" theory of the index, and in particular the assumption that the photograph is "essentially" a tautological and circular sign in which authentication always precedes and is separated from signification. Instead, I analyze these images as dynamic and open-ended *diagrams* that materially, formally, and visually register the unfolding of time as a differentiating force and produce simultaneously an image and a sign of life. One of the critical and theoretical motivations behind this book is to seriously reconsider the highly limited way that issues of temporality are addressed in essentialist theories of photography based on Barthes's suggestion that there is only one form of temporality, a general sense of "pastness," that can be associated with the photograph.[23]

Although Talbot and early practitioners did not conceive the early photographic image as a "natural copy," a direct indexical trace of nature, they also quickly realized it was not a "mechanical copy." Mechanization in the age of industrialization meant external corrective regulation and predictability, yet it was precisely these qualities which photographic images lacked during this period because of their unstandardized and manual form of production. Thus, whereas Talbot insisted that it is not the artist who makes the picture but nature, this formulation referred not to the use of machinery of any kind but to the idea of deskilled labor, as Steve Edwards has persuasively shown.[24] The emphasis on the self-agency of nature, Edwards argues, marks not a privileged epistemological status but a material and political fantasy, as figured, for example, in Andrew Ure's theory of labor, in which the automated production process is freed from actual labor while also obscuring its material conditions. Following Edwards, I show that the idea of mental and manual deskilling is crucial for understanding the association of early photography with science and industry, on the one hand, and amateur forms of cultivating entertainment like botany and drawing, on the other.

Singular Images, Failed Copies aims to offer a new model to account for the specificity of early photography. Rather than viewing the early image as a "mechanical copy" or a "natural copy," it proposes to see it as a "failed

copy," a simulacrum, through which nature *repeats* more than resembles or traces. The simulacrum, Deleuze argues, is the emblem of repetition as a "difference without concept," that is, it is a sign that interiorizes its difference from the model to the extent that it becomes a destabilizing element through which copy and model are indistinguishable. Early photography, in its dependency on the contingencies of solar light and unpredictable forms of production, resulted in singular rather than identical copies. As Talbot noticed throughout the production of his 1844 book of photographs *The Pencil of Nature,* each copy registered an irreducible difference whose source was nature itself, and consequently dismantled the possibility of a model. Rather than providing a stable "ground," nature, as an inherently temporal entity, becomes a source of change and difference.

By employing Foucault's method of historical analysis to the first decade of photography in England, this book rethinks not only notions of continuity as these pertain to the early history of photography but also notions of discontinuity in relation to contemporary theories of photography, in particular the idea that with digitalization analogical photography became obsolete, as suggested by the term *post-photography.* With the shift to digital forms of production, it is argued, photography loses its privileged "indexical" relation to its referent and thus can no longer function as a document that authenticates the "real," a form of evidentiary "truth."[25] Yet, does the shift to digital forms of production mark an "epistemological break" in the history of photography? Are notions of historical discontinuity as evident as they appear to those who proclaim "the death of photography" in the face of the "virtual"? Perhaps what the current state of "post-photography" enables is precisely the recognition that photography's philosophical and cultural significance was not always associated with the epistemological "quest" for "evidence" and objective "truth." Consequently, it was not always its status as a "mechanical" or "indexical" copy which defined the specificity of the photographic image. Photography's epistemological status never hinged solely on its material or technological mode of production but was always embedded in a highly complex, and often inconsistent, manner within broad historical and epistemological formations, organizations of knowledge, and forms of subjectivity.

In fact, what this book clearly shows is that materiality, in the context of photography, is not in itself a guarantee of "truth" that marks a

privileged "authenticating" relation to the "real." Thus, the elimination
of photochemical materiality in favor of the digital does not necessarily
signal an "epistemological break." The historicity of the photograph per-
tains not only to its material modes of production but also to its forms
of intelligibility that are much more varied and complex than the by now
exhausted reductive opposition between representation and authentica-
tion. Consequently, virtuality is not the new condition that defines pho-
tography but precisely the condition that points to its long-term and
highly complicated relation to the epistemological regimes in which it
was formed. Virtuality is the outcome not simply of a technological rev-
olution in image production but also of a different way of thinking and
making visual images beyond "representation," a form of thought that,
as Deleuze shows, is based on notions of resemblance, truth, and identity.
This operation can be performed and actualized with any photographic
means, both analogical and digital.

In this regard, one of the primary critical and theoretical motivations
of this book is to *reclaim* the early history of photography in order to re-
consider the way it came to be conceptualized in postmodern theories of
photography: primarily, the way photography is assigned essential forms
of intelligibility, such as the index and the simulacrum, and is turned into
a predominantly "theoretical model" for the deconstruction of modernist
theories of art and the formation of an "anti-aesthetic" discourse of post-
modern art.[26] Thus, by mobilizing the concept of the simulacrum, this
study problematizes the historical division between modern and post-
modern discourses of art and photography. This division has recently
been challenged by Jacques Rancière, who has shown that the historical
and theoretical assumption of a "radical" break cannot be historically
and conceptually sustained, because terms such as *political* and *nonpoliti-
cal, aesthetic* and *anti-aesthetic,* can be assigned with equal justification
to either side of the break. Rancière argues that the arts of the modern
era belong to what he calls an "aesthetic regime," which manifests not
an exclusive opposition between aesthetic autonomy and the demand
"for the integration of art into life" but an effective negotiation between
autonomy and heteronomy.[27] I employ the same critical strategy by show-
ing that the concept of the simulacrum can be credited to the early his-
tory of photography and not only to its "postmodern condition" as a
"theoretical object" or to its current "virtual" condition.

Moreover, the simulacrum illustrates the fact that criticality is not
opposed to aesthetics. It thus opens the possibility of extracting a different

genealogy of aesthetics that is not merely the "Other" of politics. Thus, one of the primary motivations of this book is to reconsider the relations between aesthetics and photography by pointing out that aesthetics is not simply a "theory of art" or a "science of beauty" but a paradoxical form of knowledge, because it points to the limits of the systematizing and universalizing claims of knowledge. In the United States, postmodern and poststructuralist theories of art developed out of a sustained criticism of Clement Greenberg's modernist notion of medium specificity, and as part of this attack the term *aesthetics* became completely conflated with formalism and reified notions of taste and beauty. This led to a highly reductive understanding of aesthetics, as Jae Emerling has recently argued.[28] Consequently, within these theories the imagination became a major target of critique because of its anthropological and humanist associations.[29] Yet, by tracing the formulation of the faculty of the imagination in Kant's and Coleridge's aesthetic theories, I show that the imagination is not simply what marks and distinguishes the "creative genius" but a central destabilizing element of the modern conditions of knowledge. For both Kant and Coleridge, the imagination points to the unresolved relations between the empirical and the transcendental, and aesthetics is the realm where this problematic is manifested most clearly, because it is the site where knowledge and experience are formed without guiding concepts. It is also striking that for both Kant and Coleridge the imagination is primarily defined as a "principle of life" and not simply as an element or factor of representation. Thus, it is in relation to these aesthetic theories that it is possible to show how in the early stages of its formation, the photographic image was an "image without a concept"; while constantly evoking specific epistemological figures, like the inductive method, or pictorial genres and systems of representation, such as the picturesque, it was also consistently pointing to their limits.

Within this study, aesthetics is analyzed as a critical form of knowledge and not merely as a subjective one. For Deleuze, aesthetics is also not a "disinterested" discourse of art but a model for "the science of the sensible" as that which manifests a modality of difference that is grounded in the sensible itself, in its history and genesis before its consolidation into "representation" as a concept or idea, a defined subject and object. More recently, Rancière has shown that aesthetics is a factor of a specific organization of social roles and communality, what he refers to as a particular distribution of the sensible that " defines the allocation of ways of doing, ways of being, and ways of saying, and sees that those bodies are assigned

by name to a particular place and task; it is an order of the visible and of the sayable that sees that a particular activity is visible and another is not, that this speech is understood as discourse and another as noise."[30]

All these historical and contemporary reconsiderations of aesthetics suggest, I argue, that just as the critical viability of photography does not necessarily hinge on its materiality and indexicality, its political currency is not predicated on the elimination of an aesthetic discourse for photography in favor of its role as a "non-aesthetic" facilitator of an ideological critique of institutions and representation.[31] In fact, it is precisely by moving beyond representation, with its shifting models of "truth," that photography's critical claims might be reconsidered. In any case, its current epistemological role will need to be defined not primarily in relation to its technological mode of production but in relation to broad and, as it now seems, highly contested "aesthetic" political regimes of sense and meaning.

Singular Images, Failed Copies: William Henry Fox Talbot and the Early Photograph is divided into two parts. The first part analyzes Talbot's two very different accounts of his discovery of photogenic drawing. It argues that his conceptualization of photogenic drawing is historically and discursively inseparable from the scientific models of discovery he employed and the philosophical premises informing them. The differences between these accounts is symptomatic, I argue, of shifting models of scientific discovery in the early nineteenth century and of the central role the imagination began to receive in discovery accounts. These models are grounded within different epistemologies that present radically different views regarding the relations between the mind and nature.

These models are analyzed in relation to three of the major methodological scientific publications during this period: John Herschel's *Preliminary Discourse on the Study of Natural Philosophy* (1830) and William Whewell's *History of the Inductive Sciences* (1837), followed by his *Philosophy of the Inductive Sciences* (1840). Herschel attributes scientific discoveries to induction as a mechanical process of generalization from experience that is necessarily validated by the "design argument," that is, the conviction of a metaphysical continuity between the human mind and nature. Contrary to this, Whewell argues that scientific discoveries consist in the creative invention of ideas independently of experience by gifted individuals, and that there can be no mechanical laws for discoveries, because the mind is an active and creative force in processes of

reasoning. While Herschel's *Discourse* is grounded in the premises of natural philosophy and presents a set of methodological rules for amateur "men of science," Whewell's *History* marks the emergence of a more specialized form of scientific practice that separates the heroic moment of discovery by a scientific "genius" from the disciplined training of scientists.

Chapter 1 thus focuses on Talbot's first account, in 1839, "Some Account of the Art of Photogenic Drawing; or, The Process by Which Natural Objects May Be Made to Delineate Themselves without the Aid of the Artist's Pencil," in which Talbot presents his object of discovery, a fixing method to prevent the complete blackening of silver-sensitive paper, as the outcome of an inductive process of reasoning. He also states that the phenomenon he discovered presents a "new proof" for the validity of the inductive method of science. I analyze Talbot's statements in relation to Herschel's *Discourse* and the tenets of Common Sense philosophy, which was formed as a response to Hume's skepticism and materialist atheism. I point out that the inductive method was an object of controversy during this period because of the emergence of new forms of scientific practice.

I also point to the close relations between methodological debates and broad historical concerns, mainly the accelerated industrialization of material production in Britain and its disturbing social and cultural effects. The idea of the division of labor, in particular, underlay discussions of the scientific method as a form of "mental deskilling" in which the mind was seen as composed of a highly regulated set of processes, like a well-organized factory. In fact, the operations of the mind can be supplemented by machines, as Charles Babbage demonstrated with his calculating machine and "Analytical engine." I discuss Babbage's theories of manufacturing and show how they informed Talbot's conceptualization of photogenic drawing as the product of deskilled labor.

Chapter 2 focuses on Talbot's second major discovery account, "A Brief Historical Sketch of the Invention of the Art" (1844), which appeared in his book *The Pencil of Nature*. In this account Talbot presents the object of his discovery as an "idea," fixing the images of the camera obscura, and attributes it to an unaccountable imaginative thought that cannot be explicated through any method. I show how this process of discovery is modeled on Whewell's writings, as well as those of other writers who, as a response to Kant's famous suggestion that Newton cannot be considered a genius because he presented his discoveries in an orderly manner,

insisted on the important role of the imagination in scientific discoveries. I trace the emergence of the imagination as a creative faculty to Kant, and analyze in detail the way it informed English romanticism, in particular Coleridge's aesthetic theories, which directly inspired Whewell's account of discovery. I analyze Coleridge's notion of the imagination as a critical reaction to empiricism and as symptomatic of the emergence of the modern episteme of knowledge. Coleridge's emphasis on the subjectivity of the poet, and on the inherent temporality of both cognitive and natural processes, marks the birth of "Man," what Foucault describes as an "empirico-transcendental doublet." The emergence of this figure manifested a radical break between the mind and nature that the imagination as a synthetic faculty was supposed to reunify, yet its very existence only emphasized the gap between the two.

It is through Coleridge's aesthetic ideas that I point to a shift in the epistemological status of the camera obscura during this time, from a disembodied model of vision into a corporeal and subjective one that displays the creative capacities of "Man." I demonstrate this shift through a discussion of the picturesque as an intermediary aesthetic category between the beautiful and the sublime that displayed the increasing role of the imagination in the appreciation and depiction of nature and the epistemological inconsistencies this new emphasis led to. I conclude this theoretical and aesthetic discussion with an analysis and discussion of Talbot's images of landscape.

Part II of the book examines the historical specificity of the early photograph as a new kind of image. It closely examines the way the early photograph was historicized, analyzed, and discussed by its early practitioners in reviews and criticism on photography in different journals and newspapers that appeared in the 1840s, as well as in the early histories of Robert Hunt. Chapter 3 shows that, for early practitioners, the photographic image was conceived to be very different from the image of the camera obscura. Many of them noticed that whereas in the camera obscura the image forms itself instantaneously and uniformly, the photograph develops through time. Thus, the camera-obscura image was always the same, because it excluded time from its process of formation, whereas the photograph introduced time as a differentiating element into its form of production, resulting in a variety of contingent, unaccountable effects. Nature might be drawing, early practitioners noticed, but not in the form of the "Same."

These insights and arguments explain the emphasis on botanical imagery in Talbot's work. Through a close visual analysis of these images, I show how in their mode of formation and compositional and formal aspects, nature appears as a dynamic force of life. I argue that once nature is conceptualized as an irreducible temporal force, the "encounter" between nature and image becomes productive more than reproductive. That is, something *new* is formed, an abstract diagram that ceaselessly folds and differentiates by inseparably linking the material, formal, and visual aspects of the image. It is these characteristics of the image which also prevented it from becoming a botanical illustration, as I show. I also address the experimental photographic work of Herschel, who argued that photographic processes "pervade all of nature," to unexpected results and effects. I discuss his "vegetable photography," in which he used juices from petals of flowers and roots to examine the possibility of color photography. I show how these experiments led Herschel to explore perceptual phenomena that could not be explained through the premises of representation.

Chapter 4 of the book is focused on *The Pencil of Nature,* in which Talbot offered a range of applications to photography. I relate Talbot's statements in *The Pencil of Nature* on the evidentiary status of the photograph to the role of documents in literary genres of writing. I show how his statements were informed by his philological and classical studies of ancient texts, the works of romantic historians such as Thomas Babington Macaulay, and the historical novels of Sir Walter Scott, to whom Talbot dedicated his second book of photographs. For Talbot, I argue, documents always manifest a specific temporal modality, because they are the products of a division between present and past, a subject of knowledge and a "mute" object that needs to be decoded. A document is therefore an inherently open and multilayered literary artifact, which inevitably manifests heterogeneous forms of intelligibility as its meaning shifts based on the specific conditions of its production, reception, and contextualization. Intelligibility is a function of time, yet time is simultaneously a source of constant change and the intellectual "absolute horizon" within which things acquire their meaning. Time becomes an "origin" in historicism, but one that cannot ever ground knowledge's claim for consistency and universality.

Moreover, romantic historians emphasized that the role of the historian is not simply to present "facts" but to construct convincing narratives that

will trigger the readers' imagination and enable them to experience the past. Thus, for Talbot in *The Pencil of Nature,* the value of the photograph as a document consists not simply in its capacity to copy, to accurately depict everything the camera sees, but also in its capacity to evoke the imagination by introducing unexpected details. Consequently, the problem for Talbot is not how to "authenticate" the past or prove "what has been" but how to make the past alive and intimate: the reenactment of the past, not its authentication.

PART I

British Science and the
Conception of Photography

1 Scientific Method

The Engine of Knowledge

Wᴵᴸᴸᴵᴀᴹ Hᴇɴʀʏ Fox Tᴀʟʙᴏᴛ presented his discovery paper "Some Account of the Art of Photogenic Drawing; or, The Process by Which Natural Objects May Be Made to Delineate Themselves without the Aid of the Artist's Pencil" at the Royal Society on January 31, 1839. In this paper Talbot announced that he discovered a "method" for "fixing" the discoloration of papers that were exposed to the violet rays of solar light, what he called the "preserving process." Although this essay contains no specific chemical details identifying the "fixing" agent that could prevent the complete blackening of the paper on which an image was formed, it nevertheless emphasizes the empiricist premises and ethos of the discovery process, in which ideas and observations are always corrected by experience and no fact can be validated by a priori arguments, only by experiments. Thus, rather than providing information on his actual experiments with chemical substances, Talbot explains in length the logical (and abstract) process of inductive reasoning that underlay his experiments.[1]

At this early point of his discovery of photogenic drawing, Talbot remained doubtful as to its practical value and possible applications to the copying of paintings and engravings,[2] but he was reassured of the epistemological value of his method of discovery:

> This remarkable phænomenon, of whatever value it may turn out in its application to the arts, *will at least be accepted as a new proof of the value of the inductive methods of modern science*, which by noticing the occurrence of unusual circumstances (which accident perhaps first manifests

3

in some small degree), and by following them up with experiments, and varying the conditions of these until the true law of nature which they express is apprehended, conducts us at length to consequences altogether unexpected, remote from usual experience, and contrary to almost universal belief.[3]

This strong statement far exceeds the modest tone of Talbot's comments about the benefits of photogenic drawing as a copying method with possible scientific applications, for example, in copying the images of the solar microscope. It proposes to see photogenic drawing as an epistemological figure in itself that provides a "new proof" for the validity of the inductive method and for science as a form of knowledge and practice. Yet, although this statement in the context of the history of photography can be read as predicting the photograph's unique future modern epistemological status as a form of "objective" and "impartial" evidence, within the specific history of early Victorian science the validation of discoveries through induction was quite generic. That is, discussions of methodology were common among "men of science" in the 1830s in Britain and functioned as important rhetorical resources to demarcate scientific from nonscientific knowledge. Science historian Richard Yeo argues that emphasizing the application of rigorous and repeatable procedures gave moral certainties to discoveries, and therefore "statements about the efficacy of a single scientific method became intimately associated with the definition of natural science. Furthermore, claims about this method entered into the apologetics by which men of science sought to promote the political, social and cultural value of their activities."[4] Similarly, Simon Schaffer argues that discoveries offer a model of scientific practice through which the knowledge and techniques are reproduced and "scientists enter and remain in a defined scientific culture."[5]

This suggests that it is not photogenic drawing that secures the validity of induction as a method of discovery but quite the other way round: it is the philosophical and scientific premises that are associated with induction and the legacy of British empiricism that secure the status of photogenic drawing *as* a scientific discovery while reconfirming Talbot's membership in the scientific milieu that is represented by the Royal Society. Yet, given that Talbot also states that photogenic drawing provides a "new" proof for the value of the "inductive method," he also implicitly indicates the *necessity* of a proof in the face of new challenges, thereby suggesting that in the 1830s both science and the inductive method were

not secured and in urgent need of "reassurance." Thus, Talbot's mode of conceptualization and characterization of photogenic drawing as a scientific discovery and copying method, I argue in this chapter, is historically and discursively inseparable from the specific conditions of knowledge that constituted natural philosophy as a viable framework for the study of nature in the early nineteenth century and its collapse in the 1830s and 1840s. In this regard, the conception of photography marks not the "birth" of an "ideal" form of empirical or positivist "truth" and evidence but precisely the *crisis* in the epistemological ground that informed the production of knowledge in the seventeenth and eighteenth centuries.[6]

Victorian Science and the "Law of Continuity"

In his statement about the inductive method, Talbot also describes a practice that is based on the observation of nature and the discovery of laws that seem to counter experience and belief. And in a letter to the *Literary Gazette,* Talbot states, "But after all, what *is* Nature, but one great field of wonders past our comprehension? Those, indeed, which are of everyday occurrence, do not habitually strike us, on account of their familiarity, but they are not the less on that account essential portions of the same wonderful Whole."[7] These statements, with their emphasis on wonder and belief, on the one hand, and law and experience, on the other, encapsulate the moral convictions of the Victorian natural philosopher as described by John Herschel in his seminal *Preliminary Discourse on the Study of Natural Philosophy* (1830): "The character of the true philosopher is to hope all things not impossible, and to believe all things not unreasonable. . . . Accustomed to trace the operation of general causes, and the exemplification of general laws, in circumstances where the uninformed and unenquiring eye perceives neither novelty nor beauty, he walks in the midst of *wonders*: every object which falls in his way elucidates some principle, affords some instruction, and impresses him with a sense of harmony and order."[8] Because Herschel's *Discourse* is described by philosophers and historians of science as "the epitome of the nature and ethos of early Victorian science,"[9] its analysis is crucial for an understanding of the cultural and philosophical premises of British science that informed Talbot's conceptualization of photography. Most important, Herschel was closely involved in Talbot's photographic experiments and was himself the inventor of a number of photographic processes that will be discussed in chapter 3. He was also the one who suggested the term *photography* for Talbot's new method of copying, as well as the terms

negative and *positive*.[10] Yet an analysis of the *Discourse* also indicates that it presents a complex view of the empiricist foundations of British science; thus, far from presenting an actual consensual view of scientific method, it opens a highly debated field of closely related epistemological, philosophical, scientific, and institutional concerns.

The *Discourse* was published as part of Rev. Dionysius Lardner's popular *Cabinet Cyclopaedia*. This educational and political project was conceived to diffuse scientific knowledge to all classes; thus, Herschel is explicitly addressing the student of natural philosophy in the *Discourse*. Each of the subject divisions in the *Cyclopaedia* opened with an introductory treatise, and Herschel's book was intended to introduce the physical sciences as part of a conscious effort to unify the study of nature under an inductive method of inquiry. Herschel precedes his methodological prescriptions with a general discussion on the advantages of the scientific study of nature. The fact that Herschel found it necessary to justify science in the *Discourse* suggests that its status and value were not securely established for the broad audience. Thus, different reviews of the book in important periodicals such as the *Athenæum* and *Fraser's Magazine* associated the popular aspect of the book with an effort to challenge the public view of science, as opposed to religion, by emphasizing the utility of the physical sciences to both material and spiritual life.[11] The publication of the *Discourse* was therefore part of a collective effort within the scientific community to define natural knowledge and to legitimize its cultural status, given that in the early part of the nineteenth century, as Yeo argues, science was a "marginal activity that had to be defined" and that did not enjoy "the cultural and institutional security" that it enjoyed in the second half of the nineteenth century. Yeo states that science's "prestige was lower than rival forms of intellectual activity, such as theology and the classics, which, even if they did not attempt to explain the natural world, stood as powerful examples of culturally sanctioned bodies of knowledge. In spite of the popularity of some sciences in the early nineteenth century, there is evidence of a distance between scientific inquiry and other intellectual pursuits."[12] Yeo's thesis is supported by the fact that in the same year in which the *Discourse* appeared, Charles Babbage published his notorious *Reflections of the Decline of Science in England*, an event that in many ways triggered the constitution of the British Association for the Advancement of Science (BAAS) in 1831.

Thus, the *Discourse*'s emblematic status in the early nineteenth century derives from its efforts to legitimize science within culture as a practice

for the cultivation and enforcement of moral values and religious convictions, and at the same time to insist on the independence of scientific inquiry from natural theology. It thus addresses scientific methodology as a specific "neutral" field within the philosophy of science, one that is detached from broad epistemological concerns. And although his formulation of induction as a scientific method is based on empiricist presuppositions regarding experience as the source of knowledge, Herschel evades any in-depth discussion of empiricism as an epistemology. In this regard the *Discourse* is situated within the British empiricist philosophical tradition, yet at the same time it displaces its main focus by evading its central epistemological concerns.

Herschel saw the *Discourse* as an adaptation and elaboration, following recent discoveries in the physical sciences, of Francis Bacon's *Novum Organum* (1620). Bacon's philosophy of science and his methodological prescriptions are mobilized by Herschel in the way he describes knowledge as power that is pursued collectively for the benefit of humankind as part of a process in which nature is subjected to human will; yet at the same time he stresses the pursuit of truth as purely moral and psychological and therefore as divorced from practical applications. Herschel also invokes Bacon's theory of prejudices as idols in relation to which any preconceived (social, cultural, linguistic, psychological) idea not grounded in experience is cleared from the mind as a condition for a reliable scientific inquiry. His main interest lies in Bacon's formulation of scientific method as a *mechanistic* system that *regulates* the operations of the mind and the senses: "There remains but one course for the recovery of a sound and healthy condition—namely, that the entire work of understanding be commenced afresh, and the mind itself be from the very outset not left to take its own course, but guided at every step; and the business be done *as if by machinery.*"[13]

Bacon's method is thus designed to eliminate the epistemological and psychological limitations of the mind and the senses by providing a system of external regulative correction for each: "For I do not take away authority from the senses, but supply them with helps; I do not slight the understanding but govern it."[14] That is, it is by being exclusively regulative that the system is corrective, because it delimits in advance the sensorial conditions for inquiry through direct observation and planned experiments. And instead of relying on the mind's unaccounted capacity for generalization, it prescribes a system of notation through which "scattered and dispersed particulars" of inquiry are organized by means of

"Tables of Discovery" (the Table of Essence and Presence, Table of Deviation or of Absence in Proximity, and Table of Degrees or Comparison). Induction is thus defined as an inherently technical process of generalization based on elimination. The main advantage of this process is that it is performed by "successive steps not interrupted or broken," in "accordance with a fixed law, in regular order" leading from lesser axioms to general ones.[15]

It is these qualities of Bacon's method that Herschel emulates in the *Discourse*. He thus starts his concrete discussion of method with definitions of observation and experiment as conditions for the rapid progress of scientific knowledge and as aids to the mind and the senses in the process of reasoning. By recuperating the main premises of Bacon's scientific method, if not necessarily the particular prescriptions of his method, the *Discourse* legitimizes his view of scientific method as "neutral" and independent from epistemological concerns. Yet this should not be taken to mean that the *Discourse* itself was not grounded in a particular epistemology that in many ways determined its ontological assumptions and methodological prescriptions. Rather, it is precisely in its avoidance of any in-depth epistemological discussions that Herschel's *Discourse* reveals its indebtedness to the Scottish school of Common Sense philosophy.

Science historian Richard Olson points out that scientific accounts in England were informed by the philosophical and methodological works of Scottish Common Sense philosophers such as Thomas Reid, Dugald Stewart, Thomas Brown, and William Hamilton. Common Sense philosophy arose out of a critical response to the philosophical work of David Hume. Reid's *Inquiry into the Human Mind* (1764) was thus conceived to defend the religious beliefs and moral tenets of moderate Scottish Presbyterianism against the corrosive influences of atheistic skepticism, on the one hand, and necessitarian materialism (as argued by David Hartley and, later, Joseph Priestley), on the other.[16] Reid's response was based on the notion that these philosophies contradict "certain principles . . . which the constitution of our nature leads us to believe, and which we are under a necessity to take for granted in the common concerns of life."[17] These principles, Olson states, the "principles of common sense," are impossible to "disbelieve and impossible to prove," so they must be accepted as unproven ultimate principles, like the axioms of geometry. No amount of reasoning can either justify or undermine genuine principles of common sense, such as man's moral free agency; if they are contradicted, then those philosophical systems which contradict them are in error.[18]

Olson explains that within Scottish philosophy discussions of scientific method were motivated by an effort to use natural science as a model for moral philosophy and for a general "science of the mind" in order to unify all branches of philosophy. And by adopting a rigorous form of an empiricist method that was founded by Bacon but reached full maturity in Newton, Reid was creating a safety measure against critical skepticism. He thus claimed that Hume and Hartley went wrong, because they became engaged in "imaginative hypotheses about natural phenomenon" and did not follow Bacon's successive ladder of reasoning. Reid constantly referred to Newton's famous claim in the third book of the *Principia*: "I frame [feign] no hypotheses, and hypotheses, whether metaphysical or physical, whether of occult qualities or mechanical, have no place in experimental philosophy. In this philosophy particular propositions are inferred from the phenomena, and afterwards rendered general by induction."[19]

Following Newton, Common Sense philosophers emphasized that the true aim of natural philosophy is not to determine efficient causes but only to discover connections between phenomena and to express them as general rules or laws. These laws, which are descriptive and not explanatory, are arranged according to levels of generality, and natural philosophers try to find a minimum number of basic laws in order to connect a maximum number of phenomena. Scientific theory was thus conceived to guarantee certainty based on one metaphysical first principle: that God governs nature by temporally immutable laws, and therefore natural connections that were observed in the past will continue to hold in the future. This principle, the "inductive principle," was considered to be one of the "principles of common sense" that cannot be rationally or empirically proved but that therefore cannot be doubted, as Reid describes it:

Upon this principle of our constitution, not only acquired perception, but all inductive reasoning, and all reasoning from analogy, is grounded; and, therefore, for want of another name, we shall beg leave to call it *the inductive principle*. It is from the force of this principle that we immediately assent to that axiom upon which all our knowledge of nature is built, that effects of the same kind must have the same cause: for *effects* and *causes*, in the operations of nature, mean nothing but signs and things signified by them. We perceive no proper causality or efficiency in any natural cause; but only a connection established by the course of nature between it and what is called its effect. Antecedently to all reasoning, we have, by our constitution, an anticipation that there is a fixed and

steady course of nature; and we have an eager desire to discover this course of nature.[20]

It is striking that as much as Reid wants to avoid Hume's skepticism, he nevertheless ends up adopting Hume's concept of causality that precludes the possibility of discovering efficient causes. Thus, like Hume, he argues that the basic belief in the notion of causation is a dictate of common sense or a law of human thought: "[W]e simply cannot avoid believing that every change or event must have a cause."[21] This radical reconsideration of causality marks, as Gilles Deleuze argues with regard to Hume's philosophy, a crucial epistemological displacement, "for it puts belief at the basis and the origin of knowledge."[22]

Herschel's *Discourse* is grounded within the epistemological and metaphysical premises of Common Sense philosophy, as his philosophy of science is based on a commonsense belief in the metaphysical argument of design. In the *Discourse,* Herschel presents the argument that God is both the creator and sustainer of a regulated and ordered physical world: "Thus he [man] is led to the conception of a Power and an Intelligence superior to his own, and adequate to the production and maintenance of all that he sees in nature."[23] And, in a way similar to Reid, Herschel states that the aim of science is to search for laws and not efficient causes or essences: "Dismissing, then, as beyond our reach, the enquiry into causes, we must be content at present to concentrate our attention on the laws which prevail among phenomena, and which seem to be their immediate results" (91).[24]

Herschel thus delimits the aims of science on the same epistemological grounds as those of Reid: the nature of the relations between the human perceptual apparatus and physical reality. His account of perception echoes Reid's: "As the mind exists not in the place of sensible objects, and is not brought into immediate relation with them, we can only regard sensible impressions as *signals* conveyed from them by a wonderful, and, to us, inexplicable *mechanism*, to our minds, which receives and reviews them, and by habit and association, connects them with corresponding qualities or affections in the objects; just as a person writing down and comparing the signals of a telegraph might interpret their meaning" (83–84; emphases added). By insisting that it is only by habit and association that we interpret signals and relate them to the object's attributes, Herschel makes clear that his theory of knowledge, like Reid's and Hume's, is empiricist and associationist. Similarly to Hume and other

empiricist philosophers such as Locke, who differentiated impressions or sensations from "ideas," Herschel distinguishes between sensation and perception as a judgmental act: "[T]hough we are never deceived in the *sensible impression* made by external objects on us, yet in forming our judgments of them we are greatly at the mercy of circumstances, which either modify the impressions actually received, or combine them with adjuncts which have become habitually associated with different judgments" (83; emphasis in original). And although in the *Discourse* Herschel never directly addresses the mind's capacity to form general or abstract ideas and judgments, in his 1841 review of William Whewell's *History of the Inductive Sciences* (1837) and *Philosophy of the Inductive Sciences* (1840), books that presented a radically different account of induction, as I will show in the next chapter, he explains the operations of the "plastic faculty" through which the mind, based on experience alone, generalizes and creates abstract and universal categories:

> Thus, from the impressions it [the mind] receives from its own acts, states, and faculties . . . the ideas or conceptions of personal existence and identity, time, and mental power arise within it. Again, from those which it receives directly (and antecedently to all *other* experience), from its connexion with the body, it is led to form in a similar way its conceptions of space and mechanical force, which are therefore, we apprehend, in the most complete and absolute sense *suggested* by experience—by the experience, that is to say, of certain *peculiar mental sensations* . . . which distance, direction, and force, when perceived, excite within us. Then again, from that mixed multitude of impressions received through the bodily senses, it frames to itself, by a similar induction, the conception, fact, or theory . . . of an independent external world. Moreover, from the impressions it receives on contemplating these external relations . . . it rises by a constantly extending and unbroken chain of experience to the *law of continuity*—which is perhaps the highest inductive axiom to which the mind of man is capable of attaining—and, as one of the most important results of this law, to the perception and admission of general truths, on the ground of particular verifications.[25]

For Herschel, the "law of continuity" is both an epistemological law and an ontological precondition. Inductive generalizations are suggested by the continuity of experience and, at the same time, function as inductive inferences regarding the uniformity and regularity of physical reality.

The law is ultimately metaphysical and circular and is based, like Reid's "inductive principle," on the design argument that grounds and validates the necessary correlation between the ontological regularity of nature and the epistemological consistency of the human mind. Thus, in the context of early nineteenth-century British empiricism, the term *induction* meant two very different operations: on the one hand, for Common Sense philosophers, the instinctive epistemic activity of the mind that is based on belief and cannot be validated in any manner; and, on the other hand, a methodical process of generalization through which the mind forms "laws" based solely on sensations "impressed" upon it by experience. In the *Discourse,* Herschel avoids an elaborated discussion of the origin of knowledge, because he wants to discuss induction from a methodological perspective as part of a reliable and valid scientific method and not merely as a principle of belief. The only way to validate induction "externally," outside epistemology, is to describe it, following Bacon, as mechanistic. Herschel thus defines laws of nature as the outcome of processes of analysis and classification of phenomena that are based on resemblance between attributes or on analogy in the relations between attributes. Laws are general propositions that are discovered by grouping together particular facts or individual objects under "points of agreement." Consequently, Herschel's description of induction follows Bacon's ladder of progressive and continuous reasoning: "[W]hen we have amassed a great store of such *general facts,* they become the objects of another and higher species of classification, and are themselves included in laws which, as they dispose of groups, not individuals, have a far superior degree of generality, till at length, by continuing the process, we arrive at *axioms* of the highest degree of generality of which science is capable. This process is what we mean by induction" (102; emphases in original). Yet Herschel might have sensed that this account of induction as a process of discovery of laws could not be validated, because he eventually states, "In the study of nature, we must not, therefore, be scrupulous as to *how* we reach to a knowledge of such general facts: provided only we verify them carefully when once detected" (164; emphasis in original). Verification, for Herschel, means inductive inference in which the applicability of a law is extended by applying it to cases that were not part of the discovery. Herschel also states that, in verification, "the successful process of scientific enquiry demands continually the alternate use of both the *inductive* and *deductive* method" (174–75; emphases in original), thus acknowledging the complex and heterogeneous nature of scientific inquiry. Moreover,

in opposition to the strict methodological prescriptions of the Common Sense philosophers, Herschel acknowledges the necessity and productivity of forming hypotheses and theories in higher levels of generalization, and the productive value of hypotheses in scientific inquiry. Theories, although "creatures of reason rather than of sense" (190), can occasionally lead to the discovery of actual proximate causes or the underlying structure and "mechanism of the universe and its parts": "[I]t may happen (and it did happen in the case of the undulatory doctrine of light) that such a weight of analogy and probability may become accumulated on the side of an hypothesis, that we are compelled to admit one of two things; either that it is an actual statement of what really passes in nature, or that the reality, whatever it be, must run so close a parallel with it, as to admit of some mode of expression common to both, at least in so far as the phenomena actually known are concerned" (196–97).

Herschel's revaluation of hypotheses and theories within the process of discovery was very much formed out of the controversy in Britain in the 1830s surrounding the wave theory of light, which challenged Newton's conception of light as a ray consisting of material particles, by, among other things, forming a mathematical hypothesis that was confirmed by an experiment and that led to a discovery.[26] Herschel took active part in the controversy and was responsible for publicly introducing the wave theory to Britain in his 1827 essay "Light," written for the *Encyclopedia Metropolitana*. The essay was not published until 1845, yet Herschel sent copies to Whewell, Talbot, Thomas Young, David Brewster, and George Airy. Science historian Geoffrey Cantor indicates that Herschel was the only figure within the British scientific establishment who was able to coherently present and evaluate the wave theory in relation to the projectile theory, as he had extensive knowledge of both physical optics and analytical mathematics. Yet Herschel's essay not only introduced the two rivaling theories of light but also included a discussion of subjects that were not related to the debate, such as the interaction of light with chemical substances, which informed his own photographic experiments.[27] Talbot also contributed to this debate, and in 1835 he published "On the Nature of Light" in support of the wave theory of light based on its explanatory power, and suggested a mechanism of light absorption. He stated that waves of light are a "theoretical possibility," since it is doubtful whether the particles composing the ether are capable of executing vibrations with a rapidity compatible with those of light. Talbot's essay on light is part of a series of essays he wrote on this topic during the 1830s,

and its significance lies in the fact that it addressed the nature of light from a physical perspective, and that he used the blackening of silver salts as an abstract technique in these experiments.[28] That is, the knowledge that silver salts darken upon exposure to light was known and used by Talbot as part of his scientific experiments before it was applied to purposes of representation. The darkening of silver salts formed an "experimental apparatus" as part of a debate on the physical nature of light. Talbot's contribution to this debate was minor, but the fact that it polarized the scientific community and challenged its methodological and scientific premises is highly significant, because it points to the fact that it was precisely the value of experiments as empirical forms of demonstration and validation that was challenged with the wave theory of light. Although Talbot constantly emphasizes the value of experiments and the primacy of experience in his discovery papers, this emphasis was much more rhetorical and moral, as Yeo argues, than epistemological, because at this historical junction it was precisely the emphasis on commonsense experience that was revealed to be inadequate for the purposes of scientific inquiry.

Cantor emphasizes that theories of light are not discrete theoretical entities but always relate to broad scientific theories, to methodological concerns, and to metaphysical or theological doctrines. A change of theory is therefore always indicative of broader and multilayered change within the research program and practice of a specific scientific community. He points out that the definition of optics became much more restricted as a result of the shift from the conceptual framework of natural philosophy to theoretical and mathematical physics. In the early eighteenth century, the study of optics referred to the study of the faculty of vision, while in the midcentury there was a shift toward an explanation of the physical qualities of light itself. The debate was therefore "not simply over theories of light but centered instead on a range of issues embracing the very aims and practice of science," what Cantor calls conflicting "scientific styles."[29] Among science historians, the emergence of the wave theory of light in the 1830s marks the birth of modern physics as a specialized scientific discipline that brought together mechanics and previously nonmechanical phenomena (such as heat, light, electricity, and magnetism) under one single conceptual structure. Within this framework, A. J. Fresnel's wave theory of light, which supposed that light was propagated by the vibrations of mechanical ether, was one of the

major developments through which speculative and qualitative theories of nonmechanical phenomena were displaced by mechanical and mathematical ones.[30] As science historian Robert H. Silliman explains, the wave theory was crucial to the emergence of modern physics:

> The establishment of the wave theory of light was the first substantial setback of the Newtonian system. The conversion to wave optics did not merely presage the more general theoretical shift away from fluid theories; wave optics provided a powerful model for reforming the other branches of physics. . . . Since evidence of intimate relations between the various classes of physical phenomena had also grown, physicists inevitably came to focus their attention on the new theory of light. *Substituting process for substance, motion for matter, and continuity of action for action at a distance*, the wave theory sanctioned general conceptions that could be applied elsewhere.[31]

The wave theory thus served as a model for other physical fields and, through its use of new mathematical quantitative deductive models, also manifested the extending gap between a mechanical and dynamic worldview that presupposes an ontology of particles of matter in motion, like Newton's mechanics, and hypothetical mechanical models that are constructed in order to demonstrate mechanical principles, or the structure of physical reality.

Consequently, the wave theory of light challenged not only Newtonian projectile theories of light but also the most profound philosophical and methodological premises of British science, which out of commitment to the legacy of Common Sense philosophers rejected the use of theories and hypotheses in scientific practice. And because in Fresnel's theory the status of the ether was hypothetical, whereas "proofs" for its mechanical operations were deductive and mathematical—but not inductive, because they couldn't be empirically observed or verified through the detection of "real" causes—the wave theory was epistemologically evaluated as a successful explanatory hypothesis but not as a "law" that describes "what really passes in nature," as Herschel states in the *Discourse*. In the debate, Herschel, Whewell, and Airy supported the theory, whereas the remaining supporters of the projectile theory, such as Brewster, Henry Brougham, and Richard Potter, rejected it. Public debates were waged in the annual meetings of the BAAS and in poplar scientific magazines, such as the

Philosophical Magazine and the *Edinburgh Review*. Cantor explains that there were also institutional factors involved, as those who rejected the wave theory had strong connections with the industrial North and attended Edinburgh University, whereas the theory's supporters were connected with university education and were educated either at Cambridge or at Trinity College Dublin, the two major centers of analytical mathematics during this period. He argues that the biographical profile of the main figures in the debate indicates "the historical connection between the new mathematics and the rise of the wave theory," and consequently it "signifies the declining role of the amateur natural philosopher in technically demanding subjects such as optics and the emergence of the highly trained mathematical physicist who was usually a specialist and professionally connected with science."[32]

This suggests that the *Discourse* and Talbot's statements about the inductive method in relation to his discovery of photogenic drawing need to be read not simply as the presentation of a consensual view on the nature and value of scientific inquiry but as a *response* to scientific and philosophical projects that undermined the belief in a unified and valid scientific method based on metaphysical considerations. In this regard the *Discourse* is a "transitory" historical source with a debated status among historians and philosophers of science, because, on the one hand, as Joseph Agassi states, it reaffirms a "philosophy whose foundations were shaking and whose tenets were thrown into serious doubt and confusion";[33] yet, on the other hand, as Larry Laudan argues, the *Discourse* is "revolutionary," as it set the ground for a new methodological regime in which the logic of scientific discovery was abandoned in favor of an effort to formulate a logic of theory evaluation, and this shift "marks one of the central watersheds in the history of philosophical thought, a fundamental cleavage between two very different perspectives on how knowledge is to be legitimated."[34] In either interpretation it is clear that Talbot's evocation of the inductive method in his discovery account does not in any way attribute a clear and consistent epistemological or cultural status to photogenic drawing or ground any claim for it as a model of "truth," because, as Yeo points out, "[D]escriptions of nineteenth century science as 'Baconian' (or even 'inductivist') immediately beg difficult, if not intractable, questions of both definition and evidence. These terms have not had a neutral and stable meaning; rather, they have been objects of controversy and multiple interpretations to an extent which renders them practically useless as simple descriptive epithets."[35]

Representation: The Order of Things

Herschel's "law of continuity" and Reid's "inductive principle" demonstrate what Michel Foucault, in his *The Order of Things,* calls "representation," a historical form of knowledge that constitutes the classical episteme. Representation excludes resemblance from knowledge, as it is grounded in the deceptive and illusionary power of the senses. Bacon's theory of idols as prejudices, for example, points to individuals' psychological tendency to find similarities where there are none, because of the unregulated activity of the faculty of the imagination. Instead of grounding knowledge on resemblance, representation is modeled on a generalized form of comparison—what Foucault calls "mathesis"—as a universal science of measurement and order. In representation, order is established in an intuitive way by creating progressive series that ascend from the simple to the complex. Yet Foucault emphasizes that the classification of things as "simple" or "complex" marks not their inherent "mode of being" but only their place in a successive series of generalizations that correspond to the development of sensations from "simple impressions" to (general or abstract) "complex ideas."[36]

The possibility of ordered successions like Bacon's ladder of reasoning or Herschel's "law of continuity" hinges on analysis as a universal method of knowledge and on the elaboration of signs that function as tools of analysis within knowledge. In this regard, knowledge breaks its direct relation to the divine, as can be seen in Herschel's *Discourse* where he insists on the separation of the creator from the creator's design. Nature is made intelligible not through revelation but through the discovery of systematic laws. Signs as sensations are both related to an object and differentiated from it, and are therefore inseparable from a specific analysis through which they are constituted as marks of identity and difference, what Herschel calls "points of agreement." The sign appears because the mind analyzes, as Foucault explains: "[T]he general theory of signs and the definition of the power of analysis of thought were so exactly superimposed to form a single and unbroken theory of knowledge. . . . In the Classical age, to make use of signs is not . . . to attempt to rediscover beneath them the primitive text of a discourse sustained, and retained, forever; it is an attempt to discover the arbitrary language that will authorize the deployment of nature within its space, the final terms of its analysis and the laws of its composition" (61–63). In its status as an instrument of analysis, language is an inherent property of thought, and thus it

precludes, argues Foucault, the need for a separate theory of signification, because "phenomena are posited only in a representation that, in itself and because of its own representability, is wholly a sign" (65). Consequently, there is no meaning or discourse that is positioned as exterior or anterior to the sign. Thus, when Herschel and Reid both define sensations as signals that are emitted from objects, the precise relation between a sensation and the object it signifies is never explicated. This is because of their mutual assumption that "there is no intermediary element, no opacity intervening between the sign and its content. Signs, therefore, have no other laws than those which may govern their contents" (66). In this regard they are coextensive with representation and thought as a whole, whereas thought itself is inseparable from being: "There will therefore be no theory of signs separate and differing from an analysis of meaning. . . . [M]eaning cannot be anything more than the totality of the signs arranged in their progression; it will be given in the complete *table* of signs. But . . . the complete network of signs will be the *image* of things. Though the meaning itself is entirely on the side of the sign, its functioning is entirely on the side of that which is signified" (66; emphasis in original). Representation binds together thought and being, nature and human nature through a genesis of differing forms progressing from the simple to the complex. Thus, a genesis of natural forms is always simultaneously a genesis of thought from simple sensations to complex ideas. Foucault's analysis elucidates the circular logic behind Herschel's "law of continuity" in which the continuity of experience epistemologically grounds the continuity of nature, while the continuity of nature makes possible and validates the gradual generalizing faculty of the mind.

Yet, as Reid's definition of the "inductive principle" makes clear, the more that representation excludes resemblance and the illusionary power of the imagination from knowledge, the more it remains grounded in both, precisely because of its metaphysical assumption of "a certain continuum of things . . . and a certain power of the imagination that renders apparent what is not, but makes possible, by this very fact, the revelation of that continuity. The possibility of a science of empirical orders requires, therefore, an analysis of knowledge—an analysis that must show how the hidden . . . continuity of being can be reconstituted by means of the temporal connection provided by discontinuous representations. Hence the necessity constantly manifested throughout the Classical age, of questioning the origin of knowledge" (72–73). This explains why the "inductive principle" can be no more than a "commonsense" principle that cannot be

"proved" but can only be believed, because the assumption of continuity is based solely on moral and religious convictions through which separate representations are linked and ordered.

It also discloses why, for Hume as well as other empiricist philosophers and ultimately for Kant as well, the imagination is a highly ambivalent faculty, precisely because it illegitimately reintroduces resemblance and consequently a sense of continuity into knowledge. Although resemblance was excluded from representation as a form of knowledge, Foucault shows that it was still present at the border of knowledge, residing below it "in the manner of a mute and ineffaceable necessity" (68). Thus, even though resemblance is no longer the fundamental relation of being to itself, it is still the simplest form in which what is to be known appears: "[I]t is through resemblance that representation can be known, that is compared with other representations that may be similar to it, analyzed into elements . . . and finally laid out into an ordered table" (68).

Reid needed to defend British empiricism from skepticism precisely because Hume's *A Treatise of Human Nature* (1739–40) exposed the dependency of knowledge on unaccounted resemblances that were made possible by the faculty of the imagination.[37] In the first part of Book 1 of the *Treatise,* Hume links the imagination to memory, because both copy direct impressions or sensations and turn them into ideas that are recalled after the source transmitting the original impression is removed: "We find by experience, that when any impression has been present with the mind, it again takes its appearance there as an idea; and this it may do after two different ways: either when in its new appearance it retains a considerable degree of its first vivacity, and is somewhat intermediate betwixt an impression and an idea; or when it intirely [*sic*] loses that vivacity, and is a perfect idea. The faculty, by which we *repeat* our impressions in the first manner, is called the MEMORY, and the other the IMAGINATION."[38] Ideas created by the imagination are less "vivid" than the ones created by memory. Another difference between memory and imagination is that in the latter, impressions do not necessarily appear in the same order or form in which they originally appeared. The imagination can change and transpose its ideas because it *divides* impressions and ideas: "Where-ever the imagination perceives a difference among ideas, it can easily produce a separation."[39] Yet, given that the imagination can separate and divide as it pleases, in operations that will make it unaccountable, Hume emphasizes that it is guided and "tamed" by the universal principles of association: resemblance, contiguity, and causality. However, for Hume, the

principles of association carry no additional or substantive epistemological value, because they are based on nothing more than habit; they are simply principles of human nature. Most important, in the last part of Book 1, Hume shows how causality, one of the principles that is supposed to "guard" the imagination, is in itself a relation that is fabricated by the imagination, not the senses or the mind, in order to attribute continuous and independent existence to objects that we perceive in impressions that are short, separate, and succeeding one another. Causality introduces a *necessary* connection, not just a repetitious one, between sense impressions that merely succeed each other. Experience can provide us with the idea of "constant conjunction," which is formed out of multiplication of instances, but not the "new" idea of a necessary relation. Only the imagination has the psychological capacity to create new ideas by going beyond the given, by moving from a present object or idea to one that is not present but resembles it.[40] That is, from *similar* repetitious sensations that the imagination "fuses," it presents to the mind an *identical* object. Yet Hume emphasizes that these "false suppositions" or deceptions are responsible for giving a sense of comfort and security in the world, as they are "the foundation of all out thought and actions, so that upon their removal human nature must immediately perish and go to ruin."[41] Hume's philosophy is caught in a paradox, as Deleuze explains: "The principles of human nature . . . impose constant rules . . . laws of passage, of transition, of inference, which are in accordance with Nature itself. But then a strange battle takes place, for if it is true that the principles of association shape the mind, by imposing on it a nature that disciplines the delirium or the fictions of the imagination, conversely, the imagination uses these same principles to make its fictions or its fantasies acceptable and to give them a warrant they wouldn't have on their own."[42] Thus, the continuous "order of things" is inseparable from the conditions under which nature is known, that is, from the principles of human nature that are grounded in the operations of the imagination, which is the only faculty that can produce a sense of continuity.

It is the metaphysical and circular "law of continuity" that underlies representation, which explains Talbot's definition of photogenic drawing as a kind of "wonder" or "natural magic," just before his evocation of the inductive method: "The phænomenon which I have now briefly mentioned appears to me to partake of the character of the *marvellous*, almost as much as any fact which physical investigation has yet brought to our knowledge. The most transitory of things, a shadow, the proverbial

emblem of all that is fleeting and momentary, may be fettered by the spells of our 'natural magic,' and may be fixed for ever in the position which it seemed only destined for a single instant to occupy."[43] This statement marks not the unique or exceptional status of Talbot's discovery but precisely its discursive one, as Talbot explicitly states that the phenomenon he discovered is (almost) "as much as any fact which physical investigation has yet brought to our knowledge," thus indicating that the "marvelous" or "magic" nature of the phenomenon he discovered is inseparable from the scientific method he employed in his discovery and from the philosophical and cultural premises informing this mode of investigation within the discourse and practice of natural philosophy. Natural phenomena are "wonders" because they repeatedly expose, against plain logic, this necessary correspondence between nature and the human mind, and consequently reinforce simultaneously religious or metaphysical convictions and the "independent" validity of physical modes of inquiry. Thus, Talbot's statement indicates the historically specific epistemological status of photogenic drawing as both a *natural* phenomenon produced by light and an inductively discovered *scientific object* produced by an artificial chemical process—a "fixed shadow."

Simon Schaffer argues that the undecided epistemological status of phenomena within natural philosophy as direct objects of observation and scientific abstractions or instrumental productions is what marks the discursive specificity of natural philosophy as a scientific practice. He emphasizes that the discourse of natural philosophy was "structured by the dialectic of the anomalous in contrast with the common-sensical."[44] Thus, "anomalies" or "obscurities" were the prime objects of the natural philosopher's experience, and through them the sense of wonder developed, as Herschel's and Talbot's statements indicate. For Herschel especially, developing this sense of wonder is what distinguishes the natural philosopher from those who possess "the uninformed and unenquiring eye." Schaffer also points out that the anomalous was instrumentally produced through experiments; thus, the experimental "imperative in natural philosophy is grounded by a set of philosophical, methodological and cultural constraints based on 'superfluity' and 'wonder.'"[45] This explains the specific discursive economy underlying Talbot's account, which emphasizes, on the one hand, the primacy of direct experience and, on the other hand, the importance of experiments, because the elucidation of natural phenomena in natural philosophy was not meant to dispel "wonder" but to present or demonstrate it in the first place.[46]

Schaffer shows that natural philosophers often presented their experiments as cultural spectacles in order to attract audiences; thus, within natural philosophy scientific principles were demonstrated through the production of "wonder." As Don Slater argues, based on Schaffer's arguments, the "production of spectacle is not extraneous to science but integral to it." He emphasizes that the "term 'natural magic' describes that kind of spectacular experience around which modern audiences as audiences for modernity are formed: science as a popular cultural experience is constituted through a demonstrable capacity to make nature wonderful, to make it do wonderful things, to have a command over nature's own principles which offer the power to make it perform at will and according to the ends of human imagination and excitement."[47] Another important source for Talbot's use of this term is David Brewster's book *Letters on Natural Magic* (1832).[48] Brewster was one of Talbot's closest scientific associates, introduced to him by Herschel.[49] This book was dedicated to Sir Walter Scott, another significant figure for Talbot, as I will show in chapter 4, who in 1830 published *Letters on Demonology and Witchcraft*. In his book, Brewster argued, in a similar way to Bacon, that it was only through science and experimental rigor that illusions and superstitions can be dispelled. Thus, the term "natural magic" was not specifically applied to photography but was used generically to describe the premises behind the study of nature as a collection of "wonders," and at the same time to highlight the experimental apparatuses through which this sense of wonder is displayed and ultimately scientifically dismissed through the inductive discovery of laws.

Some historians of photography, for example, Carol Armstrong, interpret Talbot's designation of photogenic drawing as "natural magic" in light of Roland Barthes's claim, in his *Camera Lucida,* that "the realists do not take the photograph for a 'copy' of reality, but for an emanation of *past reality*: a *magic*, not an art."[50] In its status as an emanation from a "real body," the photograph becomes an index, a "certificate of presence," the ultimate proof that something "has been." Thus, from a phenomenological point of view, Barthes argues, the photograph's "power of authentication exceeds the power of representation."[51] Based on Barthes's argument, Armstrong states that, for nineteenth-century practitioners, "photography seemed to proffer something extraordinary, without precedent, whose uses could only just begin to be imagined. That something was the photograph's unique ability to authenticate. This was a function of its fundamental indexicality, . . . its status as a 'literal emanation from the

referent,' . . . and its 'tautological' relation to it."[52] Yet Barthes's insistence on the photograph's "extraordinary" character has no conceptual and discursive affinity with Talbot's statement, regardless of their use of similar words. Talbot's formulation simply reinforces the conformity of the photograph to specific modes of physical investigation and to the philosophical conditions informing them, rather than pointing to its "extraordinary" character. It is therefore not a subjective phenomenological response to the uniqueness of the photograph as a "real" trace of the past which constitutes it as "magic," but the historical and discursive conditions of its formation within representation as a historically specific form of knowledge. The issue is not photography's "mad" status as a "direct emanation from the referent" but its reducibility to specific scientific and philosophical forms of intelligibility in which the "scientific" observation of nature is subjected to theological convictions that cannot be grounded epistemologically or materially.

Consider Talbot's photomicrograph *Insect Wings* (Figure 1.1). In his account he discusses the application of his copying method to the solar microscope and states, "The objects which the microscope unfolds to our view, curious and wonderful as they are, are often singularly complicated. The eye, indeed, may comprehend the whole which is presented to it in the field of view; but the powers of the pencil fail to express these minutiae of nature in their innumerable details."[53] The image is meant to present not a proof that an object "has been there" but Talbot's belief, as stated earlier, that nature is "one great field of wonders." The image allows one to "see" natural objects as "curious and wonderful," that is, to

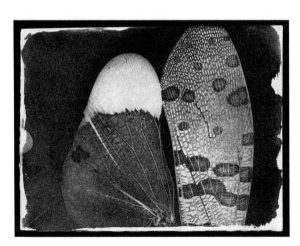

Figure 1.1. William Henry Fox Talbot, *Insect Wings*, photomicrograph, negative print, ca. 1839. National Media Museum, Bradford, U.K./ Science & Society Picture, London.

expose the dialectic between the "obscure" or "strange" and the common-sensical. On the one hand, these are simply wings of an insect, a trivial object; on the other hand, under the microscope as a scientific apparatus and its photographic transcription, these wings become "marvelous," spectacular, a "natural magic." The importance of the photograph is not that it affirms the existence of the insect but that it presents it according to the metaphysical idea of the "table of things," in which it forms a part of a continuous and successive series of objects that move from the simple to the complex. Hence, the rectangular cells and linear veins appear more complex and condensed as the eye moves to the edges of the image. The photograph is meant to display a sense of order (even in the smallest of creatures) through an emphasis on patterning, linearity, and transparency, because this table of signs is also the image of God, that is, of nature as an organized and structured whole. The term "natural magic" thus pertains not to the indexical way in which the image is made but to the cultural and epistemological premises of Victorian science, which enable one to see nature and science as simultaneously displaying and dispelling "wonders," that is, as reinforcing the claims of both science and religion regarding the "law of continuity."

Defining photogenic drawing as a "natural magic" demonstrates the fact that in the 1830s, following the challenges British empiricism faced from Hume's skepticist attack on the concept of causality and the emergence of the wave theory of light, which challenged the methodological constraints of Victorian science, the validity of induction could be based only on "commonsense" principles, which are, as Reid argued, impossible to disbelieve and impossible to prove. Thus, presenting photogenic drawing as a "new proof" not only exposes the need for proof in the first place, thereby pointing to the epistemologically vulnerable status of induction at this historical juncture, but also exposes the fact that it is precisely its status as a highly "mechanical" progressive method of reasoning that binds it, rather than separates it, to the metaphysical "law of continuity" and the grounding of knowledge on nothing more than habit and belief. This highly skepticist philosophical position is radically different from the modern conceptualization of photography as an ultimate form of "proof" that authenticates the "real." It is not Barthes's postmodern anxiety of the "loss of the real" that underlines Talbot's conceptualization of photogenic drawing as "natural magic" but the natural philosopher's ungrounded yet instinctive belief in the consistency and continuity of nature.

Engines of Discovery: Deskilling Work and Knowledge

Alongside the emphasis in Talbot's 1839 account on the empiricist premises of his inductive method of discovery, Talbot conceptualizes his discovery as mainly a method for copying preexisting images such as painting on glass and engravings, as well as the images of the microscope and the camera obscura. Although Talbot doesn't explicitly state that his method of copying is "mechanical," because at this early point most of the images Talbot produced demanded long exposure time and were mostly created by contact printing without the aid of the camera obscura, as I further show, he does suggest that his method is not manual, for example, in his discussion of portraits or silhouettes: "These are now often traced by the hand from shadows projected by a candle. But the hand is liable to err from the true outline, and a very small deviation causes a notable diminution in the resemblance. I believe this *manual* process cannot be compared with the truth and fidelity with which the portrait is given by means of solar light."[54] He thus describes his method, again in relation to the images of the solar microscope, as more efficient than manual copying, because it is based on deskilling: "The objects which the microscope unfolds to our view, curious and wonderful as they are, are often singularly complicated. . . . What artist could have skill or patience enough to copy them? or granting that he could do so, must it not be at the expense of much most valuable time, which might be more usefully employed?"[55] This statement marks another major aspect of Talbot's conceptualization of photogenic drawing and, later, the calotype—the idea that they are produced by nature itself: "You make the powers of nature work for you, and no wonder your work is well and quickly done."[56]

Steve Edwards has shown that Talbot's autogenic conception of photogenic drawing as a picture that makes itself or is made by the sun "is a powerful homologous displacement of human agency from the scene of production."[57] Edwards points to the way Talbot's emphasis on the self-making of the photograph is modeled after theories of labor such as Andrew Ure's *The Philosophy of Manufactures* (1835), which with its focus on automation creates the fantasy of autogenesis, of a production process that is freed from actual work. In their emphasis on efficiency, Talbot's statements also evoke Babbage's influential *On the Economy of Machinery and Manufactures* (1832), which showed interest in the new discovery.[58] In his book Babbage analyzes the advantages of machinery to manufacture and describes copying as embodying the essence of

mechanical labor; that is, it is copying that serves as a model to mechanization, and not vice versa:

> Nothing is more remarkable, and yet less unexpected, than the perfect identity of things manufactured by the same tool. . . . The same identity pervades all the arts of printing; the impressions from the same block, or the same copperplate, have a similarity which no labour could produce by hand. The minutest traces are transferred to all the impressions, and no omission can arise from the inattention of the operator. . . . *The accuracy with which the machinery executes its work is, perhaps, one of its most important advantages: it may, however, be contended, that a considerable portion of this advantage may be resolved into saving of time; for it generally happens, that any improvement in tools increases the quantity of work done in a given time. . . . It would be possible for a very skilful workman, with files and polishing substances, to form a cylinder out of a piece of steel; but the time which this would require could be so considerable* . . . that for all practical purposes such a mode of producing a steel cylinder might be said to be impossible.[59]

By opposing Talbot's method of copying to manual labor and emphasizing its regulatory and self-corrective or leveling logic, Talbot's comments can also be linked to the premises of Bacon's scientific method. His statements relate to a passage in *Novum Organum* in which the human hand exemplifies the unregulated and unaided faculty of understanding: "But the course I propose for the discovery of sciences is such as leaves but little to the acuteness and strength of wits, but places all wits and understanding nearly on a level. For as in the drawing of a straight line or a perfect circle, much depends on the steadiness and practice of the hand, if it be done by aim of hand only, but if with the aid of rule or compass, little or nothing; so it is exactly with my plan."[60] Bacon's comments suggest that induction itself can be described as a sort of "intellectual deskilling," that the idea of a "mechanical" ladder of reasoning is in fact closely related at this historical juncture to Talbot's emphasis on the "mechanical" nature of photogenic drawing, which marks not the use of machinery but ideas relating to efficiency and labor. That is, it is precisely the idea of deskilling that connects the philosophical premises of the inductive method to Talbot's insistence that his method of copying requires no skill and therefore can be used by anyone because the images are created by nature. As is stated earlier, public discussions of a unified and reliable

scientific method by the scientific community were meant to advance the cultural value of science; thus, the idea that induction was basically a "mechanical" method rendered, as Yeo points out, an "image of science as open to wide public involvement."[61] The inductive method was presented as accessible to the general public by emphasizing factual observation rather than theoretical knowledge. Thus, in the *Discourse* Herschel states that collection of facts within the fields of meteorology and geology will be open to the general public and that there is "scarcely any well-informed person, who, if he has but the will, has not also the power to add something essential to the general stock of knowledge, if he will only observe regularly and methodically some particular class of facts."[62]

Yet this cultural view of science was in tension with the efforts of BAAS to present science as an institutionally specialized activity that necessitated government funding, and the prevailing recognition following recent discoveries, such as the wave theory of light, that successful scientific practice necessitated highly specialized training in specific fields of knowledge such as mathematics. Science historian Timothy Alborn shows that although reformers at BAAS wanted to disseminate the idea that the advancement of science was a collective effort, at the same time they needed to differentiate their efforts from other public organizations, like the Society for the Diffusion of Useful Knowledge, which popularized science as a form of entertainment.[63] The BAAS also wanted to differentiate its activities from voluntary associations such as the Royal Society, in which, as Babbage showed in his *Reflections* essay, no significant scientific knowledge was produced. The problem on an institutional level was, Alborn argues, how to retain skill on an individual level of practicing scientists while at the same time presenting a public image of the scientific community that is broad enough to include individuals with no scientific skill but general interest.[64]

In the *Discourse*, Herschel solved this problem by applying Adam Smith's economic principle of the division of labor: "When particular branches of science have acquired that degree of consistency and generality, which admits of an abstract statement of laws, and legitimate deductive reasoning, the principle of the division of labour tends to separate the province of the observer from that of the theorist."[65] Whereas observation and the collection of data were open to the wide public, the discoveries of laws and theories were open only to specific individuals. In the 1833 BAAS meeting, Whewell attacked Herschel's suggestion that observation and theorizing could be separated, and reasserted the role of the

genius in scientific inquiry. He argued that skill should be retained at an individual level but limited to certain gifted geniuses who would function as a philosophical chamber of commerce that would direct the future progress of science. Babbage and Herschel argued against Whewell's model and defended a collective definition of mental skill. The figure of the genius underlies Whewell's own theory of induction and is highly significant for an analysis of Talbot's 1844 account of his discovery in *The Pencil of Nature,* as the next chapter will show.

By linking the inductive method to "mechanical copying" through the idea of deskilling, Talbot's account implicitly takes part, as Edwards has shown, in the efforts of members of the scientific community, mainly Herschel and Babbage, who, like Talbot, were affiliated with Cambridge University, to closely align the production of scientific knowledge with material production.[66] Thus, a comprehensive analysis of induction as a discovery method needs to relate it to a much broader set of concerns than the legacy of British empiricism. In the 1830s, the idea of deskilling as a function of the division of labor signified intensified economic growth due to the introduction of the steam engine and the expanding factory system, although at this point traditional modes of agricultural and craft production still prevailed. At the same time, this was the period in which the disturbing effects and tensions of industrialization manifested themselves, and with the optimistic belief in progress came the fear from possible revolt of the laboring masses, whose life conditions kept deteriorating. Thus, different reform bills were initiated in order to contain social and economic changes and prevent revolution. Reforms were a source of national controversy concerning the introduction of machinery into the production process. Thus, as Maxine Berg has argued, "It was economic growth and its now limitless prospects created by technological advance which became the new center, not just of the analysis of economy, but of the analysis of politics and society as well."[67]

In the *Discourse,* Herschel employs Smith's idea of the division of labor not only to differentiate the observer from the theorist but also to emphasize greater productivity and growth:

> This process is what we mean by induction; . . . it appears that induction may be carried in two different ways,—either by the simple juxtaposition and comparison of ascertained classes, and marking their agreements and disagreements; or by considering the individuals of a class, and casting about, as it were to find in what particular they all agree,

besides that which serves as their principle of classification. Either of these methods may be put in practice as one or the other may afford facilities in any case; but it will *naturally* happen that, where facts are numerous, well observed, and methodically arranged, *the former will be more applicable than in the contrary case: the one is better adapted to the maturity, the other to the infancy, of science: the one employs, as an engine, the division of labour; the other mainly relies on individual penetration, and requires a union of many branches of knowledge in one person.*[68]

In this statement Herschel applies the principle of the division of labor to differentiate not individuals but *stages* within induction as a discovery process. The point is not just to allocate different tasks to individuals but also to increase the efficient production of scientific knowledge through hierarchical divisions that are presented as "natural." Thus, the economic analogy goes much further in its implications for scientific practice.

In his *An Inquiry into the Nature and Causes of the Wealth of Nations* (1776), Smith famously argued that the division of labor increases labor productivity and is therefore the foundation for economic growth. Smith connected the division of labor with greater dexterity, economy of time, and the introduction of machinery. This resulted in a redefinition of the term *skill*. Where earlier skill was identified with an "art" or craft, now, Berg argues, it became a peculiar dexterity "which resulted from the *breakdown* of a craft." For Smith, machinery did not displace labor; rather, "it differentiated this labor by dismembering the old craft."[69] This also makes it clear that the use of the term *art* in Talbot's different accounts of his discovery and in *The Pencil of Nature* is not meant in a liberal sense of "Art," which necessitated skill, but precisely in the sense of "craft" now defined as "deskilled labor."

Just how decisive, for Herschel and Babbage, the remodeling of scientific discovery and the growth of knowledge in economic terms was is further indicated in their preface to the *Memories of the Analytical Society*, a society they founded together with George Peacock, in 1812, at Cambridge in order to introduce algebraic methods of analysis into the university:

Powerful indeed, must be that mind, which can simultaneously carry on two processes, each of which requires the most concentrated attention. Yet these obstacles must be surmounted, before we can hope for the discovery of a philosophical theory of invention; a science which Lord

Bacon reported to be wholly deficient two centuries ago, and which has made since that time but slight advances. . . . The *capital of science, however, from its very nature, must continue to increase by gradual yet permanent additions; at the same time that all such additions to the common stock yield an interest in the power they afford of multiplying our combinations, and examining old difficulties in new points of view.*[70]

Mathematics was taught at Cambridge as part of a liberal education in order to "train the mind." As June Barrow-Green argues, "[M]athematics came to be regarded as a form of intellectual, cultural, and social training for men and gentlemen in all walks of life."[71] Thus, the study of mathematics was not meant to train professional mathematicians but was part of a gentleman's liberal education alongside logic, philosophy, and theology. Herschel and Babbage wanted to change this situation by introducing the new Continental analysis method instead of Newtonian methods.[72] Talbot entered Cambridge in 1817, just months after Peacock introduced the new notation method to the Tripos examination, which was a requirement for a bachelor of arts degree at Cambridge, and it was still used in 1821, the year Talbot took the exam. Barrow-Green states that Talbot was aware of the debate and the mathematical reforms at Cambridge, and that "as a student at Trinity, Talbot would have been taught by Peacock and Whewell, both influential reformers in different ways. Whewell believed in arguing from the particular to the general, while Peacock, in line with the Analytical Society's position, took the opposite view."[73] Whewell opposed the abstract aspects of the Continental analysis and argued that it should be specifically applied to physical problems, and his positions led to a public debate with Babbage, as I will further show. Talbot's education thus exposed him to the growing gap between the cultural view of science as a leisurely and amateurish pursuit within which mathematics, like logic, simply facilitates thinking in general, and as a professional vocation in which mathematics is an abstract tool of analysis that is instrumental to the formation of theories, as the wave theory of light demonstrated, and to the "growth of knowledge." Thus, his insistence on mechanical and scientific or "intellectual deskilling" in his 1839 discovery account has to be understood, again, as a rhetorical gesture toward the audience of his paper, the members of the Royal Society who still practiced science as a leisurely activity, rather than as an adequate description of the way photographs were produced at this early stage of the invention, as will be argued in chapter 3.

Significantly, in Herschel's and Babbage's formulations, Bacon's "ladder of reasoning" is extended to the gradual accumulation of scientific discoveries by the means of (mathematical) analysis, which, through the application of a system of abstract signs, makes the operations of the mind much more efficient and thus facilitates the accumulation of scientific "capital." As William Ashworth points out, Herschel and Babbage "held that the mind, much like a mill or a factory, had to be correctly organized to retrieve ideas or data (like stored goods or materials) efficiently, without wasting human memory. In a factory, the speed and precision of production depended on its organization. Through a combination of well-arranged memory and analysis, the mind, too, could become more efficient at processing information and better at intellectual production."[74] Following this logic, the possibility of a philosophical theory of discovery is grounded in the *differentiation* of cognitive processes as a necessary condition for the growth of scientific knowledge. Moreover, in this way scientific progress is aligned with economic and technological progress, and science's cultural status increases.

Babbage's efforts to regulate cognitive operations culminated in what Schaffer calls "the mechanization of intelligence,"[75] his invention of a calculating engine, the Difference Engine. The idea came to Babbage in 1822 out of a conversation with Herschel when they were discussing the monotonous and repetitive nature of arithmetic operations required of computers that calculate astronomical tables: "[I]t would be extremely convenient if a steam-engine could be contrived to execute calculations for us; to which it was replied that such a thing was quite possible.[76] Babbage's Difference Engine was meant to carry simple mathematical operations like subtraction and addition by employing the method of finite differences to subtabulate printed values for tables between pivotal values prepared by human calculators.[77] The machine was also meant to prepare printing plates from which tables could be printed in order to prevent errors in the copying of calculations. In 1823, Babbage received a gold medal from the newly founded Astronomical Society of London for his idea of the Difference Engine, yet it was never built, although Babbage received government funding for its construction.

What unites Babbage's highly mechanical account of the mind and its processes of reasoning in the *Memoirs*, his suggestions for reforms within scientific organizations in his *Reflections* essay, and his invention of calculating machines is what Schaffer calls "a technology of universal management," which is a panoptic system of arrangement of machines and

humans that is meant to guarantee maximum production at minimum cost, whether it is the production of goods or of knowledge.[78] And it is in his most influential book, *On the Economy of Machinery and Manufactures*, which informed Talbot's conceptualization of photogenic drawing as a "mechanical" system of copying based on deskilling, that he managed to conceptually unify, through analysis, the "scientification of the labor process" and the "mechanization of intelligence." The book is divided into two parts: the first examines the mechanical principles that regulate the application of mechanical science to the production of manufactured goods; and the second, the economic principles that regulate the application of machinery to manufacture. It is in the second part that Babbage explains how to become a successful manufacturer via a complete arrangement of the "whole system of the factory" through a highly regulated division of labor of both humans and machines: "That the manufacturer, by dividing the work to be executed into different processes, each requiring different degrees of skill or of force, can pursue exactly that precise quantity of both which is necessary for each process; whereas, if the whole process were executed by one workman, that person must possess sufficient skill to perform the most difficult, and sufficient strength to execute the most laborious, of the operations into which the art is divided."[79] The emphasis is not just on division but also on calculation of precise allocations of both labor and machinery, because machines can produce force, transmit force, or both, and thus in each stage of the production process, the proper amount of force needs to calculated. For Babbage, calculation means not only regularity in terms of precision but also, and most important, predictability. It is by introducing the possibility of precise measurements and predictability that machines become corrective of undisciplined labor due to inattention and idleness.

Babbage discusses the "higher" "science of calculation" in the last chapter in the book, which directly addresses the relations between science and manufacturing. He argues that this science, which, "having grasped the mightier masses of the universe, and reduced their wanderings to laws, has given to us in its own condensed language, expressions, which are to the past as history, to the future as prophecy . . . which must ultimately govern the whole of the applications of science to the arts of life" (8:266). Babbage goes on to say that the maxim "Knowledge is power" needs to be qualified, as, since the invention of the steam engine, knowledge not only consists in control over nature's powers but "is itself the generator of physical force" (8:267). Thus, for Babbage, scientific knowledge is the ultimate

"engine" of technological progress, as science historians M. Norton Wise and Crosbie Smith eloquently describe it: "The engine metaphor now extends from the literal steam engine setting machinery in question, to capital as the engine of labour, to the machine economy as a social engine, to scientific knowledge as an engine of practical action. Inevitably, scientific knowledge represented capital in the economy of knowledge, a reservoir of moving force which continued to accumulate at compound interest."[80] Babbage ends his book by emphasizing his optimistic belief in the "ever-accelerating force" behind scientific and technological progress. He implicitly ranks science on a higher moral ground than any of the other fields of human creation, as "machinery had been taught arithmetic instead of poetry" (8:268). Thus, like Herschel in the *Discourse,* Babbage argues that science's high moral value lies in the way it presents the "resistless evidence of immeasurable design" (8:268). This idea formed the metaphysical ground for Babbage's last project of the mechanization of intelligence: the Analytical Engine. This engine differed from the Difference Engine in that it was designed to perform a broader set of operations, and because it possessed both memory and foresight, it was capable of changing its operations to anticipate needs arising in the process of computation. Babbage thus envisaged, argue Wise and Smith, "the ultimate mechanical engine as a kind of thinking machine, the embodiment of analysis as an engine of discovery."[81] In this sense, Babbage's book was designed to show, like the *Discourse,* that science in no way challenges natural theology, yet what it significantly adds is that mechanical manufacture also ultimately supports the design argument, because it also creates a highly predictable and regulated world through the employment of the principle of the "division of labor."

In 1833, Whewell implicitly challenged Babbage's project of the mechanization of intelligence in his *Astronomy and General Physics Considered with Reference to Natural Theology,* written as part of the Bridgewater treatises, which were meant to mobilize science to the defense of natural theology at a time when new discoveries in geology challenged religious dogma. Whewell claimed that mathematics cannot offer a "proof" for the design argument and that there are fields of knowledge, like moral philosophy, criticism, and politics, which cannot be reduced to one art of reasoning:

We may thus, with the greatest propriety, deny to the mechanical philosophers and mathematicians of recent times any authority with regard

to their views of the administration of the universe; we have no reason whatever to expect from their speculations any help, when we attempt to ascend to the first cause and supreme ruler of the universe. But we might perhaps go further and assert that they are in some respects less likely than men employed in other pursuits, to make any clear advance towards such a subject of speculations. Persons whose thoughts are thus entirely occupied in deduction are apt to forget that this is, after all, only one employment of the reason among more; only one mode of arriving at truth, needing to have its deficiencies completed by another.[82]

Babbage responded to Whewell by publishing his own noncommissioned *Ninth Bridgewater Treatise* in 1837, in which he showed how his Analytical Engine *was* the mechanical embodiment of a divine Author. Babbage illustrated this point by referring to a succession of operations performed by his Analytical Engine and its effects on uninformed individuals. The engine was set to print a series of integers from 1 to 1,000,000, and an uninformed observer of the machine assumed that this series would go on indefinitely. This observer was then highly surprised when, after 1,000,000, the machine started to advance in steps of 10,000, as this change looked like a "miracle" or accident. Yet, from Babbage's panoptic point of view as the machine programmer, this change was anticipated, because the initial setting of the machine had been adjusted so that at a certain point it would advance in 10,000s, and thus what seemed to be a deviation from a law was in fact a necessary consequence of the machine's subjection to a *higher* law of operations. Babbage then presented the religious implications of programming:

> In contemplating the operations of laws so uniform during such immense periods, and then changing so completely their apparent nature, whilst the alterations are in fact only the necessary consequences of some far higher law, we can scarcely avoid remarking the analogy which they bear to several of the phenomena of nature. The laws of animal life which regulate the caterpillar, seem totally distinct from those which, in the subsequent stage of its existence, govern the butterfly . . . but it cannot be doubted that, immeasurably complex as they are, they were equally foreknown by their Author.[83]

Babbage's project of the "mechanization of intelligence" and his modeling on scientific practice based on the economic principle of the division

of labor need to be seen as a response, like Herschel's *Discourse*, to what Norton and Wise define as "a fundamental change in consciousness" in British scientific culture in the 1830s and 1840s. Over a wide range of subjects, they argue, "'economy' came to mean evolution rather than balance, temporal dynamics rather than equilibrium."[84] Thus, conceptual changes within physics, such as the focus on continuous processes of motion rather than on substances and matter in the wave theory of light, exemplify, according to Wise and Smith, the introduction of new modes of temporality into the explanation of natural systems *before* their clear manifestation in evolutionary biology. Herschel's *Discourse* presented a view of society and science as ruled by self-balancing "natural" laws, but this view was increasingly found to be inadequate:

> The timeless balance turned into an unstable explosive, verging simultaneously on incomparable wealth and unspeakable poverty. In this new reality, not the balance with its natural limits but the steam engine with its capacity of change came to symbolize the economy. Change was indeed the dominant experience of every participant; whether in reality, expectation, or fear. . . . Rational liberals now saw the unlimited progress, not in an ever-finer understanding and control of the present balance of forces, but in continuous development of new productive capacities. *The societal task of science no longer hinged on explaining stability, but on explaining change*, and on harnessing the energies of change to man's purpose.[85]

In this regard, Babbage's economic principles of manufacture, when coupled with the Analytical Engine, articulated, Wise and Smith point out, "an insidious thesis within British scientific culture: the capacity for designed transformations could be built into natural law."[86] That is, Babbage's machines, in their emphasis on differentiation and regulation, were designed, like governmental reforms and bills, to exclude the possibility of change by taming it into predictable law.

This motivation is precisely what links the philosophical and epistemological premises of the "law of continuity" and representation to this much broader set of material concerns (institutional, technological, and socioeconomic) as manifested in Babbage's project of the mechanization of intelligence. What underlies representation and Babbage's fantasy of repetitious and homogeneous deskilled labor is the exclusion of time as a substantive principle of development inherent in the organization of

natural and material life. Similarly, in representation, Foucault argues that "succession and history are for nature merely means of traversing the infinite fabric of variations of which it is capable. It is not, then, that time or duration *ensures* the continuity and specification of living beings throughout the diversity of successive environments. . . . Continuity is not the visible wake of a fundamental history in which one same living principle struggles with a variable environment. For continuity *precedes* time. It is its condition."[87] And in the same way in which variations in nature, with their progressive move from simple to complex, are seen as confirming the predetermined "order of things," Babbage's and Herschel's emphasis on the shift from lower to higher forms of analysis and calculation presents "proof" of the great Author.

Underlying Talbot's first account of his discovery is the belief of the natural philosopher in the continuity and consistency of nature and of the programmer and regulator of machinery and labor in infinite progress and growth, a belief in unchangeable "natural" laws that are modeled after the empiricist premises of Newton's mechanical science, and economic manufacturing laws that are conceptualized and propagated as the "natural" laws of society. The term *induction* thus reverberated during the 1830s with a broad set of specific concerns that informed Talbot's conceptualization of photogenic drawing as a copying method through which nature is studied in order to better harness it to "work."[88]

This interrelated set of concerns was consolidated in Brewster's comprehensive account of photography, one of the earliest writings of its kind, which appeared in the *Edinburgh Review* in January 1843. As is mentioned earlier, Brewster, who was considered a highly qualified experimenter, took part in the debate around the wave theory of light and shared Herschel's interest in the study of the interaction of light with matter. During this time, he corresponded regularly with Talbot on his discovery and promoted the introduction of paper photography to Scotland. Brewster begins his review by pointing to the necessary connection between progress in knowledge and "social improvement," evoking the accumulative "law of continuity" and the belief in progress as affirming the "supreme authority." He then states that new discoveries "in the arts and sciences either abridge or supersede labour" and that by substituting "mechanical for muscular action, man rises into a higher sphere of exertion."[89] Brewster relates "the art of photography" to the art of "multiplying statues by machinery" and states that it stands as "great a step in the fine arts, as the steam engine was in the mechanical arts."[90] Yet perhaps

the most surprising statement in the review is the one in which Brewster argues, in direct reference to Talbot's own account, that although the new discovery "cannot fail to give a vigorous impulse to the fine arts, it already has become a powerful auxiliary in the prosecution of physical science; and holds out no slight hope of extending our knowledge of the philosophy of the senses."[91] What is striking in this statement is that it evokes the legacy of British empiricism not in an oblique or rhetorical way, through the prevalent reaffirmation of inductive method as securing the validity of scientific knowledge, but by directly pointing to its major epistemological concerns regarding the "source of knowledge." Brewster never explains *how* photography can function as an epistemological figure extending empiricism as a theory of knowledge, or in what way it can give new knowledge on the unregulated activities of the senses rather than "proving" what is already known. The following chapters will address this question; at this point it is sufficient to note this remark as further reaffirming the way the conception of photography was linked to and underlain by the premises of British empiricism. Nevertheless, it is precisely the challenges to these premises that inform Talbot's subsequent efforts to conceptualize the new image by employing a radically different "method of discovery."

2 | Imagination

The Art of Discovery

TALBOT'S SECOND SIGNIFICANT ACCOUNT of his discovery, "A Brief Historical Sketch of the Invention of the Art," appeared in 1844 as an introductory text to *The Pencil of Nature*. This account differs in tone and emphasis from his 1839 account, no doubt because of the fact that it was intended not for the specialized audience of the Royal Society but for a broad audience as part of Talbot's efforts to familiarize the general public with the calotype, the second photographic process he discovered, in 1840.[1] This second account is therefore written not as a scientific paper but as a historical and biographical text in which Talbot presents himself as the discoverer of "the principles and practice of photogenic drawing."[2] In this account, the inductive method is never explicitly mentioned, and although Talbot makes a number of statements evoking the primacy of experiments, he also emphasizes the importance of theory and ideas. Consequently, the discovery process is not presented as a logical process of reasoning, and its object is not a chemical fixing process for images that can be produced with or without the camera obscura. Instead, Talbot focuses on the "original idea," fixing the images of the camera obscura, which led to his experiments. He dramatizes the specific moment of discovery, which occurred during a vacation on the shores of Lake Como in 1833, in which he tried unsuccessfully (because of his lack of skill) to draw using the camera lucida and then the camera obscura:

> Such, then, was the method [tracing the images of the camera obscura] which I proposed to try again, and to endeavour, as before, to trace with my pencil the outlines of the scenery depicted on the paper. And this led

me to reflect on the inimitable beauty of the pictures of nature's painting which the glass lens of the Camera throws upon the paper in its focus—fairy pictures, creations of a moment, and destined as rapidly to fade away. It was during these thoughts that *the idea occurred to me* . . . how charming it would be if it were possible to cause these natural images to imprint themselves durably, and remain fixed upon the paper!

Such was the idea that came into my mind. Whether it had ever occurred to me before amid floating philosophic visions, I know not, though I rather think it must have done so, because on this occasion it struck me so forcibly.

Such were as nearly as I can now remember the reflections which led me to the invention of this theory, and which first impelled me to explore a path so deeply hidden among nature's secrets. And the numerous researches which were afterwards made—whatever success may be thought to have attended them—cannot, I think, admit of a comparison with the value of the *first and original idea*.[3]

Rather than describing a highly systematic and gradual "method" of discovery that was modeled on an inductive discovery of a scientific "law," Talbot now recounts a "story" in which an inexplicable stroke of inventive power led to the sudden emergence in his mind of a "new" idea. Thus, what is emphasized is precisely the lack of "method" as a way to insist on the *originality* of the discovery. That is, it is not the mechanical "law of continuity" that constitutes the reciprocity between nature and human nature that is responsible for the discovery, but precisely the mind's capacity to transcend experience in a creative way that is epistemologically unaccounted for. What underlies Talbot's new account is an awakening sense of subjectivity together with an awareness of temporality, a certain movement from the exteriority of impressions and sensations into the opaque interiority of the mind's *independent* capacity of reasoning beyond the circular "table of things."

Nevertheless, when this moment of personal "epiphany" is read in light of the history of Victorian science, it is anything but unique. As Simon Schaffer has shown, the end of natural philosophy was marked by the emergence of new models of scientific discovery that came out of the shift within the philosophy of science from discovery to justification, and out of the institutionalization of science as a professional practice.[4] He shows that when a single event is given the status of a discovery, a new fact is replicated and given a specific author. Yet historical and sociological

studies have shown that these two processes are subject to a series of negotiations inside the scientific community regarding the specific experiments and criteria of adequacy, which could lead to the discovery of different phenomena. This suggests, Schaffer claims, that if "replication and authorship are matters of negotiation, then there is no event which corresponds to an automatic or instant discovery. . . . Subsequently, the story of that process is rewritten. The lengthy enterprise is telescoped into an individual moment with an individual author."[5] Recently Herta Wolf argued that Talbot "was able to 'invent' photography on paper only with recourse to the findings and work of others. But no process requiring a knowledge of such varied fields could have been invented by a single scientist or craftsman."[6] Five years after his first announcement, which was made in haste in order to claim priority following rumors that in France a similar process would soon be announced, Talbot retells the story of his discovery in a way that defines him as the sole originator of the idea, an author, condensing years of research and experimentation into one specific moment. By analyzing Talbot's second canonical account, this chapter aims not to discredit Talbot's story of his discovery nor to challenge his priority claims but to locate its discursive and epistemological conditions of possibility in a much broader, yet specific, historical framework than the biographical one.

Significantly, Schaffer states that "where natural philosophers presented their histories as methods for training practitioners in discovery . . . historians of the sciences from the early nineteenth century separated the disciplined training of scientists from the heroic discovery moment, for which no training was possible."[7] This shift can be seen quite clearly in the differences between the two most important philosophical publications on British empirical science in the early nineteenth century: John Herschel's *Discourse* (1830) and William Whewell's *History of the Inductive Sciences* (1837), the latter of which was followed in 1840 by his *Philosophy of the Inductive Sciences*. Whereas Herschel's book, as is shown earlier, was written in order to popularize science as an "accessible" practice to every student of natural philosophy, Whewell's books focused on the "heroic" and unaccountable way in which actual discoveries were made by highly gifted and exceptional individuals whose work nonetheless formed the basis for new research traditions and scientific disciplines. Talbot had known Whewell from Cambridge, as I pointed out earlier; Talbot's biographer H. J. P. Arnold describes Whewell as a friend and mentions that he was one of the individuals who signed Talbot's certificate of

recommendation for the Royal Society.[8] Talbot's correspondence indicates that Whewell's *Philosophy* was recommended to him by his friend Thomas Worsley, the Cambridge head of house.[9]

Schaffer argues that "[t]he end of natural philosophy was accompanied by the appearance of models of discovery which appealed to *discipline* and to *genius*, and which have dominated theories of science ever since."[10] At this historical juncture, the emergence of the romantic figure of the (philosophical, scientific, and artistic) genius was inseparable from the epistemological reconsideration of the faculty of the imagination by Kant and Coleridge. Hence the implicit link in Talbot's account between an "unaccountable" idea and authorship: in the new model of discovery, it is precisely the inability to trace the logical unfolding of the discovery process that grants the discoverer the status of a genius. Thus, it is no longer membership in a specific scientific community that needs to be emphasized by reaffirming its methodological and philosophical premises, but the *privileged* status of certain members within this community, which differentiates their activities and talents from all the rest.

The implicit evocation of the imagination also explains the second major shift in Talbot's 1844 account, which focuses exclusively on the images of the camera obscura and on drawing rather than simply copying. Thus, it is not merely a "shadow" that is being fixed but "the pictures of nature's painting," that is, nature viewed *as* a picture. This picture, argues Joel Snyder, is not what Talbot saw in the camera obscura or what was actually seen in his early images, because "this image does not exist in the camera—it exists only in the meeting ground between what continuously appears and changes in flux projected onto the tracing paper and the mind of the man with the pencil." To see nature as a picture therefore meant to "imagine what was not there to be seen," that is, to look at nature through a highly cultural set of conventions that formed "picturesque" views.[11]

These shifts in Talbot's 1844 account are therefore underlain by different models of reasoning or thinking and different conceptions of nature than the ones evoked in his early account. This is highly significant, because, as is shown earlier, Talbot's specific mode of conceptualization of photogenic drawing hinges on the epistemological and conceptual premises that underlie his processes of discovery. In this regard, the shift in tone and emphasis in the second account is not simply rhetorical or stylistic but symptomatic, this chapter argues, of the new epistemological conditions through which nature and "man" came to be known in the early nineteenth century.

Whewell's Moral Philosophy of Science

The new model of discovery mobilized in Talbot's 1844 account received its most sophisticated philosophical and scientific articulation in Whewell's *History* and *Philosophy*, whose respective publication marks the introduction into the British scientific establishment of a compromised Kantian epistemology and an institutionalized form of romantic theories of creativity and intuition. These books, while preserving the ethos of an empiricist form of scientific practice, strongly reject an empiricist epistemology. Thus, as Herschel wrote in his highly critical review of the books, whereas his own work, as the *Discourse* has shown, is grounded within an empiricist "school of philosophy," Whewell's books belong to a "rationalist" one, because he is "disposed" to the writings of "German metaphysicians." Yet, regardless of these differences regarding the source of knowledge, Herschel emphasizes that Whewell's historical and philosophical work, much like his own, confirms the metaphysical design argument, where "the mind of man is represented in harmony with universal nature; that we are constantly capable of attaining to real knowledge; and that the design and intelligence which we trace throughout creation is no visionary conception, but a truth certain as the existence of that creation itself."[12] With this statement Herschel makes it clear that, regardless of their texts' major epistemological differences, they share a common motivation: to show with all means possible that science in no way challenges natural theology but presents another form of "proof" for the validity of its claims. Thus, mobilizing this model of discovery in no way indicates Whewell's or Talbot's "conversion" into a "Kantian" or a "romantic" but, as with the allusion to the inductive method in his first account, rhetorically emphasizes the moral and cultural aspects of his discovery as part of an effort to popularize his discovery beyond the scientific milieu. That is, at this historical juncture, emphasizing the creative capacities of the inventor was seen as further emphasizing the continuity and harmony between the mind and nature.

Both Herschel and Whewell tried to create a "public image" for science at a time when its insecure status led, as is shown earlier, both to the constitution of major "lobbying" organizations such as the BAAS, which aimed to promote scientific practice, and at the same time to continuous attacks from Tractarians and romantics. These attacks were meant to challenge the idea that physical science equals knowledge itself and therefore excludes the viability and validity of other forms of knowledge. Whewell thought, Richard Yeo argues, "that current associations between

physical science, empiricist epistemology, and the principle of utility were producing an image of science hostile to moral and metaphysical enquiry."[13] This was a view that no doubt also underlay Coleridge's criticism of empiricism, as I will further show, and his efforts to develop his own theories of imagination and imitation. Thus, Whewell's *History* and *Philosophy* were written in order to challenge the popular "mechanistic" and utilitarian views of science by emphasizing the moral and metaphysical aspects of scientific practice.

As Yeo shows, Whewell opposed the prevalent binary between "exact" physical science and "obscure," less valid moral knowledge by arguing, based on an analysis of the histories of different sciences, that not all of them exhibited the same form of rigorous systematic reasoning. For Whewell, the unity of the sciences, including the moral ones, did not rest on the uniformity of method and substantive natural and mechanical laws, as Herschel's *Discourse* argued. Thus, instead of insisting on a separation between methodological concerns and epistemological ones, Whewell emphasized, Yeo argues, that "[t]here was a uniformity in the way knowledge of nature was achieved, not a unity of the laws of nature."[14] For Whewell, the study of the history of science became highly conductive in showing how knowledge had been acquired throughout history as part of an effort to form and ground not simply the "philosophy of science" but a general philosophy of knowledge. For Whewell, *all* sciences are underlain by what he termed the "Fundamental Antithesis of Philosophy":

[I]n all human Knowledge both Thoughts and Things are concerned. In every part of my knowledge there must be some *thing* about which I know, and an internal act of *me* who know. . . . In all cases, Knowledge implies a combination of Thoughts and Things. Without this combination, it would not be Knowledge. Without Thoughts, there could be no connexion; without Things, there could be no reality. Thoughts and Things are so intimately combined in our Knowledge, that we do not look at them as distinct. One single act of the mind involves them both; and their contrast disappears in their union. But though Knowledge requires the union of these two elements, Philosophy requires the separation of them, in order that the nature and structure of Knowledge may be seen.[15]

Whewell's theory of knowledge, like Kant's and Coleridge's, emphasizes that knowledge is possible only through a synthesis between idea and sensation, subjective and objective, theory and fact. Ideas are inherently

different from sensations; they are not simply accumulated and less vivid copies of sensations, as Hume argued, but they form the transcendental conditions of experience: "We see objects, of various solid forms, and at various distances from us. But we do not thus perceive them by sensation alone. Our visual impressions cannot, of themselves, convey to us a knowledge of solid form, or of distance from us. Such knowledge is inferred from what we see:—inferred by conceiving the objects as existing in space, and by applying to them the Idea of space" (149). On the one hand, fundamental ideas such as space and time precede experience, which can discover general truths but cannot give those truths universality; on the other hand, universal truths, though they borrow their form from ideas, cannot be understood except by the actual study of nature. Thus, the laws of motion are exemplifications of the transcendental idea of causality, but the idea of cause can come to light only in the course of empirical research and the detection of facts.

Whewell's notion of "fundamental Ideas" is not strictly Kantian, because ideas do not stand for the transcendental *categories* of understanding; rather, they are dynamic a posteriori truths that became a priori through scientific progress: "It will hereafter be my business to show what the Ideas are, which thus enter into our knowledge; and how each Idea has been, as a matter of *historical fact*, introduced into the Science to which it especially belongs" (149; emphasis added). As Menachem Fisch explains, although both Kant and Whewell sought how one might epistemologically justify the universal and necessary status of scientific knowledge, their projects were also quite different: "Whewell's problem was not to determine how experience is possible, nor even how excellent modern science is possible. Whewell took their possibility, indeed actual existence, for granted. His concern, as opposed to Kant's, was primarily methodological: namely, to determine how, in the course of negotiating the phenomena, such knowledge is *obtained*."[16] That is, Whewell's project was conceived not in order to challenge Hume's skepticism, as Kant's transcendental philosophy was conceived to be, but precisely, as Herschel stated in his review, to further ground the belief in the "law of continuity," yet not by adhering to "commonsense" principles but through "solid" philosophical and historical a priori conditions.

Whereas it was through his historical studies that Whewell came to see how scientific knowledge was acquired, it was his theory of knowledge that provided him with a historiographical model for scientific development. Moreover, as Geoffrey Cantor points out, writing *History* and

Philosophy simultaneously enabled Whewell to develop his own theory
of induction that was radically different from both Reid's "inductive
principle" and Herschel's "inductive method."[17] Based on his Kantian
reformulation of the term *Ideas,* Whewell calls the inductive process the
"Colligation of Facts," and defines it as an "act of the intellect" through
which "a precise connexion among the phenomena" is established. This
process starts with a common observation of facts without any "habit of
thought exercised in observing," and is followed by "succeeding stages of
science" through which a "more especial attention and preparation on the
part of the observer, and a selection of certain *kinds* of facts" eventually
lead to the decomposition of facts (207–8). Facts selected in this process
become scientific only if they are organized under fundamental ideas such
as time, space, and cause, and analyzed under a specific constructed con-
ception that is a modification of the general and broad fundamental idea.
Yet, for Whewell, conceptions are not the outcome of a gradual process of
generalization; rather, they are *discontinuous junctures* within this process:

> [T]he first and great instrument by which facts, so observed with a view
> to the formation of exact knowledge, are combined into important and
> permanent truths, is *that peculiar Sagacity which belongs to the genius of
> a Discoverer*; and which, while it supplies those distinct and appropri-
> ate Conceptions which lead to its success, cannot be limited by rules, or
> expressed in definitions. It would be difficult or impossible to describe in
> words the habits of thought which led Archimedes to refer the condi-
> tions of equilibrium on the lever to the Conception of pressure, while
> Aristotle could not see in them anything more than the result of the
> strangeness of the properties of the circle. . . . *These are what are com-
> monly spoken of as felicitous and inexplicable strokes of inventive talent; and
> such, no doubt, they are. No rules can ensure us similar success in new cases;*
> or can enable men who do not possess similar endowments, to make like
> advances in knowledge. (210–11; emphasis added)

Whewell thus describes the discovery process as one involving "constant
invention and activity, a perpetual creating and selecting power at work."
Moreover, he explicitly states that it would be a mistake to suppose that
new hypotheses or conceptions are "constructed by an enumeration of
obvious cases, or by a wanton alteration of relations" that occur in previ-
ous hypotheses (212–13). New truths are discovered by formulating new
ideas in which facts are seen in a new light, not by new modifications

of old ideas. Far from defining induction either as a logical inference or as a "mechanical" generalization process, Whewell describes it as a creative and interpretive process in which concepts are formed not by structurally capturing what has already been found in the facts but by reading something new *into* them ("superinducing") through the imaginative and active act of the discoverer's mind. Based on his reformulation of induction, Whewell criticizes Bacon in *Philosophy* for undermining the role of "ideas" and the inventive genius in the process of discovery:

> [H]e [Bacon] did not justly appreciate the sagacity, the inventive genius, which all discovery requires. He conceived that he could supersede the necessity of such peculiar endowments. . . . And he illustrates this by comparing his method to a pair of compasses, by means of which a person with no manual skill may draw a perfect circle. In the same spirit he speaks of proceeding by *due rejections*; and appears to imagine that when we have obtained a collection of facts, if we go on successively rejecting what is false, we shall at last find we have, left in our hands, that scientific truth which we seek. . . . The necessity of a *conception* which must be furnished by the mind in order to bring together the facts, could hardly have escaped the eye of Bacon, if he had cultivated more carefully the ideal side of his philosophy. . . . Since Bacon, with all his acuteness, had not divined circumstances so important in the formation of science, it is not wonderful that his attempt to reduce this process to a *Technical Form* is of little value. (232–33; emphases in original)

Whewell's *Philosophy* is thus structured around a tension between his recognition that discovery cannot be reduced to a set of methodological rules, and his efforts to extract such rules from the actual process through which discoveries were made in the past. In any case, the sense of a methodological necessity, so prevalent in Herschel's *Discourse*—the notion that an adherence to method guarantees both the possibility of discovery and its epistemic validity—is missing from his account. Discovery, in this sense, is an *irreducible* epistemic process, because it is mainly creative and not logical or rational.

Whewell's historians Fisch, Yeo, and Schaffer emphasize that it was through his friendship with two of Coleridge's followers, William Rowan Hamilton and Julius Charles Hare, that he became exposed to the more moderate aspects of Coleridge's epistemology and politics.[18] Cantor explains that Whewell's attitude toward romanticism changed: whereas

initially he was critical of Coleridge's metaphysics, from 1833 onward he
became sympathetic to Coleridge's philosophy and modeled his notion of
a scientific genius and the intuitive process of discovery on Coleridge's
core aesthetic and epistemological terms and ideas.[19] Cantor also points
out that Whewell's effort to construct a historiographical model that both
describes and conceptualizes scientific development was part of a collec-
tive effort by a group of liberal Anglican historians to integrate histori-
cal facts and theories. Although their historical accounts were defined
in opposition both to the rationalist tradition, which emphasized the
accumulation of empirical knowledge, and to the speculative tradition,
represented in England by Coleridge and Wordsworth, which empha-
sized grand historical schemata over facts, they were nevertheless much
closer to the romantics.[20] This group, inspired by new German scholar-
ship, particularly the work of Barthold Niebuhr, included Thomas Arnold,
Thomas Babington Macaulay, and Whewell's friends in Cambridge Hare
and Connop Thirlwall. All these scholars emphasized the interpretative
nature of history writing and the role of the historian's imagination in
imposing order and unity on historical facts. Liberal Anglican historians
also rejected the idea of progress and accepted the romantic view of his-
tory as "the natural, law-like unfolding of a nation's inner dynamic; an
unfolding which did not presuppose progress since a nation finally decays
and becomes extinct." In order to oppose deterministic and utilitarian
views of historical development that underlay rational historical accounts,
they "emphasized the moral and intellectual characteristics exhibited by
each nation through its history," as well as imaginative individuals who
both "reflected a nation's values and shaped its history."[21]

Rationalist histories of science, such as Joseph Priestley's *The History
and Present State of Electricity* (1767), described the gradual growth of
science as marking the progress of the human mind and emphasized the
"instrumental" aspect of discoveries as well as the employment of induc-
tive generalizations. Whereas these histories excluded the achievements
of individuals in favor of an "accumulation of facts," Whewell's *History*
focused on the achievements of a gifted discoverer as a "product of his
time and as a moral agent." Following the romantic idea of a poetic
genius, Whewell argued that creativity and intuition were crucial to ex-
plain great discoverers, such as Newton and Kepler. He emphasized that
discoverers possessed the highest intellectual and moral qualities of their
time and were therefore model figures for the development of a nation.
Thus, as Cantor explains, with *History* Whewell shifted the history of

science from matter, the "knowledge of the external world," to the mind, "the internal world." By outlining the achievements of the individual human mind, the history of science became "a form of moral discourse."[22]

This romantic model of scientific discovery became, in Whewell's hands, a political weapon against a populist utilitarian view of science, such as that advocated by Babbage and Herschel. It led him, as is shown earlier, to develop an elitist view of scientific practice in which a few gifted individuals are the founders of disciplines and are distinguished from the mere "practitioners of science." Thus, in the BAAS meeting in 1833, Coleridge decried Humphry Davy's suggestion that mere researchers in scientific disciplines would be named "philosophers." This name, Coleridge claimed, should be applied only to an elevated elite and not to an army of experimenters. In response to this debate, Whewell coined the term *scientist* as a specialized designation that distinguishes the professional practitioner from both the amateur "man of science" and the scientific genius. Schaffer has shown how "Whewell's vocation was the search for an appropriate role for the intellectual élite" based on Coleridge's idea of a national "clerisy" as a body that would aim at balancing through reform the different social forces, both the "permanent" and the "progressive" ones, and would embody the intellectual accomplishments of the nation.[23] In this regard, it is clear that, as a historian and a philosopher, Whewell positioned himself not in the role of a practitioner of science like Herschel but in the new role of what Schaffer and Yeo call a "critic" of science, a position that enabled him to judge, as could be seen in his criticism of Babbage's views of mathematics, the moral values of scientific practice. And because there was no model for such a role in the scientific community at this time, Whewell found it in the romantic poet, particularly in Coleridge, who conceived himself as a poet and a critic, and in criticism as a distinct intellectual activity.[24]

It is clear that Talbot's introduction to *The Pencil of Nature*, "A Brief Historical Sketch of the Invention of the Art," is discursively informed by the model of discovery that Whewell's *History* presents, in which the history of science is described as the history of personal discoveries, and discoverers are considered to be the founders of disciplines and research schools. Just as Talbot presents himself as the discoverer of "the principles and practice of Photogenic Drawing," he also defines his discovery account as the "history of the art." Moreover, as I will show in the following chapters, in *The Pencil of Nature*, Talbot discusses the role and status of the photographic document in relation to precisely a romantic form of

historicism. And of course the shift in his accounts from an "external" form of reasoning based on "mechanical" and "impersonal" progressive stages of "generalization" to an "internal," individual, and creative process of intuitive thinking is highly significant in light of his emphasis on the camera obscura.

Talbot's professional and personal contacts with Whewell were more limited than his relations with Herschel, although all of them belonged to the "Cambridge network." Yet the point that needs to be emphasized is that although Whewell's work gave the most sophisticated and comprehensive account of the scientific discoverer as genius, its redefinition of the discoverer was in no way unique at this historical juncture. Its specific discursive importance lies in the way it points to the infiltration of romantic ideas of creativity and genius into the scientific establishment during a time when its philosophical empiricist premises were challenged. That is, Whewell's books had a double role: on the one hand, they retained and further grounded the religious and moral convictions guiding scientific practice in Britain; on the other hand, they challenged its epistemological foundations. This, again, further demonstrates not only the highly inconsistent meaning of the term *induction* during this time but also the inconsistent way in which Talbot defined photogenic drawing itself: as a "shadow" and a "natural wonder" that "proves" the premises of natural philosophy and the "law of continuity," and as an *idea* of a "picture of nature" that exists in the imagination of the discoverer but is triggered or "realized" in his encounter with nature.

The romantic definition of the discoverer as genius also underlay David Brewster's historical and biographical studies *Life of Newton* (1835) and *Martyrs of Science* (1841). Brewster, who was a much closer professional colleague of Talbot, as is previously shown, was part of a different, if not opposed, scientific establishment from Whewell's. Nevertheless, as Schaffer shows, he also emphasized, with regard to Kepler's work, that "the influence of imagination as an instrument of research has, we think, been much overlooked by those who have ventured to give laws to philosophy."[25] By emphasizing the role of the imagination, both Whewell and Brewster responded to Kant's definition of genius in his *Critique of Judgment* (1790) as the talent (or natural gift) that gives the rule to art. Works of genius could not be copied or imitated and become a rule for others to follow; thus, science could not be carried out by genius. Based on this characterization and delimitation of the term *genius* to artists, Kant famously argued that Newton cannot be considered a genius

because he presented his discoveries as an outcome of a logical process of reasoning. Reclaiming the imagination and intuition within the realm of science enabled Whewell and Brewster to emphasize the religious and moral aspects of scientific practice by granting discoverers the status of genius.[26]

Within the British scientific establishment, it was Humphry Davy, springing from his relations with Coleridge, who, in his chemical experimental and philosophical works, presented himself as a scientific genius.[27] Talbot was, of course, familiar with Davy's chemical experimental work and mentions him in his first account as a "distinguished experimenter" and the coauthor, together with Thomas Wedgwood, of the 1802 essay "An Account of a Method of Copying Paintings upon Glass, and of Making Profiles, by the Agency of Light upon Nitrate of Silver," which documented a failed attempt to copy and fix with solar light preexisting images, including the ones formed in the camera obscura.[28] It was Davy and his investigations of chemical affinity that offered a much more "heroic" model of a natural philosopher than the one suggested by Herschel and Babbage. As Christopher Lawrence points out, in many of his lectures at the Royal Institution Davy stated that to discover the animating powers of life, or "nature's hidden operations," necessitates a genius. In 1802 Davy publicly confronted the romantic poets' view of chemistry as a lower-order activity when compared with poetry. Davy argued that "[t]he son of true genius . . . in the search of discovery . . . will rather pursue the plans of his own mind than be limited by the artificial divisions of language." Thus, chemistry could "exhibit to men" that system of knowledge "which relates so intimately to their own physical and moral constitution." He also emphasized that when engaging with nature in this way, the mind of the natural philosopher must be active and creative.[29]

This necessary relation between the creative power of the discoverer's mind and nature's own creations, which "impelled" him, as Talbot states, "to explore a path so deeply hidden among nature's secrets," evokes a mode of inquiry that connects nature and human nature along much more subjective and dynamic lines than the static and mechanical "law of continuity." Talbot also explicitly mentions the creative role of the imagination in his comments to Plate 4, "The Open Door," in *The Pencil of Nature,* in which he mentions the picture's capacity to "awaken a train of thoughts and feelings, and picturesque imaginings."[30] These statements and Talbot's description of his discovery process point, I argue, to the importance of the imagination within the new epistemological conditions

of knowledge. And it is primarily within Kant's and Coleridge's philo-
sophical projects that the epistemologically destabilizing faculty of the
imagination becomes also an *aesthetic* principle of both creation and judg-
ment. Emphasizing the role of the imagination leads Kant and Coleridge
not only to reconsider the role of the genius but also to redefine the rela-
tions between nature and the newly constituted entity "man." It is thus
within new aesthetic theories of the imagination and their critical vocab-
ulary, which includes ideas such as the beautiful, the sublime, and the
picturesque, that the specific idea of a "picture of nature" and its relation
to the camera obscura can be explicated. The following sections explore
the newly defined faculty of the imagination and its philosophical, aes-
thetic, and critical status before turning to a concrete analysis of Talbot's
conceptualization of the photographic image as a "drawing" of nature.

Furthermore, within the context of the book as a whole, and not just
this specific chapter, my detailed analysis of aesthetic terms and concepts
aims to reconsider the relations between photography and aesthetics. My
discussion is meant to challenge reductive accounts of aesthetics in the
theory of photography based, for example, on Clement Greenberg's dis-
cussion of Kant in some of his writings to support his emphasis on medium
specificity and opticality.[31] The relevance of aesthetics to the history of
photography must be separated, I contend, from questions of medium
and from photography's artistic status in relation to painting. Instead,
what must be addressed are the complex relations, as I further show, be-
tween photography's inconsistent epistemological status at this histori-
cal juncture and the emergence of aesthetics at the end of the eighteenth
century as a paradoxical form of knowledge that constantly undermines
the continuity and universality of knowledge.

Kant's Secret Art of Knowledge

The emphasis in new models of discovery on irreducible subjectivity, the
idea of "genius," and "unregulated" temporality, or a moment of "epiph-
any," and, correspondingly, the shift from the exteriority of sensations
and impressions to the interiority of the discoverer's mind point to the
emergence of a certain zone of *opacity* within the highly illuminated and
transparent "table of things." Instead of the circular "law of continuity,"
what is underlined is an "event" that gains its power because it ruptures
representation by introducing a gap between nature and mind, being and
thought. Paradoxically, by the time nature inherently became an image,
a "sun-image," it was no longer *conceived* to be an image. Whereas under

the classical episteme and the logic of representation, as can be seen in Talbot's earlier account, the character and status of phenomena were conceived as inseparable from the methods through which it was possible to study nature, such that the observable empirical fact was always a part of a scientific classification "table" and simultaneously a visible "image" of a divine design, with the emergence of the modern episteme at the end of the eighteenth century, Foucault argues, nature became separated from thought and unfolded in its own space. Within new knowledge formations, time, and not the spatial table of representation, came to define the status and mode of being of things, as Foucault states:

> History in this sense is not to be understood as the compilation of factual successions or sequences as they may have occurred; *it is the fundamental mode of being of empiricities*, upon the basis of which they are affirmed, posited, arranged, and distributed in the space of knowledge for the use of such disciplines or sciences as may arise.... History, from the nineteenth century, defines the birthplace of the empirical, that from which, prior to all established chronology, it derives its own being. It is no doubt because of this that History becomes so soon divided ... into an empirical science of events and that radical mode of being that prescribes their destiny to all empirical beings, to those particular beings that we are.... Since it is the mode of being of all that is given to us in experience, History has become the unavoidable element in our thought.[32]

To conceive of living beings as "historical" or as formed in time means to move beyond the visible, observable table into the "dark" side of internal, invisible, and dynamic forces that animate nature and operate independently from any theological or metaphysical convictions. Most important, to conceive of nature as formed in time also means, as is shown in the previous chapter, to acknowledge change as the underlying condition of natural and material systems of production; hence the new emphasis in scientific practice and new physical theories, such as the wave theory of light, on continuous temporal processes rather than on a Newtonian ontology of substances and particles, and on ways to "tame" change in order to oppose the common view of science as challenging theology, as Babbage's project of the "mechanization of intelligence" demonstrated.

It is thus precisely the assumed sense of continuity and transparency that underlies the classical episteme, the inductive belief that the same form of genesis, from simple to complex, applies both to human nature,

in the movement from sensations to ideas, and to natural phenomena, in the progress from facts to laws, that seems inadequate as a foundation for valid and universal knowledge. To know, therefore, means no longer to observe and compare what is presented to the "mind's eye," that is, to the faculty of understanding that "tames" the inadequacies and contingencies of sensorial experience but precisely to form a link between the density of sensorial subjective experience and the inherent opacity of nature, because, as Foucault states, living beings have

> withdrawn into their own essence, taking their place at last within the force that animates them, within the organic structure that maintains them, within the genesis that has never ceased to produce them, things, in their fundamental truth, have now escaped from the space of the table; instead of being no more than the constancy that distributes their representations always in accordance with the same forms, they turn in upon themselves, posit their own volumes, and define for themselves an *internal* space which, to our representation, is on the *exterior*. . . . [The] space of order is from now on shattered: there will be things . . . and then representation, a purely temporal succession, in which those *things address themselves (always partially) to a subjectivity, a consciousness, a singular effort of cognition, to the "psychological" individual who from the depth of his own history . . . is now trying to know.* (239–40; emphases added)

Between being and thought, subject and object, things and words, a new space is opened in which the very *conditions* of knowledge are at stake. Thus, for Foucault, Kant's critical philosophy marks the threshold of modernity, because it questions the limits of representation and the conditions that define its universal valid form. Kant's transcendental philosophy shows that judgments regarding the universality of phenomena and experience cannot be derived from experience or empirical observations but must be grounded for their validity on an a priori foundation beyond experience. Kant's philosophy therefore formulates a transcendental field in which the nonempirical but finite subject determines, in its exterior relation to objects, all the formal conditions of experience in general. The constitution of "man" as both the subject and the object of knowledge marks the major "event" of the modern episteme, according to Foucault, and with it the possibility of a new mode of philosophical reflection, what Kant calls "critique," which is precisely concerned with the *relations* between the empirical and the transcendental conditions of knowledge,

that is, with the formation of a discourse that separates the transcendental from the empirical while being directed at both (320).

Foucault famously defines the new epistemological figure of "man" as an "empirico-transcendental doublet," "since he is being such that knowledge will be attained in him of what renders all knowledge possible" (318). The constitution of man is a logical necessity, because it is within this "anthropological form" that the empirical comes to stand for the transcendental to the extent that the transcendental *repeats* the empirical. The constitution of man therefore necessitates a specific "analytic of finitude" through which the transcendental conditions of knowledge will be revealed or extracted out of empirical contents given to knowledge. Foucault shows that this analysis was conducted in two forms, either through a physiological model, which locates the conditions of knowledge in the body, or through a historical model, in which these conditions appear as part of an eschatological narrative. This analysis explains the emphasis within Whewell's project on "history" as way to inquire how "real" knowledge is obtained by individual discoverers, as well as, consequently, the reason that, once Talbot focuses his account on his role as an "original" discoverer, he presents his account and *The Pencil of Nature* in general as outlining the "history" of the new art. That is, it is within a historicist form of knowledge that the anthropological figure of "man" becomes necessary.

Yet although the transcendental conditions of knowledge make all knowledge possible, they nevertheless remain *outside* the domain of experience and thought. Thus, man is a mode of being, Foucault explains, that always remains open, never finally delimited, extending from that part in himself that remains *unknown*: "[I]t is now a question not of truth, but of being; not of nature, but of man; not of the possibility of understanding, but of the possibility of a primary misunderstanding; not of the unaccountable nature of philosophical theories as opposed to science, but of the resumption in a *clear philosophical awareness of that whole realm of unaccounted-for experiences in which man does not recognize himself*" (323; emphasis added). Instead of the sovereign transparency of the classical *cogito,* in which being *is* thought and thought is conceptualized as self-consciousness, the modern *cogito* suggests new relations between being and thought: "In this form, the *cogito* will not therefore be the sudden and illuminating discovery that all thought is thought, but the constantly renewed interrogation as to how thought can reside elsewhere than here, and yet so very close to itself; how it can *be* in the forms of non-thinking. The modern *cogito* does not reduce the whole being of things to thought

without ramifying the being of thought right down to the inert network of what does it not think" (324). Thus, the very possibility of thought in the modern episteme lies in inscribing within itself a space that cannot be thought, what Foucault calls the "unthought."

It is this epistemological problematic that explains the central role of the faculty of the imagination in Kant's and Coleridge's critical philosophies. The imagination is symptomatic of the loss of representation as a ground for knowledge and of the philosophical effort to provide a new foundation for knowledge. It marks the eclipse of representation, because it is a *synthetic* faculty whose primary function is to link the transcendental principles of understanding to empirical sense perception, but whose very existence marks the impossibility of an epistemological synthesis of knowledge outside the space of representation. That is, the imagination becomes necessary precisely because nature and man no longer occupy the same space, and thus the validity of knowledge can no longer be grounded metaphysically through the circular law of representation. Knowledge is now located within "man," whose sensorial "physiological" density and inherent historicity challenge any claim for the universality of knowledge. Hence, the inherently aesthetic faculty of the imagination points to the creative unaccountable potential of the genius and at the same time exposes man's inherent limits, as manifested, for example, in the concept of the sublime, what Foucault calls "finitude." This also explains the emphasis in romantic aesthetic theory on the unity between man and nature as a goal to be attained, not a condition that can be safely assumed.

In this formulation, the imagination is not primarily a trait or a quality that marks the gifted genius's originality but what epitomizes the highly ungrounded new conditions of knowledge.[33] These conditions led to the fluctuating definitions of the imagination's mode of operation in both Kant's and Coleridge's theories. Kant's scholars often debate the inconsistencies between his formulation of the imagination in the *Critique of Pure Reason* (1781) and the *Critique of Judgment* (1790).[34] In opposition to the first critique, where one fundamental faculty dominates the other, the *Critique of Judgment* focuses on their relations and their ability to enter into a "spontaneous harmony," or a conflict in which they push one another to a limit. This indeterminate and unregulated relationship between the faculties becomes, Gilles Deleuze argues, "the foundation of romanticism."[35] And it is Kant's reformulation of the creative imagination in the third critique that explains the epistemological and aesthetic ramifications of the figure of the genius in the romantic project.

Yet differences also exist between the two editions of the *Critique of Pure Reason,* as Kant seems to broaden the role of the imagination from an associative empirical faculty to a synthetic transcendental one. In the first edition of the *Critique of Pure Reason,* Kant describes three forms of synthesis that make experience and knowledge possible. He explains that synthesis is necessary because of the successive order in which discrete representations appear; that is, because Kant defines time as a transcendental category, he needs to show how it is "formed" or "produced" in the very act of perception. As Deleuze explains, in Kant's philosophy, time is no longer subjected to movement or, in Foucault's terms, to the "law of continuity" that precedes time, but it becomes a unilinear element of thought itself that "imposes the succession of its determination on every possible movement." Hence the paradox of historicism in which everything changes in time, but time itself does not change or move; "it is an immutable form that does not change."[36] The synthesis of the imagination is described in the first edition as reproductive and associative because it is meant to link present and past presentations on the basis of a transcendental principle (time or space) without which no coherent experience is possible. This form of synthesis is differentiated, on the one hand, from the more basic synthesis of intuitive apprehension that combines successive separate impressions into a single representation, and, on the other hand, from the "higher" synthesis of conceptual recognition that imposes unity among perceptually separate yet similar representations.[37]

In the second edition of the *Critique of Pure Reason,* published six years after the first one, Kant differentiates between the synthesis of the reproductive imagination that is subject "solely to empirical laws, viz., to the laws of association," and that therefore "contributes nothing to the explanation of the possibility of a priori cognition" but belongs to psychology (192), and what he calls the "figurative" synthesis of the transcendental productive faculty of the imagination. The imagination is described not simply as a "reproductive" faculty that (re)presents an object in intuition without its being present but also as one that "forms" objects of intuition so that they will correspond to the concepts of understanding. The imagination, like the transcendental faculty of understanding, becomes an "exercise of spontaneity, which is determinative, rather than merely determinable, as in sense; hence this synthesis can a priori determine sense in terms of its form in accordance with the unity of apperception" (191). What Kant now emphasizes is the fact that because the imagination mediates between sense and understanding, it actually partakes of both;

thus, it remains unclear whether the imagination is an independent fac-
ulty or whether it simply has a specific role or function within the exist-
ing faculties.[38]

Later in the *Critique of Pure Reason,* Kant further elaborates on the
transcendental mediating function of the imagination. Assuming that the
pure concepts of understanding are different from empirical intuitions,
Kant needs to explain in what way intuition subsumed under a category
or how a category can be applied to appearances, that is, how the tran-
scendental and the empirical can be linked. This necessitates a "power of
judgment" and a mediating "third something" that "must be homoge-
neous with the category on one hand, and with the appearance, on the
other," both intellectual and sensible (210–11). Kant defines this form of
presentation "transcendental schema" and argues that it is always a prod-
uct of the imagination. He emphasizes that the "schema" is different from
an image. Thus, for example, rather than presenting an image of the
number 5, Kant supposes "that I only think a number as such. . . . Then
my thought is more the presentation of a *method* for presenting—in accor-
dance with a certain concept—a multitude in an image, than this image
itself" (213; emphasis added). Schemata are thus not images of objects
but "pure sensible concepts" that function as *possible* rules for the synthe-
sis of the imagination. Whereas the image is a product of the empirical
faculty the imagination, the schema of sensible concepts is a product or
"a *monogram* of the pure a priori imagination through which . . . images
become possible in the first place" (214; emphasis added). The imagina-
tion, explains Rudolf Makkreel, makes possible the transition from a
logical meaning to an objective one, from the logical possibility of objects
to the objective reality of objects. In this regard, the schemata, by specify-
ing the possible empirical predicates of the object, "realize the categorical
forms by anticipating possible objects of experience while at the same time
they restrict them by selecting what type of empirical concepts are eli-
gible to be applied to such objects."[39] In this formulation, the imagination
determines the transcendental conditions for the realization of the cate-
gories by defining in advance the *forms* of empirical objects that could
correspond to the forms of the categories. The significant point of Kant's
analysis is that the imagination is defined no longer as an "image-making"
faculty but as a formal analytical one. In this part of his discussion of the
imagination, Kant unexpectedly states, in a way similar to Hume, that
schematism is "a secret art residing in the depths of the human soul, an
art whose true stratagems we shall hardly ever divine from nature and

lay bare before ourselves" (214). Like Hume, he emphasizes the necessity of the imagination but also the impossibility of understanding and explaining its operations, which in this statement border on the "mystical" or "metaphysical." The imagination makes experience and knowledge possible, but it belongs to what Foucault defined as the "unthought."

Yet it is ultimately in the *Critique of Judgment* that the imagination's role becomes not simply productive but also creative as part of its mutual "free play" with understanding. Here Kant links the imagination to reflective judgment, in which a particular is given but no universal concept exists under which it can be subsumed or contained, in opposition to determinative judgment, in which the universal is given. Reflective judgments are meant to suggest the unity and systematization of nature not through the categories that establish the possibility of the universal laws of nature but through the *principle of purposiveness,* in which the unity of nature is judged only in terms of empirical contingent laws. This principle enables the subject to systematize the inherent diversity of nature in a way that is commensurate with the faculties. A reflective judgment is thus merely subjective because it establishes "a law for its reflection on nature," not for nature itself.[40]

For Kant, judgments of taste are reflective judgments, because the feeling of pleasure they evoke cannot proclaim an a priori necessity or an objective necessity, yet the capacity to make these judgments is a universal one and calls for a universal validity, what he calls "common sense." Kant challenges the aesthetic theories of Edmund Burke and David Hume in which judgments of beauty relate either to specific qualities of objects or to their effect on the mind. He aims to show that these judgments are not individual and "psychological," because although they are empirical and contingent, they are nevertheless grounded in the subject's transcendental principles and operations of the faculties. Reflective judgments of taste are made not out of a sensation or of a cognition that relates an object to a concept (it is divorced from knowledge) but out of the subject's feeling of the harmonious operations of his *own* faculties. Thus, "what is merely subjective in the presentation of an object . . . is its *aesthetic* character" (28; emphasis added).

When judging an object beautiful, the imagination creates a *form* of unity without presupposing a determinate concept, yet it does so in harmony with the general lawfulness of understanding. This "free lawfulness" is aligned with the free lawfulness of understanding, which assumes a form or a principle of purposiveness in the object but without a specific

purpose. The feeling of pleasure thus emerges out of the subject's recog-
nition of the indeterminate activity, a "free play" of the two faculties that
is nonetheless attuned, that is, reciprocal and harmonious, with cognition
in general (63–64). Thus, the imagination becomes a semiautonomous
faculty in the third critique that produces independent forms of intu-
itions and unities yet always in harmony with the abstract lawfulness
of understanding. And although the indeterminate unity that the imag-
ination creates can only be sensed and not known, because it is not related
to a concept, nevertheless, as Makkreel argues, it does have an epistemo-
logical significance, because it contributes to the systematization of expe-
rience by linking the lawfulness of nature with the laws of freedom that
Kant outlined in the *Critique of Practical Reason* (1788): understanding
(natural philosophy) and reason (practical moral philosophy), sensible and
supersensible knowledge.[41]

Thus, after analyzing the imagination's relations with understanding
as part of his definition of the beautiful, Kant discusses its relations with
reason as part of his designation of the sublime, as that which cannot
be exhibited or contained in any sensible form but only through the
supersensible ideas of reason. The sublime exposes the inadequacy of the
imagination to exhibit a whole of incomparable magnitude, its inability to
synthesize out of successive impressions a unity, but only in "one instant"
that "cancels the condition of time in the imagination's progression" and
thus does "violence to inner sense" that is dependent on temporal succes-
sion for the constitution of experience (116). That is, by excluding the
linearity of time, the object can be no longer synthetically "produced" in
the successive act of perception but only registered as a disruption. Yet this
inability and violence trigger the subject's consciousness of the unlimited
and infinite powers of reason to transcend "any standard of sensibility"
and therefore reassures the subject of "the superiority of the rational
vocation of our cognitive powers over the greatest powers of sensibility"
(112, 114). Thus, again, the sublime "must be sought only in the mind of
the judging person" and not in any natural object, as Burke suggested,
by the simultaneous feeling of displeasure and pleasure that emerges out
of the conflicted yet ultimately harmonious relation of the imagination
with reason.

It is within his analysis of aesthetic reflective judgments that Kant's
definition of genius needs to be understood. And although Kant defines
genius exclusively within the realm of fine art, this discussion actually
forms a very small part of the *Critique of Judgment* that is concerned not

with art but with the ability to "think" aesthetically without determining concepts or specific rules, an ability that Kant locates exclusively in the subject. In this regard, Kant further elaborates and transcendently grounds Alexander Baumgarten's definition of aesthetics not as a discourse of art but as a form of sensorial knowledge that is not subjected to conceptual knowledge and therefore should be judged not as a "lower" form of cognition but as one that contains its own independent criteria of perfection that need to be met if beauty is to be perceived. Baumgarten thus emphasizes the ability to create sensorial unity out of percepts, not qualities of things, through the richness and vividness of a singular perception. And although, for Kant, aesthetics is not a form of knowledge or a science but a mode of judgment, nevertheless he also emphasizes the independence of reflective judgments from determinative ones that are based on concepts. This understanding of aesthetics is crucial, as I will further show, for an understanding of the aesthetic terms through which photogenic drawing was conceptualized as a picture and a visual image.

Kant defines the genius as "the talent (natural endowment) that gives the rule to art" (174). Given that art, on the one hand, presupposes rules without which its products cannot be recognized, but on the other hand is subjected to a judgment of beauty that cannot be derived from a rule, it follows, for Kant, that it is the natural qualities of the subject that give rule to art. Thus, genius consists in the ability to produce something without any determinate rule, concept, or specific skill. Originality is thus the major trait of the genius and consists in his inability to describe or analyze his product. Thus, it is "as *nature* that it gives the rule": "[H]e himself does not know how he came by the ideas for it; nor is it in his power to devise such products at his pleasure, or by following a plan, and to communicate [his procedure] to others in precepts that would enable them to bring about like products" (175; emphasis in original). In this regard, the genius's products are exemplary, and although they can inspire other geniuses to follow or can give rise to schools, they cannot be imitated. Kant is inconsistent as to whether the works by genius can be imitated, but he definitely rejects the view that they can be copied or "mechanically imitated": "For in mere imitation the element of genius in the work—what constitutes its spirit—would be lost" (187).

A genius is thus determined by his "spirit" (*Geist*), an aesthetic animating principle that consists in the ability to present "aesthetic ideas" that the productive imagination creates and for which no concept can be adequate. It is in his discussion of "aesthetic ideas" that Kant emphasizes

the productive power of the imagination and its freedom, not simply its "lawfulness," when "it creates . . . another nature out of the material that actual nature gives it." The imagination frees itself from the empirical law of association and "molds" nature into "something that surpasses nature" (182). Thus, on the one hand, the imagination, like reason, forms ideas that transcend experience, yet, on the other hand, these ideas are "inner intuitions" or "pure sensations" that cannot be contained in any concept. The imagination animates reason, "makes reason think more," and "quickens the mind" by opening it to a "multitude" of presentations. Thus, the aesthetic imagination, as opposed to the one described in the *Critique of Pure Reason,* which is under the constraint of the understanding, "is free, so that, over and above that harmony with the concept, it may supply, in an unstudied way, a wealth of undeveloped materials for the understanding" (185). The genius has the ability to understand the free play of the imagination and to communicate it in a concept to which no rule applies.

Whereas Hume describes the imagination as an empirical "psychological" faculty that introduces "fictitious" resemblances unwarranted by the law of association, Kant analyzes it as a transcendental faculty that actively forms the contents of sensation in accordance with the categories. Kant celebrates the formative powers of the imagination in the third critique, where the freedom of the imagination seems to further affirm the idea of freedom that underlies practical reason, and to enrich experience. The figure of the genius thus manifests the new conditions of knowledge that are now located in "man," who has the ability to create "another nature." Nature is thus no longer simply a transparent "image" of the divine design but a synthetic formal product of sensibility and understanding, a schematic "monogram" that, as a "pure sensible concept," is both intelligible and sensible. It is a monogram that, more than illuminating the conditions of knowledge, in fact highlights the inherent opacity or "secrecy" of both nature as a "thing-in-itself" and the mind of the genius, whose creations cannot be explained through any rule or law. This, as Coleridge's romantic philosophy makes clear, enables the operations of man and nature to be aligned or "linked" but not unified. At the same time, this account of the faculty of the imagination complicates any straightforward notion of what a "picture of nature" might be at this historical juncture, because, contrary to the premises of representation and its exclusion of resemblance and the "fictions" of the imagination, what can be seen and known (in and outside the camera obscura) cannot be separated from what can be imagined.

Coleridge's Philosophical and Aesthetic Method

In his seminal *The Mirror and the Lamp,* M. H. Abrams argues that the Copernican revolution in epistemology "was effected in England by poets and critics before it manifested itself in academic philosophy."[42] This again suggests that Whewell's theory of induction and his notion of a scientific "genius" were formed in response to Coleridge's aesthetic theories, which introduced or disseminated German philosophy into Britain.[43] Significantly, historians of photography such as Geoffrey Batchen and Anne McCauley have already identified Coleridge's significance for the conception of photography. Batchen in particular argues that Coleridge's thinking is "exemplary" of the shifts transforming European epistemology and strongly emphasizes the importance of his philosophical work and his conception of nature to the protophotographers, namely, Davy and Thomas Wedgwood, with whom he had personal relationships. He outlines the biographical relations and personal correspondence between Coleridge and Wedgwood in order to show how Coleridge's views on representation, and in particular his insistence on the "interactive relation between nature and the viewing subject," informed the protophotographers' conception of photography.[44] Here I focus specifically on Coleridge's theory of the imagination as symptomatic of the new conditions of knowledge that are evoked in Talbot's 1844 discovery account with its emphasis on subjectivity and temporality. The function of the discussion that follows is not to argue that Talbot was a "romantic," and in fact there are no biographical indications that he was specifically interested in Coleridge's philosophy or poetry (Coleridge died in 1834, ten years before the publication of *The Pencil of Nature*). Yet romantic ideas and categories do underlie many of Talbot's comments in this book and are constantly referred to in early reviews of photography. There are, however, many indications that Talbot was also very much interested in the work of Sir Walter Scott, whose novels were of major interest to romantic historians, as I show in chapter 4. What I suggest in this chapter is that the shift in Talbot's account is symptomatic of a new set of epistemological and aesthetic concerns that are discursively responsible for the inconsistent way in which he came to conceptualize photogenic drawing. At the same time, I wish to rethink the relations between photography and aesthetics at this historical junction beyond the binary that is often addressed by historians of photography between art and technology.

Coleridge's seminal definition of the imagination appears in his *Biographia Literaria* (1815–17), in which he reconsidered his early political

and philosophical affiliations.[45] In the 1790s Coleridge was affiliated with a group of political and scientific dissidents who demanded, following their enthusiasm for the French Revolution, a republican political reform in England. He was part of a Unitarian circle that centered on Joseph Priestley, who rejected Newton's dualistic ontology of matter and force and the theological distinction between matter and spirit in favor of a monistic and materialistic theory of nature now defined as a substance endowed with active powers of attraction and repulsion. For Priestley, both body and mind were aspects of force and not distinct antithetical entities, as force accounts for all physical reality, and he adopted David Hartley's theory of association, as it was grounded in a strictly physiological and neurological account of perception and mental activity. This Unitarian circle included, among others, the brothers Thomas and Josiah Wedgwood and Thomas Beddoes, a physician related to a group of radical physicians in England who openly advocated John Brown's theory of life based on the excitability of the animal body. Beddoes was an advocate of German philosophy and in 1793 published one of the first English accounts of Kant's *Critique of Pure Reason*. He founded the Pneumatical Institute as a hospital for the treatment of patients by the inhalation of gases, and it was through him that Davy met Coleridge in 1799, after the latter returned from a trip to Germany. An underlying concern of this group was the idea of an "active universe" sustained by one power that permeates both mind and matter. This stance was opposed to the views of the scientific and philosophical establishment in Britain, which followed Newton's dualistic conception of inert matter and active forces.

Coleridge adopted Hartley's and Priestley's physiological and neurological theory of association, in which all sources of ideas come either from direct sense experience exciting the nerves or from a coalescence of nerve vibrations throughout the body. These theories were part of an effort, as James Engell states, to expand associationism "from a limited and mechanistic aspect of the intellect to an organic, encompassing psychological principle informing aesthetics, criticism and ethics. The progress of associationism can be seen as the drama of empiricists seeking to widen their horizons, to include more of the complexities of experience, yet always to explain these complexities and nuances by as simple and empirical a principle as possible."[46] The promise, for Coleridge, in these material associationist theories was the unification of body and soul, matter and spirit, through the idea that matter was not inert but animated and therefore spiritual.

It was these early affiliations that led to Coleridge's explicit embracing of German idealism in the *Biographia Literaria*. For him, idealism presented a much more sophisticated account of this philosophy of identity than associationism and a stronger case for rejecting empiricism in favor of Kantian transcendentalism, as Nigel Leask explains: "Coleridge's lifelong struggle against philosophical dualism, his attempt to formulate an identity between spirit and matter (increasingly in conflict with his need to postulate a transcendent and personal deity), found common cause with the idealist's bid to overcome Kant's dualistic 'distinction of powers.'"[47] Unity was now to be grounded on spirit as the eternal productivity from which matter evolves, and not in matter from which the spirit arises. As Coleridge explicitly states in the *Biographia Literaria*, "But as soon as it [materialism] becomes intelligible, it ceases to be materialism. In order to explain *thinking*, as a material phænomenon, it is necessarily to refine matter into a mere modification of intelligence, with the two-fold function of *appearing* and *perceiving*."[48]

Following Johann Fichte and Friedrich Schelling, Coleridge felt that Kant's transcendental philosophy, while locating the possibility of experience in the nonempirical self, fell short of providing a basis for the romantic idea of nature as an active organic whole, because it upheld the distinction between "things-in-themselves" and the way they appeared to the categories. Schelling thus insisted that Kant's dualism between subject and object, self and the physical world, is illusionary, and, based on Fichte, he argued that the unity and identity of self-consciousness as "I think" form the first principle of human knowledge. This unity could be achieved only in the form of infinite and pure *activity* of the self as part of a dialectic between the conscious self and the not-self. Unity turns into *identity* between subject and object in the form of the Absolute as a primary homogeneous and undifferentiated One, a spiritual principle in which duality is contained as a twofold movement from difference to unity and unity to difference.[49]

Schelling grounded the possibility of the physical world and of science within the activity of the nonempirical intellectual self. Thus, his philosophy, like Kant's, is transcendental, because the real is subjected to the ideal. Yet, for him, *Naturphilosophie*, as a philosophy complementary to transcendental philosophy, explains the ideal through the real by discovering the same principles of infinite *productive activity* in nature. Nature as pure activity forms the unconditional ground for nature as determined or finite product, precisely as the intelligent self, the "I Think," forms the ground

for the passive empirical self. Yet nature as pure productivity is accessible only to intellectual intuition, as it is not a sensible object. The distinction between productivity and product explains the prevalence of polarity concepts in *Naturphilosophie*. Productivity contains within itself the concept of restraint, by which it is able to generate determined objects. Nature as a product is the result of the active interaction between these opposing tendencies. And because these two tendencies are equal, they need to be thought of as alternately dominant.[50] As scholars have shown, the concept of polarity underlies the early terminology of photography, in particular the terms *negative* and *positive*.[51]

Schelling's idealism provided the philosophical ground not only for Coleridge's theory of the imagination and poetic creation but also for his renunciation and criticism of Hartley's materialist theory of association. Yet his criticism is directed less to the materialistic ground of Hartley's theory and much more to its mechanical logic, that is, to the way its adherence to Newtonian ontology and science necessarily leads to a highly "mechanical" associationist epistemology: "the law of association being that to the mind, which gravitation is to matter" (1:67). For him, both are reductive, because they are grounded in empiricism: "Under that despotism of the eye . . . under this strong sensuous influence, we are restless because invisible things are not the objects of vision; and metaphysical systems, for the most part, become popular, not for their truth, but in proportion as they attribute to causes a susceptibility of being *seen*, if only our visual organs were sufficiently powerful" (1:74; emphasis in original). These statements show how Coleridge's romantic project is emblematic of the shift in the conditions of knowledge in the early nineteenth century, because it is precisely the reducibility of being to representation and the subjection of vision (or "taming" of the senses) to the principles of association and understanding that are criticized. Consequently, it is the "dark," invisible side of nature and being as a constellation of forces that becomes the object of knowledge.

Coleridge shows how associationism is modeled after the mechanical laws of motion: "In our perceptions we seem to ourselves merely passive to an external power, whether as a mirror reflecting the landscape, or as a blank canvas on which some unknown hand paints it" (1:66). In associationism, ideas are conceived like atoms and temporal relations are addressed as empirical, that is, as the outcome of repeated experiences and not as *conditions* of experience. Ideas can be accumulated only as the linear continuous effects of their direct cause; they do not contribute any

motion of their own in a reciprocal response to a primary cause, thereby qualitatively modifying its effects.

The main motivation behind Coleridge's criticism of empiricism is moral, because, for him, the most significant outcomes of a reductive mechanistic philosophy are its determinism and its exclusion of subjectivity and free will: "Thus the whole universe co-operates to produce the minutest stroke of every letter, save only that I myself, and I alone, have nothing to do with it, but merely the causeless and *effectless* beholding of it when it is done. Yet scarcely can it be called a beholding. . . . The sum total of my moral and intellectual intercourse, dissolved into its elements, is reduced to *extension, motion, degrees of velocity*, and those diminished *copies* of configurative motion, which form what we call notions, and notions of notions" (1:82; emphases in original). Coleridge analyzes the basic empiricist premises of associationism, in which, as in Hume's *Treatise*, perception is described as a copying process composed of autonomous and impersonal forms of representation that are organized according to the universal principles of association. Thus, in opposition to the definite and predictable notion of human nature as a "mechanical" outcome of representation, Coleridge proposes an individual free subject with synthesizing or amalgamating faculties who functions as the source of knowledge; yet, for him, this subject is not merely an abstract "formal principle," as it is for Kant, but a moral agent. This again explains the special appeal of his ideas to Whewell, because it is precisely these qualities of the discoverer that needed emphasis in light of the legacy of British empiricism with its emphasis on a continuous "ladder of reasoning" and the popularity of utilitarian and materialist views of scientific practice during the 1830s.

For Coleridge, it is precisely the faculty of the imagination that manifests the inherently irreducible element in the subject as a creative free being, but ultimately one who, for Coleridge, is subjected to the divine Creator. In the *Biographia Literaria,* Coleridge explicitly states that he deduced the faculty of the imagination out of Schelling's philosophy of identity. Yet throughout the book Kant's formulation of the imagination as a mediating third faculty between sense impressions and the abstract concepts of understanding is evoked as well, and also Kant's oscillating views of the imagination as partly empirical and partly transcendental: "There are evidently two powers at work, which relatively to each other are active and passive; and this is not possible without an intermediary faculty, which is at once active and passive" (1:86). Coleridge in fact turns the tension in Kant's philosophy into a *critical* principle through which

the poetic imagination may be differentiated from the imagination as an element of perception, as well as genius from talent, and imagination from fancy.

Nevertheless, the concluding definition of the imagination at the end of the first volume of the *Biographia Literaria* is presented as a philosophical "deduction" from Schelling's transcendental philosophy and dynamic natural philosophy. Coleridge begins the deduction with direct reference to Schelling's and Fichte's intellectual self as the ground for the identity of subject and object and therefore as the source for all being. Like Schelling, Coleridge opposes transcendental philosophy and natural philosophy as the two possible philosophies, and points to their unification not only in the act and evolution of self-consciousness as the highest principle of knowledge, but also in God: "The result of both the sciences, or their equatorial point, would be the principle of a total and undivided philosophy. . . . In other words, philosophy would pass into religion, and religion become inclusive of philosophy. We begin with the I KNOW MYSELF, in order to end with the absolute I AM. We proceed from the SELF, in order to lose and find all self in GOD" (186). This statement, embedded as it is within Schelling's philosophical program, also marks Coleridge's departure from German romanticism, in which *Naturphilosophie* was meant to supplement religion, not to dissolve into it. Coleridge attempts to "Christianize" *Naturphilosophie,* because the idea of nature as self-subsistent could not be tolerated within the British context and was opposed to Coleridge's own religious convictions. Raimonda Modiano explains: "As much as Coleridge was attracted to the dynamic view of nature as formulated by various *Naturphilosophen*, he remained apprehensive of the pantheistic pitfalls of their system. Coleridge tried to devise a system in which a dynamic conception of nature's polar activity and intrinsic unity could be maintained side by side with a belief in a Christian God. This led Coleridge to a Trinitarian theology . . . as a foundation for a new version of dynamic philosophy."[52] Coleridge intended to construct a unified philosophical system in which the real and the ideal in nature would be both identical *and* hierarchical in order to sustain religious belief. This again explains the attraction of Coleridge's ideas to Whewell and Coleridge's efforts to reconcile empiricism and transcendentalism in order to further enforce the design argument.

Nevertheless, what is mostly stressed in the *Biographia Literaria* is the idea that intelligence is a principle of *ceaseless productive activity* that provides the ground upon which natural philosophy and transcendental

philosophy are unified. The struggle between equal and indestructible forces is "inexhaustibly re-ebullient," and thus it is development as eternal growth that forms the core of Coleridge's conception of nature and of the imagination as a creative faculty in opposition to inert matter and fancy:

> The IMAGINATION then, I consider either as primary, or secondary. The primary IMAGINATION I hold to be the living Power and prime Agent of all human Perception, and as a repetition in the finite mind of the eternal act of creation in the infinite I AM. The secondary Imagination I consider as an echo of the former, co-existing with the conscious will, yet still as identical with the primary in the kind of its agency, and differing only in degree and in the mode of its operation. It dissolves, diffuses, dissipates, in order to recreate; or where this process is rendered impossible, yet still at all events it struggles to idealize and to unify. It is essentially vital, even as all objects (as objects) are essentially fixed or dead.
>
> FANCY, on the contrary, has no other counters to play with, but fixities and definites. The Fancy is indeed no other than a mode of Memory emancipated from the order of time and space; while it blends with, and is modified by that empirical phenomenon of the will, which we express by the word CHOICE. But equally with the ordinary memory the Fancy must receive all its materials ready made from the law of association.[53]

The primary imagination forms an unconscious part of every synthetic act of human perception. Thus, seeing itself is a creative act, as it necessarily partakes in the eternal act of creation in the Absolute spirit. Human perception is the empirical, sensual correlative manifestation of the primary force of the imagination, which in itself is nonsensual, nonempirical, and nonsubjective, as it stands for the identity and unity of subject and object. The secondary imagination addresses the specific nature of conscious poetic creation, as it points to the *critical* function of the imagination as a transformative force that uncovers the dynamic unity of the contingent world beyond its "fixed and dead" appearances. The secondary imagination is described as a "formative" force that has the ability, as Kant stated, to transcend experience, whereas "fancy" is what Kant defines as the "reproductive" imagination, which is subjected to the laws of association and therefore suggests nothing new to understanding or reason.

Yet what make Coleridge's definition of the imagination so decisive are its internal inconsistencies, as the organic and moral unity that the faculty

is meant to achieve is constantly *denied* and *deferred*. In the primary imagination, the term *repetition* serves only to reintroduce the gap between the human and the divine that the imagination is meant to bridge. Then, in the secondary imagination, unity is presented as a compromise, that is, the imagination is both the cause of constant division and the principle of eventual *fictive* cohesion. As Forest Pyle states, "[R]eaders of Coleridge are confronted with the prospect that the presumed coincidence of subject and object, on which 'all knowledge rests,' and the promised unification of the two subjects of autobiography are but the illusory effects of a surreptitious desire."[54]

Moreover, Leask shows that this definition of the imagination presents a retreat, within Coleridge's intellectual biography, from an engagement with the historical and the political in the realm of the aesthetic. Art now *transcends* the world by offering a reconciled, totalizing alternative to everyday reality: "[T]he spirit no longer partakes of the Reality which it renders intelligible, and . . . which renders *it* intelligible."[55] Thus, Coleridge's definition of the imagination presents a unique articulation of the romantic desire to achieve unity, and at the same time conveys his recognition that this unity is untenable because of the very conditions of knowledge. That is, the very formation of the imagination as a synthetic faculty that fuses together the empirical and the transcendental serves only to reintroduce the gap between these two poles of experience and knowledge. The imagination can transcend experience, but it cannot resolve its basic antinomies.

Yet this recognition did not prevent Coleridge from outlining an ambitious intellectual project, which aimed at the unification of all knowledge under the idea of the Trinity through the mutual transformation of philosophy and science, as he states in his "General Introduction; or, Preliminary Treatise on Method" (1818), or as it later appeared in *The Friend* as "Essays on the Principles of Method":

> Religion therefore is the ultimate aim of philosophy, in consequence of which philosophy itself becomes the supplement of the sciences, both as the convergence of all to the common end, namely, wisdom; and as supplying the copula, which modified in each in the comprehension of its parts to one whole, is in its principles common to all, as integral parts of one system. And this is METHOD, itself a distinct science, the immediate offspring of philosophy, and the link or *mordant* by which philosophy becomes scientific and the sciences philosophical.[56]

Coleridge's unified system of knowledge was meant to reconcile man's moral freedom and the transcendence of God with the reality of external nature. For him, the term *method* stands for much more than any specific scientific method; it provides the philosophical means to reach this desired state of reconciliation and unification of all knowledge. It is thus formed as an instrumental "science" to link a dynamic conception of nature with a transcendental philosophy. While Coleridge's understanding of science as it is revealed in this essay is radically different from that of the scientific establishment in Britain, nevertheless it is still embedded within the same moral and cultural concerns as those of the scientific establishment, because it also aims to ground knowledge by unifying it under one principle or method in a way that will not challenge religion.

As part of his method, Coleridge differentiated between "law," which stands for an original creative idea that originates in the mind and is not abstracted or generalized from observation, because its object is the nonsensible principle underlying nature's productivity; and "theory," which is conceived as the outcome of an enumerative form of generalization, because its objects are the sensible objects of nature. Corresponding to law and theory are the two "fashionable" sciences of chemistry and botany, both crucial to Talbot's early experiments and images, as I will further show. Whereas botany is based on artificial classification and on the conception of nature as a visible product, chemistry is the science of nature as dynamic creativity and pure potentiality. Chemistry is the model for Coleridge's conception of science and for the idea of a philosophical genius as a figure complementary to the poet:

> [W]ith the knowledge of LAW alone dwell Power and Prophecy, decisive Experiment, and, lastly, a scientific method. . . . Such, too, is the case with the assumed indecomponible substances of the LABORATORY. They are the symbols of elementary powers, and the exponents of a law, which, as the root of all these powers, the chemical philosopher, whatever his theory may be, is instinctively labouring to extract. This instinct . . . is itself but the form, in which the idea, the mental Correlative of the law, first announces its incipient germination in his own mind: and hence proceeds the striving after unity of principle through all the diversity of forms. . . . This is, in truth, the first charm of chemistry, and the secret of the almost universal interest excited by its discoveries. . . . *It is the sense of a principle of connection given by the mind, and sanctioned by the correspondency of nature.* Hence the strong hold which in all ages

chemistry had on the imagination. If in SHAKSPEARE [*sic*] we find
*nature idealized into poetry . . . so through the meditative observation of a
DAVY, a WOOLLASTON . . . we find poetry, as it were, substantiated and
realized in nature.*[57]

Ideas are derived from the mind of the philosopher as genius and enable
him to discover the invisible powers underlying phenomena. Through
this statement one can see the importance of Davy's work to Coleridge's
conception of science and method. As Trevor Levere points out, Coleridge
and Davy's friendship informed their respective practices.[58] The very
idea of a philosopher-scientist, Levere argues, was suggested to Coleridge
through his encounter in the Pneumatic Institute with Davy, who, along
with practicing science, wrote poetry. By the same token, Davy, as was
stated earlier, modeled his conception of the natural philosopher as genius
on the ideal of the romantic poet, and formulated his ideas regarding the
importance of chemistry within the sciences based on Coleridge's defini-
tions of poetry.[59]

In light of these statements, it becomes clear that the idea of a "philo-
sophical genius" had a specific meaning in the context of chemistry as an
emblem of romantic science and as a constitutive field of knowledge for
the conception of photography. Chemistry exemplified the realization of
creative synthetic ideas in nature and thus the necessary link between the
potential and the actual, the nonsensible or intelligible and the sensible.
Yet, as with the imagination, the possibility of synthesizing different levels
of knowledge also simultaneously exposed the gap between them. This
gap is implicitly evoked in Talbot's account by his emphasis on a tempo-
ral and conceptual discontinuity between the actual moment of discovery
in which the "original" idea appears and the series of experiments that
follow. Coleridge in fact described the relations between idea and exper-
iment in similar terms: "[A]n idea is an experiment proposed, an experi-
ment is an idea realized."[60] And the very formation of the first idea is
described as a synthetic process through which the idea is initiated in the
discoverer's mind but can emerge only through an encounter with nature,
where it can be *realized* or recognized in "the pictures of nature." Thus,
at the moment of discovery, the photographic image is an unrealized
potential, an imaginative possibility that cannot at this point be realized
or even specified, precisely as Snyder argues. As the product of a genius,
it is an "aesthetic idea" not because it outlines a specific form of an image
but precisely because it *lacks* a determinate concept. This again suggests

the discursive inseparability of Talbot's conception of the photographic image and the epistemological and philosophical premises informing his model of discovery.

In Talbot's 1844 account, photogenic drawing is a synthetic and imaginative effect of an irreducible reciprocal process between a creative mind and productive nature, *an idea realized in nature*. That is, it is conceptualized not as a "natural magic" that confirms the premises of the inductive method and the law of representation but as an idea through which the inherent opacity of nature and its active forces also underlies the mind's operations. Nature and "man" are unified under these romantic premises but in a way that ultimately points to the gap separating them. This suggests that the role of the camera obscura and the connection to drawing need to be reconsidered in Talbot's account, because it is clear that, as an "imaginative" effect or an "aesthetic idea," photogenic drawing is anything but a "fixed" image, largely because the epistemological status of the camera-obscura image as a "picture of nature" significantly shifts within romantic aesthetic theories, as Jonathan Crary has shown in his *Techniques of the Observer*.[61] This becomes quite clear once the critical aspects of Coleridge's theory of the imagination are examined. More than a viable epistemological or philosophical possibility for unifying man and nature, the imagination becomes a critical tool in aesthetic theories. It is thus through an analysis of this new aesthetic critical vocabulary, so pervasive in early reviews and writings on photogenic drawing, that the epistemological status of the photographic image as an imaginative effect and as a trigger for "imaginative" picturesque feelings can be understood.

The Life of the Imagination

Significantly, for both Kant and Coleridge, the faculty of the imagination was linked to the biological, physiological, and philosophical idea of "life." Foucault in fact points to the differences between the classical episteme and the modern one by pointing out that "[w]hen the Same and the Other both belong to a single space there is *natural history*; something like *biology* becomes possible when this unity of level begins to break up, and when differences stand out against the background of an identity that is deeper and, as it were, more serious than that of unity."[62] The deeper and invisible "identity" Foucault refers to is the concept of "life" that marked the fact that the study of nature is based no longer on atoms and predictable mechanisms but on vital processes that cannot be fully accounted for. Foucault's analysis of the modern episteme is informed by François Jacob's

The Logic of Life, in which he argues that what counted in the nineteenth century were no longer external differences but resemblances in depth; thus, in order "to maintain the cohesion of the organism . . . there had to be a particular quality, there had to be *life.*" Yet, although life is the source of every living being, it cannot be reduced to biological, physical, or chemical functions; it is an obscure force, Jacob states, a "vital principle" that differentiates and separates the living being from the inanimate object, based on the notion of forces, not matter. "Vitalism [operates] as a factor of abstraction" that is as "necessary for the establishment of biology as mechanism [was] for the Classical period."[63]

Makkreel shows that the idea of life informs Kant's *Critique of Judgment* and provides an important perspective from which to understand the reflective functions of the imagination. He points out that the subject's feeling of life conveys, for Kant, an overall sense of vitality that encompasses both biological and mental life. In its "free play" and spontaneity, the imagination enhances the sense of life and existence in the subject by triggering its capacity to be affected. For Kant, "life" marks the capacity for self-determination based on an internal principle of purposiveness. In the third *Critique,* he links aesthetic judgments to teleological judgments that attribute to an organism an immanent purposiveness in which every part is both an end and a mean. Makkreel thus argues that in aesthetic judgments, "the imagination does more than represent and enhance the feeling of life; the general formative power of the imagination can be interpreted to be a manifestation of life itself."[64] That is, as a power of life, the imagination becomes a "transcendental condition for both the power to move and to be moved, and allows us to interpret the aesthetic feeling of life as a transcendental point of unity for both the active power of the understanding and the receptivity of sense."[65] In this regard, the sense of harmony that is evoked in aesthetic judgments suggests a vital immanent principle of overall synthetic, indeterminate unity.

Like Kant, Coleridge defines the imagination as a formative life force and a transcendental principle of unity. In his *Theory of Life,* Coleridge defines life as *"the principle of individuation"* and a *"power* which discloses itself from within as a principle of *unity* in the *many"* or "unity in *multeity.*"[66] Life is a force that discloses itself in a range of different phenomena as that which both divides (like polarity in magnetism) and connects (like electricity).[67] Similarly, he defines the imagination in the *Biographia Literaria* as an echo of the divine act of creation that "dissolves, diffuses, dissipates, in order to recreate; or where this process is rendered impossible,

yet still at all events it struggles to idealize and to unify. It is essentially *vital*, even as all objects (as objects) are essentially fixed or dead" (1:202; emphasis added). The imagination is a ceaseless act of differentiation that unfolds in time. It is conceptualized as a force, a "synthetic and magical power" that, "first put in action by the will and understanding, and retained under their irremissive, though gentle and unnoticed, control . . . reveals itself in the balance or reconciliation of opposite or discordant qualities: of sameness, with difference; of the general, with the concrete."[68] Like the life force, the imagination exhibits the same unresolved tension between unity and multiplicity.[69]

This "vitalist" or "organicist" turn in romantic theory defines, Abrams argues, the central epistemological and aesthetic premises of romanticism. Abrams shows how in romantic theory the mind is conceived as a living organism or a living plant through which impressions are not passively impressed, as in empiricism, but metamorphosed or synthesized into a living whole. The idea of the plant emphasizes growth as a dynamic process, and the notion of immanent assimilation through which the plant makes itself is opposed to the idea of the machine, in which parts are added but not synthesized and whose source of energy is external.[70]

These ideas form the basis of the central opposition in Coleridge's aesthetic theory between mechanical copying and organic imitation. Although, for Coleridge, the function of art as a form of mediation between man and nature is to imitate nature, he has a very specific definition of what imitation is: "[I]mitation, as opposed to copying consists either in the interfusion of the SAME throughout the radically DIFFERENT, or of the different throughout a base radically the same" (2:72). In imitation, he claims, a sense of difference is essential for aesthetic pleasure, whereas in a copy it is considered to be a defect, because it needs to be seen as if it came out of the same mold of the original. A copy can be mistaken for the real thing and can lead to delusion, but an imitation always sustains a sense of difference; thus, the audience consciously chooses to be deceived.

Coleridge exemplifies the idea of mechanical copying through visual verisimilitude: "Could a rule be given from *without*, poetry would cease to be poetry, and sink into a mechanical art. It would be a fashioning, not a creation. The rules of the IMAGINATION are themselves the very powers of growth and production. The *words*, to which they are reducible, present only the outlines and external appearance of a fruit. A deceptive counterfeit of the superficial form and colors may be elaborated; but the marble peach feels cold and heavy, and *children* only put it to their

mouths" (2:83–84; emphases in original).[71] Copying is always external and artificial, whereas imitation is organic, because it implies the conformity of all external parts to an essential principle, a necessary movement from external manifestations to a primary productive power.

Corresponding to the difference between copying and imitation is the difference between observation and mediation. Observation consists of parts and fragments that are added into an accurate copy, whereas mediation assumes a selection of a certain part by the poet that is generally true to nature, as it expresses a philosophical problem. Thus, in imitation the "*essence* must be mastered—the natura naturans, & this presupposes *a bond* between *Nature* in this higher sense and the soul of Man."[72] Imitation necessitates a withdrawal from nature in order to approach it with a form of responsiveness or intuition that is addressed not to external qualities but to principles of life and growth that are present both in nature and in the poet, who possesses the power of imagination:

> [T]he Artist must first *eloign* himself from Nature in order to return to her with full effect.—Why this?—Because—if he began by mere painful copying, he would produce Masks only, not forms breathing Life—he must out of his own mind create forms according to the several Laws of the Intellect, in order to produce in himself that co-ordination of Freedom & Law . . . which assimilates him to Nature—enables him to understand her—. *He absents himself from her only in his own Spirit, which has the same ground with Nature*, to learn her unspoken language, . . . *[n]ot to acquire . . . lifeless technical Rules, but living and life-producing Ideas, which contain their own evidence and in that evidence the certainty that they are essentially one with the germinal causes in Nature*, his Consciousness being the focus and *mirror* of both—for this does he for a time abandon the external *real*, in order to return to it with a full sympathy with its internal & actual.[73]

For Coleridge, imitation is a realization of a possible principle. He defines essence as "the principle of *individuation*, the inmost principle of the *possibility*, of any thing, *as* that particular thing. . . . Existence, on the other hand, is distinguished from essence, by the superinduction of *reality*" (2:62; emphases in original). Because man and nature partake in the same principle as the imagination, it is also defined as a principle of growth through differentiation, and every act of imitation is necessarily a form of realization. Resemblance is thus no longer one of the determining

principles of associationism as a copying process of sensations; rather, it is a process of *adaptation* to a force of life inherent in being and thought. Thus, it is simultaneously a principle of production and a condition for intelligibility. Poetic creation as realization is what enables the poet to understand nature and himself through their mutual participation in the same life principles:

> They and they only can acquire the philosophic imagination, the sacred power of self-intuition, who within themselves can interpret and under-stand the symbol, that the wings of the air-sylph are forming within the skin of the caterpillar; those only, who feel in their own spirits the same instinct. . . . They know and feel, that the potential works in them, even as the actual works on them! In short, all the organs of sense are framed for a corresponding world of sense; and we have it. All the organs of spirit are framed for a correspondence world of spirit: though the latter organs are not developed in all alike. But they exist in all, and their first appearance discloses itself in the moral being. (2:167)

This redefinition of resemblance explains Coleridge's hostility, through-out his aesthetic writings, toward visual verisimilitude. In many of his statements, visual verisimilitude not only exemplifies but embodies copy-ing, for example, when he emphasizes the difference between imagina-tion and fancy after quoting Milton: "This is *creation* rather than *painting*, or if painting, yet such, and which such co-presence of the whole picture flash'd at once upon the eye, as the sun paints in a camera obscura" (2:128; emphases in original). Yet this statement makes it clear that it is not the visual itself that is the source of hostility but the suggestion that creation is temporarily and conceptually separated from intelligibility through its subjection to external nongenerative and "accumulative" forms of rep-resentation; it is precisely the simultaneous coexistence of the sensible and the intelligible that is evoked in this statement, a whole in which parts are united in the same way that the imagination synthesizes sense and understanding.

Coleridge evokes the camera obscura not as a model of visual accuracy, given that he excludes accuracy from imitation, or as a model of under-standing in which the intelligible always precedes and "tames" the sen-sible, but precisely to emphasize the inseparability of the sensible and the intelligible in imitation understood as realization. Coleridge's romantic theory thus points to the shift in the epistemological and aesthetic function

of the camera obscura in the early nineteenth century. As Jonathan Crary has argued, a distinction needs to be made "between the enduring empirical fact that an image can be produced in this way and the camera obscura as a *historically* constructed artifact. For the camera obscura was not simply an inert and neutral piece of equipment or a set of technical premises to be tinkered with and improved over the years; rather, it was embedded in a much larger and denser organization of knowledge and of the observing subject."[74] Crary shows that the primary function of the camera obscura was not to generate pictures; in the seventeenth and eighteenth centuries, the camera obscura was the dominant model to explain human vision and to ground the validity of observations about the world. As a philosophical model, the camera obscura, an isolated "dark chamber," presented a model of self-contained and "enclosed" passive subjectivity. Thus, a "decisive function of the camera was to sunder the act of seeing from the physical body of the observer, to decorporealize vision. The monadic point of view of the individual is authenticated and legitimized by the camera obscura, but the observer's physical and sensory experience is supplanted by the relations between a mechanical apparatus and a pre-given world of objective truth."[75] The camera obscura exhibited a disembodied model of vision through which the distracting activities of the senses were excluded in favor of an optical mechanism.

Similarly, Foucault shows that in representation, the observation of things is always predetermined by an analysis that "is anticipating the possibility of naming; it is the possibility of *seeing* what one will be able to *say*, but what one could not say subsequently, or see at a distance, if things and words, distinct from each other, did not communicate in a representation."[76] This suggests that the transparency of seeing and vision is grounded not in any notion of sensorial immediacy but in the preestablished metaphysical transparency of the "law of continuity" that binds together nature and human nature, being and thought. Foucault thus explains that, in the classical paradigm, to observe, as Bacon argued, means to see systematically, that is, to see independently from the confusion and inherent temporality of sensorial experience a structure or "law" divorced from the empirical abundance of natural phenomena. Similarly, the validity of the observer's experience in the camera obscura is predicated on the exclusion of his sensorial experience and is therefore grounded in the preestablished relations between a mechanical apparatus and the natural world. In its mechanical structure, the camera obscura embodies "that translucent necessity through which representation and beings

must pass—as beings are represented to the *mind's eye*, and as represen-
tation renders beings visible in their truth."⁷⁷ The mind's eye is simply
reason or the regulated faculty of understanding, and therefore the valid-
ity of visual observations is grounded in the subjection of vision to the
metaphysical condition of continuity, as the "commonsense" "inductive
principle" indicates.

Contrary to the notion of the "mind's eye," Coleridge links the image
in the camera obscura to an overwhelming sensorial and corporeal experi-
ence, "the whole picture flash'd at once upon the eye," and to an intensi-
fied temporal sense of simultaneity, both an "at once" and a "co-presence."
In a similar formulation, Coleridge states that "[t]he power of Poetry is
by a single word to produce that energy in the mind as compels the imag-
ination to produce the picture."⁷⁸ The image in the camera obscura thus
no longer validates observation and representation by severing the sub-
ject's sensorial experience but locates the possibility of knowledge pre-
cisely in the subject's body and powers of imagination. By the 1820s,
Crary argues, vision "had been taken out of the incorporeal relations of
the camera obscura and relocated in the human body," and within the
new field of physiological optics, "the constitutive role of the body in the
apprehension of a visible world" was emphasized in what he calls "sub-
jective vision."⁷⁹ The camera obscura thus becomes a poetic and aesthetic
emblem for the productive imagination as the only faculty that can link
and synthesize the sensorial and intelligible faculties of the subject for a
profound moment. As an *aesthetic* emblem, the camera obscura becomes
not a mechanical apparatus that displays the premises of representation
but, following Kant, a sensorial organ that embodies "what is merely
subjective in the presentation of an object . . . its *aesthetic* character."

By the same token, the image of the camera obscura is conceived to be
not a copy of external objects but a *symbol*. That is, the image is not sim-
ply what one literally "sees" in the camera obscura or an "image" of the
divine design, a "natural magic"; as the product of the transcendental
imagination, it is, as Kant defines, not strictly an image but a scheme or
a "monogram," a "pure sensible concept" belonging both to sensation
and to understanding. This explains why Coleridge privileges the sym-
bol over allegory: in the former, there is no "disjunction of faculties," as
it is always a part of the whole it represents, whereas in the latter, objects
of sense are represented by abstract terms that bear no essential "organic"
relation to them but only an arbitrary one. For Coleridge, as Thomas
McFarland points out, the symbol is not simply a rhetorical trope whose

meaning is restricted to the realm of language or an "unmediated" object
of sense;[80] it is a "synthetic" object that is defined by the "translucence of
the Special in the Individual, or of the General in the Especial. . . . Above
all by the translucence of the Eternal through and in the Temporal."[81]
Nevertheless, as much as the symbol suggests a synthesis, it also manifests
an unbridgeable gap between oppositions that remain sustained but tem-
porarily suspended in a moment of simultaneous recognition. In this
regard, the symbol does not resolve the opposition between the empirical
and the transcendental but manifests the new conditions of knowledge
in which an image is no longer conceived as a copy, the most basic unit
of a reproductive perceptual process that is based on resemblance and
gradual accumulation. Rather, the image is now conceived as one that is
inseparable from the empirical and contingent conditions of its produc-
tion, which simultaneously form the conditions of its intelligibility.[82]

Yet ultimately, for Coleridge, intelligibility transcends creation and
differentiation, because at a certain point in this ceaseless temporal pro-
cess, it is the artist's own idealized consciousness that is constituted as
the "focus and mirror" of a divine order: "In nature there is no reflex
act—but the same powers without reflection, and consequently without
Morality. (Hence *Man* the *Head* of the visible Creation—*Genesis.*)"[83] As
scholars have shown, as much as Coleridge was attracted to Schelling's
Naturphilosophie, he resisted its pantheistic tendencies because of his reli-
gious convictions.[84] Rather than fully advocating the identity of thought
and being, he formulated a hierarchical order in which nature and life
are subjected to reason or God, thus compromising his vitalism with his
idealistic rationalism. By the same token, Coleridge "tamed" the dissemi-
nating and differentiating power of life as a temporal force of ceaseless
creation when he subjected it either to a cyclical natural order or to a
teleological "evolution" in which "Man" is the ultimate goal of creation.
Thus, within Coleridge's philosophical project, "life" as an inherently
creative force of production "retreats" into an atemporal source or *origin*
through which the "Same" is privileged over difference, as Foucault ex-
plains: "It is no longer origin that gives rise to historicity; it is historicity
that, in its very fabric, makes possible the necessity of an origin which must
be both internal and foreign to it: like the virtual tip of a cone in which
all differences, all dispersions, all discontinuities would be knitted together
so as to form no more than a single point of identity, the impalpable of
the Same, yet possessing the power, nevertheless, to burst open upon
itself and become Other."[85] The "Same" is simply "Man," who becomes

a form of identity against which everything is judged and reduced, as well as a condition for knowledge and what marks its limits. Still, even in this form of transcendence, "Man" is an empirical entity, as opposed to the universal "human nature," which in its inherent density is connected to a specific sensorial apparatus and grounded within a particular biography and history. This suggests that although in Coleridge's philosophical and aesthetic project the associationist epistemological premises of empiricism are challenged, his project consists not in a complete rejection of empiricism but in the preliminary outlining of a new form of empiricism that is grounded in vitalist, rather than mechanical, ontology.[86] This new form of empiricism, in which nature cannot be idealized because of its unlimited capacity to inscribe time and to manifest difference, and therefore to resist any sense of "origin" or identity, is, I argue in the next chapters, precisely what marks the "mode of being" of the early photographic image.

The correspondence between the faculty of the imagination and the idea of life as formulated by Coleridge shows that his aesthetics was grounded in the new epistemological concerns that came to redefine what an image was in terms of its double relation to both nature and thought. At the end of the eighteenth century and the beginning of the nineteenth century, aesthetic romantic distinctions and concepts such as genius, symbol, imagination, "mechanical copying," and "organic imitation" were formulated as part of epistemological projects that challenged the associationist premises of British empiricism. Thus, the inconsistency in Talbot's accounts pertains to a broad set of concerns that discursively informed his attempts to define the specificity of the new image. In light of the differences between his accounts and the analysis of the specific historical conditions informing them, it becomes clear that, as with the evocation of the inductive method, emphasizing the centrality of the camera obscura and its image to the discovery process in no way confers a determinate or "fixed" conceptual or epistemological status to photogenic drawing.

By the 1830s and 1840s, the camera obscura came to embody a significantly different set of philosophical and epistemological concerns from those in the seventeenth and eighteenth centuries. Whereas previously it exemplified a model of universal knowledge grounded on the subjection of vision to the faculty of understanding, now it came to suggest the inseparability of any act of understanding from the sensorial and generative mechanisms of man as the subject of knowledge.[87] Thus, the early

history of photography cannot simply be aligned with or "added" to the history of the camera obscura as part of a teleological, linear universal quest after visual verisimilitude, as historians of photography have often suggested.[88] Just as the cultural meanings and epistemological status of the camera obscura changed within new formations of knowledge, the precise relations between the image produced with it and Talbot's "original idea" are anything but specified in his account. That is, there is no indication that the camera image and the image Talbot conceived or "imagined" are identical on any level (technical, conceptual, formal, or visual). And although the photographic image seems to continue the Western tradition of privileging the visible as a ground for "truth," it accomplishes this out of reasons that are incompatible with the ones that informed the camera obscura; as Crary argues, "[V]ision can be privileged at different historical moments in ways that simply are not continuous with one another."[89] The discursive genealogy presented here suggests that the specific epistemological and philosophical premises underlying Talbot's new model of discovery, with its emphasis on subjectivity and temporality and on concepts of genius and originality, imagination and "pictures of nature," make the precise conceptual identity of the image, as well as its epistemological and aesthetic status, hard to define at this early historical juncture of the "invention of the art."

And although Talbot's account and certain comments in *The Pencil of Nature* emphasize the idea of nature conceived as a picture, this in no way suggests the conceptual, formal, or visual conformity of the early photographic image to preexisting pictorial conventions of representation, such as the picturesque, or its "automatic" appropriation of the philosophical and epistemological premises that informed these systems of representation. In fact, contrary to what Snyder suggests, it was not so easy to decide *how* to "imagine" the picturesque at this historical juncture, because by this point it was considered to be not simply a defined pictorial style or set of conventions but a highly unstable *aesthetic* category that triggered debates surrounding beauty, taste, judgment, and, not surprisingly, the faculty of the imagination. It is in light of these debates that Talbot's efforts to conceptualize photogenic drawing as a "picture of nature," as well as his explicit evocation of the picturesque, need to be considered.

Picturesque Imaginings

Talbot's moment of "epiphany" occurred, according to his account, while he was unsuccessfully trying to draw a sketch of the landscape of Lake

Como in Italy. In his account, he emphasizes his lack of knowledge of drawing and the fact that the operation of the camera obscura "baffles the skill and patience of the amateur" who aspires to create a "mere souvenir" in which the "outlines of the scenery" will be depicted on paper. He also defines a picture, somewhat nominally, in terms of drawing: "The picture, divested of the ideas which accompany it, and considered only in its ultimate nature, is but a succession or variety of stronger lights thrown upon one part of the paper, and of deeper shadows on another."[90] His invention is therefore conceptualized as a "photogenic drawing" because it is a form of drawing that does not necessitate any skill; as he states in his comments to Plate 17, "Bust of Patroclus," the "royal road to drawing" was found as "sundry *amateurs* have laid down the pencil and armed themselves with chemical solutions and with *camera obscura*. Those amateurs . . . who find the rules of *perspective* difficult to learn and apply . . . prefer to use a method which dispenses with all that trouble.[91] Photogenic drawing was thus conceived as a new form of drawing and simultaneously as a "negation" of drawing.

Like drawing, photography as conceived by Talbot was meant to be a cheap, simple, and portable enjoyable pastime for the amateur. As Ann Bermingham has argued, "Without the commercial reconstruction of the amateur . . . as one who practices art as a hobby, and the reconfiguration of the art-going public as one that seeks out art as a form of entertainment, Talbot's amateur would not exist."[92] That is, it is the century-long popularization of drawing as a "polite art" that enhanced aesthetic taste and sensibility and thus formed an important part in the class identity of the middle and upper classes in England in the eighteenth century and nineteenth century, which made possible the association in Talbot's account between the gentlemen amateur, drawing, and the sketching of nature.[93] As Bermingham shows, landscape sketching was the genre that was favored by the amateur draftsmen, following, among other things, the immense popularity of Rev. William Gilpin's picturesque tours and sketching books, as well as the constitution of landscape as a professional pictorial genre and the importance of landscape gardening in the early nineteenth century. She emphasizes, as other scholars have also pointed out, that the picturesque landscape was an ideological cultural artifact that was meant to mask the recent transformation of rural nature due to industrialization and to "parliamentary acts of enclosure and the political agendas that attended it."[94] The picturesque marked what Bermingham calls "the landscape of sensibility," which displayed general and unifying

views of nature and was therefore different both from the "landscape
of sense," as a topographical and factual transcription of specific sites,
and from the "landscape of sensation," which focused on the particular
conditions under which landscape was seen and the perceptual experi-
ences of the artist.[95]

By emphasizing the touristic pleasures of exploring, viewing, and sur-
veying, picturesque travel and sketching manifested a shift, Bermingham
argues, from "actual ownership to imaginative appropriation" and a spe-
cific kind of disinterested pleasure that "now [had] more to do with the
exercise of imagination and taste over natural objects than with owning
and exploiting them." It was through this "disinterested" form of visual
or imaginative appropriation that Whigs challenged "the ancient and con-
spicuously rural Tory belief in the right to govern through landed wealth
alone."[96] At the same time, it was Gilpin's picturesque tours, published
between 1782 and 1802, that promoted a collective sense of "civic virtue"
and nationalistic sentiments by exposing large audiences to the "beauties
of native British scenery." In this regard, the cultivation of taste and artis-
tic sensibilities, in a way parallel to the pursuit of amateur scientific activ-
ities such as the collection of data that Herschel promoted, was meant
to improve the amateur's moral, cultural, and social standing. Yet the
immense popularity of the picturesque also marked the intensified com-
mercialization of culture in the early nineteenth century and the democ-
ratization of taste, both crucial for the public reception of photography.

Talbot's amateur is prefigured in, among other sources, Gilpin's *Three
Essays: On Picturesque Beauty, On Picturesque Travel, and On Sketching
Landscape* (1792), which is specifically addressed not to the "master art-
ist" but to the amateur who only wishes to amuse himself by creating
not finished drawings but sketches that will fix in the memory specific
scenes and that could also be shared with others. Throughout his book,
Gilpin emphasizes that picturesque travel is purely for pleasure and self-
amusement, as opposed to utilitarian forms of travel or scientific inves-
tigations of nature. And although this form of amusement can lead to
moral and religious reflections that "Nature is but a name for an *effect*,
Whose cause is God," this in no way can be guaranteed, "for we dare not
promise him more than picturesque travel, than a rational, and agreeable
amusement."[97] Gilpin instructs the amateur to focus solely on the general
characteristic outlines of the scene, on a general and broad view in which
the aim is to "*survey nature*"; not to *anatomize matter*," to examine parts
but never to "descend" to particles (26; emphases in original).

These instructions derive from the way Gilpin defines the picturesque as a specific kind of beauty "which please from some quality, capable of being *illustrated by painting*" (3; emphasis in original). He differentiates this kind of beauty from the "beautiful" as defined by Burke in his *A Philosophical Inquiry into the Origins of Our Ideas of the Sublime and Beautiful* (1757). In contrast to Burke, Gilpin emphasizes that "ideas of beauty vary with the objects, and with the eye of the spectator," and "thus the painter, who compares his object with the rules of his art, sees it in a different light from the man of general taste" (3). Gilpin thus shows that there is a difference between objects that "please the eye" in their "natural state" and objects that please in a representation, whether in nature or in art. Thus, smoothness, as Burke showed, is an essential quality of a beautiful object, but Gilpin shows that in a picturesque representation, which is concerned with how things *appear* not how they are, it is actually roughness or ruggedness, the breaking and fracturing of surfaces and objects which pleases most: "Turn the lawn into a piece of broken ground: plant rugged oaks instead of flowering shrubs: break the edges of the walk: give it the rudeness of a road; mark it with wheel-tracks; and scatter around a few stones, and brushwood . . . and you make it also *picturesque*" (8). The emphasis in picturesque representation should be not on the resemblance or "likeness" to "real objects," Gilpin states, but on their transformation into pictorial "effects" that please the eye through contrast, "variety," and, most important, an atmospheric play of light and shade, because the richness of light "depends on the breaks, and little recesses, which it finds on the surfaces of bodies." This emphasis explains why ruins and old structures that exhibit irregular surfaces are favored in picturesque representation, and also natural objects such as lakes, which are smooth in reality but rarely in appearance: "[W]ere it spread upon the canvas in one simple hue it will be [a] dull, fatiguing object. But to the eye it appears broken by shades of various kinds; by the undulations of the water; or by reflections from all the rough objects in its neighborhood" (22).

For Gilpin, a picturesque representation thus shifts between "infinite variety," suggested by rough objects, and a sense of compositional harmony, which "consists in uniting in one whole a variety of parts" (19). And he points out that this sense of unity and harmony is rarely found in nature but has to be "constructed" or imposed by the traveler or sketcher by adding or eliminating objects in the scenery and applying Gilpin's famous "four-screens" compositional scheme, as he describe it in his *Observations on the River Wye* (1782): "Every view on a river . . . is composed of

four grand parts; the *area*, which is the river itself; the *two side-screens* which are the opposite banks, and mark the perspective; and the *front-screen*, which points out the widening of the river."⁹⁸ It is this kind of formulaic instruction and the highly generic list of picturesque objects that led commentators to ridicule Gilpin's writings and ultimately to criticize his reductive definition of the picturesque. In comparison to later, more philosophical and theoretical writings on the picturesque by Sir Uvedale Price and Richard Payne Knight, Gilpin's tedious instructions seem artificial, mere "surface effects" that signal an external and artificial concern with the merely visible character of objects.

Yet Gilpin's resistance to the theorization of the picturesque and to an engagement with broader questions of taste comes out of his skepticism and "commonsense" religious convictions, as he explicitly states after he fails to explain why it is that only rough objects are suited for picturesque representation: "Inquiries into *principles* rarely end in satisfaction. Could we even gain satisfaction in our present question, new doubts would arise. . . . What is beauty? What is taste? . . . Thus, in our inquiries into *first principles*, we go on, without end, and without satisfaction. The human understanding is unequal to the search. In philosophy we inquire for them in vain—in physics—in metaphysics—in morals. . . . We are puzzled, and bewildered; but not informed, all is uncertainty" (30–33). It is these formulations that connect Gilpin's essays to Herschel's *Discourse,* which is also addressed to the "student of natural philosophy" or amateur "man of science" and evades any in-depth discussion of the sources of knowledge or "efficient causes." For both, it is a specific *practice* that is the focus of their investigation, a practice that is intentionally defined as open to every member of society because it necessitates no special skills or prior knowledge.

Given that Talbot's "moment of discovery" is framed around his failure as an amateur to create a sketch of nature and that he also defines a "picture" in terms of drawing, it is valid to argue that when he mentions "the pictures of nature's painting," he means not any straightforward view of a particular scenery but nature as it *appears* in picturesque representation. This argument finds further support in Talbot's comments and in the plates in *The Pencil of Nature.* His comments are informed by the motivation and the vocabulary of Gilpin's popular writings. For example, in his comments to Plate 6, "The Open Door" (Figure 2.1), he states, "A painter's eye will often be arrested where ordinary people see nothing remarkable. A casual glean of sunshine, or a shadow thrown across his

Figure 2.1. William Henry Fox Talbot, "The Open Door," salt print from a calotype negative, Plate 6 from *The Pencil of Nature*, 1844. Royal Photographic Society, National Media Museum, Bradford, U.K./ Science & Society Picture, London.

Figure 2.2. William Henry Fox Talbot, "The Cloisters of Lacock Abbey," salt print from a calotype negative, Plate 16 from *The Pencil of Nature*, 1844. National Media Museum, Bradford, U.K./Science & Society Picture, London.

path, a time-withered oak, or a moss-covered stone may awaken a train of thoughts and feelings, and picturesque imagining."[99] His text for Plate 16, "The Cloisters of Lacock Abbey" (Figure 2.2), reads, "By moonlight, especially, their effect is very picturesque and solemn," and for Plate 10, "The Haystack" (Figure 2.3) he writes, "Contenting himself with a *general effect*, he [the artist] would probably deem it beneath his genius to copy every accident of light and shade. . . . Nevertheless, it is well to have the means at our disposal of introducing these minutiæ . . . for they will sometimes be found to give an air of *variety* beyond expectation to the scene represented."[100]

As Martin Kemp has shown, Talbot was familiar with the written vocabulary of the picturesque, and his images indicate a familiarity with drawing manuals and the specific formal and iconographical features of the picturesque: reflections in water, trees, old architectural structures, rural figures and objects, and asymmetrical massing of light and shade. Kemp's point is not to prove the "direct influence" of drawing manuals on Talbot but to outline "the ambience of taste and sensibility" within which his ideas of a picturesque picture took shape.[101] In fact, many of Talbot's images can be read as applying the "rules" of the picturesque, in which he found a "readymade," a preexisting model for "a picture of nature" that now had to be "translated" from manual drawing into "photogenic drawing." In *The Pencil of Nature*, Plate 15, "Lacock Abbey in Wiltshire" (Figure 2.4), in particular faces this challenge: the abbey appears as an unexpected scene rising before the eye of the picturesque traveler, and with different plants partly covering its walls it is seen as a "rough" object forming a part of a scenery rather than an isolated "smooth" object. The pond at the foreground shows the reflection of the abbey, and the surrounding trees and bushes add a variety of broken surfaces and the play of light and shade. The composition seems nonetheless unified and harmonious because of the asymmetrical point of view, which is clearly divided into three receding plans that shift from dark areas at the foreground to lighter ones at the background.

Early reviewers of Talbot's images also noticed their "picturesque effect." The *Literary Gazette*'s reviewer of Talbot's forthcoming exhibition of photogenic drawings in May 1840 at the Graphic Society stated

Figure 2.3. William Henry Fox Talbot, "The Haystack," salt print from a calotype negative, Plate 10 from *The Pencil of Nature*, 1844. National Media Museum, Bradford, U.K./Science & Society Picture, London.

Figure 2.4. William Henry Fox Talbot, "Lacock Abbey in Wiltshire," salt print from a calotype negative, Plate 15 from *The Pencil of Nature*, 1844. National Media Museum, Bradford, U.K./Science & Society Picture, London.

that the display would include positive camera images of "views of Lacock Abbey . . . ; of Bowood; of trees; of old walls and buildings, with implements of husbandry; of carriages; of tables covered with breakfast things; of busts and statues," as well as "botanical specimens and copies of ancient records." This list includes typical picturesque subjects and, according to the reviewer, also typical sensibilities:

> Among the curious effects to be observed is the distribution of lights and shades. The former, in particular, are bold and striking, and may furnish lessons to the ablest of our artists. The crystal bottles on the breakfast-table are also well worthy of attention; their transparency is marked with singular truth: but *indeed there is nothing in these pictures which is not at once accurate and picturesque.* The Album, and separately framed specimens, were to be shewn at the Graphic Society; where, no doubt, they would meet the same admiration with which we inspected, and excited the same sense of their value as hints and models upon many points connected with perspective, chiaroscuro, and minute detail, combined with great general effect.[102]

Yet it is clear from this review that the images also exhibited a sense of empirical accuracy, an emphasis on details, as Talbot's earlier quotation indicates, that could possibly function as "models" for artists but were perhaps not in themselves "picturesque." The review implicitly refers to the fact that because negatives had to be made in full sunlight, prints often resulted in high contrast and lacked tonal variations. Reviewers

constantly pointed out that photographic images lacked "artistic charac-
ter" and were not "true to nature." The reviewer of the *Athenæum*, for
example, shows how photographs *failed* to conform to pictorial conven-
tions of representation:

> The Calotype, and indeed all the photographic processes on paper which
> we now use, are defective in another point, and that is an important one,
> as far as the artistic character of these pictures is concerned, and it also
> detracts from their truth to Nature. The great charm of the natural land-
> scape, or of the artist's painting, is the gradual fading of tints in distance—
> the softening of the scene as it recedes from the eye of the observer: in
> those Calotype pictures, we see this but to a slight extent; and where the
> view is extensive, this beauty is lost. . . . When . . . we proceed to take
> our positive copies, the result is the reverse; the dark objects of the fore-
> ground in the primary picture become light ones . . . and the faint objects
> of the distance comparatively dark.
>
> There is another physical difficulty under which *all* photographic
> processes suffer. These pictures are formed by the chemically active rays
> which are reflected from the illuminated object, and these rays vary in
> quantity considerably with the colour of the reflecting body. If we place,
> side by side, in the sunshine, objects coloured blue, green, yellow, and red,
> and attempt to copy them by the camera with any photographic material,
> it will be found that the blue will make the most decided impression, but
> the yellow will scarcely leave an outline of its image. This, in practice,
> will give exaggerated effects to the chemical picture.[103]

Photographs on paper looked artistically "unnatural" because they were
monochromatic and inconsistently grainy or sharp, they exaggerated light
and darkness gradation (which resulted in either "burned-over" exposed
areas or completely undifferentiated black areas), they distorted the laws
of aerial and linear perspective, they were insensitive to green, and they
were strangely cropped. All these problems made Talbot's early photo-
graphs look not very picturesque or pleasing. For example, in *Lacock
Abbey in Reflection* (Figure 2.5), the abbey and its reflection appear not
as two separate surfaces that introduce "variety" but as one flat black area
with no details or a sense of tonal and textural differentiation; the tree at
the foreground, rather than giving a sense of receding distance between
one bank of the pond to the other, appears awkwardly big and flat, par-
allel to the picture plane.

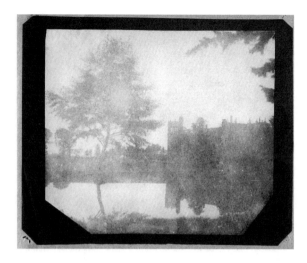

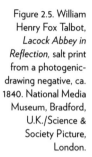

Figure 2.5. William Henry Fox Talbot, *Lacock Abbey in Reflection,* salt print from a photogenic-drawing negative, ca. 1840. National Media Museum, Bradford, U.K./Science & Society Picture, London.

In the case of *An Aged Red Cedar on the Grounds of Mt. Edgcumbe* (Figure 2.6), although the object, an old cedar, is supposedly a perfect picturesque object with its falling and spreading branches and the irregular texture of its trunk, nevertheless it does not appear at all as a "picturesque representation." The tree is depicted from a frontal, almost centralized, point of view with no foreground, and the vegetation behind the tree appears to be on the same picture plane as the tree itself, with no clear spatial differentiation; thus, both the tree and its surroundings look parallel to the picture plane, the treetop is cropped, and traces of the brush spreading the emulsion on the paper can be seen at the lower part of the image.

Kemp also notices these diversions from picturesque conventions and argues that they mark a growing awareness of "a new kind of aesthetic" that is specific to the "empirical process of recording an image."[104] Although certain features of the images analyzed here can definitely be attributed to contingent technical difficulties, there are many other images that consistently display a compositional and formal logic that is not picturesque. Thus, frontal, centralized views with a limited foreground in which trees are seen as parallel to the picture plane, rather than receding from it, appear in many of Talbot's images. For example, in *Oak Tree, Carclew Park, Cornwall* (Figure 2.7), the centralized and frontal view, the cropped treetop and side branches, and the elimination of the horizon make the oak appear less as an object and more as an irregular spreading "pattern" of black-and-white shapes and lines.

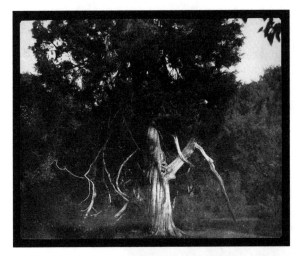

Figure 2.6. William
Henry Fox Talbot,
*An Aged Red Cedar
on the Grounds of
Mt. Edgcumbe,* salt
print from a calotype
negative, ca. 1841.
Copyright the British
Library Board (Talbot
Photo 2 [231]).

Figure 2.7. William
Henry Fox Talbot,
*Oak Tree, Carclew
Park, Cornwall,* salt
print from a calotype
negative, 1841.
National Media
Museum, Bradford,
U.K./Science &
Society Picture,
London.

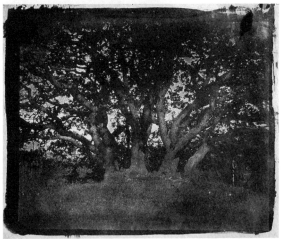

The same sense of patterning also appears in *Oak Tree in Winter* (Figure 2.8), in which it is precisely not the "variety" of textures and broken surfaces of the oak that are displayed and visually emphasized but the tree as a black abstract and flat silhouette. This image, although made with a camera, looks very similar to Talbot's cameraless botanical images, which will be analyzed in chapter 3. What is displayed in these images is not a visual transformation or translation of a "real" oak into a pictorial effect but a transcription of different light intensities into a black-and-white flat pattern.

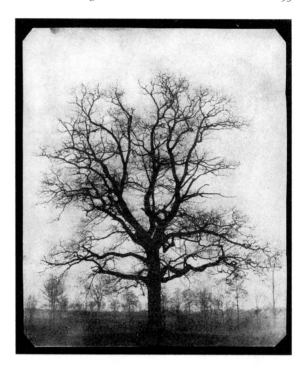

Figure 2.8. William Henry Fox Talbot, *Oak Tree in Winter,* salt print from a calotype negative, ca. 1842–43. Digital image courtesy of the Getty's Open Content Program. The J. Paul Getty Museum, Los Angeles.

As Wolfgang Kemp has shown, within the history of photography it is possible to see how picturesque images that originally emphasized the "personal view of the observer" later developed into a display of autonomous compositional studies in which, because "the picturesque requires a closer view, the tendency seems almost inevitably to be to abandon the objects themselves in favor of the 'pattern.'" Thus, it is precisely the picturesque, according to Kemp, that triggered a "process in photography whereby the structures of the object would become the structures of the image."[105] This tension is best seen in a striking image by Talbot, *Winter Trees, Reflected in a Pond* (Figure 2.9).

Here again, what is meant to a be a typical "picturesque representation" becomes something completely different because of the frontal yet oblique point of view and the cropping, which not only make the trees seem parallel to the picture plan but also create a strange sense of continuity between the trees and their reflections, a sense not of "variety" but of "doubling," of repetition; that is, what is suggested is not textural irregularity and differentiation but "dematerialization," a process whereby the spaced line of trees becomes a homogenizing "gridlike" structure of the

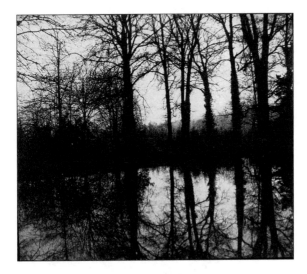

Figure 2.9. William Henry Fox Talbot, *Winter Trees, Reflected in a Pond*, salt print from a calotype negative, ca. 1841–42. The Metropolitan Museum of Art, Gilman Collection, Gift of The Howard Gilman Foundation, 2005 (2005.100.2).

image, as both the trees and their reflections look flat and dark, as they are not sufficiently visually distinguished.

These formal attributes were recognized by different writers. For example, the reviewer of the *Art-Union* stated that the use of photographic images should be reserved for "cases in which fidelity of transcript is of greater value than artistic excellence. Take for instance the books of patterns sent round by various modellers and manufactures. . . . The Talbotype would ensure fidelity of detail without any sacrifice of the general character of the design."[106] These views of the photographic image as exhibiting a new form of visual *abstraction* are compatible with Talbot's own remarks in *The Pencil of Nature*. In his comments to Plate 2, "View of the Boulevards at Paris" (Figure 2.10), he emphasizes the condition of visual indifference, as the camera "chronicles whatever it sees, and certainly would delineate a chimney-pot or a chimney sweeper with the same impartiality as it would the Apollo of Belvedere."[107] Thus, in his description of the image, Talbot demonstrates how empirical accuracy in terms of both time and place is transcribed into visual *equivalence*: "The time is afternoon. The sun is just quitting the range of buildings adorned with columns: its façade is already in the shade, but a single shutter standing open projects far enough forward to catch a gleam of sunshine. The weather is hot and dusty, and they have just been watering the road, which had produced two broad bands of shade upon it, which unite in the foreground."[108] More than it depicts, the photographic image

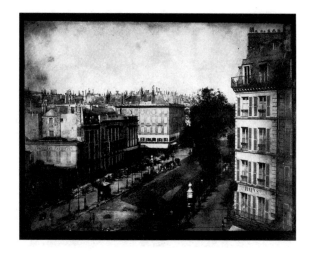

Figure 2.10. William Henry Fox Talbot, "View of the Boulevards at Paris," salt print from a calotype negative, Plate 2 from *The Pencil of Nature*, 1844. National Media Museum, Bradford, U.K./Science & Society Picture, London.

transcribes, as objects are reduced to the conditions of their illumination in the form of basically equivalent "bands" or areas of light and shade. These "bands" form abstract patterns, and it is not the specificity of the object (its broken surfaces, textures, and colors) that counts in the representation but the *homogenizing* conditions (in terms of tonality, contrast, and flatness) of its photographic transcription.

Yet it is perhaps in relation to issues of temporality that Talbot's images suggest something altogether different from a "picturesque representation." With its emphasis on ruins, the picturesque is often seen as concerned with time and change. Thus, in his comments to the first plate of *The Pencil of Nature*, "Part of Queen's College, Oxford" (Figure 2.11), Talbot notes, "This building presents on its surface the most evident marks of the injuries of time and weather."[109] Yet ruins, like any other picturesque objects, function primarily as "pictorial" and compositional effects, similar to light and weather changes. Time in the picturesque becomes less a mode of being in which all empiricities exist, as Foucault defines the modern episteme, and more a perceptual mechanism that registers external changes on largely immobile surfaces. Time becomes a *form,* or a sign that confers a certain immobility to picturesque representations, a sense of timeless, harmonious existence that is conveniently located in a remote, unidentified, and ahistorical agrarian "past."

Alternately, in some of Talbot's images, because they could not be composed in a way similar to a sketch, time is "arrested" more than composed as an "external" immobile form. For example, in *Scene in a Wood*

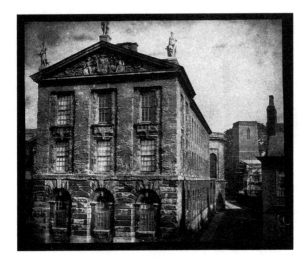

Figure 2.11. William Henry Fox Talbot, "Part of Queen's College, Oxford," salt print from a calotype negative, Plate 1 from *The Pencil of Nature*, 1844. National Media Museum, Bradford, U.K./Science & Society Picture, London.

(Figure 2.12), the point of view from which the trees, the play of light and shade, and the path are seen suggest a *place* in a particular time of the day rather than a harmonious, atemporal "composition." In its abrupt cropping, the image is felt to be a part of a continuum, not a reduced abstraction forming a whole. What is communicated is a casual scene that a traveler found himself *in,* not in front of.

An even stronger sense of presence and immediacy is communicated in *"A Breakfast Table," Set with Candlesticks* (Figure 2.13). Given that Talbot made a number of images of a table set for eating, it is easy to see how

Figure 2.12. William Henry Fox Talbot, *Scene in a Wood,* salt print from a calotype negative, ca. 1842. National Media Museum, Bradford, U.K./Science & Society Picture, London.

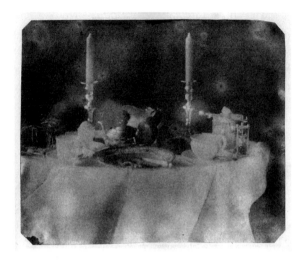

Figure 2.13. William Henry Fox Talbot, *"A Breakfast Table,"* *Set with Candlesticks,* salt print from a photogenic-drawing negative, March 1840. Copyright the British Library Board (Talbot Photo 10, f. 13).

exceptional this image is. For example, in *An Elegantly Set Table* (Figure 2.14), the table is photographed from a slightly high angle, which allows for an overall centralized view of the objects on the table; the sense is of an inventory, of a visual equivalence in which the camera "chronicles whatever it sees," and time is not arrested or composed but avoided all together. Yet, in *"A Breakfast Table,"* because of the low angle and the closer proximity of the camera to the table, as well as the abrupt cropping of the image on its left side and the fact that the table is set for only one person, the objects become not equivalent components of an inventory or general

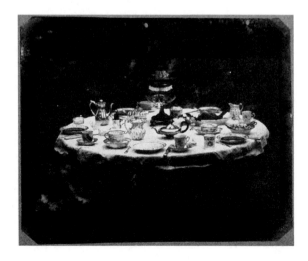

Figure 2.14. William Henry Fox Talbot, *An Elegantly Set Table,* salt print from a calotype negative, ca. 1841–42. National Media Museum, Bradford, U.K./ Science & Society Picture, London.

pictorial effects but ciphers of time not arrested but anticipated. In their proximity and slight blurriness, the objects *address* themselves to a "body," a "subjectivity" whose presence is anticipated in the structure of the image but also deferred. In both these temporal modalities, the sense of an empirical sensorial "density," of a particular biography, is evoked in a way that seems integral to the image's organization rather than preceding it.

In light of this analysis, it is clear that, for Talbot in 1844, the phrase "picture of nature" was broad and general enough to bring to mind the picturesque in the sense of nature conceived as a picture, and at the same time to suggest a radically different visual logic and consequently different applications for his process. Hence, it is precisely because some of the images in *The Pencil of Nature* displayed a familiar "repertoire" of picturesque subjects that the sense of discrepancy was noticed in the first place. That is, the notion of "picturesque representation" was simultaneously evoked and denied. Yet it is precisely this difference between the pictorial conventions of the picturesque and a photographic "picture of nature," as manifested, for example, in *Winter Trees, Reflected in a Pond* (Figure 2.9), between roughness or irregularity and immateriality, variety and repetition, that in fact connects Talbot's images to the epistemological problematic that lies at the center of the terms *representation* and *landscape* as these are used by writers on the picturesque. Thus, once the picturesque is understood to be not simply a set of generic rules but a highly indeterminate *aesthetic* term at the center of debates surrounding taste and beauty, a whole new set of concerns emerges that further complicates any fixed notion of what a "picture of nature" might be in relation to photogenic drawing. Perhaps what a striking image like *Winter Trees, Reflected in a Pond* demonstrates is thus not inadequacy but a constant circular oscillation between what can be sensed and what can be identified, what can be seen and what can be imagined, what is an impersonal "law" of human nature and what is irreducibly subjective. And it is precisely this sense of circularity, of doubling, a kind of an epistemological "hall of mirrors," that writers on the picturesque found themselves struggling with.

The picturesque is a "middle" destabilizing aesthetic term. Whereas Gilpin defines it as a specific kind of beauty, Uvedale Price, in his *An Essay on the Picturesque* (1794), defines it as an independent third category between the beautiful and the sublime. His discussion of the picturesque is made in the context of landscape design, and in his book he argues that the study of painting can improve the design of "real landscape." Richard Payne Knight, the third major writer on the picturesque, discusses the

term in his *An Analytical Inquiry into the Principles of Taste* (1805), where he also defines the picturesque as an independent category; nevertheless, he challenges Price's and Gilpin's assumption that the picturesque marks the specific attributes of external objects by arguing that it exists in the modes and "habits" of viewing and considering objects, that is, in the associative operations of the mind. Thus, the debates that followed between the 1790s and 1800s were not about generic conventions and rules but about the very nature of aesthetic judgments: What is taste? Are there any universal laws or rules regarding taste? Is beauty a quality of an object, an effect on the mind, or purely a product of the imagination? By being assigned a middle position between the more established categories of the beautiful and the sublime, the picturesque triggered questions about the aesthetic itself and not just about painterly genres and forms of representation.

This is perhaps the reason Christopher Hussey, in his canonical study on the picturesque, suggests that it is an intermediary term that marks the shift from classic to romantic art, from reason to imagination. The picturesque, he argues, "was necessary in order to enable the imagination to form the habit of feeling through the eyes."[110] In another canonical study on the picturesque, Martin Price has argued that, as a third term, the picturesque is a highly "unstable term," because "once the appeal of the picturesque is given moral or religious grounds, the picturesque moves toward the sublime."[111] He demonstrates this argument through John Ruskin's famous distinction between "lower surface picturesque" and the "noble picturesque." Whereas the first is merely concerned with the external visible character of objects without any regard for the "real nature of the thing" as an expression of pathos and human suffering, in the second, particularly as seen in J. M. W. Turner's paintings, external elements are subordinated to "the inner character of the object."[112] In Ruskin's formulation, the "noble picturesque" marks the moral attitude of the artist and his capacity for empathy. Thus, once the visual serves only as a trigger to the invisible, then, as Price suggests, the picturesque begins to exhibit the traits of the romantic symbol.

This may explain the ambivalence of the romantic poets toward the picturesque. Recent studies have shown how the picturesque informed Wordsworth's and Coleridge's early correspondence and writings and their fascination with nature and traveling.[113] In a famous statement in the second volume of the *Biographia Literaria,* Coleridge defines the picturesque as a form of unity in relation to the "grand," where the parts are

perceived without a whole; the "majestic," where the sense of the whole is so strong that the parts are abstracted; and the "sublime," where neither the parts nor the whole is perceived but instead a boundless and endless unity. Thus, it is only in the picturesque "[w]here the parts by their harmony produce an effect of a whole, but where there is no seen form of a whole producing or explaining the parts of it, where the parts only are seen and distinguished, but the whole is felt."[114] In the picturesque, the relations between the parts and the whole are balanced in a way that is not very different from an organic form of unity in which the whole is immanent and is evoked in the very process of imitation. J. R. Watson also finds correlation between the way Coleridge defined the imagination as a modifying faculty and his interest in the shifting effects of nature, its transformation under different light conditions.[115] The idea that in the picturesque nature is defined as a highly malleable entity that is unified only under the gaze of the traveler or poet appealed to Coleridge's romantic emphasis on imitation as a form of creation, not copying.

Yet there is no doubt that the sense of unity evoked in the picturesque, with its focus on the strictly visible and ultimately generic, fell short of the romantic poets' cult of originality and genius. Thus, after demonstrating a manifest interest in the picturesque, Wordsworth came to famously denounce it in book 12 of *The Prelude,* where he criticizes his mind's domination by the "bodily eye," "the most despotic of our senses," which led him to focus on the purely external and to lack a sense of humility before nature,

> giving way
> To a comparison of scene with scene
> Bent overmuch on superficial things
> Pampering myself with meager novelties
> Of color and proportion; to the moods
> Of time and season, to the moral power
> The affections and the spirit of the place
> Insensible.[116]

Thus, on the one hand, by shifting the emphasis from formal attributes of objects to their effects on the mind or the complex interaction with the "eye of the observer," writers on the picturesque opened a field of investigation in which the aesthetic becomes a *specific form of experience*;

yet, on the other hand, this experience was still defined in general "psychological" or associationist "mechanical" terms that were challenged by Coleridge in the *Biographia Literaria* and by Kant in his *Critique of Judgment*. The picturesque suggested the *irreducibility* of nature to representation and the active role of the mind in shaping sensations and impressions, yet by insisting on the primacy of the visual and on painting, it was ultimately seen by the romantics as still contained within the epistemological premises of natural philosophy.

Recently the critical and conceptual status of the picturesque has been significantly reconsidered in light of postmodern theories of art, which challenge the philosophical premises of Kantian and post-Kantian aesthetics with its emphasis on the genius and notions of originality and spontaneity.[117] In this framework it is precisely the generic form of representation that Gilpin popularized that is analyzed as demystifying any transcendental view of art. At stake in this account is the constant shift in picturesque theories between art and nature and the inconsistent use of the term *landscape* as both an attribute of nature itself and of its mode of painterly depictions. The idea that nature can be formed into a picture suggests, Rosalind Krauss argues, "that through the action of the picturesque the very notion of landscape is constructed as a second term of which the first is representation. Landscape becomes a reduplication of a picture that preceded it."[118] Yet because Gilpin also insists on the active role of the observer in the formation of a harmonious view and on the singular shifting conditions of his perceptions, Krauss points out that what the picturesque ultimately reveals is that "the 'singular' and the 'formulaic'" are "conditions" of each other: two logical halves of the concept *landscape*. The priorness and repetition of pictures is necessary to the singularity of the picturesque, because for the beholder singularity depends on being recognized as such, a re-cognition made possible only by a prior example."[119] Krauss points to a major paradox of Gilpin's writings on the picturesque: on the one hand, he emphasizes that "[t]he more refined our taste grows from the *'study of nature,'* the more insipid are the *works of art*" (57) and that "the picturesque eye abhors art; and delights solely in nature" (26); yet, on the other hand, the very possibility of picturesque beauty depends on seeing nature according to the rules of painting. The long tradition of classical landscape painting by Claude Lorrain, Salvator Rosa, and Gaspar Poussin made it possible to view nature as a "landscape," that is, *as* a representation, but ultimately art always falls short of providing the kind of pleasure that nature provides: "The art

of painting, in its highest perfection, cannot give the richness of nature. When we examine any natural form, we find the multiplicity of its parts beyond the highest finishing" (72). Representation is thus both the condition through which nature is seen as unified and *legible* in the picturesque and what marks the inherent limitation of *any* form of representation of nature. Representation, as a procedure of reduction and generalization, always stands in a *negative* relation to the infinity of nature and God, yet it offers the only possibility for understanding and appreciating the working of the divine creator. Correspondingly, the term *landscape* marks both the inherent "representability" of nature, that is, its ability to be formed into a picture that exhibits "variety," and nature's own "infinite variety," which escapes representation. As Gilpin states, "[O]bjects *in themselves* produce infinite variety. No two rocks, or trees are exactly the same. They are varied a second time, by *combination*; and almost as much, a third time, by different *lights, and shades*, and other aerial effects" (42; emphases in original).

It is the legibility of nature that is at stake, its ability to exhibit a certain "lawfulness" through an arbitrary or even "mechanical" system of representation that, as in the inductive method, is concerned not with causes but strictly with "effects" or "rules." Thus, much as Herschel defined the "eye" of the natural philosopher, to which every object is a "wonder because it elucidates some principle, affords some instruction, and impresses him with a sense of harmony and order,"[120] Gilpin argues that "the picturesque eye . . . in quest of beauty, finds it almost in every incident, and under every appearance of nature. Her works, and all her works, must ever, in some degree, be beautiful."[121] Nature *must* be beautiful, that is, harmonious and unified, in the same way that it must exhibit the "law of continuity," because representation in these circular forms of knowledge and appreciation is *both* a precondition and an end.

This suggests that the "picturesque eye" is ultimately a "disembodied eye" that marks a specific "habitual" or professional form of perception (besides the painter, also the architect and stonemason find beauty where no one else will), and not an individually original or "subjective" one in the Kantian sense of the romantic genius. As Kim Ian Michasiw has argued in a revisionist essay, "[T]he picturesque was and should be an external set of standards rather than a subjective apprehension leading to judgment."[122] He points out that Gilpin's texts, in their consistent upholding of the amateur and their complete refrain from the figure of the genius, resist the hegemony of the romantic subject and are therefore

inherently "anti-aesthetic." What is also missing from Gilpin's accounts is the reciprocal and mutually constitutive relation between the genius poet and nature, precisely the sense of an *organic* from of unity and totality. The whole that is imposed on the parts of nature marks an accumulation of segments or, as Michasiw states, "an assemblage rather than a centered totality," because "any unity is only a function of design, of the artifices with which the perceiving consciousness yanks a recalcitrant and multiple actuality into line."[123] Missing from Gilpin's account is precisely the *identity* between the constitutive generative and productive principles underlying nature and the creative mind of the genius: "The singularity of the landscape proves the efficacy of the rules, but the rules prove nothing about the nature or essence of the scene."[124] Nature exists as a *representation,* but this condition marks not the poet's consciousness or nature's essential identity but precisely the partiality and "artificiality" of any picture of nature as a unified whole.

In this regard, Gilpin's insistence on effects, Michasiw argues, should not be confused with "affect," because effect is "an arbitrary imposition deriving from the relations between the individual sketcher's technique and her or his response to a scene. . . . It seeks only to record the scene's identity and is not an attempt to register and to evoke whatever passional response occurred in the viewer."[125] That is, the sketch registers and displays not the subjective emotions and state of mind of the observer, as in romantic poetry, but his drawing capacities and mastery of the compositional and iconographical rules that Gilpin listed. Yet this argument ignores the fact that, for Gilpin, the picturesque was not only an "art of drawing" but also a form of beauty and travel; thus, some of the pleasures and responses he describes in his writings go far beyond the simple application of rules, as he states: "We are most delighted, when some grand scene, tho [*sic*] perhaps of incorrect composition, rising before the eye, strikes us beyond the power of thought—when . . . every mental operation is suspended. In this pause of intellect; this *deliquium* of the soul, an enthusiastic sensation of pleasure overspreads it, *previous to any examination by the rules of art.* The general idea of the scene makes an impression, before any appeal is made to the judgment" (49–50; emphases added). Gilpin relates this state of mind to the imagination, for example, when this intensified sense of pleasure is triggered not from nature but from a work of art: "[T]his has sometimes an astonishing effect on the mind; giving the imagination an opening into all those glowing ideas, which inspired the artist; and which the imagination *only* can translate" (50). All

this suggests awareness on Gilpin's part of precisely the "affects" of nature and art on the observer, and although these are not described in subjective, individualistic terms, they still suggest a sensorial, almost embodied form of response to nature that is not bound by or derived from the rules of picturesque composition.

Given that picturesque scenes are always artificially composed, Gilpin also encourages the amateur to create "scenes of fancy" in which "*The imagination becomes a camera obscura*, only with this difference, that the camera represents objects as they really are: while the imagination, impressed with the most beautiful scenes, and chastened by rules of art, forms its pictures, not only from the most admirable parts of nature; but also in the best taste" (52; emphasis added). Like Coleridge, Gilpin links the workings of the imagination to the camera obscura; yet in light of the preceding analysis and the terms Gilpin uses in this quotation, it is clear that he conceives the operations of the faculty of the imagination in a radically different manner than Coleridge. For Gilpin, as well as for other writers on the picturesque, in particular Knight, the imagination is an empirical, associative faculty, as it is for Hume, and not a transcendental, synthetic one, as it is for Kant and Coleridge. In the second half of the eighteenth century, as James Engell has shown, associationism "increasingly magnified the idea of the imagination." Associationists such as Abraham Tucker, Archibald Alison, and Knight "lifted the concept of the imagination to a new and more sophisticated plane." From the 1770s onward, the imagination became in associationist psychology a "perceptive and connecting activity" that, within the aesthetic realm, acquires a certain amount of *independence* from qualities of external impressions. Thus, as Engell emphasizes, "Associationist psychology and aesthetics did not simply flare up in the last half of the eighteenth century and then rapidly subside to make way for a 'more romantic' mood." Rather the movement continued throughout the Romantic period.[126]

The increased role of the imagination in the formation of aesthetic judgment underlies associationist theories of taste and is crucial for an understanding of Knight's complex definition of the picturesque in his *An Analytical Inquiry into the Principles of Taste*. Knight's discussion of the picturesque forms a small part of his ambiguous program to outline a general theory of taste partly in response to Hume's suggestion that beauty "is no quality in things themselves: it exists merely in the mind, which contemplates them, and each mind perceives a different beauty."[127] Knight's study thus focuses on the *physiological* principles behind judgments of

taste as way to show that although judgments of taste are personal, they
still derive from physiological and associative mechanisms whose mode
of operation can be explicated and generalized. Based on these distinc-
tions, Knight discusses the picturesque as a form of physiological, senso-
rial beauty and as an associative one.

In the first part of his *Inquiry*, titled "On Sensation" and dedicated to
the different senses, Knight discusses the picturesque under "sight." Sight
is produced out of the "irritation" of the optic nerves caused by light
reflected from objects. The eye sees only variations of light and colors, and
it is "only by habit and experience that we form analogies between the
perceptions of vision and those of touch, and thus learn to discover pro-
jection by the eye: for, naturally, the eye sees only superficial dimension;
as clearly appears in painting and all other optical deceptions, which pro-
duce the appearance of projection or thickness upon a flat surface" (59).
As a flat surface, a painting exposes the sensorial mechanism of sight
because although "imitations of painting extend only to the visible qual-
ities of bodies, they show those visible qualities fairly and impartially—
distinct from all others, which the habitual concurrence of other senses
has joined with them in the mind" (66–67). Painting uncovers "habit" and
the association of qualities related to other senses to what is strictly visi-
ble. Knight thus challenges Burke's suggestion that smoothness is the
defining characteristic of beautiful objects. He shows that smoothness
is related not to sight but to touch and therefore cannot be a cause of vis-
ible beauty; thus, what Burke wrongly defines as "smoothness" is actually
only the "most sharp, harsh, and angular reflections of light" from "cut
glass or polished metal." A visible form of beauty is thus one that is
abstracted from all "mental sympathies" and processes of association, what
derives strictly from "harmonious, but yet brilliant and contrasted combi-
nations of light, shade, and colour; blended, but not confused; and broken,
but not cut, into masses: and it is not peculiarly in straight or curve[d] . . .
objects that we are to seek for these; but in such as display to the eye
intricacy of parts and variety of tint and surface . . . almost all objects in
nature or art, which my friend Mr. Price so elegantly described as pictur-
esque" (69–70). As a specific form of visible beauty, the picturesque exposes
the epistemological "fictions" that are integral to habitual perception,
such as distance, volume, and space. As Knight states, "The imitative
deceptions of this art unmask the habitual deceptions of sight" (70). That
is, there is no way out of deception for the human senses; there are only
different forms of deception, some simply more pleasing than the others.

Whereas in this part of Knight's discussion, painting merely exempli-
fies sensorial perception, in the second part of his *Inquiry,* titled "Asso-
ciation of Ideas," the picturesque is defined literally as "after the manner
of painters." In this part Knight focuses on what he calls "improved per-
ception," that is, precisely those forms of habitual associations that are
"independent of the organs of sense" from which they derive. He dis-
cusses the picturesque as part of his analysis of the imagination, which he
defines, similarly to Hume, as a habitual process of association of ideas
that "has become so spontaneous and rapid in adult persons, that it seems
to be a mechanical operation of the mind, which we cannot directly influ-
ence or control" (132). In general, Knight argues, pleasures in the arts
arise "from our associating other ideas with those immediately excited
by them," and therefore on this level picturesque beauty is perceivable
and pleasing only to "persons highly conversant with the art of paint-
ing" (142), in particular, to those who are familiar with the schools of
"Venetian," "Flemish," and "Dutch" painting, which are concerned not
with "copying" or "exact imitation" of what "the mind knew to be, from
the concurrent testimony of another sense," but strictly with the "true
representation of the visible appearance of things." Given that the eye
sees "minute" parts only in "masses" and not individually, in this form of
painting "*massing* gave breath to the lights and shadows, mellowed them
into each other, and enabled the artist to break and blend them together"
(146). Knight argues that this form of depiction is picturesque because
only in it "painters adopted some distinct manner of imitating nature
which is appropriate to their own art" (147).

Thus, only people familiar with the inherently *painterly* way of repre-
senting nature will feel pleasure in viewing those objects in nature as part
of a reciprocal perceptual process through which "[t]he objects recall to
the mind the imitations, which skill, taste, and genius have produced;
and these again recall to the mind the objects themselves, and show them
through an improved medium—that of the feeling and discernment of a
great artist" (149). What Knight is describing is a circular process through
which natural objects remind the "skilled" observer of paintings by the
genius artists, and these in turn enable him to see nature through the eyes
of a painter. The important epistemological implication of this definition,
as David Marshall has shown, is that "the picturesque landscape does not
exist except insofar as the beholder perceives its relation to painting in a
relay of resemblances."[128] There are no inherent qualities in the land-
scape that make it "picturesque"; only the independent associations of

the beholder make a landscape seem "picturesque" as he experiences it through the eyes of a "great painter." Thus, in Knight's associationist psychology, the picturesque exemplifies both the deceptions of the senses and the "fictions" of the imagination. What he describes as an endless relay of associations is not very different from Hume's "hall of mirrors" in which the imagination fabricates a "principle of association," causality, that is supposed to guard its operations. In the same manner, picturesque painting "fabricates" a way of seeing nature that ultimately becomes the condition under which it is possible to judge nature as picturesque. The object of judgment is inseparable from the aesthetic criteria that are set to judge it.

Whereas Gilpin defines the picturesque as an interaction between the amateur observer and nature in which the term *landscape* signals both the primacy of representation and its inherent limitation as a form of appreciation and knowledge in the face of the infinity of nature, Knight defines it as an associative imaginative process that occurs strictly in the mind of the "skilled" observer in which past impressions are recalled or triggered in the encounter with nature. Thus, what underlies both definitions of the picturesque is a radical sense of epistemological instability, a certain indeterminacy and circularity between object and subject, nature and art, original and copy, perception and imagination. And it is precisely this sense of instability that is evoked in Talbot's extraordinary *Winter Trees, Reflected in a Pond* (Figure 2.9), where the image, more than "representing" nature, "doubles" or repeats it. That is, in its continuous oscillation between material object and dematerialized pattern, projection and flatness, legible "horizontality" and destabilizing "verticality," the image does not exemplify a "picturesque representation" but manifests, formally and conceptually, the underlying instability of *aesthetic judgments* with their ceaseless uncertainty as to what is actually seen and what is imagined, what belongs to nature and what to man. Thus, as the reviewer of the *Literary Gazette* suggested, the photographic image functioned as a *model of representation*, what Talbot called "pictures of nature's painting." In this model, nature is reduced to a "picture," but one that ultimately exposes the image's limited and "deceptive" status as a product of the imagination. Yet the sense of circularity and "doubling" is also radically intensified in *Winter Trees, Reflected in a Pond* because the image itself was a copy from a negative. The photographic image embodied the condition of nature as representation but also of representation *as* nature not because the image resembled nature or was made by "nature's hand"

but rather because it displayed nature as *unbounded* by repetition and dif-
ference instead of "infinitely varied," as Gilpin suggested. This condition
is even more explicit in Talbot's botanical images, as I will show in the
next chapter.

The discursive and philosophical genealogy presented in this chapter pro-
poses that by conceptualizing the photographic image as a form of draw-
ing and linking it to the camera obscura, Talbot's account did not grant a
"fixed" conceptual, aesthetic, or epistemological status to photogenic draw-
ing. This is, first, because in the model of discovery he employed, with
its emphasis on originality and genius, photogenic drawing is conceived
as a synthetic and imaginative effect of an unaccountable process of inter-
action between nature and the creative mind of the discoverer. What
underlies this process is precisely the discontinuous gap between man
and nature, the opacity of nature and the unregulated creations of the
genius. As a product of the creative imagination, photogenic drawing is
an "aesthetic idea," an idea without a determinate concept.

The second argument outlined here is that at this historical juncture
the camera obscura was no longer conceived to be a mechanical appara-
tus that displayed the premises of representation that, by excluding sensor-
ial experience and regulating appearances, validate knowledge. Instead it
manifested the operations of the productive imagination whose creations
cannot be sufficiently differentiated from those of nature itself. Thus, in
both romantic and associationist aesthetic theories, the creation of a "pic-
ture of nature" consists no longer in "copying" it but in reconceiving it
through the operations of the imagination as part of a specific form of
ungrounded and unstable experience. Within a romantic framework,
nature is no longer conceived to be an "image" of the great design but a
"synthetic" symbol or monogram that simultaneously reveals and tran-
scends the underlying antinomy of the modern episteme of knowledge
between the empirical and the transcendental, the sensible and the intel-
ligible. Alternately, in associationist theories of taste, a picturesque rep-
resentation marks a highly regulated and generic "picture of nature," but
one in which the epistemological status of the term *nature* or *landscape* is
constantly oscillating: it is either a copy of a preexisting representation or
an original experience that can be recognized only in the form of a copy.

With a radical form of skepticism on one side and Kantian subjective
"formalism" on the other, the epistemological status of photogenic draw-
ing is anything but secure, because it enters either into a deceptive "hall

of mirrors" or into the opaque and "unthought" anthropological territory of "man" as an "empirico-transcendental doublet." In this regard, it is precisely the early history of photography that significantly *defamiliarizes* contemporary historical and theoretical accounts of photography in which it is granted an "identity" or "essence" as a modern form of "irrefutable" evidence and authentication. These formulations find no support in the "origins" of the early history of photography, as scholars often argue by isolating specific statements from their historical conditions of enunciation. In fact, not only was Talbot's conceptualization of photogenic drawing inconsistent at this point, but the models of discovery he employed connected the early photograph to new forms of knowledge, modes of experience, and systems of representation that problematize any straightforward notion of what a "picture of nature" might be. The "birth" of photography therefore marks the emergence not of a defined and secured epistemological figure but of a highly unstable and elusive one that is much closer to the "fictions" and deceptions of the imagination than to the determinate judgments of reason.

In postmodern and poststructuralist theories, the imagination has become a major target of critique precisely because of its anthropological and humanist associations within romantic aesthetic theories that focus on the heroic "creative individual."[129] Yet the imagination is not simply an attribute of specific individuals but a specific modern epistemological condition that marks the impossibility of fully grounding the validity and universality of knowledge. Thus, by linking the early conceptualization of photogenic drawing to the faculty of the imagination, I am making a claim *not* about its artistic status (through its relation to painting or the "genius artist") but about its aesthetic one. As is pointed out earlier, the term *art* in the titles of Talbot's accounts refers to a form of craft and a skilled trade, not to any liberal concept of "Fine Art."[130] What I am proposing in this book is to reconsider the relations between photography and aesthetics through a genealogical "excavation" of the early modern meaning of aesthetics as a paradoxically sensible and "empirical" form of knowledge that resists the determinative "transcendental" claims of conceptual knowledge. In Kant's formulation, aesthetics marks the subjective conditions of reflective judgments and not simply a "disinterested" theory or discourse of art, as has been suggested in postmodern theories of art in which the reproducibility of photography is considered to be inherently "anti-aesthetic" because it challenges any modern or romantic notions of originality and spontaneity.[131]

Yet once aesthetics is defined as an epistemological condition in which, as Deleuze argues, the faculties encounter their own limits and negations because they operate outside of determinate concepts, then its relevance and viability as a tool of analysis changes with regard to the history of photography. As my analysis has shown, Talbot's efforts to conceptualize photogenic drawing in relation to existing concepts such as inductive method, drawing, camera obscura, and picturesque resulted precisely in a recognition of *limits,* as none of these concepts could at this historical point "secure" or "stabilize" meaning and epistemological status. Thus, based on this genealogy, I argue that in Talbot's accounts, photogenic drawing emerges as an image without a concept. This condition becomes quite crucial once the temporal aspects of the early image are considered within the broader framework of nineteenth-century historicism.

PART II

Botanical Images and Historical Documents:

The First Applications of Photography

3 | Time

Singular Images, Failed Copies

In both of Talbot's discovery accounts and his comments to *The Pencil of Nature,* he emphasized that photogenic drawings were "formed or depicted by optical and chemical means alone, and without the aid of any one acquainted with the art of drawing."[1] Traditionally scholars interpreted this emphasis on the removal of the "artist's hand" in favor of "nature's pencil" as marking a shift from manual to "mechanical" and more accurate or "objective" systems of representation.[2] Underlining the important role the camera obscura played in Talbot's conception of photogenic drawing, as made evident in his 1844 account, historians of photography thus argue that "the photographic camera derives directly from the camera obscura";[3] that, since it became portable, in the seventeenth century, the camera obscura was "ready for photography";[4] and consequently that the photographic image is simply a "fixed" camera image. These assumptions lead to accounts that emphasize historical continuity with regard to the philosophical and aesthetic premises informing the camera obscura and the photographic camera, whereas "the birth of photography" in 1839 is described as marking the end point of a teleological quest for visual verisimilitude and accuracy in images beyond human limitations.

Yet, as was argued earlier, not only did the philosophical and epistemological premises informing the camera obscura significantly shift in the 1820s and 1830s, but also the majority of the images Talbot produced around 1839 were made through contact printing without the aid of the camera obscura. As Joel Snyder has shown, the use of the term *mechanical* in the early years of photography simply indicated "the qualities of a

picture (its precise delineation of the subject in all its particularity)" and "the skills of hand that produced it. . . . The machinery of photographic production is in no way central to this use of 'mechanical.'"[5] Thus, by arguing that photography offered a new method of "mechanical" copying, Talbot stressed not the application of machinery but the idea of deskilling as a way to speed up copying. Following Babbage, Talbot suggested that copying was more effective in terms of labor and time once the highly skilled hand of the artist was removed in favor of the "mechanical" hand of the unskilled photographer. Yet, although Babbage emphasized the benefits of mechanization in terms of external corrective regulation, predictability, and accuracy, because all copies of products are identical, it was precisely these qualities that photographic images *lacked* during this period. Practitioners of photography, amateurs and professionals alike, frequently mentioned the unpredictability of photographic processes, particularly those on paper, due to the uneven textural surfaces of unstandardized papers and the use of homemade chemicals.[6] This of course resulted in unregulated forms of production, which simply did not adhere to a unified and coherent standard of picture making. As Robin Kelsey argues, photography's arrival "called into question the entire organization of the culture of pictures" because of "its openness to chance."[7]

Consequently, Talbot's early popular emphasis on the "mechanical" nature of photography was found by many practitioners to be extremely misleading. As Antoine Claudet, a professional photographer, stated, "In Photography the difficulties are very great, although it is generally imagined that it is merely a mechanical operation, which depends solely upon the possession of a patented apparatus, with which we expect to become painters of miniatures, as the organ boy becomes a musician by turning the handle of his instrument."[8] As late as 1857, Lady Elizabeth Eastlake, in her survey on the beginning and early development of photography in Britain, stated,

> Photography is, after all, too profoundly interwoven with the deep things of Nature to be entirely unlocked by any given method. . . . At present no observation or experience has sufficed to determine the state of atmosphere in which the photographic spirits are most propitious; no rule or order seems to guide their proceedings. . . . Happy the photographer who knows what is his enemy, or what is his friend; but in either case it is too often "something," he can't tell what; and all the certainty that the best of experience attains is, that you are dealing with one of

those subtle agencies which, though Ariel-like it will serve you bravely, will never be taught implicitly to obey.[9]

The prevailing question with regard to the new image was whether its inseparability from nature made it a "mechanical copy" or an "organic imitation." Yet this concern, again, had nothing to do with any specific machine for the production of images. Instead, it had to do with the romantic aesthetic opposition, best exemplified, as was shown earlier, in Coleridge's theory of the imagination, between copying, in which external appearances are privileged and a whole is created through an arbitrary addition of "dead" parts, and imitation, in which it is the invisible powers that animate nature that are addressed, and the whole is always more than the sum of its parts, because it synthesizes them into a new form of unity. For Coleridge, a "mechanical" copy is based on accuracy regardless of the way it was made, and within his aesthetic theory it was actually painting that manifested the logic of copying as opposed to poetry. Based on this distinction, early reviewers often criticized the photographic image by stating that "[n]o mechanical or chemical means can ever be found to supersede the necessity of the exercise of genius; mind must always be necessary to harmonize and to combine, if not to create. . . . The value of the Talbotype is its perfect precision and accuracy; but for this very reason it will be found of no great value to the mere servile copyist. It preserves all the details, but it requires a fresh exercise of the plastic powers to restore to those details the thought that gave them life and the spirit that infused them into harmonious combination."[10] Furthermore, as scholars have shown, although Talbot emphasized the absolute exclusion of the "artist's hand," he was often inconsistent with regard to the precise physical and conceptual agency of "nature's pencil." On the one hand, he stated that photographic drawing was produced through "optical and chemical means alone"; yet, on the other hand, he pointed out, while describing in his 1839 account the first architectural images taken with the camera obscura, that "this building I believe to be the first that was ever yet known *to have drawn its own picture.*"[11] From Talbot's descriptions, it is not clear what images are "impressed" on the sensitive paper: the images *of* the camera obscura or the images that natural objects produced themselves and impressed *in* the camera obscura. That is, are photographic images simply *copies* of preexisting images such as engravings, paintings on glass, and the images of the camera obscura and therefore do not possess any unique conceptual identity as images, or are they

independent depictions of nature, in which drawing is redefined accord-
ing to a new logic of production and new forms of intelligibility?[12] Does
the shift to "nature's pencil" indicate that the sun is drawing a new "pic-
ture of nature" or merely copying an already existing one? In this regard,
as Geoffrey Batchen states, photography "is both a mode of drawing and
a system of representation in which no drawing takes place."[13]

Based on these important reconsiderations of the "mechanical" nature
of early paper photography, recent historical accounts argue that the
early photograph, in its inseparability from nature, was conceived to be
an inscription of the natural world, an indexical image that traces and
"authenticates" nature rather than resembles it.[14] Yet, as was shown ear-
lier, the epistemological premises informing the concept of the index are
incompatible with Talbot's historically specific conceptualization of pho-
togenic drawing and his evocation of the inductive method. Thus, rather
than theorizing the early photographic image as an identical "mechanical
copy" or an authenticating "natural copy," this chapter argues that it was
a "failed copy." This epistemological status had nothing to do with any
inherent ontological attributes of the early photographic image, but had
to do with the new historical conditions of knowledge through which
time, and not representation, came to define the mode of being of the
empirical. Correspondingly, the study of nature and living beings became
inseparable from the idea of "life" as a vital temporal force. It is therefore
within this new "organic" economy of the empirical that the specificity
of the early photograph and its inseparability from nature need to be
accounted for. By emphasizing historical *discontinuity* and divorcing the
early history of photography from the history of the camera obscura, I
contend that, as Jonathan Crary argues, "the camera obscura and the
photographic camera, as assemblages, practices, and social objects, belong
to two fundamentally different organizations of representation and the
observer, as well as the observer's relation to the visible."[15]

Difference: A Singular Image

Historians of photography often point out that, in comparison to the
daguerreotype, photogenic drawing failed to capture the attention of
the general public. Whereas the daguerreotype, with its crispy, mirror-
like metallic surface and accentuated details, looked very different from
existing handmade images, photogenic drawings looked similar to other
manual prints, and reviewers often noted their similarity to Indian-ink
drawings, sepia, and engravings.[16] As late as 1844, with the publication

of *The Pencil of Nature*, Talbot had to insert a note to each of the six sets of facsimiles stating that the plates "are impressed by the agency of Light alone, without any aid whatever from the artist's pencil. They are the sun-pictures themselves, and not, as some persons have imagined, engravings in imitation." Moreover, due to practical reasons, the majority of images Talbot presented to the public in 1839 were of objects copied by contact printing (and not camera images), a previously known and familiar system of picture making; and, most important, these images were negative images, what Talbot called at this stage "first transfers."[17]

In his first public presentations at the Royal Institution and Royal Society, in January 1839, Talbot, according to his own account, presented "pictures of flowers and leaves; a pattern of lace; figures taken from printed glass; a view of Venice copied from an engraving; [and] some images formed by the Solar Microscope. . . . Finally: various pictures, representing the architecture of my house in the country; all made with the Camera Obscura in the summer of 1835."[18] It is very likely that many of the images presented were negatives, and the camera images definitely were, as it was only in April 1839 that Talbot started making positive images from camera images.[19] For his second major exhibition, in August 1839 at the BAAS annual meeting in Birmingham, Talbot prepared an inventory of about ninety images, which were classified according to four categories (see Appendix A).[20] In the first and largest class of images (fifty-two), Talbot presented contact negative images, mostly of botanical specimens; in the second category (twelve), contact positive images comprising copies of transparencies, lithographs, printed books, and painted glass; in the third (twenty), a single negative camera image and positive camera images of architectural views and interiors; in the fourth (seven), contact images made with the solar microscope. This list suggests that in 1839 it was the contact image, mainly a negative of a botanical specimen, through which Talbot presented the benefits of his new copying method.

This list also suggests that negative contact images formed their own independent category of images. Talbot even included a negative image of lace in *The Pencil of Nature* and stated, "In taking views of buildings, statues, portraits, &c. it is necessary to obtain a positive image, because the negative images of such objects are hardly intelligible, substituting light for shade, and vice versa. But in copying such things as lace or leaves of plants, a negative image is perfectly allowable, black lace being as familiar to the eye as white lace, and the object being only to exhibit the pattern with accuracy."[21] In Robert Hunt's *A Popular Treatise on the Art*

of Photography (1841), one of the earliest historical accounts on photography in Britain, negative and positive images are presented as two kinds of pictures and are addressed in separate and independent sections. And in a way similar to Talbot, Hunt states, "It will be found that a negative copy from an engraving, provided it be carefully taken, possesses all the sharpness of the original, however highly it is finished, but this is not the case with the second, or positive copy; this will be fainter in its shadows, and will want that definedness of outline which is the great beauty of a picture."[22] Whereas many of the early reviews of photogenic drawings, as was shown earlier, either pointed to the images' limitations in their adherence to pictorial conventions of representation or emphasized their similarity to other methods of drawing and copying, with the publication of *The Pencil of Nature* some reviewers pointed to a *discontinuity,* or a break between the photographic image and previous systems of imitation. While acknowledging the pictorial conventionality of the image, they also emphasize its peculiarity. Here, for example, is what the reviewer of the *Literary Gazette* writes about Plate 19, "The Tower of Lacock Abbey" (Figure 3.1): "Tower of Lacock Abbey is a rich and picturesque subject; upon which the distribution of light and shadow is curiously natural, and very striking as truth, if we might say so, *beyond the conceptions of imitation.* It is difficult to explain this—it consists in the faintest gradations of light throughout, not only the broader masses, but the most minute parts of the picture, and sinking into a darkness almost complete, but nevertheless not black. It must be carefully examined to have this remarkable quality fully understood and appreciated."[23] What the reviewer emphasizes is that, regardless of the conventionality of its subject, and independently from it, the photographic image simply *looks* different in a way that still needs to be formulated. That is, there is no current concept of imitation that can account for the specificity of photographic images in their "truth-to-nature." Alternately, the reviewer of the *Art-Union* aims to explain the difference between photographic images and previous systems of representation and copying along the lines suggested by Talbot, with regard to the removal of the "artist's hand":

On their [sun-pictures'] first appearance, artists who were not as yet cognizant of the discovery were utterly at a loss to pronounce upon them—they could, at once, understand that they were charactered by nothing like human handling; there was no resemblance to *touch,* for the eye to rest upon—*they resemble nothing that had ever been done, either in*

the broad or narrow styles of water-color washing—they had nothing in com-
mon with mezzotinto—nothing with lithography–nothing with any method
of engraving. By the artist all this was determinable, but still the main
question was unsolved. By the public they were considered drawings, or
some modification of lithography, or mezzotinto—and this is still exten-
sively believed. It cannot be understood that these are veritable *Phœbi*
labores—that *no two are exactly alike*, and that to copy them surpasses all
human ingenuity, inasmuch as they are a transfer to paper of the masses
and tracery of light and shade by a means utterly inimitable by the ordi-
nary resources of Art.[24]

These images, claims the reviewer, need to be understood with regard
to nature, not art, thereby supporting and reemphasizing Talbot's view
that they belong to a new category of images. The reviewer also empha-
sizes the name "sun-picture" in order to resist any suggestion that these
pictures are made by the "artist's hand," because, as pictures made by the
sun, they simply do not conform to any preconceived notion of resem-
blance. And, most important, they do not conform to the mechanical
condition of the copy, given that *"no two are exactly alike"* and therefore
they cannot be copied. What these reviews suggest is that photographic
images opened a whole new set of considerations and concerns that were
not conceived to be continuous with the aesthetic, conceptual, and epis-
temological premises of previous systems of imitation and copying.

Figure 3.1. William
Henry Fox Talbot,
"The Tower of
Lacock Abbey," salt
print from a calotype
negative, Plate 19
from *The Pencil of
Nature*, 1844.
National Media
Museum, Bradford,
U.K./Science &
Society Picture,
London.

Early practitioners of photography came quickly to see that the early photograph was not an "Image of Thought," a term Deleuze uses to describe the philosophical logic of representation in his *Difference and Repetition*.[25] The photographic image, as a new *kind* of image, was found to be very different from the image of the camera obscura, regardless of its early association with it. In the same aforementioned text by Claudet, he notes the diminished "artistic effect" of photographic portraits when compared to the images of the camera obscura. He offers an explanation in which he explicitly addresses the camera obscura as a model of vision:

> There is a great difference between the instantaneous effect by which the sight perceives objects, and that of a certain period during which the Photographic Image is produced. Whatever may be the manner in which an object is illuminated by the light of the day, the eye perceives *instantly* all the points of the object, and there exists sufficient reflected light to illuminate the parts in shadow. If we suppose that the parts strongly lighted have an intensity a hundred times greater than the parts in the shadow, *this proportion will always remain the same for the eye; there is no accumulation of effect; when the eye is fixed upon the same object, there exists for each instant a complete and instantaneous perception.* If we look at an object during one or a hundred seconds there always appears to us the same relation between the strong lights, the half-tints, and the shadows. But this is not so with the effect produced upon the Photographic Plate; *the light operates gradually*; at first the strong lights only are visible. If we stop at this point, the half-tints and shadows will be invisible; by continuing, the half-tints develop themselves, and during this time the lights have become more intense; lastly, the shadows appear; during the whole time the lights have been operating. . . . *There is nothing like this in the production of the visual image of the camera obscura; it remains always the same, and for this reason appears more perfect.*[26]

The perfection and identity of the camera image are grounded in its adherence to a model of vision in which the operation of the eye and perception in general are described in isolation from the operations of any specific body or sensorial organization. Perception is described as a relation of *spatial* synchronicity in which the identity of the object is epistemologically grounded in the consistency of perception, while the continuous receptivity of the eye is predicated on the fixed identity of the object. Time as an inherent or qualitative factor of perception is excluded

from this model, "as there is no accumulation of effect," and its exclusion is a condition for the identity of the camera image as "always the same" and therefore perfect. Sameness thus hinges on the exclusion of time as a differentiating element.

The exclusion of time and the emphasis on perceptual correspondence point to a disembodied model of vision and to a *subjective* form of thought in which the sensible is a form or quality that is presupposed by the faculties. In this model of thought, what Deleuze calls "recognition," "[a]n object is recognized . . . when one faculty locates it as identical to that of another, or rather when all the faculties together relate their given and relate themselves to a *form of identity* in the object. Recognition thus relies upon a subjective principle of collaboration of the faculties . . . while simultaneously . . . the form of identity in objects relies upon a ground in the unity of a thinking subject, of which all the other faculties must be modalities" (133; emphasis added). Thinking consists in the conformity of being to transcendental forms and concepts that determine in advance what form the empirical can have. Facilitating "recognition" is precisely the function of the imagination that determines in advance the forms and attributes empirical objects must have in order to correspond to the categories. This is why Claudet can safely assume that as long as perceptual continuity is maintained, both resemblance and sameness can be predicted, and thus camera images will always be identical. The camera image is an "Image of thought" because the camera obscura in its mechanical form exemplifies the *circular* and *tautological* logic of both the law of representation and Kant's transcendental philosophy, in which the faculties of the subject and the attributes of the object are given in advance and therefore can be represented in the form of the "Same." That is, the "Same" is the result of either the metaphysical "law of continuity," which links together human nature and nature, or the outcome of the Kantian subject as an "empirico-transcendental doublet" through which, as Foucault has shown, the empirical is extracted out of the transcendental while the transcendental repeats the empirical. In this model of thought, as Deleuze states, "[t]hought is . . . filled with no more than an image of itself, one in which it recognizes itself the more it recognizes things" (138).

In contrast, the photographic image can be seen as a site of an unregulated temporal "encounter" between light and a sensitive surface whose outcome cannot be fully predicted. The photographic image, in its inseparability from "nature," introduces unpredictability and difference as a function of the photograph's dependency on solar light. In its temporal

formation, the photographic image turns nature into a ground out of which any form of differentiation (strong lights, half-tints, and shadows) emerges. The photograph transcribes or embodies the movement of difference in a way that cannot be fixed in advance. As Talbot argued, "[I]t is not the artist who makes the picture but the picture makes itself."[27] The photographic plate thus embodies a model of thought in which the empirical becomes a sensible effect that can only be sensed in its temporal accumulation but not known, that is, cannot be presupposed and represented in an identical form, as there is no way to predict its mode of formation. Consequently, the image is not an emblem of identity and sameness but a mark of what Deleuze calls "singularity."

Within representation, only that "which is identical, similar, analogous or opposed can be considered different: *difference becomes an object of representation always in relation to a conceived identity, a judged analogy, an imagined opposition or a perceived similitude*" (138; emphasis in original). The concept of difference is thus confused, Deleuze argues, with conceptual difference, that is, with the relation between a concept and its predicates. Difference is therefore either merely "empirical" and redundant with regard to the concept or "external" with regard to being, because it is thought that "makes difference." Yet when difference is conceived as immanent and internal, it is no longer external or redundant but becomes a vital process of differentiation, which is the real, ontological, and temporal dynamic of being itself. Difference is introduced to thought, not made by thought, through the pure and empty form of time (276). In this model of thought, thinking is always an event, an "encounter" with what exceeds it, yet not because it exceeds experience in the form of the transcendental categories but precisely because it belongs to experience in a *real* and *actual* form that *precedes* the abstract identical form of the subject or the concept.

For Talbot, the unique temporality of the photographic image became particularly striking when, as part of his discovery of the calotype and the use of gallic acid as a developer, he introduced "latency" into paper photography, the idea that the image develops after an initial short exposure to light in the camera. Talbot announced his discovery of the calotype in the *Literary Gazette* in February 1841, yet the chemical details of the process were published only after Talbot presented the paper "The Process of Calotype Photogenic Drawing" to the Royal Society on June 10, 1841. In this paper Talbot presented the idea of latency in a way that echoes Claudet's description of the formation of the photographic image in the camera obscura:

The images thus received upon the Calotype paper are for the most part invisible impressions. They may be made visible by the process already related, namely, by washing them with the gallo-nitrate of silver, and then warming the paper. When the paper is quite blank, as it is generally the case, it is a highly curious and beautiful phenomenon, to see the spontaneous commencement of the picture, first tracing out the stronger outlines, and then gradually filling up all the numerous and complicated details. The artist should watch the picture as it develops itself, and when in his judgment it has attained the greatest degree of strength and clearness, he should stop further progress by washing it with the fixing liquid.[28]

The idea of a picture that "makes itself" or "develops itself" emphasizes the empirical way the photograph is formed. This process is registered not only in the botanical imagery Talbot selected, as I will further show, but also in the modes of arrangement and delimitation that underline the compositional aspects of his images. Consider Talbot's striking camera-less image *A Cascade of Spruce Needles* (Figure 3.2) of 1839, in which it is

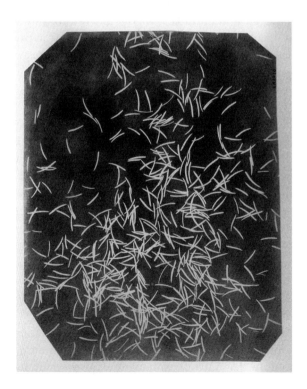

Figure 3.2. William Henry Fox Talbot, *A Cascade of Spruce Needles,* photogenic-drawing contact negative, ca. 1839. Copyright the British Library Board (Talbot 10/12).

not the plant's particular arrangement on the paper that creates the image but the different intensities of its needles' distribution on the paper surface that present the plant as an extensive diagram of entangled lines and flat, shifting planes. The needles spread out on the paper in a way that suggests no start or end point, no bottom or top of the image, but a detachable, reversible, and constantly modifiable diagram. Thus, it is not the needles that are delimited by the paper, but the paper itself that is articulated and punctuated by the needles' exceeding movement and ceaseless dispersion. The image displays neither a centralized structure nor a clear outline division into parts that can be identified or traced against a fixed "table" of classification, yet something is formed: an abstract dynamic map composed of material effects that are at the same time formal signs.

Consider also *Leaves of the Pæony* (Figure 3.3), in which the depicted object is squeezed into the paper edges and the paper is trimmed irregularly in a way that further emphasizes the pointed but also rounded shape of the leaves. The most striking features of the image are the leaves' outline forms, which are clearly emphasized against the dark background, and the leaves' legible inner veins and patterns. Yet the plant's leaves are also seen as inseparable from one another, both by "nature" and because of their specific condensed arrangement on the paper. This produces a sense of expended linear continuum in the image and dismantles the clear spatial separation between the external outline forms and the inner patterns. In its specific arrangement on the paper's surface and in its own "life" specificity, the plant suggests the infiltration of accumulating processes of differentiation. These processes spread from the inner veins' patterns, building themselves one on top of the other, into the outline forms of the leaves, which are now seen as extensions of lines expanding irregularly and continuously. Finally, even the trimmed and jagged edges of the paper now appear to be part of these processes of differentiation. Again, it is not the division into parts that marks the specificity of the depicted plant but the adding up of dimensions, the inherent variations of lines within an expansive plane. Through arrangement, delimitation, and the plant's irreducible specificity, difference is seen as working simultaneously from within and without, "growing" and evolving infinitely.

This reading of the images suggests that the early photograph, both in its mode of formation and its imagery, no longer represents the static "order of things" but registers an evolving visual map in which vital forces register themselves as they unfold in time. These images further indicate that Talbot's continuous emphasis on the self-agency of nature

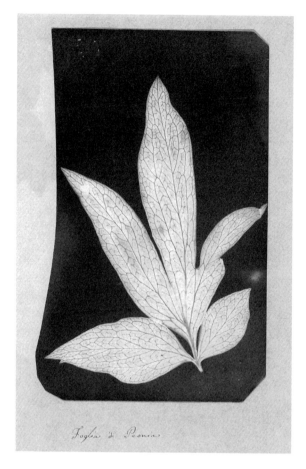

Figure 3.3. William
Henry Fox Talbot,
Leaves of the Pæony,
photogenic-drawing
contact negative,
1839. The
Metropolitan
Museum of Art,
Harris Brisbane Dick
Fund, 1936
[36.37(9)].

points not to the "mechanical" or "automatic" aspects of the image but precisely to its empirical and aesthetic ones. They are aesthetic because within the context of romanticism, the idea of life as an act of differentiation encapsulates the very idea of creation, as I argued earlier with regard to Coleridge's theory of the imagination, where the principles of divine and human creation are closely aligned. Thus, in the early photograph, as in Coleridge's definition of the symbol, the sensible is conceived to be inseparable from the intelligible, as nature is both the source of difference and its object; whereas in the camera obscura or in allegory, objects of sense are represented by predetermined abstract terms that bear no essential "organic" relation to them. Yet the crucial point here is the way Talbot's botanical images materially, formally, and conceptually evade the ultimate

idealization of nature by the symbol through its temporary suspension of difference and the movement of time in the identical form of the "Same" or "man" as the creative genius poet. That is, it is precisely the unlimited capacity of nature to manifest change and its resistance to a fixed form of identity that are marked as unique to the photograph.

What is suggested in these images, I argue, is an aesthetic form of empiricism, what Deleuze defines as "transcendental empiricism" or the "science of the sensible" (56).[29] Aesthetics functions as a model discipline for a "science" in which the sensible is not that which presupposes the exercise of the faculties but that which can only be sensed, "the very being *of* the sensible" (57). For Deleuze, the sensible is not, as it is for Kant, an indifferent occasion for the actualization of abstract conditions of possibility, as Bruce Baugh explains: "Against Kant, Deleuze argues that the empirical is not what the concept determines *would be* in a representation if it occurred, something hypothetical . . . , but actuality itself, real existence as opposed to the possibility of existence indicated by the concept."[30] Empirical actuality needs to be explained only through immanent causes, that is, through difference that belongs to the *existent* and "is first given in sensory consciousness, a receptivity which grasps what comes to thought from 'outside.'"[31] It is therefore the empirical that provides the real conditions of actual experience.

Baugh points out that Deleuze rejects an epistemological model according to which whatever does not make a difference to knowledge makes no difference; instead Deleuze claims that the empirical can and must be thought even if it cannot be known. The empirical as actual is thus not a bare particular or a mere sense datum; rather, it is a singularity "that has a determinate content in virtue of its actual *genesis*, the *history* of its coming into being. . . . Its individuality is a function of, and subsequent to, individuating causal processes, not a function of the unity or simple particularity of a 'this' or an 'I.'"[32] This concept of transcendental empiricism is thus very different from the canonical philosophical accounts of empiricism as a theory of knowledge that is based on a process of generalization from particulars, isolated "atoms" of sensations.

At the same time, this understanding of aesthetics, as I argued earlier, is preliminarily outlined or implicitly suggested in Kant's formulation of aesthetic judgments, as judgments that are made without a determinative concept, and in Coleridge's emphasis on the creative productivity of nature. Yet it is ultimately Hume's discussion of causality, his analysis of the imagination and emphasis on belief, that enables one to extract a

different genealogy of empiricism that is concerned not with experience as the source of knowledge but with the indeterminate constitution of ideas and identities *in* experience. That is, it is precisely within the historical legacy of British empiricism, in its inseparability from religion and belief, on one side, and its radical skepticism, on the other side—both crucial to Talbot's conceptualization of photogenic drawing—that this understanding of aesthetics becomes possible. It is thus Hume's philosophy that provides Deleuze with a different understanding of empiricism that is aesthetic more than simply philosophical.[33] As is shown earlier, although Hume's philosophy is embedded within the philosophical premises of representation as a form of knowledge, it also exposes its inherent contradictions, in particular its reliance on unwarranted resemblance that is introduced by the imagination. Yet it is by emphasizing the primacy of "real" experience (not abstract experience) that Hume's philosophy becomes relevant to a discussion of difference in relation to time and life; not because it is concerned with these issues, which belong to a later form of knowledge and are foreign to it, but because it clearly reveals the epistemological and philosophical implications of a sustained resistance to any form of transcendental thought. And because the photographic image was described as an image that excludes the form of "Same," these implications are applicable to it as well.

For Hume, the imagination is not a synthetic faculty of the subject but, Deleuze points out, a principle of life in which *"relations are external to their terms."*[34] These relations or principles of association (resemblance, contiguity, and causality) constitute human nature. Thus, "what is universal or constant in the human mind is never one idea or another as a term but only the ways of passing from one particular idea to another."[35] There is not a unifying principle of unity, in the form of a subject or an object, that determines the way one moves from an impression to an impression, but quite the opposite: it is through the daily *practice* of life that identities are constituted in an inherently "fictitious" manner. The question Hume raises is, How does the imagination become a faculty? Or as Jeffrey Bell formulates it, "[H]ow is the imagination able to constitute, fiction, or synthesize an identity without presupposing a predetermining identity to guide the faculty?"[36] Hume suggests that it is through belief and invention, that is, by going from something that is given to "the idea of something that has never been given to me, that isn't even giveable in experience."[37] With the idea of causality, as is shown earlier, the similar becomes identical and one goes beyond the given, but not beyond

experience, because it is only through daily encounters with the "outside" that identities are constituted in a way that is inseparable from the given but not reducible to it. Inferring and believing are constitutive elements in life, not knowledge. In this regard, beliefs are not "true" or "false" but can be illegitimate, that is, not warranted by experience or the principles of association, yet even legitimate beliefs are always inseparable from fiction.[38]

It is within this form of aesthetic empiricism that a different history of early photography can be proposed in which the epistemological status of images is defined not as "true" or "false," but as fostering belief and invention. Images are thus "productive" more than "reproductive," that is, inseparable from nature yet not reducible to representation's visual and conceptual "forms" of identity. Significantly, it is precisely the inherent productivity of the calotype negative that Talbot emphasizes: "After a Calotype picture has furnished several copies, it sometimes grows faint, and no more good copies then can be made from it. But these pictures possess the beautiful and extraordinary property of being susceptible of revival.... In reviving the picture it sometimes happens that various details make their appearance *which had not before been seen, having been latent all the time,* yet nevertheless not destroyed by their long exposure to sunshine."[39] In order that more copies may be made from it, the calotype negative image is revived by the chemical reapplication of the developer gallic acid, and this process reintroduces *potentiality*: the capacity to produce more images that are *not* identical. The latent image is actualized through further differentiation (more details are revealed) within the already-exposed paper; thus, the new image that is created is not "identical" to the other images that were created from the same negative. In Talbot's remark, the negative marks a modality of difference, not the form of the "Same." The idea that the image "develops" underlines the *singularity* of the image by emphasizing the temporal process of its production, its "genesis" or coming into being through the unpredictable reintroduction of difference that belongs to nature. What is emphasized in Talbot's writings after the discovery of the calotype is precisely the lack of mechanical identity with regard to the production of photographs. His latter statements present a reconsideration of his earlier ones:

> I remember it was said by many persons, at the time when photogenic drawing was first spoken of, that it was likely to prove injurious to art, as substituting mere *mechanical labour* in lieu of talent and experience.

Now, so far from this being the case, I find that in this, as in most other things, there is ample room for the exercise of skill and judgment. It would hardly be believed how different an effect is produced by a longer or shorter exposure to the light, and, also, by mere variation in the fixing process, by means of which almost any tint, cold or warm, may be thrown over the picture, and the effect of bright or gloomy weather may be imitated at pleasure. All this falls within the artist's province to combine and to regulate.[40]

Talbot now acknowledges that, rather than copying or tracing, nature as a force differentiates by producing multiple and irreducible effects. The identity of the image is determined by the artist according to the norms of conventional imitation and therefore implies the execution of artistic skill. Yet the agency and skill of the artist are reintroduced into the process precisely because nature *repeats* more than it "traces" or "resembles."

Repetition: Botanical Diagrams

It was mainly during the production of *The Pencil of Nature* that Talbot noticed that copies made from a single negative were not identical and differed in their colors and tonality because of changing light conditions and chemical composition. Yet rather than "correcting" this lack of uniformity, he ended up praising it: "[A]s the process presents us spontaneously with a variety of shades of color, it was thought best to admit whichever appeared pleasing to the eye, without aiming at a uniformity which is hardly attainable."[41] Talbot's photographs are singular copies; as the reviewer of the *Art-Union* stated, "[N]o two are exactly alike." Thus, as singular copies, they exemplify the epistemological logic of the simulacrum as a *failed copy,* which displays a model only in a form that dismantles its possibility.

The simulacrum is an emblem of repetition, yet although in representation repetition is understood as "perfect resemblance," for Deleuze it signals a power that is concerned with singularities, with the "universality of the singular," as opposed to the "generality of the particular." He defines repetition as a "difference without concept," a difference that is unmarked by the transcendental concept but that is nevertheless constituting itself in the existent in the form of twins, reflections, echoes, and doubles.[42] The crucial point about the simulacrum is not that it is a copy of a copy as part of a degrading Platonic line of descent but that it is a different *kind* of image, which lacks resemblance as a form of participation and

identity. It is a sign that interiorizes the conditions of its difference from the "Same" and becomes an element in which model and copy coexist and are indistinguishable. Talbot's copies are singular because each of them repeats by interiorizing an inherently irreducible difference in nature itself, which destroys the possibility of a model as a static form of identity. That is, like the simulacrum, his copies introduce unaccountable differences whose source is nature, life itself, and not thought.

Thus, in this formulation the very empiricity of the photographic image, its inseparability from nature, is a mark not of resemblance in the form of model and copy but of repetition as a difference without concept. This, I argue, explains the inherently temporal encounter between the photographic image and nature in Talbot's images of botanical specimens, as I will further show, through which the image becomes a *productive* material, a visual and formal diagram, an inscription of processes of differentiation rather than a reproductive identical or indexical copy. It also explains the image's failure to serve as a botanical illustration, which had to do precisely with the fact that it was a new kind of image that did not manifest the logic of representation and natural history, in which the empirical is part of the classificatory spatial "table of things" and an image of the divine design. Instead it came to embody the new conditions of knowledge, in which time defines the mode of being of things and the concept of life becomes possible as well as the science of biology.

As a classificatory science, botany became highly popular in Britain at the end of the eighteenth century and the beginning of the nineteenth century.[43] Like picturesque travel and drawing, which were considered "cultivating" pastime activities, botany, in its emphasis on observation and the study of nature, was conceived to be a mean through which the different classes could develop taste and sensibility for the divine order and the harmony of creation. At the same time, it exemplified the idea of deskilling and the division of labor in scientific practice, as defined by Herschel in the *Discourse,* because it was based on the collection of facts rather than theoretical knowledge. As Anne Secord explains, in the 1830s the need for observational information led expert botanists and practitioners to popularize botany "as the means by which private individuals could best be encouraged to extend their aesthetic appreciation and love of plants to an active and participatory pursuit of science."[44]

In this context, botanical illustrations acquired a new role, not just in assisting practitioners in identifying, analyzing, and classifying plants but also through the innovative production of expensive, large-scale colored

books and atlases (and the creation of a market for these publications) to encourage pleasure in learning. Thus, the use of pictures, with or without written descriptions, was meant, Secord argues, "to develop the observational skills necessary for looking at plants" and "to channel sensory perception, which involved mind and body, away from corporeal arousal and toward the pleasures of rational thought."[45] The use of images in public lectures and publications was therefore meant to develop the power of reasoning through the refinement of the passions, and in this sense it contributed to the efforts of the scientific community to present scientific activity as cultural and moral. Yet Secord shows that the use of lavish illustrations as a way to attract new practitioners was debated in the 1840s among botanists who feared that the use of plates rather than detailed written descriptions might not encourage beginners to pursue scientific knowledge but might "foster superficial appreciation of the beauties of nature."[46]

Talbot was also a kind of amateur botanist, and although he made no significant scholarly contributions to the field, Secord argues that his study of mosses provided him with "a model for both the observation and the exercise of judgments." As with the study of mathematics, botany was considered to be a way to "train the mind" and to enhance discrimination and memory capacities.[47] And as with the picturesque, botany exposed the fact that observing nature is a matter of acquired skill that is embedded in specific philosophical, epistemological, and cultural assumptions; that is, what individuals see depends on what they know. Thus, as Gill Saunders argues, "Throughout the history of botanical illustration we find the character of a representation shaped by the recasting of the unfamiliar in terms of the familiar."[48] What can be "represented" thus depends on what is considered valuable and relevant to knowledge, as well as on the technical medium of representation (for example, a woodcut cannot provide fine lines) and on the expertise of the artist and the engraver. Saunders shows that illustrations became crucial to the development of botanical science once systems of classification became focused on the *physical* character of plants, in the mid-eighteenth century. Illustrations were important and helped promote Carl Linnaeus's sexual system of classification, which focused on the number of male or female organs and the way they are arranged inside a flower.[49] Saunders thus points out that with the dissemination and canonization of the Linnaean system toward the end of the eighteenth century, a shift in the focus of illustrations took place from the whole plant to the flower, resulting in a

general reduction in the amount of information that was included in drawings.[50]

Yet perhaps the most crucial factor in the history of botanical illustrations is the shift from the general to the specific. This shift, which occurred in the 1830s in a number of scientific fields, is crucial, according to Lorraine Daston and Peter Galison, in order to understand the emergence of the concept of "mechanical objectivity" in scientific practice. This shift did not indicate a move to "truer" or more accurate representations of natural phenomena, because

> the story of objectivity is a conjoint development, implicating both observational practices and the establishment of a very specific *moral culture* of the scientist. In the first instance, objectivity had nothing to do with truth, and nothing to do with the establishment of certainty. It had, by contrast, everything to do with a machine ideal: the machine as a neutral and transparent operator that would serve both as instrument of registration without intervention *and* as an ideal for the moral discipline of the scientists themselves. Objectivity was that which remained when the earlier values of the subjective, interpretive, and artistic were banished.[51]

The concept of objectivity thus has everything to do with subjectivity, with the history of the self, with the identity, ethical character, and form of practice of the natural philosopher or scientist, and little to do with the "accuracy" and level of detail of representations. The machine offered a model, as was shown earlier with regard to Babbage, of self-correction, self-denial, and self-restraint; it was thus an emblem of objectivity long before science provided the mechanical means and apparatuses to achieve one. Thus, the concept of "mechanical objectivity" implied not necessarily the use of specific machines for representation but the idea that "nature can speak for itself," and that it speaks in the language of individual rather than general or ideal specimens.

Mechanical objectivity was constituted in opposition to norms of representation that underlay, for example, Linnaeus's illustrated book *Hortus Cliffortianus (Clifford's Garden)* of 1737. This book represented the idea of "truth-to-nature," which was promoted by eighteenth-century naturalists as a reaction to the overemphasis of earlier naturalists on the variability and monstrosity of nature.[52] Rather than focus on the contingent and the accidental, Linnaeus's book exhibited the unique capacity of the experienced naturalist to extract the essential features of the plant:

A Linnaean botanical description singled out those features common to the entire species (the *descriptio*) as well as those that differentiated this species from all others in the genius (the *differentia*) but at all costs avoided features particular to this or that individual member of the species. The Linnaean illustration aspired to generality—a generality that transcended the species or even the genus to reflect a never seen but nonetheless real plant archetype: the reasoned image.... The type was truer to nature—and therefore more real—than any actual specimen.[53]

This of course exemplifies, as is shown earlier, the logic of observation under the classical paradigm and representation in which to observe means to see independently from the confusion of sensorial experience, and to see systematically a structure or a "law" divorced from the empirical abundance of natural phenomena. In this regard, to discover a "law," as Herschel's *Discourse* demonstrates, or to create representations that are "true-to-nature," means to support the claims of natural theology by revealing the regularity of nature and God's laws. Thus, the main function of botanical illustrations and atlases was to *standardize* the objects observed in the forms of the general or the typical or the ideal or the average: to extract underlying forms, through the refined judgment and specific qualities of the botanist, beyond the surfaces of plants. And although natural philosophers might differ as to how they conceived the general (as abstract or real), illustrations were always "composite" images that showed simultaneously in one image the plant in different seasons or in different stages of growth, for example, the flower together with the fruit.

In opposition to this form of practice, in the 1830s a new ethos of practice emerged in which any form of intervention, selection, and judgment on the part of the natural philosopher was highly suspect. The new regulative ideal for scientific practice was to create unmediated representations of nature, transcriptions of individual specimens in which "objects imprint themselves" rather than highly schematized images. Yet, as Daston and Galison make clear, mechanical objectivity did not extinguish the "true-to-nature" approach, and at times the two forms of practice coincided. Botany, in fact, "was one discipline in which true-to-nature persisted as a viable standard in the realm of images."[54] They also emphasize that photography did not at any stage replace drawing in botany.[55] Finally, they strongly argue against the idea that mechanical objectivity emerged because of the invention of photography: "Far from being the unmoved prime mover in the history of objectivity, the photographic

image did not fall whole into the status of objective sight; on the contrary, the photograph was also criticized, transformed, cut, pasted, touched up, and enhanced. From the very first, the relationship of scientific objectivity to photography was anything but simple determinism."[56] In the 1830s, the fact that the photographic image could represent a real specific plant, in a process through which, as Talbot defined it, "objects imprint themselves" without the skill of the artist, was not conceived to be an advantage in botanical illustrations, because it was still the composite or reasoned image that was required, one that exhibited the skill and expertise of the botanist. Already in March 1839, Talbot tried to interest William Jackson Hooker, who would later become the director of the Royal Botanic Gardens, in publishing a book on English plants illustrated with photographic plates.[57] He sent Hooker a cameraless photograph of *Campanula hederacea,* and Hooker replied, "Your beautiful Campanula was very pretty as to general effect:—but it did not express the swelling of the flower, nor the calyx, nor the veins of the leaves distinctly. When this can be accomplished as no doubt it will, it will surely become available for the publication of good figures of plants."[58] Talbot also tried to interest the distinguished Bolognese botanist Antonio Bertoloni in his photogenic drawings and sent him five packets of examples between June 1839 and June 1840, yet no publication offer came out of this correspondence.[59] Talbot's photographs presented clear outlines, overlapping through tonal gradations that indicated thickness, but showed the specimen inverted and failed to indicate color, volume, cross-section, or internal structure, all necessary for identification and classification (Figure 3.4). As Secord argues, the fact that an image shows a "botanical specimen" does not automatically turn it into a "botanical illustration." With photographs, "the processes of botanical observation are separated from the production of the image itself. Making a botanical drawing, by contrast, required an observer to exercise the form of visual acuity that could detect which elements defined the object of scrutiny and thus, more importantly, which features should be ignored."[60] Photographs could not facilitate botanical identification and learning, because the camera "chronicles whatever it sees," and the sense of visual equivalence hindered selection and hierarchy with regard to the depiction of plants.

Thus, it was not drawing but nature printing that stood in the way of photography's becoming the major form and medium of botanical images in the early nineteenth century. Nature printing, in which plants are inked and impressed into a paper, was known since antiquity, yet in

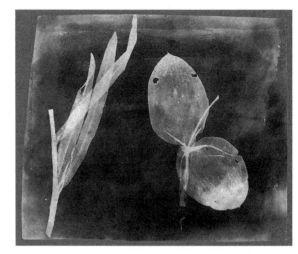

Figure 3.4. William Henry Fox Talbot, *Leaves of Orchidea,* photogenic-drawing contact negative, ca. 1839. Digital image courtesy of the Getty's Open Content Program. The J. Paul Getty Museum, Los Angeles.

the 1850s a new process was devised by Alois Auer, in which dried specimens were put between smooth sheets of copper and lead, the impression that was created in the lead was later electrotyped in copper or print, and from this new plate positive color prints were made. Thus, nature printing was like photogenic drawing in that it was also made through contact with the real specimen without human intervention. Yet, unlike photogenic drawing, it produced a positive colored imprint that could be mechanically multiplied. In the 1830s and 1840s, photographs could not be mechanically reproduced and, until the invention in the 1880s of halftone photolithography, could be reproduced only in the form of engravings or attached by hand to books, as Talbot did in *The Pencil of Nature.* As Larry Schaaf has argued, photography failed to live up to the very high expectations that were raised for it, and its contribution to botanical illustration was eventually very limited.

Based on these historical considerations, Carol Armstrong argues that the early cameraless photograph failed to serve as a form of illustration because of its inherent (ontological) failure to "signify."[61] She constructs a hierarchical spectrum of different kinds of illustrations, from the "certificate" (the real, dried specimen) to the "code" (the handmade botanical drawing), and situates photography in the middle as a form of nature print or drawing.[62] Photography, she states, "is the natural progeny of nature drawing as much as it is its alter-ego and other, its trace as much as its eclipse. This is a medium-specificity in which photography, like nature drawing, is constituted as an inscription *of* the natural world on a

surface (paper) derived *from* the natural world, whose nature-made marks are inseparable from and intertwined with the nature-made ground of which they have become an integral part."[63] Thus, for Armstrong, the early botanical photograph manifested the "essence" of photography as an indexical sign, because it could authenticate nature but could not encode or classify it, as photographs failed to indicate all the necessary attributes for identification and classification.

In contrast, I argue, that as a simulacrum, a "copy without an original," the early photograph resisted not only resemblance but also notions of identity and presence as these underline the concept of the index. The new image, in its resistance to the form of the "Same" and its empirical inscription of a "difference without concept," manifested the premises of a new form of empiricism in which photographic images are not "truer" to nature but singular, that is, they resist the very division between copy and original as these terms apply to both nature and representation. Armstrong's idea of the "natural copy" that authenticates nature corresponds to Plato's idea of the "true copy." Because, for Plato, the Idea is not yet a concept (a principle of generalization and classification, as it would become for Aristotle) but a presence, his divisions are concerned not with the identification of species but with the authentication of a "pure" line of descent within being. Plato formulates the Idea as a measuring ground that possesses qualities in the first place (justice alone is just) and that therefore allows objects to participate in true being by claiming to have a part in the idea, that is, by possessing a quality (of being just) in different degrees. True copies resemble the Idea from within, because they possess its qualities, whereas false copies, like the simulacrum, resemble the Idea only in an illusionary manner, from the outside, while differing within.

Similarly, the idea of the "natural copy" necessitates a Platonic spectrum of authentication in which things do not resemble the abstract Idea but *participate* in being as presence. The photograph is thus conceived to be a "true copy," as opposed to a handmade copy, because it is "from" nature and therefore possesses its qualities. Yet the failure of the photograph to illustrate hinges on the fact that it is a different kind of image, a simulacrum that lacks identity because it challenges the very possibility of a fixed ground. In its circular tautological (spatial) structure, the index replicates the "image of thought" that grounds representation, because nothing new is ever created in the encounter between nature and thought. Even as a "natural copy," the photograph still reproduces nature, not by resembling it but by "returning" to it. As an index, a "natural drawing,"

the photograph starts with nature, because it "emanates" from it and
returns to it as a trace, a "certificate" of nature. It is thus the "original"
identity of nature in and for itself that "grounds" the image through the
circular logic of representation. Although the index lacks resemblance, it
achieves identity by eliminating time as a differentiating factor; thus, it
remains caught within the philosophical premises of representation as a
model of thought. In contrast, the simulacrum lacks any form of identity,
and although, like the index, it produces an image that is inseparable
from nature as a physical form of agency, at the same time it dismantles
the notion of nature as a fixed ground against which images are posi-
tioned and identified. That is, although it is produced in the given, it also
exceeds it, not through idealization but through the image's actual and
singular form of genesis.

Accordingly, I locate the specificity of the early photographic image
not in its "essential" ontology but within the new historical conditions of
knowledge. Following Coleridge's aesthetic theory, this failure resulted
from the impossible encounter between botany as a science of classifica-
tion and chemistry as the science of forces. How can the dynamic forces
of nature realize themselves in the fixed and dead categories of botany
and representation, which reduce nature to its visible aspects? How can
life manifest itself in a form that resists its capacity for change and inher-
ent differentiation? For Talbot, as I argued in chapter 1, there was no
need for a "proof," because what his images displayed—nature as an orga-
nized whole—could not be proved but could only be believed as part of
commonsense religious and metaphysical convictions. Yet in some of his
images, in particular his botanical ones, it was not just order or the idea
of nature as representation that was emphasized but also, as I argued in
chapter 2 in relation to *Winter Trees, Reflected in a Pond* (Figure 2.9), the
idea of representation *as* nature, of nature as unbounded by repetition and
difference; that is, of nature as a temporal differentiating force that is
inseparable from the continuous formation of the photograph itself. This
concern reveals itself in Talbot's cameraless images of botanical specimens,
in which the "encounter" of the photograph with nature is much more
productive than simply reproductive, because it is not the picturing or
tracing of nature that is the issue but both the image's *and* nature's unpre-
dictable repetitions and powers of multiplication.

Talbot's botanical images function as temporal diagrams that unfold
through variation and expansion. What defines them is not the structural
logic of a particular sign but a substantive heterogeneity in which signs

are produced inseparably from the actual process of differentiation (both natural and chemical) that produces the image. A diagram, as John Rajchman argues, is a visual form that is not defined by an a priori "scheme," but "it involves a temporality that is always starting up again in the midst, and relations with others based not on identification or recognition, but encounter and new compositions."[64] As was shown in the analysis of *A Cascade of Spruce Needles* (Figure 3.2), the image does not trace the plant but turns it into a dynamic map, a site of an unpredictable encounter that results in material and abstract visual forms.

Consider also Talbot's *Bryonia dioca* (Figure 3.5). The depicted specimen, English wild vine, is centralized and arranged in a way that clearly displays its leaves, stem, flowers and spirals. Its leaves emphasize the flatness of the image, whereas the lines on its stem suggest three-dimensionality and depth. Thus, it seems suspended, almost floating above the surface of the image and attached to it at the same time. In its spatial isolation and reduction to outlines, it is meant to stand as an example or a representation either of a particular specimen or of a generalized category. Yet,

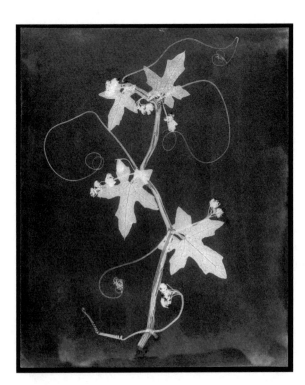

Figure 3.5. William Henry Fox Talbot, *Bryonia dioca—the English Wild Vine*, photogenic-drawing contact negative, ca. 1839. National Media Museum, Bradford, U.K./Science & Society Picture, London.

as in almost all of Talbot's botanical images, albeit in different levels of intensity, something else is at play as well. Some of the outlines and textures seen in the image are not reduced models of tracing but productions out of an encounter between live specimen, paper, and chemical substances. For example, Schaaf has pointed out that the lines on the stem were the results of a chemical interaction between juices pressed out of the stem and photographic substances.[65] Then there are the white spots of the flowers that punctuate the image, and the upper-right leaf, which displays inseparably its own texture and the paper texture.

As I argued earlier, delimitation and arrangement are important factors in Talbot's botanical images, because it is through them that the sense of ceaseless immanent differentiation and infinite expansion is suggested. Consider *Branch of Leaves of Mercuriàlis pérennis* (Figure 3.6), in which the branch is centralized, its stem is cut by the paper, and its leaves' outline forms are clearly presented, but the leaves also overlap in a manner that creates an internal pattern like a distinct visual rhythm. Another visual pattern is suggested by the irregular shift from dark to light areas and the inconsistent degrees of translucency due to the varied thickness of the leaves and the uneven sensitivity of the paper. The result is that each leaf appears different from the other leaves, while its own specific texture is presented discontinuously with areas that are erased, blocked, or blurred. This inner process of folding in the image hovers between materiality (chemical sensitivity, conditions of luminosity) and signification (patterning and coding). It produces effects that are at the same time signs and are inseparable from their objects. In this regard, the image does not "trace" or "resemble" the plant but connects different semiotic chains (material,

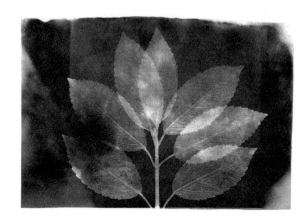

Figure 3.6. William Henry Fox Talbot, *Branch of Leaves of Mercuriàlis pérennis*, photogenic-drawing contact negative, 1839. Photographic History Collection, Natural Museum of American History, Smithsonian Institution, Washington, D.C. (AFS 206).

formal, biological, chemical) within the image's different stages of for-
mation. Signification "develops" inseparably from the material processes
of the image's formation in its encounter with the plant. This is in direct
opposition to the index, in which signification is always presented as nec-
essarily divorced from authentication, that is, from the image's process
of production. The image does not "fail to signify" but signifies in a sin-
gular manner, through its mode of temporal "development" rather than
through its resemblance to the form of the "Same," or participation in
the static identity of nature with itself.

There is an interesting conceptual and material connection between
Talbot's botanical images and his lace images.[66] Talbot even alluded to
this connection in images that include both a botanical specimen and a
piece of lace (Figure 3.7). Just as Talbot hoped that his botanical images
might be used as botanic illustrations, he also hoped that his lace images
would be used by textile manufacturers as pattern examples in their
catalogs.[67] The most obvious similarity is that both kinds of images were
created through contact printing and often existed only as negatives from
which no positive prints were made.

Yet their similar forms of arrangement and delimitation also suggest
a connection. Consider *Band of Lace* (Figure 3.8): the band is centralized
horizontally, and its grid-base form is laid on the paper, emphasizing
flatness, whereas its floral pattern looks thicker and thus seems to pro-
trude out from the paper surface. The band is cut by the paper, suggest-
ing, again, unlimitedness, but in this case the cut affects the status of the

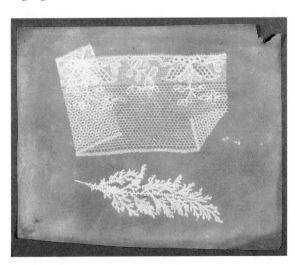

Figure 3.7. William
Henry Fox Talbot,
*Folded Lace and
Botanical Specimen*,
photogenic-drawing
contact negative, ca.
1839. National Media
Museum, Bradford,
U.K./Science &
Society Picture,
London.

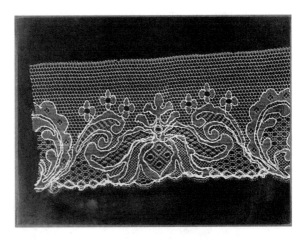

Figure 3.8. William Henry Fox Talbot, *Band of Lace,* photogenic-drawing contact negative, ca. 1839. National Media Museum, Bradford, U.K./Science & Society Picture, London.

depicted lace. Although its edge inside the image frame emphasizes its objectlike status as a band of lace, its missing edge on the other side suggests the infinite continuation of an abstract, "dematerialized" pattern. The lace is thus inseparably an industrial object, a material chemical effect, and an abstract "pattern" or sign.

Unlimitedness and continuation are further emphasized in *Lace* (Figure 3.9). As in *Spruce Needles,* the image functions like an expandable map, without limits. The lace seems to be superimposed on the paper and to define its limits, more than being delimited by it as in *Band of Lace.* Yet, as in *Band of Lace,* the image also hovers between flatness and the suggestion of depth, because of the thick and dark patterns, and there is also a sense of movement and dynamism, as in *Spruce Needles.* What is striking in this image is that its inner patterns function visually less like abstract patterns and more like *arrangements* on a surface. Therefore, in this image it is no longer the lace's objectlike status that is evoked against its abstract pattern but its conceptual relation to specific forms of arrangement that appeared in Talbot's botanical images (Figure 3.10). Thus, in *Lace,* the particular mode of arrangement that echoes the maplike abstraction of the botanical images functions also as a form of patterning, in the sense of immanent differentiation, variation, and unlimited expansion.

Folding also displays itself in Talbot's lace images on literal, material, and conceptual levels. As in the botanical images, such as that of *Mercuriàlis pérennis,* it becomes a productive strategy. Consider Plate 20 in *The Pencil of Nature,* which presents a folded lace (Figure 3.11). One of the lace's edges is cut by the image frame, whereas the other is folded, again

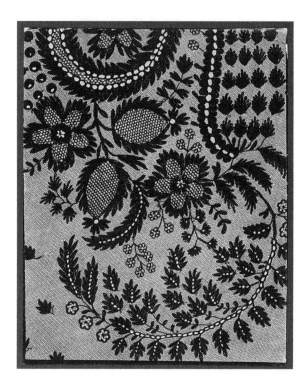

Figure 3.9. William Henry Fox Talbot, *Lace,* salt print from a photogenic-drawing negative, ca. 1840. National Media Museum, Bradford, U.K./Science & Society Picture, London.

Figure 3.10. William Henry Fox Talbot, *Botanical Specimen,* photogenic-drawing contact negative, ca. 1839. National Media Museum, Bradford, U.K./Science & Society Picture, London.

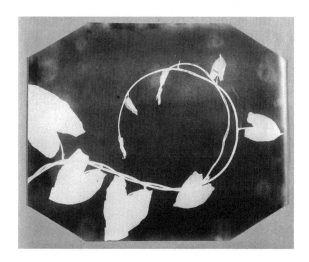

Figure 3.11. William
Henry Fox Talbot,
"Lace," salt print
from a calotype
negative, Plate 20
from *The Pencil of
Nature*, 1844.
National Media
Museum, Bradford,
U.K./Science &
Society Picture,
London.

Figure 3.11. William Henry Fox Talbot, "Lace," salt print from a calotype negative, Plate 20 from *The Pencil of Nature*, 1844. National Media Museum, Bradford, U.K./Science & Society Picture, London.

suggesting both infinite, "abstract," patternlike continuity and objectlike status. Yet the folding in the right edge also brings another factor to the image. Visually it does not function as a superimposition through which two translucent textures are seen or as a texture that is formed out of two materially inseparable textures, like *Bryonia dioca* (Figure 3.5). Rather, it suggests a *modification*, an alteration in the lace itself, a redistribution or division of its basic shapes and lines. Something new is created, which consists both of a modification of a pattern and of a change in the material status of the object. Thus, it cannot be traced to a specific point of origin, the object, nor to a preexisting form of identity and sameness.

In this reading of Talbot's botanical images, the inherent productivity of nature is inscribed in the photograph's mode of production. Correspondingly, in its temporal form of production, the image transcribes processes of differentiation and patterning through which new objects are "produced." Nature repeats because it introduces an irreducible difference whose source is life, the plant itself, and its unpredictable "encounter" with chemical substances. Thus, a good way to summarize the failure of the early photograph to function as a botanical illustration is to analyze it in relation to different concepts or levels of repetition that are analyzed by Deleuze in *Difference and Repetition*.[68]

In the first level, repetition is "mechanical and stereotypical." What constitutes "mechanical" repetition is indistinctiveness, indifference, the impossibility to distinguish one from another. Consider Talbot's *Sprig of*

Mimosa (Figure 3.12), a good example to illustrate his famous statement in his 1839 account:

> It is so natural to associate the idea of labour with great complexity and elaborate detail of execution, that one is more struck at seeing the thousand florets of an *Agrostis* depicted with all its capillary branchlets, than one is by the picture of the large and simple leaf of an oak or a chestnut. But in truth the difficulty is in both cases the same. The one of these takes no more time to execute than the other; for the object which would take the more skillful artists days or weeks of labour to trace or copy, is effected by the boundless powers of natural chemistry in the space of a few seconds.[69]

Indifference with regard to production, in the form of leveling and de-skilling, is translated into visual indistinctiveness, given that the camera "chronicles whatever it sees." In this image, every leaf is "transcribed" in precisely the same manner, and the way it is layered on the paper suggests a gridlike spatial homogeneity. Yet the "identical" copy as an outcome of

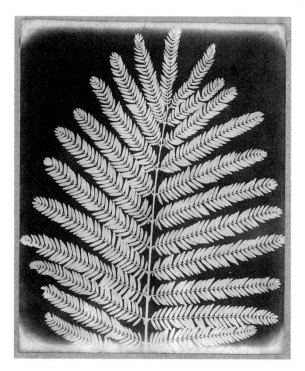

Figure 3.12. William Henry Fox Talbot, *Botanical Specimen (Sprig of Mimosa),* photogenic-drawing contact negative, ca. 1839. National Media Museum, Bradford, U.K./Science & Society Picture, London.

a mechanical form of production turned out to be unattainable in the 1840s, whereas empirical accuracy in the form of visual "transcription" was undesirable in botanical illustration. That is, visual emphasis and marking, through color and volume, were deemed necessary for classification and identification in botany. If all plants were visually homogenized through the conditions of their photographic transcription, then there would be no way they could be differentiated from each other.

In the second level of repetition, individual identity is marked, but only in the form of the "Same"; that is, differentiation is achieved, but only by becoming *like* an "origin," the "One" that is identical *in itself*. Consider *Sprig of Fennel* (Figure 3.13), in which the whole problematic of certification and encoding can be exemplified. It is a specific plant, from "nature," isolated from any illustrational apparatus and exhibited in the same size of the original. The plant is presented as an object of knowledge, centralized, its hairy branches are spread, and its stem is presented in its entirety, suggesting depth and volume. Yet its spatial isolation is precisely what deems it worthless for botanical identification, not only because of the things it lacks as a form of illustration (color, cross-section, inner structure)

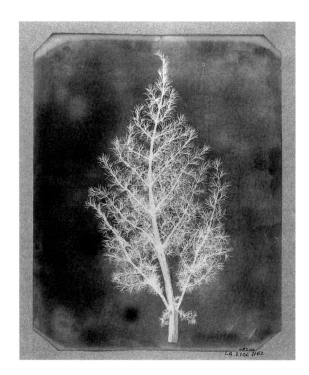

Figure 3.13. William Henry Fox Talbot, *Botanical Specimen (Sprig of Fennel)*, photogenic-drawing contact negative, ca. 1839–40. Copyright the British Library Board (Talbot Photo 10, f. 48).

but also because of what it unnecessarily adds: the specificity of a particular plant. It is neither a composite image nor a "reduced" or highly schematized image, an encoded or reasoned image that can enable classification. The image, according to Armstrong, is nothing more and nothing less than a trace of the "real," a certificate of nature. The image thus has an identity: it is differentiated, yet not in relation to the abstract and general categories of resemblance or knowledge but with regard to the original "truthfulness" of nature itself, which grounds the image's specificity through the circular form of the "return" of the "Same."

Finally, in the third level of repetition, what is repeated is not the form of the "Same" or the identity of the "One" but what *differs*, the very potentiality of nature and life for change, precisely what is excluded from representation in general and botany in particular. Consider Talbot's extraordinary *Wild Fennel* (Figure 3.14) as an emblem of singularity and not of particularity that, in its entangled linearity and excessive intricacy, presents not the reproduced or "traced" structure of a plant but an abstract yet actual diagram of change and growth. The early photographic image could not be a "mechanical" copy because of the specific conditions of its production; at the same time, it could not function as a "natural copy," because within the specific historical conditions of its formation, it was no longer possible to conceive of nature as a static "image" that tautologically reinforced the necessary epistemological correspondence between nature and human nature. Thus, as a "failed copy," a simulacrum, it manifested

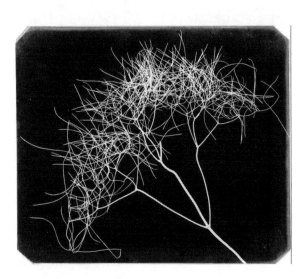

Figure 3.14. William Henry Fox Talbot, *Wild Fennel,* photogenic-drawing contact negative, 1841–42. The Metropolitan Museum of Art, Gilman Collection, Purchase, Denise and Andrew Saul Gift, 2005 (2005.100.260).

the limits of representation and the epistemological incompatibility of its pictorial and visual forms in the face of the disseminating force of time through which things come into being. It therefore failed to present the schematized and reduced forms of botanical illustration, not only because it was too particular or "mechanical" but also, and mainly, because of its own inherent abstractness as an unmediated productive image of immanent difference. As *Wild Fennel* clearly shows, the early photographic image came to embody, materially, formally, and conceptually, not the visible "table of things" but the invisible potential forces of "life."

For some scholars, notably Rosalind Krauss, the simulacrum is the very condition of the photographic image and not of its historical specificity, as is argued here. Krauss argues that the condition of photography as the "false copy" deconstructed "the whole system of model and copy." Photography introduces the same and the indifferent into the modern aesthetic discourse of art, which reifies difference, as it is grounded in notions of authenticity, originality, and uniqueness. She thus concludes, "There *is* a discourse proper to photography; only, we would have to add, it is not an aesthetic discourse. It is a project of deconstruction in which art is distanced and separated from itself."[70] Yet, in the early years of its formation, it was rather the incompatibility of the photographic image with resemblance and identity that marked its condition. Its status as a simulacrum resulted not in the abolition of difference through mechanical resemblance but precisely in the reintroduction of difference through repetition. The photographic image repeats and dismantles the possibility of model and copy, as Krauss states, yet this possibility has to do not with representation but with time. Whereas for postmodern thinkers like Jean Baudrillard, the simulacrum is a sign that indicates that there is no reality but only "reality effect, the product of simulations and signs,"[71] for Deleuze, it is what marks the inherent ontological temporal capacity of being to introduce difference and change. For Deleuze, the operations of the simulacrum are not reducible to logical or linguistic models and are therefore not spatial or semiotic but substantive in the sense that they precede any form of "representation." This is why Deleuze's criticism does not end up, like Krauss's criticism, excluding the possibility of an aesthetic discourse as part of a postmodern critique of the "real," but instead offers the suggestion that aesthetics will become the model science of the sensible, yet one in which the sensible is not that which presupposes the exercise of the faculties but that which can only be sensed, "the very being *of* the sensible."

Thus, while the simulacrum is not an essential form of photographic intelligibility but a historically specific one, its operations do not in any way exclude the possibility of an aesthetic discourse for photography and art. They obviously exclude the possibility of a modernist discourse that is grounded on notions of originality and authenticity, as Krauss demonstrates, yet this should not suggest that aesthetics in toto should be rejected. As "the science of the sensible," aesthetics is not simply a "disinterested" discourse of art that upholds notions of originality and genius but, as Deleuze suggests, a virtual set of possibilities within that which exists, a modality of difference that is grounded in the sensible itself, in its history and genesis before its consolidation into "representation" as a concept or idea, a defined subject and object.

Thus, by conceptualizing the early photograph as a "failed copy," I am not suggesting a new form of essential or ontological form of intelligibility for photography. Quite the opposite: my argument is Foucauldian in the sense that it aims to point to historical difference and epistemological *discontinuity* between different forms of photographic intelligibility: the mechanical copy, the natural copy, and the failed copy. In the 1830s and 1840s, the incompatibility of the photographic image with the form of the "Same" and the unstandardized and partly amateurish mode of its production led to an *experimental* exploration of the image's dynamic mode of formation through, among other things, the idea of latency. Within this experimental field, different photographic processes coexisted side by side, as I will further show, without necessarily conforming to one model or to a unified conception of representation and copying. Yet once the image incompatibility with the "Same" was acknowledged, it could also be surpassed, that is, made to "imitate" the "Same," as Talbot suggests when he reinserts the artist's skill into the production of photogenic drawings. Thus, by the 1850s, the photographic image entered into a different discursive order, in which its mode of production and forms of intelligibility were redefined. As Crary states, photography became the dominant mode of visual consumption in the nineteenth century, because

it [photography] recreated and perpetuated the fiction that the "free" subject of the camera obscura was still viable. Photographs seemed to be a continuation of older "naturalistic" pictorial modes, but *only because their dominant conventions were restricted to a narrow range of technical possibilities (that is, shutter speeds and lens openings that rendered elapsed time invisible and recorded objects in focus)*. But photography has already

abolished the inseparability of observer and camera obscura, bound together by a single point of view, and made the new camera an apparatus fundamentally independent of the spectator, yet which masqueraded as a transparent and incorporeal intermediary between observer and the world.[72]

It is precisely by narrowing and standardizing photographic processes and thereby making them "mimic" pictorial conventions of representation that photography came to be defined as a transparent medium of resemblance and representation. Yet this condition marks a shift in the discursive order of the photographic image, whose "infancy" was marked by difference and repetition as a function of its inseparability from "nature's hand." That is, this new condition is not the logical outcome of the shift from the "artist's hand" to "nature's pencil" but precisely the opposite: the *historical* displacement of nature in favor of the "second nature" of industrial capitalism.

Materia photographica: Herschel's Vegetable Photography

Reviewers often emphasized that the emerging field of photography was experimental and varied. They connected the extensive experimentation to the image's unique mode of production and its dependency on solar light:

> Several other inquirers have been labouring in the same field, and the result of their researches has been the extraordinary discovery, that all bodies are constantly undergoing changes under the influence of the solar rays. It is a startling fact, that *all* substances . . . have been found capable of receiving light-impressed pictures. A shadow cannot fall upon any solid body without leaving evidence behind it, in the disturbed and undisturbed condition of its molecular arrangements in the parts in light or shade. *It is evident then, that all bodies are capable of photographic disturbance, and might be used for the production of pictures*—did we know of easy methods by which the pictures might be developed; and we are not without hope that these means may be discovered. It must be remembered, that in all the best photographic processes, the images are invisible at first. In the Calotype, they are developed by the agency of gallic acid. In the Daguerréotype, the picture is brought out by mercurial vapour. In the Chromatype, nitrate of silver is the active material for the same purpose. . . . In the Chrysotype, a beautiful process discovered by Sir John Herschel, a dormant picture is brought into view as a powerful negative one.[73]

Many of the photographic processes this reviewer names were discovered or invented by Herschel as part of his scientific and material investigation of photographic processes. Herschel, as is stated earlier, was closely involved with and informed of Talbot's experiments and suggested the term *photography* for Talbot's first process, as well as the terms *negative* and *positive*.

Herschel's primary interest in photographic processes had to do with his light experiments, which focused on the interaction between light and chemical substances. In his first two papers on photography, he thought of it mainly in terms of an abstract analytical experimental apparatus through which the action of the invisible chemical rays could be detected and measured on nitrated silver surfaces. In his "A Note on the Art of Photography; or, The Application of the Chemical Rays of Light to the Purposes of Pictorial Representation" (1839), he argued that in the same manner in which, in absorption, colored glasses were used to delimit different color rays, they could now be used to track the action of distinct chemical rays on nitrated silver. And through the detection of photographic processes, a chemical spectrum might be discovered that was distinct from both the calorific and the colorific spectrums. Thus, in his second paper, "On the Chemical Action of the Rays of the Solar Spectrum on Preparations of Silver and Other Substances, Both Metallic and Non-metallic, and on Some Photographic Processes" (1840), Herschel outlined the results of his experiments in differential analysis, through which he tried to separate the chemical effects that are caused by colorific and calorific rays from those caused by strictly invisible chemical rays that are responsible for the most interesting photographic impressions. Yet he concluded that "[l]est the title of this communication should induce an expectation of its containing any regular and systematic series of researches developing definite laws, or pointing to any distinct theory of photographic action, it may be as well to commence it by stating its pretensions to be of a much lower kind, its object being simply to place on record a number of insulated facts and observations respecting the relations both of white light and of the differently refrangible rays to various chemical agents."[74] Yet, regardless of his inability to formulate a "law" or "theory" out of his photographic experiments, Herschel nevertheless continued experimenting with photographic processes, exploring new sensitive substances and forms of image production. He frequently emphasized the centrality of experimentation to the new field of photography, not only as a problem-solving mechanism but also as a way to

open up new possibilities of production that could emerge only as part of an ongoing experimental process. In February 1839 he wrote to Talbot that it was not enough just to copy engravings: "[T]o do it beautifully is an art to be learned, & many and curious minutiæ will be discovered and reduced into practice before either of us can arrive at that perfection. . . . And it is very probable that in studying those processes each may hit on something useful in different lines and on comparing notes a process may arise better than either would have devised separately."[75] Herschel's most fascinating experiments are outlined in his third paper on photography, "On the Action of the Rays of the Solar Spectrum on Vegetable Colours, and on Some New Photographic Processes" (1842), which combines his scientific investigations of the chemical spectrum together with practical concerns of image copying. What is particularly interesting in relation to the concerns of this chapter is Herschel's decision to use organic substances, which further increase the unpredictability of photographic processes by significantly extending exposure and development time, as he explicitly states:

> In photographic processes, where silver and other metals are used, the effect of light is so rapid that the state of the weather, as to gloom or sunshine, is of little moment. It is otherwise in the class of photographic actions now to be considered, in which exposure to the concentrated spectrum for many hours, to clear sunshine for several days, or to dispersed light for whole months, is requisite to bring on many of the effects described, and those some of the most curious. Moreover, in such experiments, when unduly prolonged by bad weather, the effects due to the action of light become mixed and confounded with those of spontaneous changes in the organic substances employed, arising from the influence of air, and especially of moisture . . . and so give rise to contradictory conclusions, or at all events preclude definite results.[76]

Herschel's decision to employ organic substances precluded the possibility that his experiments would result in any systematic laws because of the impossibility to differentiate between the "natural" processes that the organic substances underwent in time and the ones that were caused by the long exposure to light. And although he still continued to analyze and measure color as an effect of the activity of the chemical spectrum, he was now more concerned with an exploration of a variety of substances from which color could be extracted *before* its exposure to the spectrum,

color that could therefore be employed to the production of "beautiful" pictures, although not necessary for practical purposes because of long exposure time. Color is the main subject of Herschel's investigations into image production as an outcome of his failed analysis of the chemical spectrum, through which he came to view the photographic process not exclusively in terms of the blackening effects of the violet rays but in terms of a variety of color effects. These investigations enabled him to reveal different image-formation processes and to further explore the idea of latency. Most important, they led him into a study of sensorial optical phenomena that were unaccountable within representation and the "law of continuity." Herschel's experiments thus point to the richness of photographic experimentation in the 1840s and to the way the photographic image came to mark new modalities of experience and knowledge.

Because Herschel was mainly interested in color, he was very rarely concerned with the representational aspects of the photographic image, and by 1842 all his photographic images were contact copies of engravings. In fact, there is only one known camera image by Herschel from his first period of photographic experiments. Shortly after the announcement of Daguerre's discovery, in January 1839, and before any details were released, Herschel conducted a number of experiments in fixing images using his previous research into the chemical properties of hyposulphites, which dissolve compounds of silver in water while leaving reduced metallic silver untouched.[77] For these experiments, Herschel produced a limited number of leaf and lace images (Figure 3.15). He shared his fixing method with Talbot, who continued to use plain salt for his fixing process until finally adapting Herschel's method at a later point.[78]

After Herschel saw a daguerreotype during a visit to Paris in May 1839, he realized that the main advantage of photogenic drawing over the daguerreotype lay in its capacity to produce multiple copies.[79] To facilitate this capacity, Herschel looked for a more durable and unified surface than paper and, upon his return, succeeded in producing a negative image on glass that, when it is smoked, becomes a positive image like the daguerreotype. For this glass negative, Herschel produced a photograph of his father, William Herschel's, telescope just before it was pulled down, in December 1839, and there are also paper negatives and prints of this image (Figure 3.16).[80] Glass negatives entered photographic production a full decade later, yet Herschel's process was a working one, and it is mentioned in Robert Hunt's *A Popular Treatise on the Art of Photography* (1841) and in his later histories.

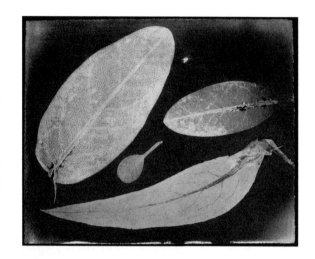

Figure 3.15. John Herschel, *Four Leaves*, photogenic-drawing contact negative, 1839. National Media Museum, Bradford, U.K./Science & Society Picture, London.

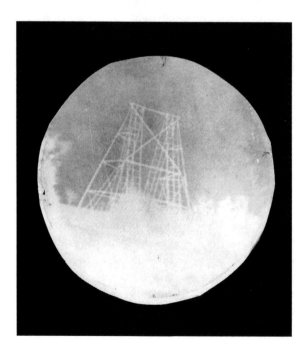

Figure 3.16. John Herschel, *The Telescope of Sir William Herschel*, silver-based negative, 1839. National Media Museum, Bradford, U.K./Science & Society Picture, London.

Although Herschel's color experiments are not concerned with the representational aspects of the photographic image, they do in fact continue a line of inquiry that historians of photography identify as integral to the broad and dispersed field of investigations that eventually led to the conception of photography. These historians often mention that silver nitrate was used for dyeing purposes through its exposure to solar light long before it was used for pictorial purposes. Josef Maria Eder mentions William Lewis's *Commercium Philosophico-Technicum* (1763), in which as part of a chapter on the history of colors Lewis stated that a solution of silver could be used to dye wood, white bones, and other animal substances by dropping the solution on the object and exposing it to sun and air.[81] Eder also describes Jean Senebier's investigation of color changes of wood and resin when exposed to the sun as part of a plant-physiology research project, and of the bleaching effects of the sun on colored ivory, wax, and silk. As part of these investigations, Senebier examined the color changes of chloride of silver when exposed to light under materials with varying degrees of thickness, such as paper, wood, and glass.[82] Herschel himself mentioned the work of Elizabeth Fulhame on the reduction of gold by the sun in his 1839 paper on photography as an important source for future investigations in the new field of photography. In Fulhame's *An Essay on Combustion; with a View to a New Art of Dying and Painting* (1794), light is described as one of the means of reducing chloride of gold and silver to metal in order to dye and decorate cloth. She also suggested using this chemical property to make maps in which rivers would be marked and formed by silver.[83]

These investigations of the visible color effects of light on silver were not conducted for the purposes of representation. Thus, they are often presented as "missed opportunities" by historians of photography and are marginalized within what is described as a linear and teleological "quest" after the legible pictorial image. Yet the fact that Herschel continued this line of investigation *after* the discovery was announced suggests that there was nothing inherently exclusive in the announcement that chemical rays could be applied to the purposes of pictorial representation. That is, the announcement was a starting point for experimentation through which the identity and mode of formation of the photographic image were explored in dispersed directions during this period, and these investigations did not preclude lines of inquiry that were not concerned with questions of pictorial representation. As Herschel's work indicates, the announcement actually triggered varied forms of experimentation, because

light as a natural agent could be applied to many substances, organic and inorganic, producing radically different effects on varied material surfaces.

Herschel named his photographic experiments on organic substances "vegetable photography" (196). In these experiments he crushed petals of flowers to a pulp in a marble mortar, squeezed the juice from them using clean linen, and spread it on paper. The image produced after long exposure to light was positive, as light either destroyed color totally or left a residual tint, resulting in "a sort of chromatic analysis, in which two distinct elements of color are separated, by destroying the one and leaving the other outstanding" (188–89). In his discussion of the flower *Mathiola annua,* Herschel explains the idea of "dormant" photographic impressions. Images made from this flower are red, varying from scarlet to purplish red (Figure 3.17). If acids or ammonia stains this paper after the image is formed, the image whitens and color disappears from it, but is restored after exposure to the sun. In this case, light affected color in an opposite way, and Herschel states that the restoration of color was caused by rays complementary to those which destroyed it in its original state. Herschel then explored the different ways in which what he called the dormant "coloring principle" was annihilated and recovered, and extended that principle to other components of the image.

Herschel experimented not only with flowers juices but also with juices of leaves, stalks, and roots of plants. It is almost as if Herschel took literally the claim of the inseparability of photography from nature to the point where, based on "the great number and variety of substances" that appear to be photographically impressible, he concludes,

Figure 3.17. John Herschel, *Copy of an Engraving Made with the Juice of the Petals of* Mathiola annua, 1841–42. Gernsheim Collection, Harry Ransom Center, The University of Texas at Austin.

It [the subject of photographically impressible substances] is no longer an insulated and anomalous affection of certain slats of silver and gold, but one which, doubtless, in a greater or less degree *pervades all nature*, and connects itself intimately with the mechanism by which chemical combination and decomposition is operated. The general instability of organic combinations might lead us to expect the occurrence of numerous and remarkable cases of this affection among bodies of that class, but among metallic and other elements inorganically arranged, instances enough have already appeared, and more are daily presenting themselves, to justify its extension to all cases in which chemical elements may be supposed combined with a certain degree of laxity, and in a state of tottering equilibrium. (201; emphasis added)

The fact that the photographic image is "intimately" connected to natural mechanisms of chemical decomposition led Herschel to the recognition that there are no inherent limits to photographic production (both organic and inorganic substances can be used) and consequently no necessary or fixed constituents for the photographic image itself. That is, it is precisely photography's inherent connection to nature that triggered Herschel's experiments and his reluctance to delimit and regulate the image. Instead, he aimed to extend the limits of photographic experimentation.

In the second part of his paper, Herschel describes exploring inorganic substances and his discovery of two photographic working processes: the cyanotype and the chrysotype. He applied a newly manufactured chemical substance, ferrocyanuret of potassium, to produce photographs in Prussian blue that were fixed with water.[84] The first cyanotypes he produced were negative pictures that required long exposure time. Yet when Herschel began adding ammonio-citrate of iron, he noted that "the photographic effects are among the most various and remarkable that have yet offered themselves" (203), and exposure time was shortened. It was as part of his efforts to produce a positive cyanotype in order to prevent the need for a second, less sharp transfer that Herschel came to explore dormant pictures and the dynamic ways in which photographic impressions are formed:

If paper be washed with a solution of ammonio-citrate of iron and dried, and then a wash passed over it of the yellow ferrocyanuret of potassium, there is no immediate formation of the true Prussian blue, but the paper rapidly acquires a violet purple colour, which deepens after a few minutes, as it dries, to almost absolute blackness. In this state it is a positive

photographic paper of high sensitivity, and gives pictures of great depth
and sharpness, but with this peculiarity, that they darken again spontane-
ously on exposure to air in darkness, and are soon obliterated. The paper,
however, remains susceptible to light and capable of receiving other pic-
tures, which in their turn fade, without any possibility . . . of arresting
them. . . . If washed with ammonia or its carbonate, they are for a few
moments entirely obliterated, *but presently reappear, with reversed lights and
shades*. In this state they are fixed, and their color becomes a pure Prus-
sian blue, which deepens much by keeping. (204; emphasis in original)

Herschel now saw that dormant pictures not only disappeared and
reappeared but were also reversed from positive to negative. When Her-
schel finally succeeded in producing a positive cyanotype (Figure 3.18),
the process was also based on the concept of latency:

This process consists in simply passing over the ammonico-citrated paper
over which a latent picture has been impressed, *very sparingly and evenly*,

Figure 3.18.
John Herschel, *Copy of
an Engraving*, positive
cyanotype, 1842.
National Media
Museum, Bradford,
U.K./Science & Society
Picture, London.

a wash of the solution of the common yellow ferrocyanate (prussiate) of potash. The latent picture, if not so faint as to be quite invisible . . . is negative. As soon as the liquid is applied . . . the negative picture vanishes, and by very slow degrees is replaced by a positive one of a violet-blue colour on a greenish yellow ground, which at a certain moment possesses a high degree of sharpness and singular beauty and delicacy of tint. (210; emphasis in original)

Herschel therefore suggested the word *cyanotype* to name all the different and varied processes that involved cyanogens and iron. The most well known application of Herschel's negative cyanotype is in Anna Atkins's botanical books of British algae.[85]

Herschel also used iron in his chrysotype process, in which a paper washed with ammonio-citrate of iron is exposed to the sun either with a camera or directly, and developed with a solution of gold; the result is a purplish image (Figure 3.19).

Figure 3.19. John Herschel, *Copy of an Engraving*, chrysotype, 1842. Copyright the Royal Society, London.

Herschel compares the chrysotype to the calotype and argues that it is "a process no wise inferior in the almost magical beauty of its effect to the calotype process of Mr. Talbot, which in some respects it nearly resembles, with this advantage, as a matter of experimental exhibition, that the disclosure of the dormant image does not require to be performed in the dark, being not interfered with by moderate daylight" (206). Thus, what differentiates the chrysotype from the calotype, other than its lower level of sensitiveness, is the way the image develops, the way *"extremely feeble impressions once made by light, go on afterwards darkening spontaneously, and very slowly, apparently without limit, so long as the least vestige of unreduced chloride of gold remains in the paper"* (207; emphasis in original).

In 1843 Herschel published a short supplement to his 1842 paper, "On Certain Improvements on Photographic Processes," in which he added further information on processes involving gold and iron. On March 25, 1843, he proudly wrote to Talbot about new photographic experiments he was conducting: "In none of these experiments does either silver or gold occur—*and our Materia Photographica is extending daily.*"[86] He invented a new process involving mercury, iron, and lead that he named the "celænotype," "from the blackness and engraving-like effect of some of them." These images were originally negative and could be kept as such (sometimes fading), yet they could also undergo a process through which they became positive. In his response letter, Talbot suggested the name *Amphitype,* from the Greek word for "to change," because "your new process involves a very remarkable peculiarity viz. the change from negative to positive of the same photograph."[87] Larry Schaaf claims that as late as 1843, Talbot was "less than fully convinced" that the negative/positive approach was the best for paper photography, yet his own positive process papers were not sensitive enough to register an image.[88] From Herschel's and Robert Hunt's experiments, it is clear that the efforts to produce a positive image were not completely abandoned by 1843, nor was the effort to introduce color to photographic production.

Herschel's photographic experiments indicate that, for him, the photographic image was a highly dynamic and malleable entity. In fact, what defined the image for him was precisely its varied modes of inherently temporal formation and possibilities of transformation. For Herschel, therefore, the concept of latency or "dormant pictures" was broader than it was for Talbot, and included pictures that were "slowly developing themselves by lapse of time, or at once revivable by stimuli, as well as of the spontaneous fading and disappearance of such impressions" (194).

Moreover, the idea of latency suggested to Herschel an explanation for visual phenomena that *exceeded* the camera-obscura model of vision, because they occurred independently from external stimuli and their source was the human body, as he explicitly states following his discussion of dormant pictures: "I would here only observe, that a consideration of many such phenomena led me to regard it as not impossible that the retina itself may be *photographically* impressible by strong lights, and that some at least of the phenomena of visual spectra and secondary colors may arise from sensorial perception of actual changes in progress in the physical state of that organ itself, subsequent to the cessation of the direct stimulant" (194; emphasis in original). These observations Herschel developed in a lecture, "On Sensorial Vision," which was delivered before the Philosophical and Literary Society of Leeds in 1858. In this lecture Herschel defines sensorial vision as "visual sensations or impressions bearing a certain considerable resemblance to those of natural or *retinal* vision, but which differ from these in the very marked particular of arising when the eyes are closed and in complete darkness."[89] He exemplifies sensorial vision through the concept of ocular spectra, "which are produced by the impression of a strong light on the retina of the eye, and which continue to force themselves on the attention, sometimes in a very pertinacious and disagreeable way for some time afterwards, when the eyes are closed" (401). He then models his physical explanation of the production of ocular spectra on the formation of photographic impressions:

> The production of Ocular Spectra refers itself . . . to what I have described as the purely physical branch of the general subject of vision. Their seat, it can hardly be doubted, is the retina itself, and their production is in all probability, part and parcel of that photographic process by which light chemically affects the retinal structure, and of the gradual restoration of that structure to its normal state of sensitiveness by the fading out of the picture impressed. Cases are not wanting in artificial photography where an impression made on sensitive paper dies out, and can be replaced by another without the renewed application of any chemical agent. (402–3)

It is clear that Herschel's color-photographic experiments into dormant impressions and the dynamic formation of photographs triggered his interest in sensorial vision and provided him with ways to analyze visual sensations in relation to time and change. Most important, these

experiments enabled him to claim that ocular spectra are "things *actually seen*," in direct opposition to waking impressions or dreams, because they are successors or remnants of retinal pictures. Herschel opposed daydreams, in which the "imagination may interpret forms, in themselves indefinite, as the conventional expressions of realities not limited to precise rules of form" (406), to the abstract geometrical and colorful forms of ocular spectra, either rectilinear or circular, which are always sensorially involuntary and uncontrolled. Like dormant or singular images, these visual impressions are *real*, yet they are not *actual* impressions, because they do not correspond to any presently seen object, and thus their source, Herschel argues, is internal and not external: "It may be said that the activity of the mind, which in ordinary vision is excited by the stimulus of impressions transmitted along the optic nerve, may in certain circumstances take the initiative, and propagate along the nerve a stimulus, which, being conveyed to the retina, may produce on it an impression analogous to that which it receives from light, only feebler, and which, once produced, propagates by a reflex action the sensation of visible form to the sensorium" (411–12). The suggestion that real visual impressions are produced by the mind and are transmitted through the body leads to radical mental and epistemological implications that Herschel is well aware of, as he explicitly states, "[W]e have evidence of a *thought*, an intelligence, working within our own organization distinct from that of our own personality. Perhaps it may be suggested that there is a kaleidoscopic power in the sensorium to form regular patterns by the symmetrical combination of causal elements" (412). Ocular spectra, precisely because they are actually seen, cannot be accounted for by the faculties of the imagination and memory, given that, for Herschel, "[m]emory does not produce its effect by creating before the eyes a visible picture of the object remembered" (413). These faculties involve no actual activity of seeing, as they are reproductive faculties through which images and ideas are copied but not produced. Herschel thus insists that ocular spectra are not copies of sensations, like reflections, but *primary* sensations whose source is internal, that is, they are *of* the mind and the human body. This is why he argues that ocular spectra necessitate a form of organization that is not that of representation and the "law of continuity," "distinct from that of our personality," by which Herschel means distinct from human nature. Vision is now located in the body in the form of an *independent* sensorial apparatus and therefore not entirely subjected to the nonsensorial faculty of understanding.

Herschel was not the only figure whose investigations into color led him to identify and analyze visual impressions that persist after the external stimulus is removed. In fact, by the time Herschel was conducting his photographic experiments, color had become a contested issue in the European scientific community. Much in the same manner in which *Naturphilosophie* challenged mechanical Newtonian science, Johann Wolfgang von Goethe's *Theory of Colours* (1810) challenged Newton's optical account of colors. Goethe claimed that colors need to be studied independently of optics and mathematics, and his book aimed "to rescue the attractive subject of the doctrine of colours from the atomic restriction and isolation in which it has been banished, in order to restore it to the general dynamic flow of life and action which the present age . . . recognize[s] in nature."[90] For Goethe, color and light belong to nature as a whole, yet whereas light is indifferent, color is always specific. Color is thus *experienced* as part of a specific act of seeing in which the eye is constantly adapting to external changing relations of light and darkness, brightness and obscurity. The perception of color, Goethe argued, is something altogether different from the physical definition of color, which is based on wavelengths.

Within Newton optical theory, white light consists of different colors that are differentiated according to their degrees of refrangibility. This implies, as Dennis Sepper explains, that colors are inherent not in physical bodies or in the eye but in rays, and that the colors of the spectrum are not the colors of any body; rather, they are produced from white light. Thus, the color of a natural object is "nothing more than a function of its predisposition to reflect or absorb the various components of white light."[91] Goethe, Sepper states, insisted that a theory of colors needs to investigate colors as they appear in real circumstances, because in his own investigations Goethe found discrepancy between theoretical color and perceived color, and argued that the two are not reducible to each other. A comprehensive theory of colors therefore must include the "contribution of the eye, the contribution of the medium through which the image-bearing light passes, and the contribution of the illuminated and perceived object."[92]

The most epistemologically challenging aspect of Goethe's theory of colors is his claim that there can be no purely objective definition of color, because there is no direct correspondence between external stimuli and sensation. Goethe investigated the existence of "physiological colors" through an analysis of phenomena such as ocular spectra, which exhibit

the relative independence of the act of seeing from external stimuli. He noticed, for example, that when "we look on a white, strongly illuminated surface, the eye is dazzled, and for a time is incapable of distinguishing objects moderately lightened."[93] Thus, like Herschel, he argued that during the retina's adjustment time, images appear in the eye even after an external stimulus is removed. In both Goethe's after-vision phenomena and Herschel's ocular spectra, the sense of discrepancy between internal sensation and external stimuli is evoked out of a realization that the act of seeing is embedded in *time*, that is, the eye adapts to different stimuli in its own *independent* temporal sequences, and these do not necessarily correspond to shifts in cognitive and perceptual processes. Yet Herschel emphasized that ocular phenomena appear when the eyes are closed, whereas Goethe insisted that afterimages are integral components of *every* act of seeing, although we notice them only in extreme conditions, such as in shifts between black to white objects or vice versa: "[I]mpressions derived from such objects remain in the organ itself, and last for some time, even when the external cause is removed. In ordinary experience we scarcely notice it, for objects are seldom presented to us which are very strongly relieved from each other, and we avoid looking at those appearances that dazzle sight. In glancing from one object to another, the succession of images appears to us distinct; we are not aware that some portion of the impression derived from the object first contemplated passes to that which is next looked at."[94] Goethe's argument that colors belong "to the *subject*—to the eye itself" introduces an *irreducible* individual element to the act of seeing, thus challenging the philosophical premises of representation and its subject, as Crary explains: "The corporeal subjectivity of the observer, which was a priori excluded from the concept of the camera obscura, suddenly becomes the site on which an observer is possible. The human body, in all its contingency and specificity, generates 'the spectrum of another color,' and thus becomes the active producer of optical experience."[95] Although Goethe embraced the idea of the subject as a producer of optical sensations, because it further supported his romantic and dynamic view of nature, Herschel ends his lecture stating that "it would lead me into . . . a labyrinth of metaphysical considerations, out of which I should find some difficulty of getting disentangled, if I were to go into a discussion on those points of connection between our mental and our bodily organization which these facts seem to suggest" (416). Thus, rather than further developing his argument regarding the relative independence of the corporeal act of seeing from

understanding, he ends his essay in a reassuring discussion of the human will as "necessarily" compatible with the moral principles of human conduct because of habit and the "associative principle."

Thus, it was through his photographic experiments that Herschel identified and analyzed visual impressions that could not be accounted for through the epistemological model of representation. These impressions suggested that the sensorial and embodied eye sometimes acts independently of cognition and perception, and therefore the continuous receptivity of the eye is not necessarily predicated, as Claudet claimed, on the fixed identity of the object or on the consistency of perception in the form of the "law of continuity." Moreover, the idea of dormant pictures showed that latency is a dynamic and *productive* principle that is inherently temporal in the same way in which ocular spectra indicated that perception occurs in time during which the body produces *real* sensations that are not copies of impressions, impressions which are real but not actual, like the latent image.

This discussion of Herschel's color-photographic experiments is not meant to suggest that his photographic experiments turned him into a "romantic" natural philosopher. Rather, it proposes that Herschel's and Talbot's efforts to explain and analyze the specificity of the early photographic image in terms of its dynamic mode of production necessitated an appeal to principles and phenomena that exceeded the camera-obscura model of vision and the "law of continuity." For both, the inseparability of the image from nature resulted in an exploration of the latent, dynamic, and inherently temporal ways in which images are formed in unpredictable and often unaccounted-for processes. And whereas in Talbot's case the unlimitedness of nature as both an agent of production and an object of representation is materially and formally inscribed in his botanical images, in Herschel's case it becomes the primary drive for an ever-growing body of experiments into varied organic and nonorganic substances and "dormant" principles. Thus, again, the shift from the "artist's hand" to "nature's hand" indicated a shift not to more "accurate" or "objective" systems of representation but precisely to rich experimental investigations of the varied ways in which solar light and chemical substances can be used for the purposes of copying and representing. The emphasis on the agency of nature, rather than creating a set of fixed criteria and standards for the photographic image, actually led to the recognition that there are no defined limits to photographic processes, which, because they "develop" in time, cannot be sufficiently regulated.

These investigations also challenge any teleological, linear historiographical model of the "invention" of photography. They indicate that it was precisely through the actual production of images and experimentation that the new image was found to be very different from the image of the camera obscura in its temporal mode of formation and consequently its epistemological status. They also further support my argument that, based on Talbot's accounts, photogenic drawing was an image without a concept, because even after 1839 there was no single idea that motivated the rich field of experimentation that resulted from the announcement. As I will further show in my analysis of Hunt's histories, there was not a clear sense of what the image should be or how it should be made and whether it ought to be a positive or a negative image. Thus, because the early photographic image was not conceived as continuous with the premises of older forms of picture-making, mechanical and nonmechanical, it cannot be regarded and analyzed as the "inevitable" outcome of a "pursuit" after visual resemblance and mechanical indifference. Rather, it came to mark the new organization of knowledge and modes of subjectivity in the early nineteenth century.

Robert Hunt's *Treatises* and *Manuals*

Andre Jammes and Eugenia Parry Janis have pointed out that canonical histories of photography uphold a model of technological progress in which photographic processes are invented, explored, and die once new and better processes emerge in an ever-progressive pursuit after the sharp image and short exposure time. Yet they argue that "a full reading of nineteenth-century sources suggests the opposite, that variants not only overlapped but cascaded by the score into innumerable manuals and treatises in an overwhelmingly rich panorama of technical alternatives. What is interesting about techniques in such an array is not their sequence, but the coexistence of a multitude of distinctions between techniques and variants; the precise conditions, from taste to necessity, dictating the selection of one technique or variant over another."[96] They analyze this rich field of photographic experimentation in terms of pictorial traditions, such as classic versus romantic or linear versus painterly, in order to argue that the calotype was not surpassed by the daguerreotype because it offered to artists aesthetic effects that corresponded to romantic sensibilities.

Robert Hunt's early histories and popular manuals support these claims, yet they also significantly qualify them by suggesting that the exploration of new techniques was not necessarily taken out of strictly pictorial

considerations, as Jammes and Janis argue.[97] His publications show that early nineteenth-century histories and manuals were necessarily diverse, although obviously marked by national sentiments, because the specific identity of their subject was just forming itself as well as its audience. Given that Hunt published his first history in 1841, only two years after the announcement of the discovery, and continued to publish new books and editions at least until 1854, his work offers the possibility of analyzing how photography was conceptualized and historicized in the early years of its formation as a new field. These histories indicate that technical concerns in the early nineteenth century were part of an experimental exploration of working processes and therefore inseparable from conceptual concerns. By analyzing Hunt's treatises and manuals, I further argue for a discontinuity between the way the conception of photography is presented in modern histories as a unified pursuit after a coherent pictorial image and the way it was conceptualized in early accounts as a rich field of experimentation.

Hunt was not only a historian but also an inventor of a number of iron-based photographic processes and a positive process. He was also instrumental in the establishment of the Royal Photographic Society in 1853 and in legally challenging Talbot for his photographic patents.[98] His *A Popular Treatise on the Art of Photography* (1841) is one of the first comprehensive texts on photography that is written not from the point of view of the inventors. The *Treatise* was in fact written in response to a strong sense of disillusionment, following Talbot's early comments, with regard to the facility of attaining images with solar light, and also in order to arrange "all the *various* processes which have been devised, into a systematic form."[99] Its stated purposes are therefore to offer assistance "not only to those whom it may induce to experiment in photography, but even where the practice of the art has given a considerable degree of certainty in manipulation."[100] Hunt encourages experimentation both as a mean to assure predictability in the production of images and in order to advance photography from a "philosophical toy," which for him marked its status when it was first announced, into a useful tool in manufacturing and the "arts of industry." Hunt's introduction suggests that at this early stage practicing photography was inseparable from experimenting with it, because the field was dispersed, uncertain, and unregulated. Hunt thus addresses the *Treatise* indiscriminately to amateurs and experimenters.

The *Treatise* includes a short historical section that explores discoveries in photochemistry by, among others, Johann Wilhelm Ritter and John

Herschel, and then follows the invention of the art from Thomas Wedgwood and Humphry Davy to Joseph Nicéphore Niépce, Louis Daguerre, and Talbot, including a brief discussion of Herschel's processes. Hunt divides the main part of the *Treatise* into three sections: processes on paper, processes on metallic and glass tablets, and miscellaneous processes (see Appendix B). The largest section is on paper processes, in which Hunt discusses separately not only the production of negative and positive photographs but also the use of paper for taking copies of botanical specimens and engravings and the use of paper in the camera obscura. Hunt states that "the most important object of the photographic art, is the securing the shadowy images of the camera obscura—the fixing of a shade, and multiplying its likeness,"[101] yet he describes papers not only in terms of their sensitivity but also in terms of their different effects based on their chemical proponents. In fact, Hunt states that it is precisely the increased sensitivity of papers that results in unpredictable and uncertain effects:

[T]he increased sensitiveness given to the paper, by alternate ablutions of saline and argentine washes—the striking differences of effect produced by accidental variations of the proportions in which the chemical ingredients are applied—and the spontaneous change which takes place, even in the dark, on the more sensitive varieties of the paper, are all subjects of great interest, which demand yet further investigation, and which, if followed out, promise some most important explanations of chemical phenomena at present involved in uncertainty, particularly of some which appear to show the influence of time—an element not sufficiently taken into account—in overcoming the weaker affinities.[102]

The sections on processes on metallic and glass tablets and miscellaneous processes are almost of the same length. Hunt includes Herschel's process on glass as an integral working process, and also describes a variety of processes (involving nonmetallic preparations or the use of gold salts as photographic agents) that are conceived not for the camera obscura or for the production of black-and-white images but for the production of monochromic color images.

Hunt's *Treatise* is read both as a manual that aims to instruct amateurs in the practice of photography and as an informed popular-scientific treatise on chemical processes. Particularly in the section on miscellaneous processes, photography as a picture-making practice is not significantly

carved out from the field of the chemical investigation that led to its discovery. Chemical experimentation conceived to facilitate the production of pictures is therefore presented as indistinguishable from scientific experimentations on light and heat where photographic papers are used as abstract tools for analysis.

In this regard, it is not surprising that Hunt's next publication, his *Researches on Light* (1844), was concerned not with the production of pictures in the form of a treatise or manual but with a scientific explication of the chemical processes that are involved in the production of photographic images. In this book Hunt argued that photographic chemical processes challenge the wave theory of light and therefore offer further support to Newtonian projectile theories of light. Hunt's next treatise, *Photography: A Treatise of the Chemical Changes Produced by Solar Radiation, and the Production of Pictures from Nature, by the Daguerreotype, Calotype, and Other Photographic Processes*, was published in 1851 as part of the second, revised edition of the *Encyclopædia Metropolitana* where it appeared in the division of applied sciences (see Appendix C). Hunt states in the preface that "[a] reprint of the 'Popular Treatise' was at first intended, with such additions as might be necessary from the improved state of our knowledge. It was, however, found impracticable to do justice to the subject in this way; therefore, an entirely new arrangement has been adopted, and only so much of the original work retained as represented the history of one of the most beautiful of the applications of Physical Science to Art."[103]

The 1851 *Treatise* is no longer a popular work that aims to assist amateurs with the production of pictures but rather, as could be inferred from the title, a comprehensive book on the "subject," not just the "art," of photography, which is conceptually divided into a chemical scientific part and a part that is concerned with the production of pictures. By defining photography as a "subject," Hunt signals that photography had moved beyond its "infancy" and correspondingly from the "hand" of the amateur to the "hand" of the professional:

To pursue photography with success, it is essentially necessary that, by practice, the hand should be accustomed to the numerous manipulatory details; that, by repeated experiments, the causes leading to failure should be ascertained; and that a knowledge of the conditions under which the chemical change takes place should be obtained. This study, without which there will be no success, is most favourably pursued by

experiments on paper. . . . Previously, however, to explaining the practice
of photography, it appears important that the physical conditions of the
elements with which we have to work should be understood.[104]

Failure to practice photography is attributed no longer to the insufficiently
advanced state of the art but to a lack of skill and knowledge on the part
of its practitioners. The work thus aims to educate, not just instruct,
because by now it is clear that the production of pictures by solar light is
a complex practice. So, after a short historical section, identical to the one
published in 1841, Hunt includes a strictly scientific chemical chapter.

In many ways the new *Treatise* is a transitional work that is situated
between the loosely organized *Popular Treatise* of 1841 and Hunt's highly
structured manuals of 1853 and 1854. The work lacks a systematic struc-
ture or a clear division into sections, and is read almost like an inventory
of processes and concerns that again move back and forth from the sci-
entific to the practical. Paper processes still receive considerable atten-
tion, because Hunt claims that they are more easily practiced than other
processes. Yet the new *Treatise* also incorporates a variety of experimental
processes, including a positive process and all of Herschel's photographic
processes that involve gold, mercury, and vegetable substances. These
appear not under a unified broad category, as they did in the 1841 *Treatise*,
but in separate chapters, resulting in a structure that lacks clear hierarchy
between popular processes and marginal or "miscellaneous" processes.
Thus, for example, the chapter on miscellaneous paper processes is as
long as the chapter on the calotype.

The new *Treatise* is thus highly inclusive, and the logic behind this
strategy is explicated in the chapter on Talbot's processes. Hunt quotes
Jean Biot's presentation of the calotype in the Academy of Science in
Paris:

It is not to be expected that photogenic drawings, made on paper, can
ever equal the clearness and fineness of those obtained on level and pol-
ished metallic plates. The texture of paper, its superficial roughness, the
depth of the imbibitions, and the capillary communication established
between the various unequally marked parts of its surface, are so many
obstacles to absolute strictness of delineation, as well as to the regular
gradation of tints in the camera obscura; and the influence of these obsta-
cles is greater when the chemical operation is slowly carried on. But
when there is no pretense or necessity for submitting to the delicacies of

art—when it is required, for example, to copy rare manuscripts faith-
fully—if we have papers which are very susceptible of receiving impres-
sions in the camera obscura, they will suffice perfectly; particularly when
they present, like those of Mr. Talbot, the facility of immediately procur-
ing copies of the primitive drawing.[105]

Biot points out the necessary irregularity of photogenic drawing and its
difference from the images of the camera obscura. Hunt further empha-
sizes Biot's comments by addressing Talbot's copies of busts and statues:

> Truly, there is not found in them the strict perfection of trace, nor the
> admirable gradation of lights and shades, which constitutes the charm of
> M. Daguerre's impressions. . . . But *I also repeat, that representations on
> sensible papers must be considered as principally applicable to a different
> object*, which does not impose such strict conditions of art, requiring only
> faithful images, sufficiently clear in their details to be readily recognized,
> and which, moreover, being obtained with rapidity, by an easy manipu-
> lation, may be kept with very little care, comprised in great number in a
> small compass, and moved from place to place with facility.[106]

Hunt's statements and his inclusive organization of the new *Treatise*
make it clear that photographic processes were conceived as optional,
rather than exclusive, depending on function and necessity. Hunt does
not evaluate the different processes he names in relation to a unified goal
or criterion. The sense one gets from his conceptualization of photog-
raphy is of a highly dispersed field in which individual figures pursue
different goals: Herschel is concerned with color, Hunt with positive
images, Talbot with copying processes. Although the advantages of the
daguerreotype are acknowledged, it still forms a part of a broad field that
is organized not hierarchically as a linear sequence but as an inventory
of technical possibilities.

Hunt's *A Manual of Photography* (1853) was published also as part of
the *Encyclopædia Metropolitana* (see Appendix D).[107] This publication
marks a shift from Hunt's earlier publications. The change of title from
a "treatise" to a "manual" points to an increasing professionalization in
the practice of photography by the 1850s, to the point where these publi-
cations were no longer considered to be "popular" or addressed to a broad
audience. At this point the audience for publications on photography was
differentiated and could no longer be addressed indiscriminately. Thus,

in his preface to a new edition of *A Manual of Photography* in 1854, Hunt states that what motivated his new organization and division of the subject was that "the amateur will advance more readily in his photographic studies, and the experienced artist will find the references more easy to any particular mode of manipulation which he may desire to consult."[108]

The *Manual* establishes a clear division in the subject of photography between the practical and the scientific, as if finally the field of photography as a practice for picture making had achieved sufficient evidence of its independence and maturity. The scattered organization of the 1851 *Treatise* is replaced with a clear division into three broad parts: history of discoveries of photography, scientific investigations on photography, and practice of photography. The historical part is organized not as a linear succession of techniques but in separate chapters for each discovery, moving from the earliest one to the latest. The division into chapters is based on individual discoverers and not only on the nature of the process. Thus, discoveries on paper processes are discussed in three separate chapters, given that they were made by different individuals.[109] The scientific part is concerned with investigations that are related to developments *within* the field of photography as a practice and to its scientific applications, rather than to general chemical fields.

The practical part mirrors the diversity of the historical part, as Hunt names all working photographic process as optional. Hunt's inventory suggests that although the collodion and albumen processes on glass combined together the capacity of producing a clearly resolved image and the possibility of copying multiple images, these developments did not in any way make the calotype obsolete. Hunt still includes Biot's remarks on the advantages of the calotype in the *Manual*, as well as a positive process. Nothing in the organization of the chapters suggests that different processes are exchangeable, as they are practiced for the same ends.

Perhaps the most fascinating part from a historiographical point of view is the chapter titled "General Summary of the History of Photography," which ends the historical section (see Appendix E). This summary still appears in the 1854 edition of the *Manual*, which is almost identical to the 1853 edition except that it now includes an extended chapter on the albumen process and a new chapter on Talbot's photographic engraving process, both in the practical section. Hunt compiled the summary in 1850 for the BAAS as a report on the history of discoveries in photography. It is composed as a table in which photographic processes are differentiated according to the primary sensitive chemical substances that

are employed in them, and corresponding to these are the inventors' names and dates. Although it is clear that the main purpose of the table is to credit inventors with their specific discoveries, it is still surprising to see how small a part silver-based processes on metal and glass plates form in this table. Not that every process named developed into a working process or was conceived as a photographic process in the first place; nonetheless, the field of what are considered to be "discoveries in photography" is mainly experimental, that is, it is diverse experimental initiatives that define and organize this field, and not a particular concept of an image. There is thus no self-evident coherency, or explicit progressive line of inquiry, around which this experimental field is organized at this stage. Moreover, by organizing this table and the manuals themselves as inventories that emphasize the specific advantages of different techniques, Hunt's histories suggest that in its early stages of formation, photography was conceived as a highly dispersed and loose field of practice and inquiry that was open to different levels of engagement and various forms of experimental investigations. The story of the conception of photography as a progressive sequence of techniques emerged at a later point in the historicization of photography in light of its professionalization and industrialization in the 1850s.[110] It is within canonical new histories of photography that a continuous narrative is constructed and an "origin" for the conception of photography is assigned or looked for, in a way that is inconsistent, I argue, with the early stages of its formation as a site of experimental exploration devoid of any presupposed ends.

Hunt's histories, I argue, convey the sense of experimentation and unpredictability that this chapter has analyzed with regard to early photography, the way reviewers searched for the right terminology for photography and emphasized its difference from early systems of representation. Their understanding was that "no two images were alike" and therefore that the production of photographs hinged on unaccountable processes that pertain to nature as well as to the image's temporal mode of formation. Talbot's own reconsideration of photography, rather than presenting it as a mechanical procedure, describes its latent process of registration as one that allows for consequent processes of differentiation to register themselves. Thus, in his botanical photographic diagrams, nature appears not as a static table but as a force of expansion and repetition. Finally, in Herschel's vegetable experiments, nature is a source for a proliferation of photographic processes in a way that undermines the "identity" and "fixity" of photography. Hunt's histories are thus emblematic, because they

outline the consolidation of the "subject" of photography, from an image without a concept to an emblem of resemblance and mechanical identity in the 1850s. In this regard, they point to historical difference, and not to "logical inevitability" or a linear quest for verisimilitude and "objectivity," because it is not any notion of "progress" that underlies them but the compilation of simultaneous photographic processes.

4 | History

Displaced Origins and The Pencil of Nature

Within histories of photography, Talbot's *The Pencil of Nature* (1844) is often analyzed as the first mass-produced photographically illustrated book, a forerunner to what photography became in the modern era.[1] In fact, as Larry Schaaf has shown, *Pencil* was published in a small run of expensive copies. Out of its six sets of facsimiles, it is estimated that about three hundred copies of the first set were sold and one hundred of all six sets.[2] The production of *Pencil*, for which a publication business was established in Reading, England, by Talbot's previous employee Nicolaas Henneman, with Talbot's assistance, exposed the gap between his initial rhetoric emphasizing the "mechanical" nature of photogenic drawing because of the paper negative's capacity to produce multiple copies, and his growing understanding that the production process itself was manual and therefore unregulated and unpredictable.[3] The plates also had to be attached manually to the book pages, and this proved to be a highly complex process that eventually led Talbot to scale down his original plans for the publication.[4] Talbot's notes show that he had planned to include at least fifty negatives in *Pencil*, many more than the twenty-four that were eventually included. Schaaf thus points out that "in evaluating *The Pencil of Nature* today, we are examining the fragmentary evidence of a much grander plan."[5]

Already in March 1839 Talbot stated in a letter to John Herschel that photogenic drawing allowed "'[e]very man his own printer & publisher'—to enable poor authors to make facsimiles of their own handwriting."[6] And although during this time he was aware that "the perfection of the French method of Photography cannot be surpassed in some respects,"

he insisted that his method was decidedly superior in "the capacity of multiplication of copies, & therefore of publishing a work with photographic plates."[7] Talbot published *Pencil* in order to demonstrate this capacity and to further familiarize the public with his newly discovered calotype by suggesting possible applications for the process. The title, *The Pencil of Nature,* was used by William Jerdan, the editor of the *Literary Gazette,* in an article on the daguerreotype published in February 1839. The term is taken from Edward Gibbon's *The History of the Decline and Fall of the Roman Empire* (1776–88).[8] Yet, although it is clear what Talbot wanted to achieve with the publication of *Pencil*, it is not clear what *kind* of book he conceived it to be, especially given that his initial plans were modified during the production process. Although he did not conceive it to be a "manual" or "treatise," it does contain chemical and optical information, together with instructions on how to photograph and to print. By the same token, it was obviously not meant to be an inventor's account of his discovery, as by this time Talbot had already published in separate pamphlets his discoveries of both photogenic drawing and the calotype. Nevertheless, *Pencil* does contain "A Brief Historical Sketch of the Invention of the Art," and Talbot explicitly states, in his text to Plate 6, "The Open Door" (Figure 2.1), that "The chief object of the present work is to place on record some of the early beginnings of a new art, before the period, which we trust is approaching, of its being brought to maturity by the aid of British talent."[9] Thus, it was not only the history of the invention or the discovery that *Pencil* aimed to convey but also the history of the art *itself.* In this regard, *Pencil* is a book with a complex discursive identity, because it evokes all the existing discourses and publication formats *on* photography up to this point while also exceeding these as a book *of* photography.[10] That is, it struggles to formulate a specific discourse for photography, a form of intelligibility that is not simply that of its technical production or of the chemical and optical principles behind its invention.

Nevertheless, already in Talbot's remarks for "The Open Door," it is clear that the condition for the intelligibility of photography as a new art is missing, namely, its maturity. This statement suggests that time determines the precise mode of being of things, and therefore it is through history, as a form of knowledge, that things become intelligible. The emphasis on time and history underlines *Pencil*'s major concern with "documents" and "monuments," images and texts. The book reveals a specific concern with "pastness" and the visible effects of time, together with

an awareness of the gap between past and present. For example, in his comments to Plate 1, "Part of Queen's College, Oxford" (Figure 2.11), Talbot states, "This building presents on its surface the most evident marks of the injuries of time and weather, in the abraded state of the stone, which probably was of a bad quality originally." In his comments to Plate 18, "The Gate of Christchurch," Talbot remarks on the silence that infused Oxford University during the summer: "Those ancient courts and quadrangles and cloisters look so beautiful so tranquil and so solemn at the close of a summer's evening, that the spectator almost thinks *he gazes upon a city of former ages, deserted, but not in ruins: abandoned by man, but spared by Time.*"[11] These remarks, as I argued in chapter 2, pertain to the occupation with ruins in picturesque views. I pointed out there that time in the picturesque is addressed not as a mode of being but as a perceptual mechanism that registers the visual signs of change. As a pictorial genre, the picturesque avoids history by "naturalizing" it, that is, by presenting harmonious views that suggest a remote agrarian past unaffected by historical change and conflict.

Yet in the context of *Pencil* as a whole, these remarks are emblematic of different concerns, because in the book it is no longer just time that is addressed but history. Talbot's comments to "The Gate of Christchurch" convey a specific gaze and consciousness through which "monuments" become visible "documents" of another time, and written "documents" become unofficial "monuments" or "records" for people living in a different period.[12] This is also the perspective from which the photograph is addressed: the time it takes to make it, the time it explicitly registers and unintentionally reveals, and the form of temporality it embodies as the camera "chronicles whatever it sees."[13]

Although the photograph manifests different temporalities, the "art of photography" lacks a history, because, as Talbot emphasizes, it is still in its "infancy." *Pencil* is therefore a highly *reserved* book with regard to the possibilities of paper photography, as by this time Talbot had already received indications that photographs could not supplement botanical illustrations, nor could paper negatives produce an infinite number of copies as lithographic plates could. And although he does make some suggestions regarding the use of photographs as "documents" of some kind, he is always ambivalent and very careful with regard to the epistemological and conceptual implications of his suggestions and in most cases avoids any clear-cut statements.

The question what kind of "document" a photograph is remains undecided in *Pencil,* because, on the one hand, the image presents an impartial and accurate "record"; on the other hand, it has the capacity, as is shown earlier, to present picturesque "details" that trigger the workings of the imagination. Yet this problematic was not specific to the photographic document but emerged during this time as a central methodological and conceptual concern within romantic historicism in which, through narrative, the past was not simply described in an accurate and impersonal manner but was made present and alive. It is therefore in relation to this general impulse of the imaginative reenactment of the past, which underlay literary historical genres of writing as well as antiquarian, classical, and philological studies, that Talbot discusses the future of the photograph and its role as a document. Rather than addressing *Pencil* as an "origin" for photography's future industrialized applications and privileged evidentiary status, this chapter emphasizes the historical specificity of the book and the unresolved status of the early photograph as part of the emergence of historicism as a form of knowledge in the early nineteenth century.

The Historical Imagination

Stephen Bann has written extensively on the centrality of the past and its representations in romanticism. He attributes the rise of history as a form of knowledge that underlay a variety of cultural phenomena such as the historical novel, history painting, and educational popular displays, including the diorama and the museum, to the romantic movement's "desire" to turn history into an "autonomous vehicle for imaginative reflection."[14] He argues that with romanticism a shift occurred through which history developed from a "localized and specific practice within the cultural topology" into "a flood that overrode all disciplinary barriers" and finally into "a substratum to almost every type of cultural activity."[15] He also emphasizes that England, because of its strong romantic legacy, was slow to adopt professional and academic codes of historical writing, and resisted the notion of disinterested historical research. As late as the middle of the nineteenth century, Bann points out, "the intellectual prestige of history in British culture was still dependent on the independent status of writers like Thomas Carlyle and Thomas Babington Macaulay who adopted no professional affiliations."[16] It was Macaulay in particular who, in his 1828 essay "Hallam," clearly articulated the romantic desire to "make the past present, to bring the distant near, to place us in the society of a

great man on an eminence which overlooks the field of a mighty battle, to invest with the reality of human flesh and blood beings whom we are too much inclined to consider as personified qualities in an allegory."[17]

Romantic historicism emerged, Maurice Mandelbaum argues, as a rebellion against the Enlightenment historiography, for example, Edward Gibbon's *The History of the Decline and Fall of the Roman Empire* (1776–88), and David Hume's *The History of England* (1754–62). For eighteenth-century historians, reason functioned as a universally valid standard for human achievements in all times and places. Human history was described in terms of the development or progress of humankind from "infancy" to "maturity," that is, from unreason and superstition to reason. Reason thus provided both an external model of explanation and a general and abstract evaluative standard for different periods. The faith and belief in progress, also announced by Francis Bacon in the *Novum Organum*, remained unchallenged for Enlightenment historians, although it was obvious to them, as Mandelbaum states, "that the society in which they lived was not a society ordered in accordance with that standard, and that no society which conformed to the standard had ever been achieved within historic times."[18] Nevertheless, this unavoidable gap only strengthened their belief that the source for this disparity was ignorance, which would ultimately be dispelled.

Moreover, as Hayden White has shown, in the Enlightenment historical knowledge was used for polemical purposes in order to ground general moral and intellectual truths regarding, among other things, a universal human nature. The role of the historian was therefore one of a "meta-critic," who judged the past according to rationalist principles. This position of judgment entailed "distance" and resulted in irony and skepticism, what White calls "an Ironic awareness—of the limitation which nature places on every effort to comprehend the world in either thought or imagination. But they [Enlightenment thinkers] did not fully exploit their ascent to this level of awareness. They did not believe in their own prodigious powers of dreaming, which their Ironic self-consciousness should have set free. For them the imagination was a threat to reason and could be deployed only in the world under the most rigorous rational constraints."[19] White points out that although Hume turned to history writing in order to find a way out of the radical skepticist impasse he found himself in after completing the *Treatise*, his *History of England* further enforced his skepticism and his ideas about human nature.[20]

Applying the rhetorical tropes of irony and paradox, argues F. R.
Ankersmit, also offered to resolve, on the level of language, an inherent
tension in Enlightenment historiography that derived from its philo-
sophical premises and belief in natural laws and an ontology of fixed
matter, in "substantialism," the idea that "reality is made up of entities
essentially remaining the same in the course of time."[21] Change is thus
always described as peripheral and external, a redundant or contingent
cause or effect that in no way challenges the permanence of entities and
substances. The role of the historian is thus to emphasize continuities by
integrating change into the "nature" of the substance, with the result that
it becomes both cause and effect. Ankersmit demonstrates this circular
form of reasoning in the way Gibbon described Rome as the cause of its
own decline; thus, what made it rise in the first place also made it fall.
I have already pointed to this form of circular reasoning in Herschel's
"law of continuity" and in the way Babbage thought to integrate change
in the programming of his calculating machines. Although change was
acknowledged in Enlightenment historiography, it also had to be "dis-
pelled" or delegated to the realms of language and rhetoric, because it
implied time and difference, precisely things that needed to be avoided
if the consistency and regularity of nature and human nature were to be
universally grounded.

If the primary stance of the Enlightenment historians was one of irony
and judgment, that of the romantic historians was one of metaphor and
empathy. And whereas the subject of history for the Enlightenment was
humanity, for the romantics it was specific individuals and nations, "man"
in its geographical, national, ethnic, and cultural particularity. The major
metaphor for the romantics, as I argued earlier, was organicist, human
life unfolding like the life of a plant, and change was therefore an intrinsic
principle of development, with its own specific, integral end. For roman-
tic historians, in particular Johann Gottfried Herder, the historical field
is composed of an infinite web of particularities that are connected to one
essential whole in a way that is not causal or teleological. Things *become*
what they are out of their concrete position and relations within a specific
environment. Thus, rather than judging preceding periods or civiliza-
tions according to a universal standard, Herder emphasized (as White
shows) "that everything that has ever existed was adequate to the condi-
tions of its existence." Consequently, the "spectacle of coming into being
and passing away which the historical record displays to consciousness was
no occasion for despair to Herder. Time did not threaten him, because

he did not take time seriously. Things pass away when *their* time has come, not when Time requires it of them. Time is internalized in the individual."[22]

For Herder and other romantic historians, such as Jules Michelet, the primary subject of history was the "life of the people" as a unitary thing, which is expressed and manifested in their laws, institutions, customs, and cultural achievements. The role of the historian was thus to grasp, Mandelbaum explains, "the inner core of feeling which binds a people together . . . to see the people as a single, living, historical and history-making entity whose value must be judged in terms of its inner harmony."[23] Revealing this "inner core" necessitated a move beyond appearances into "hidden" internal origins, processes, and meanings. It demanded a specific form of "hermeneutic" through which, as Lionel Gossman has shown, the "role the Romantic historian attributed to himself was similar to that of the Romantic poet": his role was to "recover and read the lost languages of the mute past" and thus to unveil a hidden or neglected history. "By making the past speak and restoring communication with it," the historian could point to continuities between "remotest origins and the present, between the other and the self."[24] The historical imagination of the nineteenth century was thus strongly drawn, Gossman argues, "to what was remote, hidden, or inaccessible: to beginnings and ends, to the archive, the tomb, the womb, the so-called mute peoples, such as the Egyptians and the Etruscans, whose language remained an enigma."[25]

In the same manner in which the romantic poet was supposed to adapt and remain attuned to nature, the romantic historian was to be empathetic to the past. It was through the imagination as a unifying faculty that the historian pointed to the gap between past and present, and at the same time made the past present and alive. In England it was Macaulay, in his canonical essay "History" (1828), who emphasized the important role of the imagination in history writing. Macaulay starts his essay with the assertion that "we are acquainted with no history which approaches our notion of what a history might be." The reason, he argues, for this state of things is that

> [t]his province of literature is a debatable land. It lies on the confines of two distinct territories. It is under the jurisdiction of two hostile powers; and, like other districts similarly situated, it is ill-defined, ill cultivated, and ill regulated. Instead of being equally shared between its two rulers, the Reason and the Imagination, it falls alternately under the sole

and absolute domination of each. It is sometimes fiction. It is some-
times theory. History, it has been said, is philosophy teaching by exam-
ples. Unhappily, what the philosophy gains in soundness and depth the
examples generally lose in vividness. A perfect historian must possess
an imagination sufficiently powerful to make his narrative affecting and
picturesque.[26]

For Macaulay, history begins in a novel or romance and ends in an essay.
He also compares the writing of history to painting: "He who is able to
paint what he sees with the eye of the mind will surely be able to paint
what he sees with the eye of the body. He who can invent a story, and tell
it well, will also be able to tell, in an interesting manner, a story which he
has not invented" (385). A historian is therefore like a portrait painter.
Macaulay applies Coleridge's distinction between mechanical copying and
organic imitation in order to argue that good portraits are based not on
"likeness" but on the painter's ability to condense into one point of time
the whole history of a person. Truth in history, as opposed to truth in the
abstract sciences, is like the truth of imitation in the fine arts: an imper-
fect and graduated truth: "No picture . . . and no history, can present us
with the whole truth: but those are the best pictures and the best histories
which exhibit such parts of the truth as most nearly produce the effect of
the whole" (387).

Although Macaulay emphasizes the role of narration in history writing
and its power to "produce an effect on the imagination," he also stresses
the differences between fiction and history. Whereas in fiction the prin-
ciples are given and the writer needs to find the facts, in history the facts
are given and the historian needs to extract the principles. A historian
"who does not explain the phenomena as well as state them performs
only one half of his office. Facts are the mere dross of history. It is from
the *abstract truth which interpenetrates them, and lies latent among them* . . .
that the mass derive its whole value" (390; emphasis added). In many
ways, Macaulay's essay was written as a response to the immense popular-
ity in the early nineteenth century of Sir Walter Scott's historical novels.[27]
In his novels Scott combined the low literary genre of the romance with
historical subjects. Macaulay praises Scott's work in his essay:

> At Lincoln Cathedral there is a beautiful painted window, which was
> made by an apprentice out of the pieces of glass which had been rejected
> by his master. It is so far superior to every other in the church. . . . Sir

Walter Scott, in the same manner, has used those fragments of truth which historians have scornfully thrown behind them in a manner which may well excite their envy. He has constructed out of their gleanings works which even considered as histories, are scarcely less valuable than theirs. But a truly great historian would reclaim those materials which the novelist has appropriated. (428–29)

The materials Macaulay refers to are those that belong to the culture of everyday life, as opposed to strictly political or military events, which were considered to be the materials for traditional historians. The role of the historian was not simply to "direct our judgment of events and men" and "draw from the occurrences of former times general lessons of moral and political wisdom," but also to "call up our ancestors before us in all their particularities of language, manners, and garb, to show us over their houses, to seat us at their tables, to rummage their old-fashioned wardrobes, to explain their uses of their ponderous furniture."[28]

Scott's achievement consisted in opening historical writing to varied aspects of experience by focusing on the motives and private lives of specific individuals. His novels therefore not only invited identification on the part of his readers but also conveyed to them, in a way proper historical writing did not, the specific character of the social and physical environment, the "customs and habits" of a particular historical age. Scott's novels, as Georg Lukács has shown, depicted a rich and broad picture of the "being of an age" by focusing on the everyday life of the people and the way they are formed in relation to specific geographical, economical, and cultural milieus. It was through his modes of characterization and dramatization that Scott was able to "give human embodiment to historical-social types." What matters in Scott's historical novels, Lukács states, is "not the re-telling of great historical events, but the poetic awakening of the people who figured in those events. What matters is that we should re-experience the social and human motives which led men to think, feel and act as they did in historical reality." And it is precisely through small and insignificant events as well as "average" or mediocre heroes that these social and human motives are best revealed.[29] For Scott, therefore, historical necessity was shown to be a result, not a precondition, of an interaction between concrete human beings and specific historical circumstances and their transformation; change happened not because of individual or essential "psychological" drives but through often-unintended consequences of chains of events and social and political forces.[30]

Ina Ferris points out how Scott's narratives and plots, in their loose structure and constant shift from description to dialogue to character, reveal an interest in the particularity of heterogeneous cultural "manners" rather than in the universality of human nature. She shows that his novels still rely on oral traditions of storytelling in which the narrative, rather than revealing the unfolding of a specific consciousness, as in the modern novel, becomes a "product of cultural memory." Scott places the narrator and reader alongside rather than "inside" the world that the novel represents; thus, the narrative itself "embodies the doubleness of memory in the sense that memory depends at once on an awareness of time present and time past."[31] In his novels, Ferris argues, Scott assigns himself the role of the "transmitter" of cultural memory and tradition rather than the originator of literary conventions and plots: "His novels exploit the oral forms of folktale, anecdote, and ballad, and they typically present themselves as compilations made out of bits and pieces of traditional lore."[32] This explains the inherently open and unfixed nature of Scott's texts, with their proliferation of notes, appendixes, and prefaces. Thus, Scott's historicism lies less in his perception of culture as a historical product and more in his "specific recognition of the sedimentation of a culture at any given historical moment."[33]

Ann Rigney also emphasizes how Scott often imitates fictional literary and poetic forms from earlier periods as useful tools for the "re-enactment of the past." She points out that Scott was a collector and annotator of noncanonical texts and documents from different periods. His literary collections formed a part of a new kind of antiquarianism, one that was focused on texts, not objects, which flourished in England from the end of the eighteenth century until the beginning of the nineteenth. These collections, she argues, were often compiled "not so much for their literary merit as for the valuable information about the past they contained— in particular information about the 'manners' of our ancestors."[34] They were inherently fragmentary in their organization, because their aim was not to convey a coherent and systematized knowledge about the past but to evoke subjective and imaginative feelings in the reader. In this regard, a poem or a tale is simultaneously "a piece of the past itself, a source of evidence, and a focus for our longing to know more, to go beyond the evidence to the broader situation the object invokes without describing."[35] More than "authenticating" the past, a poem evokes a desire, which cannot be fulfilled in either objective or subjective forms of knowledge about the past, for the overcoming of temporal distance.

Talbot was also a literary antiquarian of a sort. His first book, *Legendary Tales in Verse and Prose,* was published in 1830 and recounted folk stories from Germany, Italy, and Denmark.[36] His second book, which appeared in two volumes in 1838 and was sent to Macaulay, *Hermes; or, Classical and Antiquarian Researches,* was a collection of short, mainly philological essays on classical antiquity. Talbot's aim in writing and publishing these essays was to "demonstrate the evidences," following recent archaeological discoveries in Greece, Italy, and Egypt, for "points of contact" and influence between these countries through a philological analysis of original documents.[37] Talbot's next book, published in 1839, *The Antiquity of the Book of Genesis,* was meant to argue, through "a chain of evidence sufficiently strong," that the Hebrew scriptures are older than classical texts. In this book Talbot emphasizes the scholarly importance of legends that were handed down by oral tradition, and especially of "the Grecian mythology—a singular medley of tales . . . a tangled web, difficult to unravel—but in which at least this much may be discerned— that it contains stories, the growth of very different times and countries; and that, mixed with many things, the mere imagining of poets, it has preserved many relics of real belief—the serious worship—of a prior age."[38] Talbot's interest in antiquity is therefore not that of a historian but that of a "literary antiquarian" or cultural "transmitter" who is interested in "relics" of the past, from single words to tales and genres, in order to reveal, like Scott, the "belief, manners, and customs of primitive times," as he explicitly states in his *English Etymologies* (1847).[39] These kinds of antiquarian and classical investigations, he points out, often present "such a force of evidence as to leave no doubt whatever on the mind of the inquirer of the occurrence of particular events, or the existence of peculiar customs, respecting which *History is entirely silent.*"[40] The most explicit connection between Talbot and Scott lies in Talbot's second book of photographs, *Sun Pictures of Scotland,* published in 1845, which presented views related to the life and writings of Scott.[41] This collection of photographs was part of the popular response to Scott's novels that consisted in the production of visual and literary works aimed to identify the locations and characters figuring in his novels.

Talbot's idea of a document, I argue, is related to procedures of evidence that come from a specific literary antiquarianism that displays a fascination with "origins" and remote cultures. His idea of the document is thus inseparable from romantic historicism in which the past is constituted as a "mute" object that needs to be deciphered in a way that both

acknowledges its inherent "Otherness" and, at the same time, tries to transcend it through imaginative identification and empathy. A document is therefore an inherently "open" and multilayered literary artifact in which the "sedimentation of culture" appears as "a tangled web" of overlapping temporalities, geographies, and meanings. It is therefore accessible to different kinds of intellectual engagements (antiquarian, philological, historical), and its meaning shifts based on the specific conditions of its production, reception, and contextualization. Intelligibility is a function of time, yet time is simultaneously a source of constant change and the intellectual "absolute horizon" within which things acquire their meaning. Time becomes an "origin" in historicism, but one that cannot ever ground knowledge's claim for universality, as Foucault explains:

> History constitutes . . . for the human sciences, a favorable environment which is both privileged and dangerous. To each of the sciences of man it offers a background, which establishes it and provides it with a fixed ground and, as it were, a homeland; it determines the cultural area—the chronological and geographical boundaries—in which that branch of knowledge can be recognized as having a validity; but it also surrounds the sciences of man with a frontier that limits them and destroys, from the outset, their claim to validity within the element of universality.[42]

This, I contend, forms the discursive framework within which Talbot's views on the document and testimony are formed: on the one hand, the desire for an "origin" or a "ground"; on the other hand, the recognition that time disperses and dismantles any claim for the unity and consistency of knowledge.

The Mute Document

In *Pencil,* the photographic image is related to texts, but in a way that remains extremely opaque, and in many cases the relation between a specific image and its accompanying text is not stated. And although the photograph is constantly related to written documents of different sorts, its own status as a document remains elusive, because Talbot ends every suggestion he makes about the photograph with either a reference to some kind of "external" authority or a question. Talbot addresses the photographic image as a form of testimony in two important statements in *Pencil.* The first is in his commentary to Plate 3, "Articles of China" (Figure 4.1):

From the specimens here given it is sufficiently manifest, that the whole cabinet of a Virtuoso and collector of old China might be depicted on paper in little more time than it would take him to have a written inventory describing it in the usual way. The more strange and fantastic the forms of his old teapots, the more advantage in having their pictures given instead of their descriptions. And should a thief *afterwards* purloin the treasures—*if the mute testimony of the picture were to be produced against him in court—it would certainly be evidence of a novel kind; but what the judge and jury might say to it, is a matter which I leave to the speculation of those who possess legal acumen.* (emphasis added)

Carol Armstrong analyzes this statement in terms of the opposition between the functions of authentication and legibility. She states that Talbot admits that he is not a legal expert, and thus he does not know how the photograph might be interpreted in court. Nevertheless, "[d]ifficult to interpret or not, the photograph is irrefutable evidence, of that much Talbot is sure. This claim rests on a particular determination as to what kind of 'specimen' a photograph is. Putting the photograph in place of the written document, it detaches the photograph's evidentiary status from any pre-given system of signification or interpretation. The photograph is evidence just because it is a photograph, and not because it is governed by a body of law or by the rules of the legal game."[43] Thus, although Talbot acknowledges the necessity of a legal discourse within which the intelligibility of the photograph will be attained, he also emphasizes,

Figure 4.1. William Henry Fox Talbot, "Articles of China," salt print from a calotype negative, Plate 3 from *The Pencil of Nature,* 1844. National Media Museum, Bradford, U.K./Science & Society Picture, London.

Armstrong claims, that because its nature is one of efficiency and impartiality as a "specimen" of "Nature's art" and a document drawn by its pencil, "the photograph is a guarantee of its own verity; hence, its evidentiary status is ontological, in the nature of its being as an image. Everything, in short, rests on its tautological naturalness. *Talbot's conception of the document, then, is a photographic distillation of the evidentiary structure of positivism, of the circular, naturalizing, self-confirming model of evidence shared by the modern discourses of science, history and law.*"[44] The status of the photograph as a document therefore hinges on its ontology as a direct trace of nature—an index—yet it is also modeled on the evidentiary structure of positivism, which was extended in the modern period to other forms of knowledge.[45]

Armstrong interprets the muteness of the photograph as part of its ontology, and therefore as that which precedes signification and guarantees authentication. Yet, in Talbot's text, muteness is a function of a specific narrative, of a "before" and "afterward." Talbot relates the photograph to two forms of temporality in *Pencil*. The first has to do with time as empty and homogeneous, the time of efficient and "mechanical" labor that eliminates any sense of change and variety, as "the camera chronicles whatever it sees" consistently and indifferently. The second has to do with a break in this form, an event (the story of a theft) that is specific and carries with it consequences as part of the intelligibility of a narrative as a temporal form. In this regard, the photograph is indeed a new kind of document and, as such, provides "evidence of a novel kind," but its "mute testimony" has to do, as is shown earlier, with the specific *form* of historical discourse and consciousness through which the past and its relics are constituted as mute. Michel de Certeau also argues that historiographical modern discourse in Western culture was born from "the rift between a subject that is supposedly literate, and an object that is supposedly written in an unknown language. The latter always remains to be decoded." This discourse is therefore built around a constant division "between the body of knowledge that utters the discourse and the mute body that nourishes it."[46]

Muteness is the *structural* effect of a historiographical discourse that is formed out of a division between present and past, a subject of knowledge and an "object" that needs to be decoded. This suggests that *every* object of a historical discourse, every form of testimony, is by itself "mute," and this has to do with its discursive identity. Once the photograph is extracted from empty time and inserted into a narrative or event, that is, once it

becomes a part of the structural division between before and after, past and future, it immediately turns into a document that is mute and needs to be decoded, yet not because of its ontology but because of its specific discursive status and temporal modality.

In one of his essays in *Hermes*, "Eurystheus in the Pithos," Talbot traces the origin of a story that traditionally has been interpreted as a joke: Hercules brought to Eurystheus the wild boar of Erymanthus, and the monarch was so terrified that he hid himself in a brazen vessel. Yet, because the story has been represented on many works of art and in canonical texts, Talbot sees it as a part of an authoritative tradition. Thus, rather than reading the story in a literal way, as part of classical mythology, he reads it as an allegorical, fragmentary relic of "the very ancient religious mythology of the East." Talbot explains: "In process of time . . . this fable became in great measure forgotten and lost among the thousand other exploits and adventures of Hercules. The monuments, however, remaining, long after their traditional explanation had been forgotten, a new story was devised, to account for the figure of the Man in the Pithos."[47] For Talbot, monuments (and by extension "original" documents and texts) do not "authenticate" the past as part of a demand for "irrefutable evidence"; rather, they point to the radical difference and inherent dispersal of the past and therefore to the impossibility of grounding knowledge on any form of evidence. Within these recurring divisions between past and present, old and new, muteness is constituted as a necessary condition for discourse, for commentary and engagement. It is precisely what provokes the desire for intelligibility and what simultaneously indicates its limits. Thus, once the photograph is extracted from the time of the present in which the camera "depicts all at once," and becomes a part of the past, of a "before," its conditions of intelligibility change in a way that necessitates a discourse. It is therefore not as a trace of "Nature" that the photograph can become a form of evidence, but as a document that inevitably manifests heterogeneous and sometimes conflicting forms of intelligibility. By the same token, it is not the tautological evidentiary structure of positivism that determines the intelligibility of the photograph as a document, but the discontinuous temporal form of historical discourse that turns the photograph into an open document, which, more than simply presenting "evidence," evokes the desire for the grounding of knowledge that cannot be fulfilled. Moreover, as my discussion of Macaulay's text indicates, romantic historians at this point still resisted scientific forms of writing and evidence, what Macaulay calls "theories," and insisted on the

association of history to literature, not to science. Thus, one cannot argue that positivistic forms of evidence were "automatically" transformed to the field of history at this juncture.

As an image, "Articles of China" is analogous in its visual arrangement to Plate 4, "Articles of Glass" (Figure 4.2), and to Plate 8, "A Scene in a Library" (Figure 4.3). In all these images, objects are organized on shelves in a gridlike manner, and the shelves themselves seem to be cut by the image's frame. In the images, the objects are displayed symmetrically, with a central object that is flanked by similar objects on both sides. The objects seem as if they were photographed indoors, but it is known that in order to get the full benefits of direct light Talbot actually photographed these images, including the books, outdoors.[48] In these images, signification is not detached from the image as an "authentic" trace but, as is argued earlier in relation to the botanical images, is suggested by a specific form of arrangement and delimitation, in particular the sense of infinite continuity. Thus, in these images, it is not their specific mode of reference ("a specimen *from* nature") that is emphasized but the way different signification systems (material, intellectual, antiquarian, domestic) are connected, the way the images oscillate between an abstract order, forms of classification or knowledge, and specific material collections or individual domestic possessions.[49]

The second instance in which Talbot evokes the photographic image as a form of testimony is in his commentary to "A Scene in a Library," in what is perhaps one of the most enigmatic texts in *Pencil*. Talbot suggests

Figure 4.2. William Henry Fox Talbot, "Articles of Glass," salt print from a calotype negative, Plate 4 from *The Pencil of Nature*, 1844. National Media Museum, Bradford, U.K./Science & Society Picture, London.

a speculative experiment that will put into use the knowledge, attained through the discovery of photography, of the invisible chemical rays beyond the limits of the visible spectrum:

> Now, I would propose to separate these invisible rays from the rest, by suffering them to pass into an adjoining apartment through an aperture in a wall or screen of partition. This apartment would thus become filled (we must not call it *illuminated*) with invisible rays, which might be scattered in all directions by a convex lens placed behind the aperture. If there were a number of persons in the room, no one would see the other: and yet nevertheless if a *camera* were so placed as to point in the direction in which any one were standing, it would take his portrait, and reveal his actions. . . . [T]he eye of the camera would see plainly where the human eye would find nothing but darkness. . . . Alas, this speculation is too refined to be introduced with effect into a modern novel or romance; for what a *dénouement* we should have, if we could suppose the secrets of the darkened chamber to be revealed by the *testimony of the imprinted paper*. (emphasis added)

This text, of course, bears no direct relation to the image, except for the obvious connection between literary forms: the novel, romance, and actual books. Yet most of the books that are displayed in the image are scholarly ones. The book titles have been identified by André Jammes and include three volumes of John Gardner Wilkinson's *Manners and Customs of the Ancient Egyptians* (1842); *Philological Essays; Miscellanies of Science; Botanische Schriften;* Luigi Lanzi's *La storia pittorica dell'Italia*; the first three volumes of the *Philosophical Magazine*; and the first three volumes of Thomas Gaisford's edition of *Poetæ Minores Græci*.[50] Although Talbot mentions low literary genres like the romance, the books that are seen in the image are "serious" scholarly studies. His text also evokes the sense of inappropriateness between a novel or romance and its end. The photograph's testimony cannot function as a resolution for the novel's or romance's narrative, because the form of proof it offers, imprinted paper, is described as *incompatible* with the effects that are expected of its ending by readers. Here, it is not only the muteness of the photograph as a document that is emphasized but the very idea of testimony, which is, by necessity, Talbot implies, lacking in "effect" and which therefore by its very nature cannot reveal the "secrets" of the dark chamber in which people are gathered. These secrets cannot be revealed by the camera or

Figure 4.3. William
Henry Fox Talbot,
"A Scene in a
Library," salt print
from a calotype
negative, Plate 8
from *The Pencil of
Nature*, 1844.
National Media
Museum, Bradford,
U.K./Science &
Society Picture,
London.

by "portraits," because they involve a different *kind* of "truth," one that addresses the imagination and not the senses.

In her discussion of the popular reception to Scott's novels, Rigney states that readers were very rarely concerned with the accuracy of the historical information presented in the novels. More often, readers were concerned with the "seriousness" of the information, that is, with the mixture of the elevated historical subjects and the low literary form of the romance. Scott was therefore constantly criticized for "the shortcomings of the plot," best "exemplified by the dénouement, which came in for a lot of derogatory comment as being novelistic and contrived."[51] The endings reflected too much the writer's self-consciousness rather than the logic of the narrative. Talbot seems to allude to these discussions, because he is concerned with the "effect" a narrative resolution has on readers.

I also mentioned earlier Macaulay's statement that history should begin as a romance and end as an essay. Thus, whereas Scott was criticized for his plots and contrived endings, Macaulay criticizes historians such as Gibbon for distorting their narratives to conform to theory. Historians despise writers of memoirs and biographies, because they seem to be occupied with trivial details that are considered to be beneath "the majesty of history." Macaulay opposes this view and argues, "No past event has any intrinsic importance. The knowledge of it is valuable only as it leads us to form just calculations with respect to the future" (424). Historians, Macaulay states, should not write like advocates who participate in "legal" disputes through the presentation of official documents, because "[a] history in which every particular incident may be true may on the

whole be false. The circumstances which have most influence on the happiness of mankind, the changes of manners and morals, the transition of communities from poverty to wealth, from knowledge to ignorance . . . these are, for the most part, noiseless revolutions. Their progress is rarely indicated by what historians are pleased to call important events. They are not achieved by armies, or enacted by senates. They are sanctioned by no treaties and recorded in no archives" (425). Modern historians write as if the body politic were homogeneous, like a flat surface, and ignore, Macaulay states, the "mighty and *various organization* which lies deep below." The perfect historian is therefore the one who occupies himself with the character and spirit of an age. And although the historian relates no fact that is not supported by sufficient testimony, it is mainly by "selection, rejection, and arrangement" that truth emerges through the form of a well-organized narrative. In this form of history, "Man will not merely be described, but will be made intimately known to us. The changes of manners will be indicated, not merely by a few general phrases or a few extracts from statistical documents, but by appropriate images presented in every line" (428; emphasis added).

For Talbot in *Pencil*, the status of the photograph as a document and a testimony oscillates between its capacity to copy, to accurately depict everything the camera sees (like a "legal" or "statistical" document), and its capacity to evoke the imagination by introducing unexpected "trivial" details, and therefore *variety*, into what Talbot often describes as a visually homogeneous surface. What Talbot seems to ask in his commentary to "A Scene in a Library" is, What kind of knowledge will the photograph produce, what kind of "book" will it be a part of: one that is composed of copies, of "look-alike" portraits in "which every particular incident may be true" but "may on the whole be false," or one in which we will intimately be introduced to "man" through the knowledge of his hidden "customs and manners"?[52] Will photographs, in their mode of accurate transcription, present the "mere dross" of history; or will they, in their capacity to "copy" details that no artist will bother to draw, reveal the "inner core" of the people, their manners and morals, which are "noiseless" and "invisible" and therefore perhaps not compatible at all with the photograph, as his text suggests? That is, for Talbot, the value of the photograph as a form of evidence does not simply hinge on its explicit visual nature or on its status as a direct "emanation from the referent"; the problem is not to prove "what has been" but how to make, through well-selected and arranged images, the past alive and intimate: *the reenactment*

of the past, not its authentication. Both the text and the image of "A Scene in a Library" are thus crucial for understanding the historical specificity of the early photograph and the forms of "evidence" it was requested to provide as part of a specific intellectual and cultural milieu, as displayed in Talbot's own library.

Talbot further emphasized these concerns in his commentary to Plate 14, "The Ladder" (Figure 4.4), the only plate in *Pencil* that includes people, where he uses the term *record* to describe the kind of "image" and "book" that photographs can produce. While acknowledging the difficulties of taking portraits at this early stage of the art, he states that "family groups are especial favorites: and the same five or six individuals may be combined in so many varying attitudes, as to give much interest and a great air of reality to a series of such pictures. *What would be the value to our English Nobility of such a record of their ancestors who lived a century ago?* On how small a portion of their family pictures galleries can they rely with confidence!" (emphasis added). A record is defined by the variety of its subjects' representations and not by the likeness of these representations to their subjects, which could not be accomplished through photographs at this point. It is precisely by presenting various forms of arrangement and not a unified form that a record is valuable for historical understanding. Talbot evokes the term *record* also in the text to Plate 16, "The Cloisters of Lacock Abbey" (Figure 2.2), in which

Figure 4.4. William Henry Fox Talbot, "The Ladder," salt print from a calotype negative, Plate 14 from *The Pencil of Nature*, 1844. National Media Museum, Bradford, U.K./Science & Society Picture, London.

he tells the history of the abbey and the cloisters and states that only few records of the sisterhood were left "to tell us how they lived and died." The important thing about a record is not that it authenticates by presenting "irrefutable evidence" but that it allows later generations to intimately familiarize themselves with the way people lived, with their "customs and manners," and, as such, affects the mind with "pleasing imagining."

In *Pencil*, Talbot's intellectual commitment to literary antiquarianism and romantic historicism is clearly evident in his comments on the images of his house, Lacock Abbey. It is also here that the epistemological problematic of historicism, of time as simultaneously an absolute horizon of intelligibility and a force that constantly dismantles any claims for universality and finitude, manifests itself most clearly. And although in these texts Talbot evokes a variety of historical sources, from oral traditions to legends and "official" histories, he remains silent about the images themselves. In each of these texts, the very idea of an "origin" as a primary source of meaning is presented only in the form of an inherent *deferral* and therefore of an epistemological incertitude and doubt.

His text to the first of the Lacock images to appear in *Pencil*, Plate 15, "Lacock Abbey in Wiltshire" (Figure 2.4), identifies it as his own country seat and as a "religious structure of great antiquity." Talbot dates the different parts of the building from newer to older parts, emphasizing that the lower part of the abbey's tower was "coeval with the first foundation of the abbey." He ends his text with a separate comment, a kind of note: "In my first account of 'The Art of Photogenic Drawing,' read to the Royal Society in January 1839, I mentioned this building as being the first 'that was ever yet known to have drawn its own picture.' It was in the summer of 1835 that these curious self-representations were first obtained." Thus, the "origins" of the building evoke, for Talbot, the "origins" of the new art, from its official announcement to the first photographs to be taken. These two "histories" overlap in his text and reflect each other: the house evokes the memory of the first photograph, whereas taking the photograph now evokes thoughts on the antiquity of the building. And it is perhaps not accidental that Lacock appears in the plate both as a material object and as a reflected object: a view and an image.

The history of this art is therefore inseparable from other histories and also from a particular form of historical consciousness in which, as Foucault states, "It is no longer origin that gives rise to historicity; *it is historicity, that, in its very fabric, makes possible the necessity of an origin which*

must be both internal and external to it.[53] The effort to provide a "history" for the new art necessitates the continuous recession toward an ever-receding "vanishing point" of origin from 1839 to 1835, and the same with regard to the building itself. Talbot's comments on the other two Lacock images in *Pencil* further complicate the idea of an "origin" in relation to meaning and knowledge. In his comments to Plate 16, "The Cloisters of Lacock Abbey" (Figure 2.2), Talbot focuses on the foundation of the abbey and speculates on the use of the cloisters: "Here, I presume, the holy sisterhood often paced in silent mediation; though, in truth, they have left but few records to posterity to tell us how they lived and died. The 'liber de Lacock' is supposed to have perished in the fire of the Cottonian library. What it contained I know not—perhaps their private memories. Some things, however, have been preserved by tradition, or discovered by the zeal of antiquaries, and from these materials the poet Bowles has composed an interesting work, the History of Lacock Abbey, which he published in 1835." What "really" happened in the cloisters is unknown, because the "original" documents perished, yet it is also not known what these documents contained and whether they could have functioned as "records" for the way the sisters lived. And although the official "History" of Lacock exists, it still does not lead to definite knowledge—only an "interesting" one, since, for Talbot, as I showed earlier, "History" often remains silent on particular events and therefore does not necessarily contribute to our knowledge of the "customs and manners" of early ages. A sense of careful skepticism pervades this text, together with a desire for a definite and reliable "source" that will make the past intimately accessible.

This form of skepticism is most evident in Talbot's commentary for Plate 19, "The Tower of Lacock Abbey" (Figure 3.1). In his text, Talbot tells the story of Olive Sherington, who threw herself from the tower into the arms of her lover, John Talbot, because her father objected to their marriage. She broke only a finger, whereas her lover was for some time unconscious. After telling this story as a factual one, without any reservations, Talbot nevertheless states, "Unwritten tradition in many families has preserved ancient stories which border on the marvellous, and it may have embellished the tale of this lover's leap by an incident belonging to another age. For I doubt the story of the broken finger, or at least that Olive was its rightful owner. Who can tell what tragic scenes may not have passed within these walls during the thirteenth and fourteenth centuries?" As it is in his antiquarian and classical studies, an "origin," for

Talbot, is defined by its "inevitable retreat" and is therefore known only through its dispersed forms of displacement. As is shown earlier, the antiquity of the Hebrew scriptures is affirmed through scattered allusions in classical mythology, whereas the true meaning of the tale of "Eurystheus in the Pithos" is recognized through its misrepresentation as a classical tale. Talbot looks for the origins of words and stories, yet he acknowledges that these can be identified only in a confused and dispersed manner that makes it impossible to differentiate old from new, truth from fiction, romance from history. This problematic is precisely what connects *Pencil* to romantic historicism: the desire to look for "origins" and decipher "mute" documents or monuments, which is at the same time inseparable from the recognition that the past can be not known but only *imagined,* in the narrative form of a story or romance. This is because "History" is a form of finitude in which, as Foucault argues, "by discovering that it was its own foundation, caused the figure of man to appear in the nineteenth century: *a finitude without infinity is no doubt a finitude that has never finished, that is always in recession with relation to itself, that always has something still to think at the very moment that it thinks, that always has time to think again what it has thought.*"[54]

In *Pencil,* the intelligibility of the photograph is grounded in its historicity, which is yet to come, whereas the intelligibility of other forms of historical representation is presented as inherently heterogeneous and ungrounded. Talbot's efforts to formulate the photograph as a document in *Pencil* are thus embedded, I argue, within this problematic, which is specific to the condition of the "new art" and symptomatic of the emergence of "History" and the figure of "Man" as new forms for the organization of knowledge in the early nineteenth century. In this regard, *Pencil* is a very specific book, one that *defamiliarizes* our modern notion of the photographic document rather than reinforcing it. Far from conforming to modern forms of photographic intelligibility, such as the index or the archive, through which the photograph is assigned the roles of authentication and identification, *Pencil* suggests the inherent *historicity* of the photograph and its shifting forms of intelligibility and applicability. That is, in the early stages of the "new art," it is not the photograph that defines the epistemological premises of the "document," but the discursive status of the "mute" and inherently displaced historical document that defines the form of "testimony" the photograph can provide. And within these specific historical conditions, it is not certitude or "irrefutable proof" that documents were asked to provide but *belief,* which could never be fully

"grounded" but could only be "invented" through the time and life of the imagination.

Just as the phrase "the pencil of nature" didn't mark a shift from a manual to a mechanical and more accurate or "objective" system of representation, the first photographically illustrated book, *The Pencil of Nature,* didn't conceptualize the early photograph as an "impartial" authenticating document. This study was written in order to challenge the prevalent view in histories of photography that the "birth" of photography in the early nineteenth century marks the "inevitable" end result of a long-term Western quest for resemblance and verisimilitude. Photography, I argue, was not born out of a desire to exclude the "human" from representation, but in fact its conception registered the irreducibly subjective, sensorial, and temporal constitutes of any form of knowledge: scientific, literary, and aesthetic. By the 1830s and 1840s, the "fictions" of the imagination, with its unwarranted "inferences" and the inconsistencies of time, were acknowledged as necessary conditions for the production of both experience and knowledge. The imagination grounds knowledge on *belief* that is necessary for life, because it enables one to move beyond what is known in experience to what cannot be known or given. By looking at early photography, this book has aimed to propose a new project for histories and theories of photography—not to reveal or expose the "truth" of representation but to invent new aesthetic and political forms of seeing and thinking that are grounded not on "truth" but on the practices of life.

Acknowledgments

This book developed from my PhD thesis at Columbia University. I sincerely thank my adviser, Jonathan Crary, for his continuous support in this research project, and I am grateful to John Rajchman and Keith Moxey for their encouragement and assistance when I was at Columbia.

I thank those who offered valuable critical comments on this book during its formation: Seth McCormick, William Kaizen, Beth Hinderliter, Siona Wilson, and Jaleh Mansoor.

Research for this book would not have been possible without dissertation research and travel grants I received from Columbia University and from the Getty Foundation, which provided me with a postdoctoral fellowship.

I am grateful to Steve Edwards for his significant comments on this book and for his encouragement. I appreciate the helpful critical suggestions provided by the anonymous readers of the manuscript.

Finally, my deepest gratitude goes to Roy Kozlovsky for his enduring love and endless support during the years I worked on this book.

Appendixes

A BRIEF DESCRIPTION

OF THE

PHOTOGENIC DRAWINGS

EXHIBITED AT THE MEETING OF THE

BRITISH ASSOCIATION,

AT BIRMINGHAM.

IN AUGUST, 1839,

BY H. F. TALBOT, ESQ.

CLASS I.

Images obtained by the direct action of light, and of the same size with the objects.

1. The Great Seal of England, copied from an engraving with the Anaglyptograph.
2. Reverse of the same.
3, 4. Copies of Lithography.
6 to 15. Copies of Lace, of various patterns.
16. Muslin.
17, 18. Calico.
19. Copy of a Wood Engraving.
20, 21. Coats of Arms, taken from old painted glass.
22. Copy of a Berlin pattern.
23. Jessamine.
24. Grass.
25 and 26. Grass. *Aira caryophyllea.*
27, 28. *Bromus maximus*, native of Genoa.
29. *Agrostis.*
30. Coltsfoot (*Tussilago farfara*). The winged seeds are represented flying away.`
31. *Veronica.*
32. *Sisymbrium Cumingianum.*
33, 34. Fern.
35. Campanula.
36. *Kitaibelia vitifolia.*
37. *Orobus vernus.*
38. *Athamanta Matthioli.*
39. *Erodium elegans*, a new species, discovered by the author in the Island of Zante.
40. *Erigeron* and *Aconitum.*
41. *Clypeola Jonthlaspi*, from the Island of Corfu.
42. Leaves of Fig and Pæony.
43. Tansy and Chærophyllum.
44. Horse Chestnut and Pæony.
45. Celandine, *Chelidonium majus.*
46. *Eryngium*, from Corfu.
47. Ladies' Mantle, *Alchemilla.*
48. Various leaves represented on paper of much lighter tint.
49. Rose Leaves.
50. Leaves of Spruce Fir.
51, 52. Feathers.

CLASS II.

Reversed images, requiring the action of light to be TWICE employed.

53 to 58. Copies of Lithography.
59, 60. Copies of Transparencies, representing Moonlight among Ruins.
61. Copy of an old Printed Book - The Statutes of King Richard II.
62 to 64. Copies of old Painted Glass.

CLASS III.

Views taken with the Camera Obscura.

The pictures, when taken out of the instrument, represent the scene reversed with respect to right and left, and also with respect to light and shade. This is exemplified in No. 65. Both these defects are remedied at the same time, by exposing the picture first made to the renewed action of light, and thus obtaining from it a *transfer* or reversed image. Such are the following:
66. South front of Lacock Abbey, Wilts.
67. Nearer View of the Tower.
68 to 82. Other Views of the same building.
83 to 86. Windows in ditto, taken from the inside.

CLASS IV.

Images made with the Solar Microscope.

87 to 91. Lace, magnified 100 times in surface.
92, 93. Ditto, magnified 400 times.

Appendix A. William Henry Fox Talbot, "A Brief Description of the Photogenic Drawings Exhibited at the Meeting of the British Association," August 1839. National Media Museum, Bradford, UK.

A POPULAR TREATISE

ON THE

ART OF PHOTOGRAPHY,

INCLUDING

DAGUERRÉOTYPE,

AND

ALL THE NEW METHODS OF PRODUCING PICTURES

BY THE CHEMICAL AGENCY OF LIGHT.

BY

ROBERT HUNT,

SECRETARY OF THE ROYAL CORNWALL POLYTECHNIC SOCIETY.

ILLUSTRATED BY ENGRAVINGS

GLASGOW:

PUBLISHED BY RICHARD GRIFFIN AND COMPANY.

MDCCCXLI.

Appendix B. Robert Hunt, *A Popular Treatise on the Art of Photography* (Glasgow, 1841). Epstean Collection, Columbia University Rare Book and Manuscript Library, New York.

CONTENTS.

Page

HISTORY OF PHOTOGRAPHY, 1

PROCESSES ON PAPER, 6
 1. ON THE SELECTION OF PAPER FOR PHOTOGRAPHIC PURPOSES, . . . 6
 2. NEGATIVE PHOTOGRAPHS, 9
 A.—On the Preparation of the Sensitive Paper with the Salts of Silver, . 9
 a. Nitrated Paper, 10
 b. Muriated Paper, 11
 c. Iodidated Papers, 18
 d. Bromidated Papers, 19
 e. Phosphated Papers, 21
 f. Papers Prepared with other Salts of Silver, 21
 g. Dr. Schafhaeutl's Negative Process, 23
 B.—On the Methods of Using the Photographic Papers prepared with the
 Salts of Silver.—Negative Kind, 24
 a. On taking Copies of Botanical Specimens, Engravings, &c., . . 24
 b. On using the Photographic Paper in the Camera Obscura, . . 26
 C.—On Fixing the Negative Photographs, 30
 3. POSITIVE PHOTOGRAPHS, 32
 A.—On the Production of Photographs with Correct Lights and Shadows,
 by means of Transfers, 32
 B.—Positive Photographs from Etchings on Glass Plates, 34
 C.—On the Production of Positive Photographs, by the Use of the Hy-
 driodic Salts, 35
 D.—Directions for taking Photographs, 41

PROCESSES ON METALLIC AND GLASS TABLETS, 48
 1. HELIOGRAPHY, 48
 2. DAGUERRÉOTYPE, 53
 A.—Original Process of Daguerre, 53
 B.—Improvements in Daguerréotype, 60
 a. Improved Method of Iodizing the Silver, 60
 b. Methods of Fixing the Daguerréotype Pictures, 61
 C.—Engraving the Daguerréotype Designs, 62
 D.—Application of the Daguerréotype to taking Portraits from Life, . 63
 E.—Simplification of the Daguerréotype Processes, 67
 F.—On the Manner in which the Light operates to produce the Daguerréo-
 type Designs, . 70
 3. PROCESSES ON GLASS PLATES, BY SIR JOHN HERSCHEL, 71

		Page
MISCELLANEOUS PROCESSES,		73
1. On the Application of the Daguerreotype to Paper,		73
2. Photographic Processes without any Metallic Preparation, . .		76
3. Dr. Schaphaeutl's Process on Carbonised Plates,		79
4. A New Construction of the Photographic Camera Obscura, . .		80
5. On the Possibility of Producing Photographs in their Natural Colours,		82
6. Invisible Photographs, and their Reproduction,		84
7. On the Spontaneous Darkening of the White Photographic Papers,		84
8. On the Use of the Salts of Gold as Photographic Agents, . .		85
9. On the Action of Heat on the Hydriodic Photographic Papers, .		86
10. On Copying Letter-Press, &c., on the Photographic Papers, by means of Juxtaposition,		86
11. On the Use of Photographic Paper for Registering the Indications of Meteorological Instruments,		87
12. The Influence of Chlorine and Iodine in rendering some kinds of Wood sensitive to Light,		89
13. Process for Preparing the Hyposulphite of Soda,		90
CONCLUSION,		91
SUPPLEMENTARY CHAPTER,		94
A New Photographic Process by the Author, for Producing Pictures with the Camera Obscura in a Few Seconds,		94

PHOTOGRAPHY:

A TREATISE

ON THE

CHEMICAL CHANGES PRODUCED BY SOLAR RADIATION,

AND THE

PRODUCTION OF PICTURES FROM NATURE,

BY

THE DAGUERREOTYPE, CALOTYPE,

AND OTHER PHOTOGRAPHIC PROCESSES.

By ROBERT HUNT,

PROFESSOR OF MECHANICAL SCIENCE IN THE MUSEUM OF PRACTICAL GEOLOGY,
AUTHOR OF " RESEARCHES ON LIGHT," " THE POETRY OF SCIENCE," ETC.

LONDON:

PUBLISHED BY JOHN JOSEPH GRIFFIN & CO.
53, BAKER STREET, PORTMAN SQUARE:
AND RICHARD GRIFFIN & CO. GLASGOW.

1851.

CONTENTS.

PAGE

CHAPTER I.

EARLY HISTORY OF PHOTOGRAPHY 1

CHAPTER II.

GENERAL REMARKS ON THE SOLAR AGENCY PRODUCING CHEMICAL
CHANGE 6

CHAPTER III.

SELECTION OF PAPER FOR PHOTOGRAPHIC PURPOSES . . . 14

CHAPTER IV.

ON THE GENERAL MODES OF MANIPULATION ADOPTED IN THE PREPARA-
TION OF SENSITIVE PAPERS AND THE MORDANT BASES . . . 21

CHAPTER V.

ON THE APPARATUS NECESSARY FOR THE PRACTICE OF PHOTOGRAPHY
ON PAPER 31

CHAPTER VI.

ON FIXING THE PHOTOGRAPHIC PICTURES 39

CHAPTER VII.

ORDINARY PHOTOGRAPHIC PROCESSES ON PAPER OF THE EARLIEST
VARIETY 46

CHAPTER VIII.

ON THE PRODUCTION OF POSITIVE PHOTOGRAPHS BY THE USE OF THE
HYDRIODIC SALTS 56

CHAPTER IX. PAGE

THE PROCESSES OF MR. H. FOX TALBOT, AND MODIFICATIONS . . 69

CHAPTER IX *.

PHOTOGRAPHIC PROCESSES ON GLASS PLATES . . . 90

CHAPTER X.

THE PROCESSES OF SIR JOHN HERSCHEL 109

CHAPTER XI.

MISCELLANEOUS PROCESSES ON PAPER 127

CHAPTER XII.

DAGUERREOTYPE 151
 SECTION I. The Original Process of Daguerre . . . 151
 SECTION II. Improvements in Daguerreotype . . . 158

CHAPTER XIII.

ON THE APPLICATION OF THE DAGUERREOTYPE TO PAPER . . 188

CHAPTER XIV.

ON THE THEORY OF THE DAGUERREOTYPE 192

CHAPTER XV.

ON INSTRUMENTS FOR DETERMINING THE VARIATIONS OF ACTINIC
POWER, AND FOR EXPERIMENTS ON THE CHEMICAL FOCUS, AND THE
REGISTRATION OF PHILOSOPHICAL INSTRUMENTS . . . 208

CHAPTER XVI.

THERMOGRAPHY 222

A

MANUAL

OF

PHOTOGRAPHY.

BY

ROBERT HUNT,

PROFESSOR OF MECHANICAL SCIENCE IN THE GOVERNMENT SCHOOL OF MINES;
KEEPER OF MINING RECORDS IN THE MUSEUM OF PRACTICAL GEOLOGY.

THIRD EDITION, ENLARGED.

Illustrated by Numerous Engravings.

LONDON:

PUBLISHED BY JOHN JOSEPH GRIFFIN & CO.
53, BAKER STREET, PORTMAN SQUARE;
AND RICHARD GRIFFIN AND CO. GLASGOW.

1853.

CONTENTS.

PART I.

HISTORY OF DISCOVERIES IN PHOTOGRAPHY.

CHAPTER I.

PAGE

EARLY RESEARCHES ON THE CHEMICAL ACTION OF THE SOLAR RAYS 3

CHAPTER II.

HELIOGRAPHY. THE PROCESS OF M. NIEPCE . . . 13

CHAPTER III.

MR. H. FOX TALBOT'S PHOTOGENIC DRAWINGS, CALOTYPE, &c. . 19

 SECTION I. Photogenic Drawing . . . 19
 ,, II. The Calotype 21
 ,, III. Improvements in Calotype . . 28
 ,, IV. Pictures on Porcelain Tablets . . 29
 ,, V. Instantaneous Process . . . 32

CHAPTER IV.

DAGUERREOTYPE—THE DISCOVERY OF M. DAGUERRE . . 35

 SECTION I. The Original Process of Daguerre . . 35
 ,, II. Improvements in Daguerreotype . . 44

CHAPTER V.

THE PHOTOGRAPHIC PROCESSES ON PAPER OF SIR JOHN HERSCHEL . 51

 SECTION I. Cyanotype 51
 ,, II. Chrysotype 57
 ,, III. Photographic Properties of Mercury . 60
 ,, IV. Ferro-Tartrate of Silver . . 61
 ,, V. The Amphitype . . . 62
 ,, VI. The Colouring Matter of Flowers . . 64

CHAPTER VI.

PAGE

PROCESSES BY THE AUTHOR AND OTHERS 72

SECTION I. Mr. Ponton's Process. (Bichromate of Potash.) 72
„ II. The Ferrotype 76
„ III. The Catalysotype 79
„ IV. Ferrocyanide of Potassium . . 83
„ V. The Fluorotype 84
„ VI. Bromide of Silver and Mercurial Vapour 85
„ VII. Positive Photographs by One Process . 88
„ VIII. On the Application of the Daguerreotype to Paper 91
„ IX. Salts of Gold as Photographic Agents . 95
„ X. Dr. Schafhaeutl's Negative Process . 96
„ XI. Dr. Schafhaeutl's Process on Carbonised Plates 97
„ XII. The Influence of Chlorine and Iodine in rendering some kinds of Wood sensitive to Light 98

CHAPTER VII.

PHOTOGRAPHS ON GLASS PLATES, AND RECENT IMPROVEMENTS . 100

SECTION I. Precipitates of Silver Salts . . 100
„ II. Albumen 103
„ III. Collodion 103

CHAPTER VIII.

PORTRAITURE BY THE DAGUERREOTYPE 104

CHAPTER IX.

GENERAL SUMMARY OF THE HISTORY OF PHOTOGRAPHY . . 108

PART II.
SCIENTIFIC INVESTIGATIONS ON PHOTOGRAPHY.
CHAPTER I.

GENERAL REMARKS ON THE SOLAR AGENCY PRODUCING CHEMICAL CHANGE 115

CHAPTER II.

CHEMICAL CHANGES ON SENSITIVE PREPARATIONS . . . 124

SECTION I. Nitrate of Silver 124
„ II. Chloride of Silver 124
„ III. Iodide of Silver 130
„ IV. Bromide of Silver 131

CHAPTER III.

PAGE

THE THEORY OF THE DAGUERREOTYPE 137

CHAPTER IV.

ON THE PHOTOGRAPHIC REGISTRATION OF PHILOSOPHICAL INSTRU-
MENTS AND THE MEANS OF DETERMINING THE VARIATIONS OF
ACTINIC POWER, AND FOR EXPERIMENTS ON THE CHEMICAL FOCUS 153

SECTION I. Photographic Registration . . . 153
,, II. Instruments for Measuring Actinic Varia-
tions, &c. 157
The Photographometer . . . 157
The Focimeter 159
The Dynactinometer . . . 160

CHAPTER V.

THERMOGRAPHY 165

CHAPTER VI.

ON THE POSSIBILITY OF PRODUCING PHOTOGRAPHS IN THEIR NATU-
RAL COLOURS 172

CHAPTER VII.

ON LENSES FOR THE PHOTOGRAPHIC CAMERA . . . 177

PART III.

PRACTICE OF PHOTOGRAPHY.

CHAPTER I.

SELECTION OF PAPER FOR PHOTOGRAPHIC PURPOSES . . 187

CHAPTER II.

ON THE APPARATUS NECESSARY FOR THE PRACTICE OF PHOTOGRAPHY
ON PAPER 195

CHAPTER III.

ON THE MODES OF MANIPULATION ADOPTED IN THE PREPARATION OF
SENSITIVE PAPERS 205

SECTION I. Nitrate of Silver . . . 205
,, II. Chloride of Silver . . . 206

CHAPTER IV.

ON FIXING THE PHOTOGRAPHIC PICTURES . . . 211

CHAPTER V.

PAGE

THE TALBOTYPE AS NOW PRACTISED, AND ITS MODIFICATIONS . 218
 SECTION I. Mr. Cundell's Process . . . 218
 ,, II. Modified Processes . . . 218
 ,, III. M. Martin's Calotype Process . . 224
 ,, IV. Calotype Process on Waxed Paper . . 226
 ,, V. M. Flacheron's Process . . . 231
 ,, VI. Mr. Muller's Process . . . 233
 236

CHAPTER VI.

THE DAGUERREOTYPE 237
 SECTION I. Daguerre's Improved Manipulation . 237
 ,, II. Polishing the Plate . . . 241
 ,, III. To give the Sensitive Surface to the Plate . 242
 ,, IV. To Develope the Image formed on the Plate 249
 ,, V. Fixing the Daguerreotype Image . . 251
 ,, VI. Simplification of the Daguerreotype . 254

CHAPTER VII.

THE COLLODION PROCESS 259

CHAPTER VIII.

THE USE OF ALBUMEN ON GLASS PLATES AND ON PAPER . . 277
 Positive Photographs from Etchings on Glass Plates . 284
 Albumenized Paper 285

CHAPTER IX.

ON THE PRODUCTION OF POSITIVE PHOTOGRAPHS BY THE USE OF THE
 HYDRIODIC SALTS 288

CHAPTER X.

GENERAL REMARKS ON THE USE OF THE CAMERA OBSCURA . . 299
 SECTION I. Buildings, Statues, Landscapes, and Foliage 299
 ,, II. Portraits from the Life . . . 301

CHAPTER XI.

THE STEREOSCOPE 303

APPENDIX 311
 The Photographic Patent Right 311
 Correspondence of English and French Weights and
 Measures 314

INDEX 315

CHAPTER IX.

GENERAL SUMMARY OF THE HISTORY OF PHOTOGRAPHY.

IT is thought that it may prove of some interest to append the following table, compiled with much care for the British Association, by the author, and printed by that body in their Reports for 1850, and to which now numerous additions are made. It is believed that the dates of discovery are accurately given, the date of publication being, of course, in all cases, taken where there was the slightest doubt.

SILVER.

Nitrate of	Ritter	1801
—— (photographically employed)	Wedgwood & Davy	1802
—— with organic matter . . .	J. F. Herschel . .	1839
—— with salts of lead	J. F. Herschel . .	1839
Chloride of	C. W. Scheele . .	1777
—— (photographically employed) {	Wedgwood . . .	1802
	Talbot	1839
—— darkened, and hydriodic salts	Fyfe, Lassaigne .	1839
Iodide of (photographically used) {	Herschel . . .	1840
	Ryan	1840
—— with ferrocyanate of potash	Hunt	1841
—— with gallic acid (Calotype) .	Talbot	1841
—— with protosulphate of iron (Ferrotype)	Hunt	1844
—— with iodide of iron (Catalysotype)	Woods	1844
Bromide of	Bayard	1840
Fluoride of	Channing . . .	1842
Fluorotype	Hunt	1844
Oxide of	Davy	1803
—— with ammonia	Uncertain.	
Phosphate of	Fyfe	1839
Tartrate — Urate—Oxalate—Borate, &c.	Herschel . . .	1840

Appendix E. Robert Hunt, chapter 9, "General Summary of the History of Photography," *A Manual of Photography* (London, 1853). Epstean Collection, Columbia University Rare Book and Manuscript Library, New York.

SILVER—continued.

Benzoates of Hunt 1844
Formiates of Do. 1844
Fulminates of Do. 1842

SILVER PLATE.

With vapour of iodine (Daguerreo-
type) Daguerre . . . 1839
With vapour of bromine . . . Goddard 1840
With chlorine and iodine . . . Claudet 1840
With vapour of sulphur Niepce 1820
With vapour of phosphorus . . Niepce 1820

GLASS PLATE.

Precipitates of silver Herschel . . . 1839
Albumen on Niepce de St. Victor 1848
Collodion Archer and Fry . 1850

GOLD.

Chloride of { Rumford 1798
 Herschel 1840
Etherial solution of Rumford . . . 1798
Etherial solution of, with percya-
nide of potassium . . . Hunt 1844
Etherial solution of, with protocya-
nide of potassium . . . Do. 1844
Chromate of Do. 1844
Plate of gold and iodine vapour . Goddard 1842

PLATINUM.

Chloride of Herschel 1840
Chloride of, in ether Herschel 1840
Chloride of, with lime Herschel 1832
Iodide of Herschel 1840
Bromide of Hunt 1844
Percyanate of Do. 1844

MERCURY.

Protoxide of Uncertain.
Peroxide of Guibourt.
Carbonate of Hunt 1844

MERCURY—continued.

Chromate of	Hunt	1843
Deutiodide of	Do.	1843
Nitrate of	Herschel	1840
Protonitrate of	Herschel	1840
Chloride of	Boullay	1803
Bichloride of	Vogel	1806

IRON.

Protosulphate of	Hunt	1844
Persulphate of		
Ammonio-citrate of	Herschel	1840
Tartrate of		
Attention was first called to the very peculiar changes produced in the iron salts in general, by	Herschel	1845
Cyanic compounds of (Prussian blue)	Scheele	1786
	Desmortiers	1801
Ferrocyanates of	Fischer	1795
Iodide of	Hunt	1844
Oxalate of	Do.	1844
Chromate of	Do.	1844
Several of the above combined with mercury	Herschel	1843

COPPER.

Chromate of (Chromatype)	Hunt	1843
—— dissolved in ammonia	Do.	1844
Sulphate of	Do.	1844
Carbonate of	Do.	1844
Iodide of	Do.	1844
Copper-plate iodized	Talbot	1841

MANGANESE.

Permanganate of potash	Frommherz	1824
Deutoxide and cyanate of potassium	Hunt	1844
Muriate of	Do.	1844

LEAD.

Oxide of (the puce-coloured)	Davy	1802
Red lead and cyanide of potassium	Hunt	1844
Acetate of lead	Do.	1844

NICKEL.

Nitrate of)
——with ferroprussiates . . } Hunt 1844
Iodide of)

TIN

Purple of cassius Uncertain.

COBALT Hunt 1844
Arsenic sulphuret of Sage 1803
Arsenical salts of

ANTIMONY)

BISMUTH |
 }
CADMIUM } Hunt 1844

RHODIUM)

CHROMIUM.

Bichromate of potash. . . . Mungo Ponton . . 1838
—— with iodide of starch . . E. Becquerel . . . 1840
Metallic chromates (Chromatype) Hunt 1843

CHLORINE AND HYDROGEN. . . { Gay-Lussac and Thé-
 nard 1809
Chlorine (tithonized) Draper 1842
—— and ether Cahours 1810

GLASS, manganese, reddened . . Faraday 1823

CYANOGEN, solution of Pelouse & Richardson 1838

METHYLE Cahours 1846
Crystallisation of salts influenced (Petit 1722
 by light { Chaptal 1788
 (Dizé 1789
Phosphorus { Schulze 1727
 { Ritter 1801
—— in nitrogen Beckman 1800
Phosphorus and ammonia . . Vogel 1806
Nitric acid decomposed by light Scheele 1786

METHYLE—continued.

Fat matter	Vogel 1806
Development of pores in plants	Labillardière	. . . 1801
Vitality of germs	Michellotti 1803
RESINOUS BODIES (*Heliography*)	Niepce 1814
Asphaltum	Niepce 1814
Resin of oil of lavender . . .	Niepce and Daguerre	1830
Guaiacum	Wollaston 1803
Bitumens all decomposed . .	Daguerre 1839
All residua of essential oils . .	Daguerre 1839
Flowers, colours of, expressed, and spread upon paper . .	Herschel 1842
Yellow wax bleached	Senebier. 1791
	Licetas 1646
	Kircher 1646
Phosphorescent influences of solar rays	Canton 1768
	Biot 1840
	E. Becquerel	. . . 1839
Vegetation in stagnant water .	Morren 1841
Influence of light on electrical phenomena	E. Becquerel	. . . 1839

In the foregoing chapters every thing has been included which appeared necessary to the complete illustration of the history of the very beautiful art of Photography. It may appear to many that the manipulatory details included in this division should have been reserved for that which is more strictly technical. The difficulty of doing this without repeating in an unnecessary manner has led me to adopt what I consider to be the clearer course.

Notes

Introduction

1. Jonathan Crary argues that the photographic camera and the camera-obscura image belong to two different systems for organizing knowledge in the nineteenth century. See his *Techniques of the Observer: On Vision and Modernity in the Nineteenth Century* (Cambridge, Mass.: MIT Press, 1990), 32.

2. Helmut Gernsheim, *The Origins of Photography* (New York: Thames & Hudson, 1982), 7; see also Helmut Gernsheim and Alison Gernsheim, *The History of Photography*, rev. ed. (London: Thames & Hudson, 1969), 27.

3. Beaumont Newhall, *The History of Photography: From 1839 to the Present,* 5th ed. (New York: Museum of Modern Art, 1982), 11.

4. Martin Kemp, *The Science of Art* (New Haven, Conn.: Yale University Press, 1992), 167. See also Bernard Marbot's assertion that "among the many inventions which followed one upon another during the nineteenth century, photography . . . was a historical necessity. The rapid and far-reaching progress made in agriculture, transport, industry and demography produced the upheaval now known as the industrial revolution. The domain of images was bound to be affected by these changes. . . . The rapid and unrelenting progress of science and technology called now for an iconographical system of a different kind, one that was capable of carrying it forward." Bernard Marbot, "Towards the Discovery (before 1839)," in *A History of Photography: Social and Cultural Perspectives*, ed. Jean-Claude Lemagny and André Rouillé, trans. Janet Lloyd (Cambridge: Cambridge University Press, 1987), 12, 15.

5. Mary Warner Marien, *Photography and Its Critics: A Cultural History, 1839–1900* (Cambridge: Cambridge University Press, 1997), 5–6. For similar historiographical approaches, see Naomi Rosenblum, *A World History of Photography*, 3rd ed. (New York: Abbeville Press, 1997), 16–17; and Robert Hirsch, *Seizing the Light: A History of Photography* (Boston: McGraw-Hill, 2000), 9–10. For a significantly different approach to the history of photography, see Michel Frizot, ed., *A New History of Photography* (Cologne: Könemann, 1994).

6. Scott Walden, "Truth in Photography," in *Photography and Philosophy: Essays on the Pencil of Nature,* ed. Scott Walden (Oxford: Wiley-Blackwell, 2010), 105–6. See also in this collection Arthur Danto's essay "The Naked Truth," in which he states that "Talbot, after all, invented photography because of his own limitations as a draftsman: the camera was to do by means of light what he did by means of pencil—only, of course, more accurately and better" (300).

7. On the modern notion of objectivity, see Lorraine Daston and Peter Galison, *Objectivity* (New York: Zone Books, 2007). This book challenges any "essential" understanding of the term *objectivity* by carefully historicizing it and differentiating it from other historical notions of scientific truth, such as "truth to nature."

8. For the use of these terms, see Larry Schaaf, *The Photographic Art of William Henry Fox Talbot* (Princeton, N.J.: Princeton University Press, 2000), 17–22.

9. Ibid., 11.

10. See H. J. P. Arnold, *William Henry Fox Talbot: Pioneer of Photography and Man of Science* (London: Hutchinson Benham, 1977); and Larry Schaaf, *Out of the Shadows: Herschel, Talbot, and the Invention of Photography* (London: Yale University Press, 1992). Another biography is by Gail Buckland: *Fox Talbot and the Invention of Photography* (Boston: Godine, 1980). Other major publications on Talbot include Russell Roberts and Mark Haworth-Booth, *Specimens and Marvels: William Henry Fox Talbot and the Invention of Photography* (New York: Aperture, 2000); and Michael Gray, Arthur Ollman, and Carol McCusker, *First Photographs: William Henry Fox Talbot and the Birth of Photography* (New York: PowerHouse Books, 2002).

11. Schaaf is the project director of the online research source *The Correspondence of William Henry Fox Talbot,* which includes transcripts of all of Talbot's letters and information about his addressees. See http://foxtalbot.dmu.ac.uk/. Talbot's notebooks were formerly housed in the National Trust Fox Talbot Museum at Lacock Abbey and are now in the Talbot Collection at the British Library. Another major research source is the National Media Museum, Bradford, England, which holds many of Talbot's photographs and his two photography notebooks, covering the period 1839–43.

12. Schaaf, *Photographic Art of William Henry Fox Talbot,* 28–30. The emphasis on Talbot as a photographer also underlies Geoffrey Batchen's *William Henry Fox Talbot* (London: Phaidon Press, 2008).

13. Michel Foucault, *The Archaeology of Knowledge,* trans. A. M. Sheridan Smith (London: Routledge, 1992), 21–50.

14. I am referring to Foucault's argument in his *Archaeology of Knowledge* that traditionally history was understood to "'memorize' *monuments* of the past, [and] transform them into *documents*"; an archaeological approach to the past, by contrast, will consist in transforming documents into monuments, that is, it will no longer try to "reconstitute what men have done or said" but will analyze the historical conditions of possibility for formations of knowledge and modes of subjectivity (ibid., 7; emphasis in original).

15. Ibid., 9.

16. Geoffrey Batchen, *Burning with Desire: The Conception of Photography* (Cambridge, Mass.: MIT Press, 1997), 100–102.

17. This scholarly motivation underlies recent publications on Talbot. See in particular Mirjam Brusius and Chitra Ramalingam's introduction to the collection *William Henry Fox Talbot: Beyond Photography*, ed. Mirjam Brusius, Katrina Dean, and Chitra Ramalingam (New Haven, Conn.: Yale Center for British Art, 2013), 1–24.

18. See Anne Secord, "Talbot's First Lens: Botanical Vision as Exact Science," and June Barrow-Green, "'Merely a Speculation of the Mind'? William Henry Fox Talbot and Mathematics," both in Brusius, Dean, and Ramalingam, *William Henry Fox Talbot*, 41–66 and 67–94, respectively.

19. For an important criticism on Batchen's position, see Joel Snyder, "Enabling Confusion," *History of Photography* 26, no. 2 (Summer 2002): 154–60.

20. Michel Foucault, *The Order of Things: An Archaeology of the Human Sciences* (1966; repr., New York: Vintage, 1994); Gilles Deleuze, *Difference and Repetition*, trans. Paul Patton (New York: Columbia University Press, 1994).

21. Carol Armstrong, "Cameraless: From Natural Illustrations and Nature Prints to Manual and Photogenic Drawings and Other Botanographs," in *Ocean Flowers: Impressions from Nature*, ed. Carol Armstrong and Catherine de Zegher (Princeton, N.J.: Princeton University Press, 2004), 94–95. See also Armstrong's *Scenes in a Library: Reading the Photograph in the Book, 1843–1875* (Cambridge, Mass.: MIT Press, 1998).

22. The status and meaning of Barthes's notion of the index has become highly debated in recent photography theory. See the collection of essays, comments, and in particular the roundtable discussion in *Photography Theory,* in which it is suggested that the way the term *index* is applied to photography theory by art historians is based on a misreading of C. S. Peirce's analysis of signs. James Elkins, ed., *Photography Theory* (New York: Routledge, 2007). See also James Elkins, "What Does Peirce's Sign System Have to Say to Art History?," *Culture, Theory, and Critique* 44, no. 1 (2003): 5–22. See also the essays that are included in the section "Beyond the Index" in *The Meaning of Photography*, ed. Robin Kelsey and Blake Stimson (Williamstown, Mass.: Sterling and Francine Clark Art Institute; New Haven: Yale University Press, 2008), 3–49.

23. On this problem in Barthes's theory, see Peter Wollen, "Fire and Ice," *Photographies* 4 (March 1984). On recent efforts to analyze photography in relation to complex notions of temporality and Deleuze's philosophy, see Damian Sutton, *Photography, Cinema, Memory: The Crystal Image of Time* (Minneapolis: University of Minnesota Press, 2009). See also issue 23 (2012) of the online journal *Rhizomes,* on Deleuze and photography, ed. Michael Kramp, http://www.rhizomes.net/.

24. See Steve Edwards, *The Making of English Photography* (University Park: Pennsylvania State University Press, 2006). See also his essay "The Dialectics of Skill in Talbot's Dream World," *History of Photography* 26, no. 2 (Summer 2002): 113–18.

25. The canonical text on the condition of post-photography is William J. Mitchell, *The Reconfigured Eye: Visual Truth in the Post-photographic Era* (Cambridge, Mass.: MIT Press, 1992). For a critical response to Mitchell's conceptualization of

digital photography, see Lev Manovich, "The Paradoxes of Digital Photography," in *Photography after Photography: Memory and Representation in the Digital Age*, ed. Hubertus v. Amelunxen, Stefan Iglhaut, and Florian Rötzer (Amsterdam: G+B Arts, 1996), 57–65. See also the anonymous collection *Metamorphoses: Photography in the Electronic Age* (New York: Aperture Foundation, 1994); Anne-Marie Willis, "Digitization and the Living Death of Photography," in *Culture, Technology, and Creativity in the Late Twentieth Century*, ed. Philip Howard (London: Libbey, 1990), 197–208; Kevin Robins, "The Virtual Unconscious in Post-photography," *Science as Culture* 3, no. 1 (1992): 99–115; Geoffrey Batchen, "On Post-photography," *Afterimage* 20, no. 3 (October 1992): 17; and Martin Lister, ed., *The Photographic Image in Digital Culture*, 2nd ed. (London: Routledge, 2013).

26. Rosalind Krauss, "Reinventing the Medium," *Critical Inquiry* 25 (Winter 1999): 290. It was nineteenth-century photography, read through Foucault's archaeological notion of the "archive," that provided the historical and theoretical ground for the postmodern critique of authorship and originality. See, for example, Krauss's essay "Photography's Discursive Spaces," in *The Originality of the Avant-Garde and Other Modernist Myths* (Cambridge, Mass.: MIT Press, 1986); Abigail Solomon-Godeau, "Canon Fodder: Authoring Eugène Atget," in *Photography at the Dock* (Minneapolis: University of Minnesota Press, 1991); and Molly Nesbit, *Atget's Seven Albums* (New Haven, Conn.: Yale University Press, 1992).

27. See Jacques Rancière, *The Politics of Aesthetics*, trans. Gabriel Rockhill (London: Continuum, 2004), 7–45.

28. See Jae Emerling, *Photography: History and Theory* (London: Routledge, 2012).

29. On postmodern theories' parody and criticism of the imagination, see Richard Kearney, *The Wake of Imagination* (London: Routledge, 1988), 251–95.

30. Jacques Rancière, *Disagreement*, trans. Julie Rose (Minneapolis: University of Minnesota Press, 1999), 29.

31. On the new critical tasks of photography and the need to move beyond the rhetoric of suspicion (against institutions and ideology) that underlay postmodern theories of photography, see Robin Kelsey and Blake Stimson's introduction to their collection of essays *The Meaning of Photography* (vii–xxxi).

1. Scientific Method

1. Talbot states, "If it should be asserted that exposure to sunshine would *necessarily* reduce the whole to one uniform tint, and destroy the picture, the *onus probandi* evidently lies on those who make the assertion. If we designate by the letter A the exposure to the solar light, and by B some indeterminate chemical process, my argument was this: Since it cannot be shown, à priori, that the final result of the series of processes A B A will be the same with that denoted by B A, it will therefore, be worthwhile to put the matter to the test of experiment, viz. by varying the process B until the right one be discovered, or until so many trials have been made as to preclude all reasonable hope of its existence. My first trials were unsuccessful, as indeed I expected; but after some time I discovered a method

which answers perfectly." William Henry Fox Talbot, "Some Account of the Art of Photogenic Drawing; or, The Process by Which Natural Objects May Be Made to Delineate Themselves without the Aid of the Artist's Pencil," in *Photography in Print: Writings from 1816 to the Present*, ed. Vicki Goldberg (Albuquerque: University of New Mexico Press, 1981), 40 (emphasis in original).

2. Talbot's first photographic process, photogenic drawing, was a "print-out" process that fully depended on solar energy for the production of negative images. His second photographic process, the calotype, was a "developed-out" process in which, after a short exposure time, an invisible image is formed and later developed by chemical means (gallic acid, the chemical agent Talbot claimed he discovered in 1841). These terms are used by Larry Schaaf in his *The Photographic Art of William Henry Fox Talbot* (Princeton, N.J.: Princeton University Press, 2000), 17–22.

3. Talbot, "Some Account," 41 (emphasis added).

4. Richard Yeo, "Scientific Method and the Rhetoric of Science in Britain, 1830–1917," in *The Politics and Rhetoric of Scientific Method: Historical Studies*, ed. John A. Schuster and Richard Yeo (Dordrecht, Neth.: Reidel, 1986), 260.

5. Simon Schaffer, "Scientific Discoveries and the End of Natural Philosophy," *Social Studies of Science* 16, no. 3 (August 1986): 398.

6. Carol Armstrong, for example, argues for a complete structural and historical homology between the evidentiary "essence" of photography and the inductive method: "That 'organon of proof,' with its tautological twinning of the indexical (the causal) and the inductive (empirical), could as well be the organon of photography, too." See her *Scenes in a Library: Reading the Photograph in the Book, 1843–1875* (Cambridge, Mass.: MIT Press, 1998), 55–56.

7. William Henry Fox Talbot, letter in *Literary Gazette,* February 2, 1839, 74 (emphasis in original).

8. John Herschel, *A Preliminary Discourse on the Study of Natural Philosophy* (Chicago: University of Chicago Press, 1987), 8, 15 (emphasis added).

9. See Richard Yeo, "Reviewing Herschel's *Discourse*," *Studies in History and Philosophy of Science* 20, no. 4 (1989): 541.

10. Herschel suggested the term *photography* in his 1839 paper "A Note on the Art of Photography; or, The Application of the Chemical Rays of Light to the Purposes of Pictorial Representation," reprinted in *History of Photography* 3, no. 1 (January 1979): 57–60. The terms *negative* and *positive* were suggested by Herschel in his paper "On the Chemical Action of the Rays of the Solar Spectrum on Preparations of Silver and Other Substances, Both Metallic and Non-metallic, and on Some Photographic Processes," in *Philosophical Transactions of the Royal Society of London* 130 (1840): 3. On the relations between Talbot's and Herschel's photographic experiments, see Larry Schaaf, *Out of the Shadows: Herschel, Talbot, and The Invention of Photography* (London: Yale University Press, 1992). On Herschel's proposed terminology for photography, see Geoffrey Batchen, "The Naming of Photography," *History of Photography* 17, no. 1 (Spring 1993): 26–29; and Kelley Wilder, "Ingenuity, Wonder, and Profit: Language and the Invention of Photography" (PhD diss., Oxford University, 2004). See also Armstrong's discussion of the *Discourse* in her *Scenes in a Library*, 33–43, 56–63.

11. Reviews of *A Preliminary Discourse on the Study of Natural Philosophy,* by John Herschel, in *Athenæum,* January 8, 1831, 38–39, and *Fraser's Magazine,* July 1831, 698–703.

12. Richard Yeo, *Defining Science: William Whewell, Natural Knowledge, and Public Debate in Early Victorian Britain* (Cambridge: Cambridge University Press, 1993), 32–33.

13. Francis Bacon, *The New Organon and Related Writings*, trans. James Spedding, Robert Leslie Ellis, and Douglas Denon Heath (1620; repr., New York: Liberal Arts Press, 1960), 34 (emphasis added).

14. Ibid., 115.

15. Ibid., 96–99.

16. Richard Olson, *Scottish Philosophy and British Physics, 1750–1880* (Princeton, N.J.: Princeton University Press, 1975), 27–28.

17. Thomas Reid, quoted in ibid., 29–30.

18. Olson, *Scottish Philosophy and British Physics,* 30.

19. Ibid., 36.

20. Ibid., 46 (emphases in original).

21. Ibid., 42–43.

22. Gilles Deleuze, "Hume," in *Pure Immanence: Essays on Life*, trans. Anne Boyman (New York: Zone Books), 40.

23. Herschel, *Discourse,* 4. Subsequent citations of this source appear parenthetically in the text.

24. On Herschel's notion of causality in relation to the aims of science, see Chaman Lal Jain, "Methodology and Epistemology: An Examination of Sir John F. W. Herschel's Philosophy of Science with Reference to his Theory of Knowledge" (PhD diss., Indiana University, 1975). See also Curt J. Ducasse, "John Herschel's Methods of Experimental Inquiry," in *Theories of Scientific Method: The Renaissance through the Nineteenth Century*, ed. Curt J. Ducasse, Ralph M. Blake, and Edward H. Madden (New York: Gordon & Breach Science Publishers, 1989), 164–73; and Walter F. Cannon, "John Herschel and the Idea of Science," *Journal of the History of Ideas* 22, no. 2 (April–January, 1961): 221–22.

25. John Herschel, review of *The History of the Inductive Sciences* and *The Philosophy of the Inductive Sciences,* by William Whewell, *Quarterly Review* 68 (1841): 205 (emphases in original).

26. On the wave theory of light, see Jed Z. Buchwald, *The Rise of the Wave Theory of Light* (Chicago: University of Chicago Press, 1989); and Geoffrey N. Cantor, *Optics after Newton* (Manchester, Eng.: Manchester University Press, 1983).

27. Herschel's early light experiments were conducted within the projectile theory of light and in relation to the specific interests of British scientists, like Brewster, who focused on the interaction of light and matter. In this context, light was often addressed as a chemical phenomenon that not only affected matter but also transmuted into matter. Herschel was not convinced of the materiality of light, yet he was interested in the way substances acted on light, and in the properties of those substances through which light passed. In 1822 he proposed a new

method, spectral analysis, to study the effects of crystals on light in such optical phenomena as double refraction and polarization. On Herschel's optical experiments, see Gregory Good, "J. F. W. Herschel's Optical Researches: A Study in Method" (PhD diss., University of Toronto, 1983); and M. A. Sutton, "Sir John Herschel and the Development of Spectroscopy," *British Journal for the History of Science* 7, no. 25 (1974): 42–60.

28. William Henry Fox Talbot, "On the Nature of Light," *Philosophical Magazine,* 3rd ser., 7, no. 38 (August 1835): 115. The use of sensitive paper as indicating chemical change also appears in Talbot's essay "On a New Property of the Iodide of Silver," *Philosophical Magazine,* 3rd ser., 12, no. 74 (March 1838): 258–59. On Talbot's optical experiments, see H. J. P. Arnold, *William Henry Fox Talbot: Pioneer of Photography and Man of Science* (London: Hutchinson Benham, 1977), 72–77.

29. Cantor, *Optics after Newton*, 173. On the debate, see also Xiang Chen, "Theories, Experiments, and Human Agents: The Controversy between Emissionists and Undulationists in Britain, 1827–1859" (PhD diss., Virginia Polytechnic Institute and State University, 1992).

30. See P. M. Harman, *Energy, Force, and Matter* (Cambridge: Cambridge University Press, 1982), 2–5.

31. Robert H. Silliman, "Fresnel and the Emergence of Physics as a Discipline," *Historical Studies in the Physical Sciences* 4 (1974): 156–57 (emphasis added).

32. Cantor, *Optics after Newton*, 174.

33. Joseph Agassi, "Sir John Herschel's Philosophy of Success," *Historical Studies in the Physical Sciences* 1 (1969): 2.

34. Larry Laudan, "Why Was the Logic of Discovery Abandoned?," in *Science and Hypothesis* (Dordrecht, Neth.: Reidel, 1981), 183.

35. Richard Yeo, "An Idol of the Market-Place: Baconianism in Nineteenth Century Britain," *History of Science* 23 (1985): 252.

36. Michel Foucault, *The Order of Things: An Archaeology of the Human Sciences* (1966; repr., New York: Vintage, 1994), 54. Subsequent citations of this source appear parenthetically in the text.

37. On Hume's definitions of the imagination, see Deleuze, "Hume," 41–47; William Clark Gore, *The Imagination in Hume and Spinoza* (Chicago: University of Chicago Press, 1902), 32–46; and Mary Warnock, *Imagination* (Berkeley: University of California Press, 1976), 13–41.

38. David Hume, *A Treatise of Human Nature* (1739–40; repr., London: Penguin, 1985), 56 (emphasis added).

39. Ibid., 57.

40. Gore, *Imagination in Hume and Spinoza*, 41–42.

41. David Hume, quoted in Warnock, *Imagination*, 25.

42. Deleuze, "Hume," 41–42.

43. Talbot, "Some Account," 40–41 (emphases in original).

44. Simon Schaffer, "Natural Philosophy," in *The Ferment of Knowledge*, ed. G. S. Rousseau and Roy Porter (Cambridge: Cambridge University Press, 1980), 78.

45. Ibid., 81.

46. Ibid., 83.

47. Don Slater, "Photography and Modern Vision: The Spectacle of 'Natural Magic,'" in *Visual Culture,* ed. Chris Jenks (London: Routledge, 1995), 226–27.

48. David Brewster, *Letters on Natural Magic* (New York: J & J. Harper, 1832).

49. On the relations between Brewster and Talbot, see Graham Smith, *Disciples of Light: Photographs in the Brewster Album* (Malibu, Calif.: J. Paul Getty Museum, 1990).

50. Roland Barthes, *Camera Lucida,* trans. Richard Howard (New York: Hill & Wang, 1982), 88 (emphases in original).

51. Ibid., 89.

52. Armstrong, *Scenes in a Library,* 12–13.

53. Talbot, "Some Account," 43.

54. Ibid., 42 (emphasis added).

55. Ibid., 43.

56. William Henry Fox Talbot, quoted in *Literary Gazette,* February 2, 1839, 72.

57. Steve Edwards, *The Making of English Photography* (University Park: Pennsylvania State University Press, 2006), 44.

58. On the relations and correspondence between Talbot and Babbage, see Graham Smith, "Rejlander, Babbage, and Talbot," *History of Photography* 18, no. 3 (Autumn 1994): 285–86. For an effort to connect the conception of photography to Babbage's early computers, see Geoffrey Batchen, "Obedient Numbers, Soft Delight," in *Each Wild Idea: Writing, Photography, History* (Cambridge, Mass.: MIT Press, 2001), 165–74.

59. Charles Babbage, *On the Economy of Machinery and Manufactures* (1832), in *The Works of Charles Babbage,* ed. Martin Campbell-Kelly (London: Pickering, 1989), 8:47–48 (emphasis added).

60. Bacon, *New Organon,* 58–59.

61. Yeo, "Scientific Method," 264.

62. Herschel, *Discourse,* 133.

63. Timothy L. Alborn, "The Business of Induction: Industry and Genius in the Language of British Scientific Reform, 1820–1840," *History of Science* 34 (1996): 103.

64. On the institutional organization of scientific societies and organizations in Britain in the 1830s and 1840s, see Jack Morrell and Arnold Thackray, *Gentlemen of Science: Early Years of the British Association for the Advancement of Science* (Oxford: Clarendon, 1981); Jack Morrell and Ian Inkster, *Metropolis and Province: Science in British Culture, 1780–1850* (London: Hutchinson, 1983); Morris Berman, "Hegemony and the Amateur Tradition in British Science," *Journal of Social History* 8 (Winter 1975): 30–50; and Susan Faye Cannon, *Science in Culture: The Early Victorian Period* (New York: Neale Watson Academic, 1978).

65. Herschel, *Discourse,* 131.

66. Steve Edwards, *Making of English Photography,* 36–40.

67. Maxine Berg, *The Machinery Question and the Making of Political Economy, 1815–1848* (Cambridge: Cambridge University Press, 1980), 10.

68. Herschel, *Discourse,* 102–3 (emphasis added).

69. Berg, *Machinery Question*, 33–34.

70. Charles Babbage and John Herschel, preface to the *Memoirs of the Analytical Society* (1813), in *Works of Charles Babbage*, 1:59 (emphasis added).

71. June Barrow-Green, "'Merely a Speculation of the Mind'? William Henry Fox Talbot and Mathematics," in *William Henry Fox Talbot: Beyond Photography*, ed. Mirjam Brusius, Katrina Dean, and Chitra Ramalingam (New Haven, Conn.: Yale Center for British Art, 2013), 70.

72. England lay behind the Continent in the field of analytics, particularly behind France, which, through the works of L. Euler and J. L. Lagrange, made significant progress in this field since the eighteenth century. Mathematics historian Philip C. Enros points out that the first decades of the nineteenth century witnessed a great change in English mathematics because of the transition from the Newtonian dot notation and synthetic methods to the Continental differential notation and analytic methods. Cambridge University was instrumental in the adoption of Continental mathematics. Mathematics provided the only basis for a Cambridge honors degree, and until 1848 mathematical competence determined a student's ranking in the Tripos, the honors examination. Yet, despite its dominant status in the university syllabus, the standard of mathematic thought in Cambridge was very low. In none of the textbooks taught in the university was there any real advance beyond the mathematics of the *Principia*. Moreover, the use of Newton's dot notation severed the university from the influence of the Continent, which used a different system of notation: Leibniz's "d" notation. Thus, a strong nationalistic commitment to Newton's legacy, combined with anti-French prejudice, left the university practically isolated from any developments in the field of algebraic analysis. In 1812, Babbage and Herschel, then students at Cambridge, established the Analytical Society in order to change this state of affairs. The society's reform program included not just the change of the notation of Newton's fluxional calculus but also the change of the fluxional calculus itself with Lagrange's formal differential calculus. On the Analytical Society, see Philip C. Enros, "Cambridge University and the Adoption of Analytics in Early Nineteenth-Century England," in *Social History of Nineteenth Century Mathematics*, ed. Herbert Mehrtens, Henk Bos, and Ivo Schneider (Boston: Birkhäuser, 1981), 135–47; William J. Ashworth, "Memory, Efficiency, and Symbolic Analysis: Charles Babbage, John Herschel, and the Industrial Mind," *Isis* 87, no. 4 (December 1996): 629–53; Menachem Fisch, "'The Emergency Which Has Arrived': The Problematic History of Nineteenth-Century British Algebra—A Programmatic Outline," *British Journal for the History of Science* 27 (1994): 247–76; and Joan L. Richards, "The Art and the Science of British Algebra: A Study in the Perception of Mathematical Truth," *Historia Mathematica* 7 (1980): 343–65.

73. Barrow-Green, "'Merely a Speculation of the Mind'?," 71.

74. Ashworth, "Memory, Efficiency, and Symbolic Analysis," 631.

75. Simon Schaffer, "Babbage's Intelligence: Calculating Engines and the Factory System," *Critical Inquiry* 21 (Autumn 1994): 207.

76. Charles Babbage, "The Science of Number Reduced to Mechanism" (1822), in *Works of Charles Babbage*, 2:15.

77. On the Difference Engine, see Alan G. Bromley's general introduction to *The Works of Charles Babbage*, 1:23.

78. Schaffer, "Babbage's Intelligence," 207.

79. Babbage, *On the Economy of Machinery and Manufactures,* 8:125. Subsequent citations of this source appear parenthetically in the text.

80. M. Norton Wise and Crosbie Smith, "Work and Waste: Political Economy and Natural Philosophy in Nineteenth Century Britain, Part 2," *History of Science* 27 (1989): 414.

81. Ibid., 415.

82. William Whewell, *Astronomy and General Physics Considered with Reference to Natural Theology* (1833), in Whewell, *Selected Writings on the History of Science*, ed. Yehuda Elkana (Chicago: University of Chicago Press, 1984), 324–25.

83. Charles Babbage, *Ninth Bridgewater Treatise* (1837), in *Works of Charles Babbage*, 9:9–10.

84. Wise and Smith, "Work and Waste," 392.

85. Ibid. (emphasis added).

86. Ibid., 415.

87. Michel Foucault, *Order of Things*, 155 (emphasis added).

88. In his "Talbot's Natural Magic," Douglas R. Nickel also argues that "[t]he basic assumption of natural magic was that nature teemed with hidden forces that could be harnessed, imitated, improved upon, and used for human gain." Nickel points to the way natural theology informs Talbot's understanding of science and photography. *History of Photography* 26, no. 2 (Summer 2002): 134–35. In his "Obedient Numbers, Soft Delight," Geoffrey Batchen states that photography and early computers share a common history and embody comparable logics. Based on the *Ninth Bridgewater Treatise,* he shows that Babbage conceived "of his computer as a cultural artifact that enabled nature (and therefore God) to represent itself in the form of mathematical equations." Thus, the computer, he argues, like photography, "collapses the boundaries of subject and object altogether; it is *this* power above all else—this ability to undermine the comfortable Cartesian dualities of the previous century—that astonished its maker [Babbage]." In *Each Wild Idea*, 167, 171. Yet, as Simon Schaffer shows in his "Babbage's Intelligence," Babbage's computers manifested the fantasy of the subjection of the human body and mind to a technology of maximum control. Babbage, like Herschel, continued to believe in the idea of a well-balanced and predictable social and material world even in the face of changes that suggested otherwise.

89. David Brewster, "Photogenic Drawing; or, Drawing by the Agency of Light," *Edinburgh Review,* January 1843, 311.

90. Ibid., 312.

91. Ibid.

2. Imagination

1. Talbot's second photographic process, the calotype, was a "developed-out" process in which, after a short exposure time, an invisible image is formed and

later developed by chemical means (using gallic acid, the chemical agent Talbot claimed he discovered in 1840). It was this second process that greatly facilitated the application of his processes to the camera obscura. These terms are used by Larry Schaaf in his *The Photographic Art of William Henry Fox Talbot* (Princeton, N.J.: Princeton University Press, 2000), 17–22.

2. William Henry Fox Talbot, "Brief Historical Sketch of the Invention of the Art," in *The Pencil of Nature* (1844–46; repr., New York: Da Capo Press, 1969), n.p.

3. Ibid., n.p. (emphasis added).

4. Simon Schaffer, "Scientific Discoveries and the End of Natural Philosophy," *Social Studies of Science* 16, no. 3 (August 1986): 387–420.

5. Ibid., 397.

6. Herta Wolf, "Nature as Drawing Mistress," in *William Henry Fox Talbot: Beyond Photography*, ed. Mirjam Brusius, Katrina Dean, and Chitra Ramalingam (New Haven, Conn.: Yale Center for British Art, 2013), 120.

7. Schaffer, "Scientific Discoveries," 387.

8. Arnold also mentions a number of social gatherings surrounding the BAAS meetings in which the two participated, as well as a professional scientific correspondence. See H. J. P. Arnold, *William Henry Fox Talbot: Pioneer of Photography and Man of Science* (London: Hutchinson Benham, 1977), 65, 80, 82, 313.

9. Letter, Thomas Worsley to Talbot, January 29, 1840. This letter is transcribed as document no. 4009 in the website *The Correspondence of William Henry Fox Talbot*, http://foxtalbot.dmu.ac.uk/letters/transcriptDocnum.php?docnum=4009.

10. Schaffer, "Scientific Discoveries," 407 (emphases in original).

11. Joel Snyder, "Enabling Confusion," *History of Photography* 26, no 2 (Summer 2002): 159.

12. John Herschel, review of *History of the Inductive Sciences* and *Philosophy of the Inductive Sciences,* by William Whewell, in *Quarterly Review* 68 (1841): 182.

13. Richard Yeo, "William Whewell's Philosophy of Knowledge and its Reception," in *William Whewell: A Composite Portrait*, ed. Menachem Fisch and Simon Schaffer (Oxford: Clarendon Press, 1991), 178.

14. Ibid., 198.

15. William Whewell, *Selected Writings on the History of Science*, ed. Yehuda Elkana (Chicago: University of Chicago Press, 1984), 139–40 (emphases in original). Subsequent citations of this source appear parenthetically in the text.

16. Menachem Fisch, *William Whewell, Philosopher of Science* (Oxford: Clarendon Press, 1991), 126–27. On the way Whewell came to develop his theory of ideas and his familiarity with Kant's writings, see Donald H. McNally, "Science and the Divine Order: Law, Idea, and Method in William Whewell's *Philosophy of Science*" (PhD diss., University of Toronto, 1982), 141–52.

17. Geoffrey N. Cantor, "Between Rationalism and Romanticism: Whewell's Historiography of the Inductive Sciences," in Fisch and Schaffer, *William Whewell*, 70–74.

18. On Whewell's relations with Hamilton and Hare and the influence of Coleridge's ideas on his work, see Yeo, "William Whewell's Philosophy," and Simon

Schaffer, "The History and Geography of the Intellectual World: Whewell's Politics of Language," both in Fisch and Schaffer, *William Whewell*, 175–99 and 201–31, respectively. See also Fisch, *William Whewell, Philosopher of Science*, 63–68.

19. Cantor, "Between Rationalism and Romanticism," 77. On the way Coleridge's ideas informed Whewell's model of discovery, see McNally, "Science and the Divine Order," 152–60.

20. Cantor, "Between Rationalism and Romanticism," 75.

21. Ibid., 77.

22. Ibid., 80.

23. Schaffer, "History and Geography," 205.

24. Ibid., 230–31. See also Richard Yeo, *Defining Science: William Whewell, Natural Knowledge, and Public Debate in Early Victorian Britain* (Cambridge: Cambridge University Press, 1993), 70.

25. Brewster is quoted in Schaffer, "Scientific Discoveries," 410.

26. On the relations between science and romanticism in the context of natural philosophy, see Stefano Poggi and Maurizio Bossi, eds., *Romanticism in Science: Science in Europe, 1790–1840* (Dordrecht, Neth.: Kluwer Academic, 1994); David M. Knight, *Science in the Romantic Era* (Aldershot, Eng.: Ashgate, 1998); and Andrew Cunningham and Nicholas Jardine, eds., *Romanticism and the Sciences* (Cambridge: Cambridge University Press, 1990). On the centrality of the idea of the genius to natural philosophy, see Simon Schaffer, "Genius in Romantic Natural Philosophy," in Cunningham and Jardine, *Romanticism and the Sciences*, 82–98.

27. On Davy's scientific work, see Trevor H. Levere, *Affinity and Matter: Elements of Chemical Philosophy, 1800–1865* (Oxford: Clarendon Press, 1971). On his relations with Coleridge, see Trevor H. Levere, *Poetry Realized in Nature: Samuel Taylor Coleridge and Early Nineteenth-Century Science* (Cambridge: Cambridge University Press, 1981), 20–35. See also Ferdinando Abbri, "Romanticism versus Enlightenment: Sir Humphry Davy's Idea of Chemical Philosophy," in Poggi and Bossi, *Romanticism in Science*, 31–45.

28. Thomas Wedgwood and Humphry Davy, "An Account of a Method of Copying Paintings upon Glass, and of Making Profiles, by the Agency of Light upon Nitrate of Silver," in *Photography: Essays and Images*, ed. Beaumont Newhall (New York: Museum of Modern Art, 1980), 15–16.

29. Christopher Lawrence, "The Power and the Glory: Humphry Davy and Romanticism," in Cunningham and Jardine, *Romanticism and the Sciences*, 213–20.

30. Talbot, *Pencil of Nature*, n.p.

31. See, for example, Clement Greenberg, "Modernist Painting," in *Art Theory, 1900–2000*, ed. Charles Harrison and Paul Wood (Oxford: Blackwell, 2006), 773–79.

32. Michel Foucault, *The Order of Things: An Archaeology of the Human Sciences* (1966; repr., New York: Vintage, 1994), 219 (emphasis added). Subsequent citations of this source appear parenthetically in this passage of the text.

33. For general books on the imagination, see Mary Warnock, *Imagination* (Berkeley: University of California Press, 1976); James Engell, *The Creative Imagination: Enlightenment to Romanticism* (Cambridge, Mass.: Harvard University

Press, 1981); and Richard Kearney, *The Wake of Imagination: Toward a Postmodern Culture* (London: Routledge, 1998).

34. On Kant's definition of the imagination and the debates surrounding it, see Rudolf A. Makkreel, *Imagination and Interpretation in Kant: The Hermeneutical Import of the "Critique of Judgment"* (Chicago: University of Chicago Press, 1990); Sarah L. Gibbons, *Kant's Theory of Imagination: Bridging Gaps in Judgment and Experience* (Oxford: Clarendon Press, 1994); and Martin Heidegger, *Kant and the Problem of Metaphysics*, trans. Richard Taft (Bloomington: Indiana University Press, 1990).

35. Gilles Deleuze, "On Four Poetic Formulas That Might Summarize the Kantian Philosophy," in *Essays Critical and Clinical*, trans. Daniel W. Smith and Michael A. Greco (Minneapolis: University of Minnesota Press, 1997), 34.

36. Ibid., 28–29.

37. Immanuel Kant, *Critique of Pure Reason*, trans. Werner S. Pluhar (Indianapolis: Hackett, 1996), 150–60. Subsequent citations of this source appear parenthetically in the text.

38. On the complexities and tensions of this definition, see Gibbons, *Kant's Theory of Imagination*, 14–53.

39. Makkreel, *Imagination and Interpretation in Kant*, 41.

40. Immanuel Kant, *Critique of Judgment*, trans. Werner S. Pluhar (Indianapolis: Hackett, 1987), 25. Subsequent citations of this source appear parenthetically in the text.

41. Makkreel, *Imagination and Interpretation in Kant*, 52.

42. M. H. Abrams, *The Mirror and the Lamp* (London: Oxford University Press, 1953), 58.

43. See McNally, "Science and the Divine Order," 141.

44. Geoffrey Batchen, *Burning with Desire: The Conception of Photography* (Cambridge, Mass.: MIT Press, 1997), 60–62, 84–90. In her essay "Talbot's Rouen Window: Romanticism, *Naturphilosophie,* and the Invention of Photography," Anne McCauley also discusses the common philosophical concerns of Coleridge, Davy, and Wedgwood. See *History of Photography* 26, no. 2 (Summer 2002): 124–31. McCauley emphasizes the sense of subjectivity that is evoked in this image.

45. On Coleridge's theory of the imagination, see I. A. Richards, *Coleridge on Imagination* (Bloomington: Indiana University Press, 1960); John Spencer Hill, *Imagination in Coleridge* (Totowa, N.J.: Rowman & Littlefield, 1978); Nigel Leask, *The Politics of Imagination in Coleridge's Critical Thought* (Basingstoke, Eng.: Macmillan, 1988); and Forest Pyle, *The Ideology of Imagination: Subject and Society in the Discourse of Romanticism* (Stanford, Calif.: Stanford University Press, 1995), 27–58.

46. Engell, *Creative Imagination*, 168.

47. Leask, *Politics of Imagination*, 87.

48. Samuel Taylor Coleridge, *Biographia Literaria,* vol. 1 (London: Oxford University Press, 1962), 91 (emphasis in original). Subsequent citations of this source appear parenthetically in the text.

49. On Schelling's criticism of Kant, see Barry Gower, "Speculation in Physics: The History and Practice of *Naturphilosophie*," *Studies in History and Philosophy of Science* 3, no. 4 (1973): 307–10.

50. Ibid., 317.

51. Reese Jenkins argues that the conception of photography was informed by the romantic view of polar forces, most clearly in terminology like *positive* and *negative*, which were suggested by Herschel. See his essay "Science, Technology, and the Evolution of Photography," in *Pioneers of Photography: Their Achievements in Science and Technology*, ed. Eugene Ostroff (Springfield, Mass.: Society of Photographic Scientists and Engineers, 1987), 18–24. Geoffrey Batchen also claims that magnetism informed Talbot's conception of photography, in his *Burning with Desire*, 149–57.

52. Raimonda Modiano, *Coleridge and the Concept of Nature* (Tallahassee: Florida State University Press, 1985), 139.

53. Coleridge, quoted in ibid., 202.

54. Pyle, *Ideology of Imagination*, 43–44.

55. Leask, *Politics of Imagination*, 142 (emphasis in original).

56. Samuel Taylor Coleridge, "Essays on the Principles of Method" in *The Friend*, in *The Collected Works of Samuel Taylor Coleridge*, ed. Barbara E. Rooke, vol. 4 (London: Routledge & Kegan Paul; Princeton, N.J.: Princeton University Press, 1969), 463 (emphasis in original).

57. Ibid., 470–71 (emphasis added).

58. Levere, *Poetry Realized in Nature*, 20–35.

59. Levere emphasizes the importance for Coleridge of Davy's lectures at the Royal Institution: "Coleridge, looking back to his attendance at Davy's lecture, recalled . . . how chemistry could break down accustomed artificial divisions of thought. He often used chemistry and chemical processes as images for human psychology. This was possible in part because he believed that chemical changes, reactions leading to products, could themselves only be described metaphorically. . . . The structure of chemical metaphor—combination, exchange, saturation, affinity—embedded in the language and grammar of chemistry, reflected for him . . . the structure of human thought and human language. . . . The metaphor that Coleridge drew from chemistry was not mechanical. . . . [He] kept mechanics distinct from chemistry, and used chemistry to illustrate the difference between synthesis and juxtaposition. . . . Imagination was the synthetic power in mind. Chemical metaphor could thus take one beyond the psychology of association to creativity in thought and language." Ibid., 28–29.

60. Coleridge, "Essays on the Principles of Method," 488–89.

61. Jonathan Crary, *Techniques of the Observer: On Vision and Modernity in the Nineteenth Century* (Cambridge, Mass.: MIT Press, 1990), 25–66.

62. Foucault, *Order of Things*, 265.

63. François Jacob, *The Logic of Life: A History of Heredity*, trans. Betty E. Spillmann (New York: Pantheon, 1982), 90–92 (emphasis in original).

64. Makkreel, *Imagination and Interpretation in Kant*, 100–101.

65. Ibid., 105–6.

66. Samuel Taylor Coleridge, *Hints towards the Formation of a More Comprehensive Theory of Life* (New York: Harper, 1853), 1:386–87 (emphases in original). On Coleridge's *Theory of Life,* see R. Male, "The Background of Coleridge's *Theory of Life,*" *Studies in English* 33 (1954): 60–68; and Alice D. Snyder, *Coleridge on Logic and Learning* (New Haven, Conn.: Yale University Press, 1929).

67. Applying Schelling's idea of polarity, Coleridge argues that there are two tendencies in nature: detachment (like gravitation) and attachment (like chemical reduction). Thus, each element in nature can manifest either unity and identity with nature (for example, metals) or separation from the life of the universe (as man exhibits). The most general law of this tendency is *"polarity,* or the essential dualism of Nature, arising out of [its] productive unity, and still tending to reaffirm it, either as equilibrium, indifference, or identity. . . . Life, then, we consider as the copula, or the unity of thesis and antithesis, position and counterposition,—Life itself being the positive of both; as, on the other hand, the two counterpoints are the necessary conditions of the *manifestations* of Life." Coleridge, *Hints towards the Formation,* 391–92 (emphasis in original).

68. Coleridge, *Biographia Literaria,* vol. 2, in *The Collected Works of Samuel Taylor Coleridge,* ed. James Engell and W. Jackson Bate, vol. 7 (London: Routledge & Kegan Paul; Princeton, N.J.: Princeton University Press, 1983), 15–16. Subsequent citations of this source appear parenthetically in the text.

69. On the relations between Coleridge's *Biographia Literaria* and his *Theory of Life,* see Timothy Corrigan, "The *Biographia Literaria* and the Language of Science," in *Samuel Taylor Coleridge,* ed. Harold Bloom (New York: Chelsea House, 1986).

70. Abrams, *Mirror and the Lamp,* 171–73, 220–21.

71. The words *fashioning* and *creation* appear in Greek in the original text.

72. Coleridge, *Lectures, 1808–1819, on Literature,* vol. 2, in *The Collected Works of Samuel Taylor Coleridge,* ed. R. A. Foakes, vol. 5 (London: Routledge & Kegan Paul; Princeton, N.J.: Princeton University Press, 1987), 220–21 (emphases in original).

73. Ibid., 222 (emphasis added).

74. Crary, *Techniques of the Observer,* 27 (emphasis added).

75. Ibid., 39–40.

76. Foucault, *Order of Things,* 130 (emphases in original).

77. Ibid., 311 (emphasis added).

78. Coleridge, *Lectures, 1808–1819, on Literature,* 2:361–62.

79. Crary, *Techniques of the Observer,* 16.

80. Thomas McFarland, "Involute and Symbol in the Romantic Imagination," in *Coleridge, Keats, and the Imagination: Romanticism and Adam's Dream,* ed. J. Robert Barth and John L. Mahoney (Columbia: University of Missouri Press, 1990), 29–57. McFarland's essay was written in response to Paul de Man's famous attack on Coleridge's definition of the symbol and his defense of allegory in his "The Rhetoric of Temporality," in *Interpretation: Theory and Practice,* ed. Charles S. Singleton (Baltimore: Johns Hopkins University Press, 1969), 173–91.

81. Samuel Taylor Coleridge, *Lay Sermons,* in *The Collected Works of Samuel Taylor Coleridge*, ed. R. J. White, vol. 6 (London: Routledge & Kegan Paul; Princeton, N.J.: Princeton University Press, 1972), 30.

82. Jonathan Culler proposes a similar argument when he attributes the shift in literary sensibilities from allegory to symbol to the shift that Foucault outlined in *The Order of Things* from natural history and classical taxonomy to new botany and biology, "in which hidden properties become the most significant and the true defining characteristics of the organism. Instead of imposing on visible relations a nomenclature which made fauna and flora moments of an allegory of order, the new organicism tries . . . to establish the correspondence between exterior and interior forms which are all integral parts of the animal's essence." Jonathan Culler, "Literary History, Allegory, and Semiology," *New Literary History* 7 (1976): 262.

83. Coleridge, *Lectures, 1808–1819, on Literature,* 2:221 (emphases in original).

84. Raimonda Modiano argues that Coleridge tried to devise a system in which a dynamic conception of nature's polar activity and intrinsic unity could be maintained side by side with a belief in a Christian God. He thus intended, among other things in his *Theory of Life*, to construct a unified philosophical system in which he could point not only to the identity of the real and the ideal in nature but also to the continuity between the two based on hierarchical differences that separate them. Modiano, *Coleridge and the Concept of Nature*, 139–40. See also Thomas McFarland, *Coleridge and the Pantheist Tradition* (Oxford: Clarendon Press, 1969).

85. Foucault, *Order of Things*, 329–30.

86. Romanticism is often identified as an important predecessor to the work of vitalist philosophers such as Henri-Louis Bergson. See Jack H. Haeger, "Samuel Taylor Coleridge and the Romantic Background to Bergson," and George Rousseau, "The Perpetual Crisis of Modernism and the Traditions of Enlightenment Vitalism: With a Note on Mikhail Bakhtin," both in *The Crisis in Modernism: Bergson and the Vitalist Controversy*, ed. Frederick Burwick and Paul Douglass (Cambridge: Cambridge University Press, 1992), 98–108 and 15–75 respectively. See also George Rousseau, "Science and the Discovery of the Imagination in Enlightened England," *Eighteenth-Century Studies* 3, no. 1 (Autumn 1969): 108–35.

87. Geoffrey Batchen also shows, through the personal correspondence between Coleridge and Wedgwood, that "the camera whose images were the 'first object' of Wedgwood's desire was not the same instrument that had so preoccupied artists in previous centuries." Batchen, *Burning with Desire*, 90. He argues that historical transformations in the meaning of the camera obscura and of mirrors, from direct and unmediated reflections of reality to dynamic metaphors manifesting the new and uncertain relations between observer and observed, informed the protophotographers' conception of photography as "an apparatus of seeing that involved both reflection and projection." Geoffrey Batchen, "Desiring Production," in *Each Wild Idea: Writing, Photography, History* (Cambridge, Mass.: MIT Press, 2001), 22.

88. See, for example, Helmut Gernsheim's discussion of the camera obscura and his determinate assertion that "the photographic camera derives directly from

the camera obscura," in his *The Origins of Photography* (New York: Thames & Hudson, 1982), 7.

89. Crary, *Techniques of the Observer*, 57.

90. Talbot, *Pencil of Nature*, n.p.

91. Ibid., n.p. (emphases in original).

92. Ann Bermingham, *Learning to Draw: Studies in the Cultural History of a Polite and Useful Art* (London: Yale University Press, 2000), 241.

93. On the way issues of class are interrelated with issues of gender in Talbot's account, see Steve Edwards, *The Making of English Photography* (University Park: Pennsylvania State University Press, 2006), 27–28.

94. Bermingham, *Learning to Draw*, 77. On the ideological and political motivations behind picturesque landscape, see John Barrel, *The Dark Side of the Landscape: The Rural Poor in English Painting, 1730–1840* (Cambridge: Cambridge University Press, 1980). Talbot's own estate, Lacock Abbey, was directly affected by the acts of enclosure during the 1830 Swing Riots, in which the poor protested their deteriorating living conditions. See Arnold, *William Henry Fox Talbot*, 55–57.

95. Bermingham, *Learning to Draw*, 78.

96. Ibid., 91.

97. William Gilpin, *Three Essays: On Picturesque Beauty, On Picturesque Travel, and On Sketching Landscape* (London: R. Blamire, 1792), 47. Subsequent citations of this source appear parenthetically in the text.

98. William Gilpin, *Observations on the River Wye* (Oxford: Woodstock Books, 1991), 8.

99. Talbot, *Pencil of Nature*, n.p.

100. Ibid., n.p. (emphasis added).

101. Martin Kemp, "Talbot and Picturesque View," *History of Photography* 21, no. 4 (Winter 1997): 274–76.

102. Anonymous review of Talbot's 1840 exhibition, *Literary Gazette*, May 16, 1840, 315–16 (emphasis added).

103. Anonymous review of *The Pencil of Nature*, *Athenæum*, February 22, 1845, 202 (emphasis in original).

104. M. Kemp, "Talbot and Picturesque View," 279.

105. Wolfgang Kemp, "Images of Decay: Photography in the Picturesque Tradition," *October* 54 (Autumn 1990): 112.

106. "The Application of the Talbotype," *Art-Union*, July 1, 1846, 195.

107. Talbot, *Pencil of Nature*, n.p.

108. Ibid., n.p.

109. Ibid., n.p.

110. Christopher Hussey, *The Picturesque: Studies in a Point of View* (London: Cass, 1927), 4.

111. Martin Price, "The Picturesque Moment," in *From Sensibility to Romanticism*, ed. Frederick W. Hilles and Harold Bloom (New York: Oxford University Press, 1965), 262.

112. John Ruskin, *Modern Painters*, vol. 4, part 5 (New York: Willey & Halsted, 1857), 6.

113. See J. R. Watson, *Picturesque Landscape and English Romantic Poetry* (London: Hutchinson Educational, 1970); Matthew Brennan, *Wordsworth, Turner, and Romantic Landscape* (Columbia, S.C.: Camden House, 1987); and Alan Liu, *Wordsworth: The Sense of History* (Stanford, Calif.: Stanford University Press, 1989).

114. Coleridge is quoted in Watson, *Picturesque Landscape*, 111.

115. Ibid., 113–18.

116. Wordsworth is quoted in ibid., 94.

117. See the collection of essays *The Politics of the Picturesque*, ed. Stephen Copley and Peter Garside (Cambridge: Cambridge University Press, 1994), in particular the essays by John Whale, "Romantics, Explorers, and Picturesque Travelers," and Raimonda Modiano, "The Legacy of the Picturesque: Landscape, Property, and the Ruin," 175–95, 196–219, respectively.

118. Rosalind Krauss, *The Originality of the Avant-Garde and Other Modernist Myths* (Cambridge, Mass.: MIT Press, 1986), 163.

119. Ibid., 166 (emphasis in original).

120. John Herschel, *A Preliminary Discourse on the Study of Natural Philosophy* (Chicago: University of Chicago Press, 1987), 15.

121. Gilpin, *Observations on the River Wye*, 16.

122. Kim Ian Michasiw, "Nine Revisionist Theses on the Picturesque," *Representations* 38 (Spring 1992): 92.

123. Ibid., 88.

124. Ibid., 89.

125. Ibid., 91.

126. Engell, *Creative Imagination*, 167.

127. Hume is quoted in Richard Payne Knight, *An Analytical Inquiry into the Principles of Taste,* 2nd ed. (London: Luke Hansard, 1805), 16. Subsequent references to Knight appear parenthetically in the text.

128. David Marshall, "The Problem of the Picturesque," *Eighteenth-Century Studies* 35, no. 3 (Spring 2002): 430.

129. On postmodern theories' parody and criticism of the imagination, see Kearney, *Wake of Imagination*, 251–95.

130. See, for example, Edwards, *Making of English Photography*, 45.

131. See the collection *The Anti-aesthetic: Essays on Postmodern Culture*, ed. Hal Foster (Port Townsend, Wash.: Bay Press, 1983).

3. Time

1. William Henry Fox Talbot, *The Pencil of Nature* (1844–46; repr., New York: Da Capo Press, 1969), n.p.

2. See Martin Kemp, *The Science of Art* (New Haven, Conn.: Yale University Press, 1992), 167. See also Beaumont Newhall, *The History of Photography: From 1839 to the Present,* 5th ed. (New York: Museum of Modern Art, 1982), 11.

3. Helmut Gernsheim, *The Origins of Photography* (New York: Thames & Hudson, 1982), 7.

4. Bernard Marbot, *A History of Photography: Social and Cultural Perspectives*, ed. Jean-Claude Lemagny and André Rouillé, trans. Janet Lloyd (Cambridge: Cambridge University Press, 1987), 12.

5. Joel Snyder, "Res Ipsa Loquitur," in *Things That Talk: Object Lessons from Art and Science*, ed. Lorraine Daston (New York: Zone Books, 2004), 202.

6. Larry Schaaf states, "Photographic chemicals were often made up in the kitchen by the photographer himself. Those purchased from a chemist adhered to no standard. Even discounting cheating and dishonest practices, few chemists employed the same approaches as others, and often were not consistent themselves from week to week. Similar capriciousness was found in the manufacture of papers, which presented even greater problems." See his *Out of the Shadows: Herschel, Talbot, and the Invention of Photography* (London: Yale University Press, 1992), 59.

7. Robin Kelsey, "Photography, Chance, and *The Pencil of Nature*," in *The Meaning of Photography*, ed. Robin Kelsey and Blake Stimson (Williamstown, Mass.: Sterling and Francine Clark Art Institute; New Haven: Yale University Press, 2008), 17.

8. Antoine Claudet, "Progress of Photography," in *Transactions of the Society for the Encouragement of Art, Manufactures and Commerce* (London, 1852), 205. A similar view is expressed by Robert Hunt in the introduction to his *Popular Treatise,* the first history of photography published in England. See Robert Hunt, *A Popular Treatise on the Art of Photography* (Glasgow: Griffin, 1841), iii–iv.

9. Lady Elizabeth Eastlake, "A Survey of the Beginnings and Early Development of Photography in Great Britain, 1839–1856," *London Quarterly Review* (April 1857): 248–49.

10. "The Application of the Talbotype," *Art-Union,* July 1, 1846, 195.

11. William Henry Fox Talbot, "Some Account of the Art of Photogenic Drawing; or, The Process by Which Natural Objects May Be Made to Delineate Themselves without the Aid of the Artist's Pencil," in *Photography in Print: Writings from 1816 to the Present,* ed. Vicki Goldberg (Albuquerque: University of New Mexico Press, 1981), 46 (emphasis in original).

12. Joel Snyder formulates the problem in terms of physical agency: "This equivocation about the physical agency or the efficient cause of the photograph—is it the building or the camera obscura image that causes the picture?—is vexing." See his, "Enabling Confusion," *History of Photography* 26, no. 2 (Summer 2002): 157.

13. Geoffrey Batchen, *Burning with Desire: The Conception of Photography* (Cambridge, Mass.: MIT Press, 1997), 68.

14. See Carol Armstrong, *Scenes in a Library: Reading the Photograph in the Book, 1843–1875* (Cambridge, Mass.: MIT Press, 1998). See also her essay "Cameraless: From Natural Illustrations and Nature Prints to Manual and Photogenic Drawings and Other Botanographs," in *Ocean Flowers: Impressions from Nature*, ed. Carol Armstrong and Catherine de Zegher (New York: Drawing Center; Princeton, N.J.: Princeton University Press, 2004), 87–165.

15. Jonathan Crary, *Techniques of the Observer: On Vision and Modernity in the Nineteenth Century* (Cambridge, Mass.: MIT Press, 1990), 32.

16. See Joel Snyder, "Inventing Photography, 1839–1879," in *On the Art of Fixing a Shadow: One Hundred and Fifty Years of Photography,* ed. Sarah Greenough et al. (Washington: National Art Gallery; Chicago: Art Institute of Chicago, 1989), 11.

17. In his first statements Talbot did not use the terms *negative* and *positive* but, respectively, the descriptions "images obtained by the direct action of light, and of the same size with the objects" and "reversed images, requiring the action of light to be twice employed." At a later point Talbot adopted the terms *negative* and *positive,* which were suggested by John Herschel in his paper "On the Chemical Action of the Rays of the Solar Spectrum on Preparations of Silver and Other Substances, Both Metallic and Non-metallic, and on Some Photographic Processes," *Philosophical Transactions of the Royal Society of London* 130 (1840): 3.

18. William Henry Fox Talbot, quoted in "The New Art," *Literary Gazette,* February 2, 1839, 74.

19. Schaaf claims that although Talbot was familiar with the concept of the negative/positive process as early as 1835, he might have attained positive images only from contact images. Larry Schaaf, *The Photographic Art of William Henry Fox Talbot* (Princeton, N.J.: Princeton University Press, 2000), 50. Schaaf bases this observation on a letter Talbot wrote to Herschel on April 27, 1839, in which he states, "I have found that the Camera pictures transfer very well, & the resulting effect is altogether Rembrandtish." The letter is transcribed as document 3872 in the website *The Correspondence of William Henry Fox Talbot,* http://foxtalbot.dmu .ac.uk/letters/transcriptDocnum.php?docnum=3872. The original letter is in the collection of Herschel's papers in the Royal Society, London, HS 17:293.

20. The inventory is reproduced in Mike Weaver, ed., *Henry Fox Talbot: Selected Texts and Bibliography* (Oxford: Clio Press, 1992), 58.

21. Talbot, *Pencil of Nature,* n.p.

22. Hunt, *Popular Treatise,* 33.

23. Anonymous review of *The Pencil of Nature, Literary Gazette,* January 10, 1846, 38 (emphasis added).

24. "The Talbotype—Sun Pictures," *Art-Union,* June 1846, 143 (emphasis added).

25. Gilles Deleuze, *Difference and Repetition,* trans. Paul Patton (New York: Columbia University Press, 1994), 129–67. Subsequent citations of this source appear parenthetically in this passage of the text.

26. Claudet, "Progress of Photography," 207–8 (emphasis added). Claudet was a French-born merchant and professional photographer who lived in London and developed a method to increase the sensitivity of the daguerreotype plate. In his text Claudet refers to the daguerreotype plate in the camera obscura. Still, his observations hold for the paper negative as well, because light affects sensitive surfaces made of paper and of metal in a similar manner. The difference lies in the degree of sensitiveness of the chemical solution that is applied to the surface upon which the picture is impressed, and this determines only the speed of the action of light, not the nature of the action.

27. William Henry Fox Talbot, quoted in *The Literary Gazette* 1150 (February 2, 1839), p. 73.

28. William Henry Fox Talbot, "The Process of Calotype Photogenic Drawing," in *Photography: Essays and Images*, ed. Beaumont Newhall (New York: Museum of Modern Art, 1980), 34.

29. On Deleuze's notion of transcendental empiricism, see Bruce Baugh, "Deleuze and Empiricism," *Journal of the British Society for Phenomenology* 24, no. 1 (January 1993): 15–31; Patrick Hayden, *Multiplicity and Becoming: The Pluralist Empiricism of Gilles Deleuze* (New York: Peter Lang, 1998); John Rajchman, introduction to *Pure Immanence: Essays on a Life,* by Gilles Deleuze (New York: Zone Books, 2001), 7–23; and Jeffrey Bell, *Deleuze's Hume: Philosophy, Culture, and the Scottish Enlightenment* (Edinburgh: Edinburgh University Press, 2009).

30. Baugh, "Deleuze and Empiricism," 16.

31. Ibid., 16–17.

32. Ibid., 24 (emphasis added).

33. See Gilles Deleuze's *Empiricism and Subjectivity: An Essay on Hume's Theory of Human Nature*, trans. Constantin V. Boundas (New York: Columbia University Press, 1991); see also his essay "Hume," in *Pure Immanence*, 35–52.

34. Deleuze, "Hume," 37 (emphasis in original).

35. Ibid., 39.

36. Bell, *Deleuze's Hume*, 34.

37. Deleuze, "Hume," 40.

38. Ibid., 42–43.

39. Talbot, "Process of Calotype Photogenic Drawing," 35 (emphasis added).

40. Talbot's statement appears in a letter he sent to the editor of the *Literary Gazette,* February 15, 1841, 108 (emphasis added).

41. Talbot, *Pencil of Nature*, n.p.

42. Deleuze, *Difference and Repetition*, 15.

43. On the social and cultural history of botany in Britain, see David Elliston Allen, *The Naturalist in Britain: A Social History* (Princeton, N.J.: Princeton University Press, 1976); and Keith Thomas, *Man and the Natural World: A History of Modern Sensibility* (New York: Pantheon, 1983). See also Ann Bermingham, *Learning to Draw: Studies in the Cultural History of a Polite and Useful Art* (London: Yale University Press, 2000), 202–27.

44. Anne Secord, "Botany on Plate: Pleasure and the Power of Pictures in Promoting Early Nineteenth-Century Scientific Knowledge," *Isis* 1 (March 2002): 28.

45. Ibid., 32, 52.

46. Ibid., 35.

47. Anne Secord, "Talbot's First Lens: Botanical Vision as Exact Science," in *William Henry Fox Talbot: Beyond Photography*, ed. Mirjam Brusius, Katrina Dean, and Chitra Ramalingam (New Haven, Conn.: Yale Center for British Art, 2013), 42, 44–46.

48. Gill Saunders, *Picturing Plants: An Analytical History of Botanical Illustration* (London: Victoria and Albert Museum; Berkeley: University of California Press), 14. On the history of botanical illustrations, see also Wilfred Blunt, *The Art of Botanical Illustration* (London: Collins, 1950).

49. On Linnaeus's system of classification and its reception in England see Allen, *Naturalist in Britain*, 35–37.

50. Saunders, *Picturing Plants*, 92.

51. Peter Galison, "Judgment against Objectivity," in *Picturing Science, Producing Art*, ed. Caroline A. Jones and Peter Galison (New York: Routledge, 1998), 332 (emphases in original).

52. Lorraine Daston and Peter Galison, *Objectivity* (New York: Zone Books, 2007), 58.

53. Ibid., 60.

54. Ibid., 105.

55. Ibid. This is also argued by Saunders, *Picturing Plants*, 12.

56. Daston and Galison, *Objectivity*, 125.

57. Talbot's letter to Hooker is transcribed as document 3845 in the website *The Correspondence of William Henry Fox Talbot*, http://foxtalbot.dmu.ac.uk/letters/trans criptDocnum.php?docnum=3845. The original letter is in the collection of the Royal Botanic Gardens in London.

58. Ibid., document 3895, http://foxtalbot.dmu.ac.uk/letters/transcriptDocnum .php?docnum=3895. The original letter is in the Fox Talbot Collection, British Library, London.

59. On this correspondence, see Graham Smith, "Talbot and Botany: The Bertoloni Album," *History of Photography* 17, no. 1 (Spring 1993): 33–43. On Talbot's botanical images, see Douglas R. Nickel, "Nature's Supernaturalism: William Henry Fox Talbot and Botanical Illustration," in *Intersections: Lithography, Photography, and the Traditions of Printmaking*, ed. Kathleen Stewart Howe (Albuquerque: University of New Mexico Press, 1998), 15–23.

60. Secord, "Talbot's First Lens," 60.

61. See Armstrong, "Cameraless."

62. Armstrong, *Scenes in a Library*, 207.

63. Armstrong, "Cameraless," 93 (emphasis in the original).

64. Rajchman, introduction, 15.

65. Schaaf, *Photographic Art of William Henry Fox Talbot*, 52.

66. On the relation between Talbot's botanical and lace images, see Nickel, "Nature's Supernaturalism," 19–20.

67. In January 1839, Talbot sent a letter to Hooker with photogenic drawings of lace, asking him to take it to Glasgow and "show it to some of the manufactures." The letter is transcribed as document 3772 in the website *The Correspondence of William Henry Fox Talbot*, http://foxtalbot.dmu.ac.uk/letters/transcriptDocnum.php ?docnum=3772. The original letter is in the collection of the Royal Botanic Gardens in London.

68. Deleuze, *Difference and Repetition*, 295–96.

69. Talbot, "Some Account," 39.

70. Rosalind Krauss, "A Note on Photography and the Simulacral," in *The Critical Image: Essays on Contemporary Photography*, ed. Carol Squiers (Seattle: Bay Press, 1990), 24 (emphasis in original).

71. Ibid.

72. Crary, *Techniques of the Observer*, 133–36 (emphasis added).

73. Anonymous review of *The Pencil of Nature, Athenæum,* February 22, 1845, 203 (emphasis added).

74. Herschel, "On the Chemical Action," 1.

75. The letter is transcribed as document 3805 in the website *The Correspondence of William Henry Fox Talbot,* http://foxtalbot.dmu.ac.uk/letters/transcript Docnum.php?docnum=3805. The original letter is in the Talbot Collection at the National Media Museum, Bradford, England.

76. John Herschel, "On the Action of the Rays of the Solar Spectrum on Vegetable Colours, and on Some New Photographic Processes," *Philosophical Transactions* 132 (1842): 181–82. Subsequent citations of this source appear parenthetically in this passage of the text.

77. John Herschel, "On the Hyposulphurous Acid and Its Compounds," *Edinburgh Philosophical Journal* 1 (June 1819): 8–29.

78. On Talbot's and Herschel's different conceptions of fixing, see Schaaf, *Photographic Art of William Henry Fox Talbot,* 20.

79. Herschel wrote to Talbot from Paris on May 9, 1839, stating that the daguerreotypes were "miraculous": "Certainly they surpass anything I could have conceived as within the bounds of reasonable expectation. The most elaborate engraving falls far short of the richness & fidelity which sets all painting at an immensurable distance." Yet after his initial enthusiasm subsided, he wrote to Talbot on July 6, 1839, "After reflexion I feel no way disposed to abate in my admiration. However that has not prevented my wishing that the processes which have paper for their field of display should be perfected, as I do not see how else the multiplication of copies can take place, a branch of the photographic art which Daguerre's processes do not . . . admit of. " The letters are transcribed as documents 3875 and 3905 in the website *The Correspondence of William Henry Fox Talbot,* http://foxtalbot.dmu.ac.uk/letters/transcriptDocnum.php?docnum=3875 and http://foxtalbot.dmu.ac.uk/letters/transcriptDocnum.php?docnum=3905, respectively. The original letters are in Talbot's collection at The National Media Museum, Bradford, England

80. Larry Schaaf suggests that the image is round because Herschel might have employed a circular telescope tube as a makeshift camera. See his "The Poetry of Light," in *John Herschel, 1792–1871: A Bicentennial Commemoration,* ed. D. G. King-Hele (London: Royal Society, 1992), 98n30. See also Schaaf, *Out of the Shadows,* 85–88.

81. Josef Maria Eder, *History of Photography,* trans. Edward Epstean, 4th ed. (New York: Dover, 1945), 92.

82. Ibid., 103–5.

83. Elizabeth Fulhame, *An Essay on Combustion; with a View to a New Art of Dying and Painting* (London: J. Cooper, 1794), iii–vii. On Fulhame's biography and experiments, see Schaaf, *Out of the Shadows,* 23.

84. On Herschel's discovery of the cyanotype, see Mike Ware, "John Herschel's Cyanotype: Invention or Discovery?," *History of Photography* 22, no. 4 (Winter 1998): 371–79.

85. On Atkins's botanical books of British algae, see Larry Schaaf, *Sun Gardens: Victorian Photograms* (New York: Aperture, 1985); see also Armstrong's analysis of Atkins's albums in her *Scenes in a Library*, 179–276.

86. The letter is transcribed as document 4778 in the website *The Correspondence of William Henry Fox Talbot*, http://foxtalbot.dmu.ac.uk/letters/transcriptDoc num.php?docnum=4778. The original letter is in the Talbot Collection at the National Media Museum, Bradford, England.

87. Ibid. The name *Amphitype* was later used by Talbot for another photographic process, in which the same photograph can be viewed simultaneously as positive or negative, and it eventually became known in the 1850s as an additional name for collodion direct positives.

88. Schaaf, *Out of the Shadows*, 133.

89. John Herschel, "On Sensorial Vision," in *Familiar Lectures on Scientific Subjects* (London: Alexander Strahan, 1866), 401. Subsequent citations of this source appear parenthetically in this passage of the text.

90. Johann Wolfgang von Goethe, *Theory of Colours*, trans. Charles Lock Eastlake (1810; repr., London: F. Cass, 1967), 298.

91. Dennis Sepper, *Goethe contra Newton* (Cambridge: Cambridge University Press, 1988), 12.

92. Ibid., 91.

93. Goethe, *Theory of Colours*, 3.

94. Ibid., 7.

95. Crary, *Techniques of the Observer*, 69.

96. Andre Jammes and Eugenia Parry Janis, *The Art of French Calotype: With a Critical Dictionary of Photographers, 1845–1870* (Princeton, N.J.: Princeton University Press, 1983), xi.

97. Abigail Solomon-Godeau criticizes Jammes and Janis's efforts to produce an exclusively aesthetic discourse for nineteenth-century paper photography. See her "Calotypomania: The Gourmet Guide to Nineteenth-Century Photography," in *Photography at the Dock: Essays on Photographic History, Institutions, and Practices* (Minneapolis: University of Minnesota Press, 1991), 4–27. Although I agree with her criticism, I also support Jammes and Janis's claim regarding the richness of photographic experimentation in the early nineteenth century, and their implied criticism of linear histories of photography.

98. On these legal battles, see H. J. P. Arnold, *William Henry Fox Talbot: Pioneer of Photography and Man of Science* (London: Hutchinson Benham, 1977), 175–216; see also R. Derek Wood, "J. B. Reade, F. R. S., and the Early History of Photography, Part II: Gallic Acid and Talbot's Calotype Patent," *Annals of Science* 27, no. 1 (March 1971): 47–83.

99. Hunt, *Popular Treatise*, v.

100. Ibid.

101. Ibid., 26.

102. Ibid., 12–13.

103. Robert Hunt, *Photography: A Treatise of the Chemical Changes Produced by Solar Radiation, and the Production of Pictures from Nature, by the Daguerreotype, Calotype, and Other Photographic Processes*, in *Encyclopædia Metropolitana*, 2nd rev. ed., vol. 16 (London: John Joseph Griffin, 1851), vii.

104. Ibid., 6.

105. Jean Biot, quoted in ibid., 69–70.

106. Hunt, *Photography*, 72–73 (emphasis added).

107. Hunt, *A Manual of Photography*, 3rd ed., in *Encyclopædia Metropolitana*, 2nd ed., vol. 16 (London: John Joseph Griffin, 1853).

108. Hunt, preface to *A Manual of Photography*, 4th ed., in *Encyclopædia Metropolitana*, 2nd ed., vol. 16 (London: Richard Griffin, 1854).

109. This organizational change is responsive to the many priority debates and trials surrounding new inventions in photography during the 1850s. Hunt was involved in efforts to dismantle Talbot's 1841 calotype patent, because it was perceived to be a major obstacle to the establishment of the Royal Photographic Society.

110. For a historiography of early and canonical histories of photography (by Newhall and Gernsheim), see Martin Gasser, "Histories of Photography, 1839–1939," *History of Photography* 16, no. 1 (Spring 1992): 50–60.

4. History

1. In his introduction to the 1969 republication of *The Pencil of Nature*, Beaumont Newhall states, "It is the first book illustrated with photographs and the first mass production of photographs." In this standard account of the book in classical histories of photography, *Pencil*'s conception and function are determined by what photographically illustrated books became in the modern era. Beaumont Newhall, introduction to *The Pencil of Nature*, by William Henry Fox Talbot (1844; repr., New York: Da Capo Press, 1969), n.p.

2. Larry Schaaf, commentary volume to *The Pencil of Nature: Anniversary Facsimile* (New York: Hans P. Kraus Jr., 1989), 9. See also Schaaf, "Third Census of H. Fox Talbot's *The Pencil of Nature*," *History of Photography* 36, no. 1 (February 2012): 99–120.

3. On the Reading establishment, see Nancy Keeler, "Inventors and Entrepreneurs," *History of Photography* 26, no. 1 (Spring 2002): 29–30. In 1844, when the production of *Pencil* started, Schaaf explains, "Each sheet of paper went through several technical steps (all applied by hand) and the number of variables that could creep in was astounding. Even the paper itself was a fickle base. It varied in chemical content, wet strength, and absorbency, and there was very little . . . Talbot could do to control what was purchased." Commentary volume, 25.

4. Schaaf, commentary volume, 27–35.

5. Ibid., 35.

6. The letter is transcribed as document 3843 in the website *The Correspondence of William Henry Fox Talbot*, http://foxtalbot.dmu.ac.uk/letters/transcriptDocnum

.php?docnum=3843. The original letter is in Herschel's papers in the Royal Society, London.

7. Ibid., document 3987, http://foxtalbot.dmu.ac.uk/letters/transcriptDocnum .php?docnum=3987. The original letter is in Herschel's papers in the Royal Society, London.

8. Larry Schaaf, *Out of the Shadows: Herschel, Talbot, and the Invention of Photography* (London: Yale University Press, 1992), 138.

9. Talbot, *The Pencil of Nature*, n.p. See also Herta Wolf, "Nature as Drawing Mistress," in *William Henry Fox Talbot: Beyond Photography*, ed. Mirjam Brusius, Katrina Dean, and Chitra Ramalingam (New Haven, Conn.: Yale Center for British Art, 2013), 126–29.

10. Ian Jeffrey argues that "*The Pencil of Nature* is by turns a romantic family history, an advertising brochure, antiquarian tract, guidebook, news sheet and rudimentary technical treatise." Ian Jeffrey, *Photography: A Concise History* (New York: Oxford University Press, 1981), 12.

11. Talbot, *The Pencil of Nature*, n.p. (emphasis added). Subsequent citations of this unpaginated source appear in the text.

12. I am referring to Michel Foucault's distinction between "monuments" and "documents" in his *The Archaeology of Knowledge*, trans. A. M. Sheridan Smith (London: Routledge, 1992), 7. See also the Introduction to this volume.

13. In his comments to Plate 13, "Queen's College, Oxford," Talbot states that sometimes after an image is taken, the photographer notices details he was not aware of when taking the image. In the case of this image, Talbot notices that it includes a "distant dial-plate" that allows him to determine the precise time the view was taken. Talbot, *The Pencil of Nature*, n.p.

14. Stephen Bann, *Romanticism and the Rise of History* (New York: Twayne; Toronto: Maxwell Macmillan, 1995), 11. See also his *The Clothing of Clio: A Study of the Representation of History in Nineteenth-Century Britain and France* (Cambridge: Cambridge University Press), 1984; and *The Inventions of History: Essays on the Representation of the Past* (Manchester, Eng.: Manchester University Press, 1990).

15. Bann, *Romanticism and the Rise of History,* 6–7.

16. Ibid., 18. This is also suggested in Philippa Levine, *The Amateur and the Professional: Antiquarians, Historians, and Archaeologists in Victorian England, 1838–1886* (Cambridge: Cambridge University Press, 1986), 3.

17. Thomas Macaulay, "Hallam," in *Critical and Historical Essays* (London: Electric Book Company, 2001), 1:10.

18. Maurice Mandelbaum, *History, Man, and Reason* (Baltimore: Johns Hopkins University Press, 1971), 52.

19. Hayden White, *Metahistory: The Historical Imagination in Nineteenth-Century Europe* (Baltimore: Johns Hopkins University Press, 1973), 69.

20. On the relations between Hume's *Treatise* and *The History of England,* see S. K. Wertz, "Hume, History, and Human Nature," *Journal of the History of Ideas* 36, no. 3 (July–September 1975): 481–96.

21. F. R. Ankersmit, "Historicism: An Attempt at Synthesis," *History and Theory* 34, no. 3 (October 1995): 146.

22. White, *Metahistory*, 75.

23. Mandelbaum, *History, Man, and Reason*, 55.

24. Lionel Gossman, "History as Decipherment: Romantic Historiography and the Discovery of the Other," *New Literary History* 18, no. 1 (Autumn 1986): 24.

25. Ibid., pp. 24–25.

26. Thomas Macaulay, "History," in *Critical, Historical, and Miscellaneous Essays* (Boston: Houghton Mifflin, 1860), 1:376–77. Subsequent citations of this source in this passage appear parenthetically in the text.

27. On the relations between Macaulay and Scott, see Mark Philips, "Macaulay, Scott, and the Literary Challenge to Historiography," *Journal of the History of Ideas* 50, no. 1 (January–March 1989): 117–33.

28. Macaulay, "Hallam," 10–11.

29. Georg Lukács, *The Historical Novel*, trans. Hannah Mitchell and Stanley Mitchell (Lincoln: University of Nebraska Press, 1983), 42.

30. On Scott's historicism, see Harry E. Shaw, *The Forms of Historical Fiction: Sir Walter Scott and His Successors* (Ithaca, N.Y.: Cornell University Press, 1983), 100–252; see also David Brown, *Walter Scott and the Historical Imagination* (London: Routledge & Kegan Paul, 1979).

31. Ina Ferris, "Story-Telling and the Subversion of Literary Form in Walter Scott's Fiction," in *Critical Essays on Sir Walter Scott: The Waverley Novels*, ed. Harry E. Shaw (New York: G. K. Hall; London: Prentice Hall International, 1997), 101.

32. Ibid., 102.

33. Ibid., 106.

34. Ann Rigney, *Imperfect Histories: The Elusive Past and the Legacy of Romantic Historicism* (Ithaca, N.Y.: Cornell University Press, 2001), 127.

35. Ibid., 130.

36. On Talbot's first book, see H. J. P. Arnold, *William Henry Fox Talbot: Pioneer of Photography and Man of Science* (London: Hutchinson Benham, 1977), 53–54.

37. William Henry Fox Talbot, *Hermes; or, Classical and Antiquarian Researches* (London: Longman, Orme, Brown, & Longman, 1838), vii. Talbot sent a copy of the book to Macaulay, with whom he was corresponding for a while, and Macaulay urged him to "undertake some extensive work," like a translation of Herodotus. The letter from October 1838 is transcribed as document 3734 in the website *The Correspondence of William Henry Fox Talbot*, http://foxtalbot.dmu.ac.uk/letters/transcriptDocnum.php?docnum=3734. The original letter is in the Fox Talbot Collection, British Library, London.

38. A segment of Talbot's *The Antiquity of the Book of Genesis* appears in *Henry Fox Talbot: Selected Texts and Bibliography*, ed. Mike Weaver (Oxford: Clio Press, 1992), 42.

39. William Henry Fox Talbot, *English Etymologies* (London: John Murray, 1847), vi.

40. Ibid. (emphasis added).

41. On Talbot's *Sun Pictures in Scotland* (1845), see Graham Smith, "Views of Scotland," in Weaver, *Henry Fox Talbot,* 117–24. See also his "In the Shadow of Scott: Talbot and the Wizard of the North," in Brusius, Dean, and Ramalingam, *William Henry Fox Talbot*, 95–115.

42. Michel Foucault, *The Order of Things: An Archaeology of the Human Sciences* (1966; repr., New York: Vintage, 1994), 371.

43. Carol Armstrong, *Scenes in a Library: Reading the Photograph in the Book, 1843–1875* (Cambridge, Mass.: MIT Press, 1998), 142.

44. Ibid., 143 (emphasis added).

45. Robin Kelsey argues against Armstrong's reliance on positivism in her discussion of *The Pencil of Nature.* He states that although August Comte emphasized the invariability of natural and social laws, Talbot's comments "run counter" to Comte, because they acknowledge the "inherent variability of photography" and the "interventions of chance." See Robin Kelsey, "Photography, Chance, and *The Pencil of Nature*," in *The Meaning of Photography*, ed. Robin Kelsey and Blake Stimson (Williamstown, Mass.: Sterling and Francine Clark Art Institute; New Haven: Yale University Press, 2008), 27.

46. Michel de Certeau, *The Writing of History*, trans. Tom Conley (New York: Columbia University Press, 1988), 3.

47. Talbot, *Hermes*, 168.

48. Geoffrey Batchen discusses these images in his "A Philosophical Window," *History of Photography* 26, no. 2 (Summer 2002): 105.

49. On Talbot's choice of objects for photographing as well as his habit of photographing his domestic possessions, see Julia Ballerini, "Recasting Ancestry: Statuettes as Imaged by Three Inventors of Photography," in *The Object as Subject: Studies in the Interpretation of Still Life*, ed. Anne W. Lowenthal (Princeton, N.J.: Princeton University Press, 1996), 50–54.

50. This inventory appears in Larry Schaaf, *The Photographic Art of William Henry Fox Talbot* (Princeton, N.J.: Princeton University Press, 2000), 190.

51. Rigney, *Imperfect Histories*, 35.

52. Armstrong argues that Talbot chose this image because he wanted to emphasize the fact that *The Pencil of Nature* was itself a book that forms part of a library. See her "A Scene in a Library: An Unresolved Mystery," *History of Photography* 26, no. 2 (Summer 2002): 90–99.

53. Foucault, *The Order of Things,* 329 (emphasis added).

54. Ibid., 372 (emphasis added).

Index

Abbri, Ferdinando, 230n27
Abrams, M. H., 63, 75, 231n42
abstraction: views of photographic
 image as exhibiting new form of
 visual, 94–95
"Account of a Method of Copying
 Paintings upon Glass, and of
 Making Profiles, by the Agency of
 Light upon Nitrate of Silver, An"
 (Davy and Wedgwood), 51
adaptation: resemblance as process
 of, 77
aesthetic judgments: debates over
 nature of, 99; increased role of
 imagination in formation of,
 104–5; Kant's formulation of, 61, 74,
 109, 126; underlying instability of,
 107, 110
aesthetics: aesthetic form of
 empiricism, 126–28; Baumgarten's
 definition of, 61; camera obscura as
 aesthetic emblem, 79; Coleridge's
 philosophical and aesthetic method,
 63–73, 80–81; criticality and, xx–
 xxii; Deleuze on, xxi, 110, 147,
 148; Kant's discussion of "aesthetic
 ideas," 61–62; as paradoxical
 form of knowledge, xxi, 52, 109;

photogenic drawing as aesthetic
 idea, 108; the picturesque as
 intermediary category between the
 beautiful and the sublime, xxiv,
 98–101; relations between photogra-
 phy and, 109–10; romantic aesthetic
 opposition between copying and
 imitation, 75–77, 115; as "science of
 the sensible," 147–48
Agassi, Joseph, 16, 225n33
*Aged Red Cedar on the Grounds of
 Mt. Edgcumbe, An* (Talbot), 91, 92
Airy, George, 13, 15
Alborn, Timothy L., 27, 226n63
Alison, Archibald, 104
allegory: Coleridge's privileging of
 symbol over, 79–80, 125
Allen, David Elliston, 239n43
amateur: botany as pastime activity
 for, 130–31; Gilpin's picturesque
 travel for amateur artist, 84–86, 102,
 104, 107; "man of science," 16, 30,
 49, 84, 86; photography for, 83, 166,
 167, 171; professionalization of
 photography in 1850s, 168–71;
 professional scientist distinct from,
 16, 49
ammonio-citrate of iron, 156

Amphitype, 159, 242n87
analysis: Continental analysis method, 30, 227n72; as universal method of knowledge, 17–18
Analytical Engine, Babbage's, 33, 34, 35; religious implications of programming, 34
Analytical Inquiry into the Principles of Taste, An (Knight), 99, 104–7; "Association of Ideas," 106–7; "On Sensation," 105
Analytical Society, 29–30, 227n72
analytics: field of, 227n72
Ankersmit, F. R., 180, 244n21
antiquarianism, 184–86; Talbot's intellectual commitment to literary, 185, 195
Antiquity of the Book of Genesis, The (Talbot), 185
Aristotle, 136
Armstrong, Carol, 146, 187, 221n21, 223n6, 223n10, 237n14, 242n85, 246n43, 246n45, 246n52; attribution of essential ontology to photograph as indexical sign, xvii, 136; on cameraless photographs of botanical specimens, xvii, 135–36; on photograph's unique ability to authenticate, 22–23, 136, 187–88
Arnold, H. J. P., xiii, 41–42, 220n10, 225n28, 229n8, 242n98, 245n36
Arnold, Thomas, 48
art: in Coleridge's definition of imagination, 70, 75; Gilpin on imagination and sense of pleasure triggered by, 103–4; Kant's definition of genius within realm of fine, 60–62; of picturesque landscape, 83–84, 101–2, 106–7, 235n94
"Articles of China" (Talbot), 186–88, 190
"Articles of Glass" (Talbot), 190
Art-Union: reviews in, 94, 118–19, 129
Ashworth, William J., 31, 227n72

associationism: Coleridge and, 64, 66–67, 81; Hartley's and Priestley's physiological and neurological theory of association, 64, 66; imagination in associationist psychology, 104, 106–7; picturesque representation in associationist theories of taste, 108; universal principles of association, 19–20, 66, 67, 77, 127, 128. *See also* causality; resemblance
Astronomical Society of London, 31
Astronomy and General Physics Considered with Reference to Natural Theology (Whewell), 33–34
atheistic skepticism: Reid's defense of Scottish Presbyterianism against, 8, 9, 19
Athenæum, 90
Atkins, Anna, 158, 242n85
Auer, Alois, 135
automation, 25

BAAS. *See* British Association for the Advancement of Science
Babbage, Charles, xiii, xxiii, 6, 27, 28, 49, 132, 180, 226nn58–59, 227n70, 227n76, 228n79, 228n83; on advantages of machinery to manufacture, 25–26, 32–33, 114; Analytical Engine project, 33, 34, 35; Analytical Society and, 29–30, 227n72; invention of Difference Engine, 31, 228n77; mechanization of intelligence, project of, 31–36, 53, 228n88; scientific knowledge as ultimate engine of technological progress for, 32–33
Bacon, Francis, 7–8, 9, 78, 179, 224n13; formulation of scientific method, 7–8, 12, 26, 31; theory of idols as prejudices, 7, 17; Whewell's criticism of, 47
Ballerini, Julia, 246n49
Band of Lace (Talbot), 140–41

Bann, Stephen, 178–79, 244n14
Barrel, John, 235n94
Barrow-Green, June, 30, 221n18,
 227n71
Barthes, Roland, 22–23, 24, 226n50;
 essentialist theory of photography,
 xvii, xviii; notion of the index, 22,
 221n22
Batchen, Geoffrey, 63, 116, 220n12,
 221n16, 222n25, 223n10, 226n58,
 231n44, 232n51, 237n13, 246n48;
 analysis of metaphorical language
 and rhetoric of Talbot's discovery
 texts, xv; on common history of
 photography and early computers,
 228n88; on historical transforma-
 tions in meaning of camera obscura
 and of mirrors, 234n87
Baudrillard, Jean, 147
Baugh, Bruce, 126, 239n29
Baumgarten, Alexander, 61
beauty: Burke on the "beautiful," 85,
 105; Hume on, 104; Kant on judg-
 ments of, 59–60, 61; picturesque
 as form of, 85, 104–7
Beddoes, Thomas, 64
beliefs: Hume's concept of imagination
 and, xi, 127–28
Bell, Jeffrey, 127, 239n29
Berg, Maxine, 28, 29, 226n67
Bergson, Henri-Louis, 234n86
Berman, Morris, 226n64
Bermingham, Ann, 83–84, 235n92,
 239n43
Bertoloni, Antonio, 134
Biographia Literaria (Coleridge),
 233n69; definition of imagination
 in, 67–70, 74–75; early political and
 philosophical associations discussed
 in, 63–65; on the picturesque,
 99–100, 101
Biot, Jean, 169–70, 171, 243n105
Blunt, Wilfred, 239n48
Bossi, Maurizio, 230n26

botanical imagery in Talbot's work,
 xxv, 123–26, 129–49, 172; failure of
 early photograph to function as
 botanical illustration, 134, 143–47;
 inherent productivity of nature
 inscribed in photograph's mode of
 production of, 143; lace images and,
 140–43, 240n66; modes of arrange-
 ment and delimitation underlining
 compositional aspects of, 123–24,
 139–43; temporal encounter
 between photographic image and
 nature in, 130, 137–38. See also
 botany, science of
Botanical Specimen (Talbot), 142
Botanical Specimen (Sprig of Fennel)
 (Talbot), 145–46
Botanical Specimen (Sprig of Mimosa)
 (Talbot), 143–45
botany, science of, 71, 234n82, 239n43;
 nature printing and, 134–35;
 popularization of, in 1830s, 130, 131;
 role of botanical illustrations, 130–
 33, 134, 239n48; as science of
 classification, 130, 137; "true-to-
 nature" approach in, 132–33
Bowles (poet), 196
Branch of Leaves of Mercuriàlis Pérennis
 (Talbot), 139–40, 141
Breakfast Table, Set with Candlesticks,
 A (Talbot), 96–98
Brennan, Matthew, 236n113
Brewster, David, xiii, 13, 15, 226nn48–
 49, 228n89; comprehensive account
 of photography, 36–37; on "natural
 magic," 22; romantic definition of
 discoverer as genius underlying
 historical and biographical studies
 by, 50–51
Bridgewater treatises, 33–35, 228n88
"Brief Description of the Photogenic
 Drawings Exhibited at the Meeting
 of the British Association, A"
 (Talbot), 202

"Brief Historical Sketch of the
 Invention of the Art, A" (Talbot),
 xxiii–xxiv, 39–41, 42, 43; focus on
 "original idea," 39–40; influence
 of Whewell's *History* on, 49–50;
 nature viewed as picture in, 42,
 82–108
British Association for the Advance-
 ment of Science (BAAS), 6, 27, 49,
 117, 171, 229n8
Bromley, Alan G., 228n77
Brougham, Henry, 15
Brown, David, 245n30
Brown, John, 64
Brown, Thomas, 8
Brusius, Mirjam, 221n17
Bryonia dioca (Talbot), 138–39, 143
Buchwald, Jed Z., 224n26
Buckland, Gail, 220n10
Burke, Edmund, 59, 60; on beauty, 85,
 105
*Burning with Desire: The Conception of
 Photography* (Batchen), xv
"Bust of Patroclus" (Talbot), 83

Cabinet Cyclopaedia (Lardner), 6
calotype, xii–xiii, 25, 39, 89, 90, 149,
 165, 223n2, 228n1; Biot's presenta-
 tion of, in Academy of Science
 in Paris, 169–70, 171; chrysotype
 compared to, 159; Hunt's efforts to
 dismantle Talbot's patent for, 166,
 243n109; productivity of calotype
 negative, 128–29; Talbot's
 announcement of discovery of, 122–
 23. *See also Pencil of Nature, The*
 (Talbot)
Cambridge University, 16, 28, 41, 50;
 Analytical Society at, 29–30, 227n72;
 reforms of mathematics at, 30,
 227n72
cameraless images, xvii, 92, 123–24,
 134, 135–36, 137
Camera Lucida (Barthes), 22

camera obscura, 77–80, 234n88; asso-
 ciation of early photograph with, ix,
 x; Gilpin on imagination linked to,
 104; historical shift in meaning of,
 xv, xxiv, 234n87; image of, as sym-
 bol, 79–80; image of, philosophical
 premises of "representation" as
 form of knowledge manifested in,
 xvi; image of, shift in epistemologi-
 cal status as "picture of nature," 52,
 73, 77–79, 81–82, 108, 113; image of,
 time as differentiating element
 between photographic image and,
 xxiv, 116, 120–22, 165; as model
 of vision, 78, 120, 121; primary
 function of, 78; Talbot's "developed-
 out process" and use of, xiii, 223n2,
 228n1; Talbot's second account of
 discovery and, 39–40, 50, 73, 113
Cannon, Susan Faye, 226n64
Cannon, Walter F., 224n24
Cantor, Geoffrey N., 225n29, 229n17;
 on theories of light, 13–14, 16; on
 Whewell, 45–49
Carlyle, Thomas, 178
Cascade of Spruce Needles, A (Talbot),
 123–24, 138, 141
causality: Herschel's notion of, 224n24;
 Hume's concept of, xi, 10, 20, 24,
 126, 127–28; Reid's inductive
 principle and, 9–10
celænotype: Herschel's invention of,
 159
Certeau, Michel de, 188, 246n46
change: Enlightenment vs. romantic
 view of, 180
chemistry: Davy's defense of, 51;
 Herschel's vegetable photography
 and exploration of, 149–65; Hunt
 on photographic chemical processes,
 168; as model for Coleridge's
 conception of science, 71–72,
 232n59; as science of forces, 137
Chen, Xiang, 225n29

chromatype, 149
chrysotype, 149; Herschel's discovery
of, 156, 158–59
classical episteme, 53; sovereign trans-
parency of classical vs. modern
cogito, 55–56
class identity in England, 83
classification: botanical photograph
and, 136; botany as classificatory
science, 130, 137; Linnaean system
of, 131, 240n49
Claudet, Antoine, xii, 114, 120, 121,
122, 164, 237n8, 238n26
"Cloisters of Lacock Abbey, The"
(Talbot), 87, 194–95, 196
cogito: classical vs. modern, 55–56
Coleridge, Samuel Taylor, xi, 62,
231n48, 232n56, 233nn66–69,
234n81; associationism and, 64,
66–67, 81; central opposition
between mechanical copying and
organic imitation for, 75–77, 81,
115, 182; chemistry as model for
conception of science, 71–72,
232n59; criticism of empiricism, 44,
65, 66–67, 81; definition of life,
74–75, 233n67; difference between
observation and mediation for, 76;
early political and philosophical
affiliations, 63–66; imagination,
notion of, xxi, xxiv, 42, 52, 63–70,
73, 74–75, 79, 104, 115, 125, 231n45,
232n59; influence on Whewell,
47–48, 49, 63, 67, 68, 229n18,
230n19; Kant's influence on, 67–68;
on law vs. theory, 71; life of the
imagination for, 73–82; philo-
sophical and aesthetic method,
63–73, 80–81; philosophical genius,
meaning in context of chemistry,
71–72; on the picturesque, 99–100,
101; privileging of symbol over
allegory, 79–80, 125; redefinition
of resemblance, 76–77; unified

system of knowledge, 68, 70–72,
234n84
color: as contested issue in European
scientific community, 162–63; as
main subject of Herschel's photo-
graphic experiments, 152, 154, 155,
162
Commercium Philosophico-Technicum
(Lewis), 154
common sense: Kant on, 59; Reid's
inductive principle as principle of,
9–10, 17, 18–19
Common Sense philosophy, xxiii;
indebtedness of Herschel's *Discourse*
to, 8–10, 12–13
Comte, August, 246n45
conceptual recognition: synthesis of, 57
contact printing, 25, 113, 117, 140,
238n19
Continental analysis method, 30,
227n72
continuity, law of, 5–16, 24; Babbage's
project of mechanization of intel-
ligence and, 35–36; Brewster on, 36;
Foucault on, 78; Herschel on,
11–13, 17, 18, 20–21, 164, 180; leg-
ibility of nature and, 102; Reid's
inductive principle and, 18–19;
representation and, 17–18, 20–21,
24, 35–36; Talbot's second account
of discovery beyond, 40
copying: central opposition in
Coleridge's aesthetic theory between
organic imitation and mechanical,
75–77, 115, 182; as model to mecha-
nization, 25–26; natural copy, idea
of, 136–37, 146; perception as copy-
ing process, in Hume's *Treatise,* 67;
Plato's idea of "true copy," 136;
simulacrum as failed copy, 116, 129,
146–49; Talbot's conceptualization
of photogenic drawing as method
of, xii, xxiii, 5, 25, 32, 36, 114–16,
175–76, 220n6

Copy of an Engraving (chrysotype)
(Herschel), 158
Copy of an Engraving (cyanotype)
(Herschel), 157
*Copy of an Engraving Made with the
Juice of the Petals of Mathiola annua*
(Herschel), 155
Corrigan, Timothy, 233n69
Crary, Jonathan, 82, 116, 219n1,
232n61, 237n15; on camera obscura,
73, 78, 79; on corporeal subjectivity
of observer, 163
criticality: aesthetics and, xx–xxii,
54–55
Critique of Judgment (Kant), 50, 59–
62, 101; idea of life informing,
74
Critique of Pure Reason (Kant), 56, 64;
first edition of, 57; second edition
of, 57–59, 60, 62
Culler, Jonathan, 234n82
culture: commercialization of, 84; of
everyday life, role of historian to
call up, 183; Herschel's justification
of science within, 6–7; Scott's role as
"transmitter" of cultural memory in
his historical novels, 184
Cunningham, Andrew, 230n26
cyanotype: Herschel's discovery of,
156–58, 242n84

Daguerre, Louis Jacques Mandé, xii,
152, 167, 241n79
daguerreotype, 149, 165, 170, 176;
Claudet's method to increase sensi-
tivity of daguerreotype plate,
238n26; Herschel on, 152, 241n79;
invention of, xii; photogenic draw-
ing compared to, 116, 152
Danto, Arthur, 220n6
Daston, Lorraine, 132, 133–34, 220n7,
240n52
Davy, Humphry, 49, 51, 63, 167,
230nn27–28; chemical experimental

work, 51; Coleridge and, 51, 64, 72,
232n59
Deleuze, Gilles, xx, 10, 56, 127,
221n20, 224n22, 225n37, 231n35,
238n25, 239n33; on aesthetics, xxi,
110, 147, 148; on difference, 122; on
foundation of romanticism, 56;
model of thought, 120, 121, 122; on
paradox in Hume's philosophy, 20;
philosophical criticism of represen-
tation, xvi, 120; on recognition, 121;
repetition, analysis in *Difference and
Repetition* of levels of, 143–47;
repetition defined as "difference
without concept" by, xix, 129–30;
on simulacrum, xix, 129–30, 147;
on singularity, 122; on time in
Kant's philosophy, 57; on "tran-
scendental empiricism" or the
"science of the sensible," 126, 147,
148, 239n29
design argument, 10, 12, 33, 43, 68
deskilling, mental and manual, xviii,
xxiii, 25–37; botany as example
of, 130; induction as sort of
intellectual deskilling, 26–27, 28,
30; "mechanical" repetition and,
144; Talbot's autogenic conception
of photogenic drawing and, 25–27,
114
diagrams: Rajchman on, 138; Talbot's
botanical images as dynamic and
open-ended, xviii, 123–26, 129–49,
172
difference, 116–29; Deleuze on, 122;
nature as both source of, and its
object, 125; repetition as "difference
without concept," xix, 129–30, 136;
the "Same" privileged over, in
Coleridge's philosophical project,
80–81; seen through arrangement
and delimitation underlining com-
positional aspects of Talbot's images,
123–24

Difference and Repetition (Deleuze), xvi, 120; analysis of levels of repetition in, 143–47
Difference Engine: Babbage's invention of, 31, 228n77
digitalization, xix, xx
discipline: models of discovery appealing to, 42
discontinuity: between experiment and discovery, temporal and conceptual, 72–73; historical, x–xi, xiv, 116; Whewell's notion of conceptions as discontinuous junctures, 46–47
discovery, 39–110; Babbage's mechanization of intelligence and, 31–36, 53, 228n88; Coleridge's philosophical and aesthetic method, 63–73; division of labor applied to, 27–29; empiricist premises and ethos of process of, 3–4; engines of, 25–37; genius and, models of discovery appealing to, 27–28, 42, 46–50, 63; Herschel's revaluation of hypotheses and theories within process of, 13; Kant's secret art of knowledge and, 52–62, 109; life of the imagination, 73–82; picturesque imaginings, 42, 82–108; scientific models of, xxii–xxiv, 52; Talbot's first account of (1939), xii–xiii, xxiii, 3–6, 25, 30, 36, 39, 53, 81, 115, 195; Talbot's second account of (1944), 28, 39–41, 42, 43, 49–50, 63, 73, 81, 82, 108, 113; temporal and conceptual discontinuity between experiment and, 72–73; Whewell's moral philosophy of science and, 43–52
division of labor, xxiii; Babbage on, 32, 33; Herschel's application of Smith's principle of, 27–29, 130; between observation and theorizing in science, 27–28, 130; productivity and growth and, 28–29

document: Foucault on, 220n14, 244n12; photograph as mute, in *Pencil of Nature*, xxv–xxvi, 177–78, 186–98; Talbot's idea of, 185–86
drawing: Gilpin's instructions on the picturesque, 84–86; as "polite art," 83. *See also* photogenic drawing; picturesque, the
Ducasse, Curt J., 224n24

Eastlake, Lady Elizabeth, 114–15, 237n9
economy: remodeling of scientific discovery and growth of knowledge in terms of, 28–35. *See also* discovery; division of labor
Eder, Josef Maria, 154, 241n81
Edinburgh Review, 16, 36
Edinburgh University, 16
Edwards, Steve, xviii, 25, 28, 221n24, 226n57, 235n93
Elegantly Set Table, An (Talbot), 97
Elkins, James, 221n22
Emerling, Jae, xxi, 222n28
empiricism, British: aesthetic form of, 126–28; Coleridge's criticism of, 44, 65, 66–67, 81; Herschel's *Discourse* and, 7, 12, 43; induction in context of early nineteenth-century, 12, 50; inseparability of scientific forms of inquiry from religious/metaphysical concerns, xi, 127; legacy of, in Brewster's account of art of photography, 37; new form of, 136–37; shift to investigation of "organic" and dynamic temporal forces of life and thought, xvii, 35; skepticism haunting, xi–xii, 19, 24, 127; Whewell's rejection of epistemology of, 43
"empirico-transcendental doublet": Foucault on new epistemological figure of "man" as, xxiv, 55–56, 109, 121

Encyclopædia Metropolitana, 168, 170
Engell, James, 64, 104, 230n33
engines of discovery, 25–37; induction
 as mechanical method, 26–27, 28,
 29; remodeling of scientific discov-
 ery and growth of knowledge in
 economic terms, 28–35. *See also*
 scientific method
English Etymologies (Talbot), 185
English Wild Vine (Talbot), 138–39, 143
Enlightenment: romantic historicism
 as rebellion against historiography
 of, 179–80
Enros, Philip C., 227n72
equivalence: empirical accuracy in
 terms of both time and place
 transcribed into visual, 94–95
*Essay on Combustion: With a View to a
 New Art of Dying and Painting, An*
 (Fulhame), 154
Essay on the Picturesque, An (U. Price),
 98
"Essays on the Principles of Method"
 (Coleridge), 70
essence: Coleridge's definition of, 76
essentialist theories of photography,
 xvii–xviii
Euler, L., 227n72
"Eurystheus in the Pithos" (Talbot),
 189, 197

failed copy: simulacrum as, 116, 129,
 146–49
fancy: Coleridge on, 69
Ferris, Ina, 184, 245n31
ferrocyanuret of potassium, 156
Fichte, Johann, 65, 68
Fisch, Menachem, 45, 47, 227n72,
 229n16
Folded Lace and Botanical Specimen
 (Talbot), 140
Foucault, Michel, 17, 57, 220nn13–14,
 221n20, 225n36, 228n87, 230n32,
 246n42; analysis of modern

episteme, 73–74, 95; on "discursive
 rules of formation," xiv; distinc-
 tion between "monuments" and
 "documents," 220n14, 244n12;
 "empirico-transcendental doublet,"
 new epistemological figure of
 "man" as, xxiv, 55–56, 109, 121; on
 finitude, 56; historical and episte-
 mological analysis of knowledge,
 xvi, xix, 53, 54, 220n14; on history
 and historical consciousness, 53, 186,
 195–96, 197, 220n14; on notion of
 discontinuity, xiv; on observation in
 classical paradigm, 78–79; on repre-
 sentation, 17–18, 36, 54, 78–79; on
 role of imagination, xi; on shift
 from natural history and classical
 taxonomy to new botany and
 biology, 234n82; on the unthought,
 56, 59
Four Leaves (Herschel), 153
Fresnel, A. J., 14–15
Friend, The (Coleridge), 70
Frizot, Michel, 219n5
Fulhame, Elizabeth, 154, 241n83
fundamental Ideas: Whewell's notion
 of, 44–45, 46

Gaisford, Thomas, 191
Galison, Peter, 132, 133–34, 220n7,
 240nn51–52
gallic acid as developer, 122, 128, 149,
 223n2, 229n1
Gasser, Martin, 243n110
"Gate of Christchurch, The" (Talbot),
 177
"General Introduction: or, Preliminary
 Treatise on Method" (Coleridge), 70
genius: centrality of idea of, to natural
 philosophy, 230n26; emergence of
 romantic figure of, 42, 48–51; as
 figure complementary to poet,
 Coleridge's idea of, 71–72; Kant's
 definition of, 50–51, 56, 60–62;

missing from Gilpin's account of
the picturesque, 102–3; models of
discovery appealing to, 27–28, 42,
46–50, 63; originality as major trait
of, 61
Gernsheim, Alison, 219n2
Gernsheim, Helmut, x, 219n2, 234n88,
236n3
Gibbon, Edward, 176, 179, 180, 192
Gibbons, Sarah L., 231n34
Gilpin, Rev. William, 83, 84–87, 101,
235nn97–98; "four-screens" com-
positional scheme, 85–86; on the
picturesque, 84–86, 101–4, 107, 108
glass negative: Herschel's, 152
Goethe, Johann Wolfgang von, 162–
63, 242n90
Good, Gregory, 225n27
Gore, William Clark, 225n37
Gossman, Lionel, 181, 245n24
Gower, Barry, 232n232
Graphic Society: Talbot's exhibition of
photogenic drawings at, 88–89
Gray, Michael, 220n10
Greenberg, Clement, xxi, 230n31

Haeger, Jack H., 234n86
half-tone photolithography, 135
"Hallam" (Macaulay), 178–79
Hamilton, William Rowan, 8, 47,
229n18
Hare, Julius Charles, 47, 48, 229n18
Harman, P. M., 225n30
Hartley, David, 8, 9, 64, 66
Haworth-Booth, Mark, 220n10
Hayden, Patrick, 239n29
"Haystack, The" (Talbot), 87, 88
Heidegger, Martin, 231n34
Henneman, Nicolas, 175
Herder, Johann Gottfried, 180–81
*Hermes: or, Classical and Antiquarian
Researches* (Talbot), 185, 245n37;
"Eurystheus in the Pithos," 189, 197
Herschel, John, xii, xiii, xxii, xxiii, 49,

84, 167, 223n8, 224n25, 227n70,
229n12, 236n120, 238n19, 241nn76–
80, 242n89; Analytical Society and,
29–30, 227n72; Babbage's Difference
Engine and, 31; on character of Vic-
torian natural philosopher, 5, 102;
correspondence with Talbot, 152,
175–76, 238n19, 241n79; critical
review of Whewell's books, 11, 43;
on daguerreotypes, 152, 241n79; on
division of labor in science, 27–29;
"dormant" pictures or latency,
exploration of, 152, 155, 156–61,
164; experimental photographic
work of, xxv, 150–65, 223n10,
242n84; on induction, xxii, 12–13,
27, 28–29; law of continuity, 11–13,
17, 18, 20–21, 164, 180; laws of
nature defined by, 12–13, 17; light
and optical experiments, 224n27;
notion of causality, 224n24; on per-
ception, 10–11; revaluation of
hypotheses and theories within pro-
cess of discovery, 13; on sensorial
vision and ocular spectra, 160–61,
163–64; terms suggested to Talbot
for new method of copying, 5–6,
150, 223n10, 232n51, 238n17; veg-
etable photography of, xxv, 149–65,
172; on verification, 12; wave theory
of light debate and, 13, 15, 36.
*See also Preliminary Discourse on
the Study of Natural Philosophy*
(Herschel)
Herschel, William, 152
Hill, John Spencer, 231n45
Hirsch, Robert, 219n5
historical discontinuity, x–xi, xiv, 116
historical imagination, 178–86; Macau-
lay on role of imagination in history
writing, 181–83, 192–93
historical novels, 182–84, 192
history: differences between fiction
and, 182–83; Enlightenment

historiography, 179–80; epistemo-
logical problematic of historicism,
195–98; Foucault on, 53, 186, 195–
96, 197, 220n14; idea of, underlying
condition of modern episteme
embodied in photographic image,
xvi; paradox of historicism, 57;
photographic image as record of
customs and manners in, 194–95;
role of the historian, xxv–xxvi,
178–83, 192–93; romantic view of,
48, 178–86; time as "origin" in
historicism, xxv, 186, 195–98
"History" (Macaulay), 181–83
*History and Present State of Electricity,
The* (Priestley), 48
History of England, The (Hume), 179
*History of the Decline and Fall of the
Roman Empire, The* (Gibbon), 176,
179
History of the Inductive Sciences
(Whewell), xxii, xxiii, 41, 43, 44,
45–46; shift of history of science
from matter to mind in, 48–49
Hooker, William Jackson, 134, 240n57,
240n67
Hortus Cliffortianus (Clifford's Garden)
(Linnaeus), 132–33
Hume, David, xxiii, 59, 67, 225n38,
244n20; on beauty, 104; Common
Sense philosophy and critical
response to, 8, 9, 10; concept of
causality, xi, 10, 20, 24, 126, 127–28;
Deleuze's understanding of empiri-
cism and, 127; on imagination,
19–20, 62, 104, 106, 107, 126,
127–28, 225n37; on imagination,
similarity of Kant's analysis to,
58–59; skepticism of, 45, 179
Hunt, Robert, xii, xxiv, 117–18, 152,
159, 203, 243n103, 243nn106–9;
efforts to dismantle Talbot's
calotype patent, 166, 243n109;
experimentation encouraged by,

166; *Treatises* and *Manuals,* 165–73,
203–18, 237n8
Hussey, Christopher, 99, 235n110
hyposulphites: Herschel's research on,
152

Idea: Plato's formulation of, 136
idealism: Coleridge's embracing of
German, 65–66
Ideas: Whewell's notion of fundamen-
tal, 44–45, 46
identity: of camera image in Claudet's
model of vision, 120–21; Coleridge's
attempt to formulate, between spirit
and matter, 65, 69–70, 80–81,
234n84; Deleuze on difference as
object of representation in relation
to conceived, 122; Deleuze on levels
of repetition and, 145–46; Foucault
on deeper and invisible, 73; missing
from Gilpin's account of the pictur-
esque, 103; nature's resistance to
fixed form of, 126, 128–29, 172;
Schelling's philosophy of, 65–66, 67,
68, 80; simulacrum's lack of, 129–30,
136, 137, 147
imagination: aesthetic theories of,
52–73; associationism and, 104,
106–7; camera obscura as poetic and
aesthetic emblem for productive, 79;
Coleridge's theory of, xxi, xxiv, 42,
52, 63–70, 73, 74–75, 79, 104, 115,
125, 231n45, 232n59; emergence, as
creative faculty, xxiv, 69; emergence
of romantic figure of genius and, 42;
exclusion from knowledge, repre-
sentation and, 18–19; Gilpin on,
103–4; historical, 178–86, 192–93;
Hume on, 19–20, 58–59, 62, 104,
106, 107, 126, 127–28, 225n37; Kant
on, xxi, xxiv, 42, 52, 56–62, 67–68,
69, 74, 104, 231n34; life of, 73–82; as
necessary condition for production
of both experience and knowledge,

198; picturesque imaginings, xv, xxiv, 42, 82–108; primary, 69, 70; role of, xi–xii, 50–52, 198; secondary, 69, 70; synthesis of, 57–58; as threat to reason, in Enlightenment, 179

imitation: central opposition in Coleridge's aesthetic theory between mechanical copying and organic, 75–77, 115, 182

index: Barthes's notion of, 22, 221n22; as historical tool of analysis, theoretical limitations of, xvii–xviii; photograph as, 22–23, 116, 136–37, 188; photograph as simulacrum vs., 136, 137; signification divorced from authentication in, 140

induction: in Bacon's formulation of scientific method, 8, 26; in context of early nineteenth-century British empiricism, 12, 50; early image associated with, xi; Herschel on accessibility of inductive method to general public, 27, 41; Herschel's attribution of scientific discoveries to, xxii, 12–13, 27, 28–29; inconsistent meaning of the term, 50; Reid's inductive principle as "principle of common sense," 9–10, 17, 18–19; as sort of intellectual deskilling, 26–27, 28, 30; Talbot's conceptualization of photogenic drawing as copying method, set of concerns informing, 36; Talbot's new proof for validity of, xxiii, 3–4, 16, 24; Whewell's theory of, 46–47, 50

industrialization: invention of photography as historical necessity and, 219n4; picturesque landscape as ideological cultural artifact masking transformation by, 83; social and cultural effects, xxiii, 28

Inkster, Ian, 226n64

Inquiry into the Human Mind (Reid), 8

Inquiry into the Nature and Causes of the Wealth of Nations, An (Smith), 29

Insect Wings (Talbot), 23–24

intelligence: Babbage's mechanization of, 31–36, 53; Coleridge on, as principle of ceaseless productive activity, 68–69

intuitive apprehension: synthesis of, 57

invention: Hume's concept of imagination and, 127–28

irreducible subjectivity, 47, 52, 67, 73, 98, 163, 198. *See also* genius; imagination

Jacob, François, 73–74, 232n63

Jain, Chaman Lal, 224n24

Jammes, André, 165, 166, 191, 242nn96–97

Janis, Eugenia Parry, 165, 166, 242nn96–97

Jardine, Nicholas, 230n26

Jeffrey, Ian, 244n10

Jenkins, Reese, 232n51

Jerdan, William, 176

judgment, Kant on, 59–62, 74; formulation of aesthetic judgments, 61, 74, 109, 126; imagination linked to reflective, 59–60

Kant, Immanuel, xi, xxiii–xxiv, 79, 101, 231n37, 231n40; aesthetics as mode of judgment to, 61, 74, 109, 126; definition of genius, 50–51, 56, 60–62; dualistic "distinction of powers," idealists' bid to overcome, 65; imagination, notion of, xxi, xxiv, 42, 52, 56–62, 67–68, 69, 74, 104, 231n34; influence on Coleridge, 67–68; on judgment, 59–62, 74, 109, 126; on schema, 58–59; secret art of knowledge, 52–62, 109; transcendental philosophy, 54–62, 121; Whewell's project compared to, 45

Kearney, Richard, 222n29, 231n33, 236n129
Keeler, Nancy, 243n3
Kelsey, Robin, 114, 221n22, 222n31, 237n7, 246n45
Kemp, Martin, x, 88, 91, 219n4, 235n101, 236n2
Kemp, Wolfgang, 93, 235n105
Kepler, Johannes, 48, 50
Knight, David M., 230n26
Knight, Richard Payne, 86, 98–99, 236n127; on the picturesque, 104–7
knowledge: aesthetics as paradoxical form of, xxi, 52, 109; analysis as universal method of, 17–18; Coleridge's project to unify all, under idea of the Trinity, 68, 70–72, 234n84; "critique," new mode of philosophical reflection, xx–xxii, 54–55; emergence of historicism as a form of, 178; Foucault's historical and epistemological analysis of, xvi, xix, 53, 54, 220n14; introduction of time into formations of, xvi, 35–36, 53, 116; Kant's secret art of, 52–62, 109; "man" as both subject and object of, 54–55; new historical conditions of, 137; role of the imagination in, xi–xii, 198; scientific, as ultimate engine of technological progress, 32–33; shifts within conditions of, in early nineteenth century, xv, xvi–xvii, 63, 66; Whewell's theory of, 44–52
Krauss, Rosalind, 101, 222n26, 236n118, 240n70; on photography as project of deconstruction, 147

labor: Babbage on mechanical, 25–26, 32; Ure's theory of, xviii, 25. See also deskilling, mental and manual; division of labor
Lace (Talbot), 141, 142

lace images, 117, 240n67; connection between Talbot's botanical images and his, 140–43, 240n66
Lacock Abbey in Reflection (Talbot), 90, 91
"Lacock Abbey in Wiltshire" (Talbot), 88, 89, 195
"Ladder, The" (Talbot), 194
Lagrange, J. L., 227n72
landscape: historical shift in meaning of, xv; the picturesque and notion of, 83–84, 101–2, 106–7, 235n94
language: as instrument of analysis, 17–18
Lanzi, Luigi, 191
Lardner, Dionysius, 6
latency: Herschel's explorations of idea of, 152, 155, 156–61, 164; Talbot's introduction of, into paper photography, 122–24, 128, 172
Laudan, Larry, 16, 225n34
law and theory: Coleridge's differentiation between, 71
Lawrence, Christopher, 51, 230n29
Leask, Nigel, 65, 70, 231n45
Leaves of Orchidea (Talbot), 135
Leaves of the Pæony (Talbot), 124, 125
Legendary Tales in Verse and Prose (Talbot), 185
Leibniz, Gottfried Wilhelm von, 227n72
Letters on Demonology and Witchcraft (Scott), 22
Letters on Natural Magic (Brewster), 22
Levere, Trevor H., 72, 230n27
Levine, Philippa, 244n16
Lewis, William, 154
life: Coleridge's definition of, 74–75, 233n67; Foucault's deeper and invisible "identity" as, 73; idea of life as act of differentiation in romanticism, 125; of the imagination, 73–82; invisible potential forces of, early photographic image

embodying, 147; Jacob on, 74; in Kant's *Critique of Judgment,* 74
Life of Newton (Brewster), 50
light: Newtonian projectile theories of, 13, 15, 168, 224n27; wave theory of, xvi, 13–16, 24, 36, 53, 168, 224n26
"Light" (Herschel), 13
Linnaeus, Carl, 131, 132–33, 240n49
Lister, Martin, 222n25
Literary Gazette, 176; reviews in, 88–89, 107, 118; Talbot's announcement of discovery of the calotype in, 122–23
Liu, Alan, 236n113
Logic of Life, The (Jacob), 74
Lorrain, Claude, 101
Lukács, Georg, 183, 245n29

Macaulay, Thomas Babington, xxv, 48, 189–90, 244n17, 245nn26–27, 245n37; on role of imagination in history writing, 181–83, 192–93; on romantic historicism, 178–79
machinery. *See* mechanization
McCauley, Anne, 63, 231n44
McCusker, Carol, 220n10
McFarland, Thomas, 79, 233n80
McNally, Donald H., 229n16, 230n19
Makkreel, Rudolf A., 58, 60, 74, 231n34
Male, R., 233n66
"Man": birth of, xxiv, 197; as both subject and object of knowledge, 54–55; figure of genius manifesting new conditions of knowledge now located in, 62; Foucault on, as empirico-transcendental doublet, xxiv, 55–56, 109, 121; the "Same" as, 80–81, 126; as subject of history for romantics, 180
Man, Paul de, 233n80
Mandelbaum, Maurice, 179, 181, 244n18

Manovich, Lev, 222n25
Manual of Photography, A (Hunt), 170–72, 209–18; "General Summary of the History of Photography," 171–72, 214–18
manufacturing: Babbage on advantage of machinery to manufacture, 25–26, 32–33, 114; science and, 32–33. *See also* division of labor; mechanization
Marbot, Bernard, 219n4, 237n4
Marien, Mary Warner, x, 219n5
Marshall, David, 106, 236n128
Martyrs of Science (Brewster), 50
Materia photographica, 149–65
mathematics: Babbage's Difference Engine and, 31, 228n77; reforms at Cambridge, 30, 227n72; wave theory of light and new, 16; Whewell on, 33–34
mathesis, 17
mechanization: Babbage on advantages of machinery to manufacture, 25–26, 32–33, 114; Babbage on, of intelligence, 31–36, 53, 228n88; Brewster on art of photography and, 36–37; emergence of concept of "mechanical objectivity" in scientific practice, 132, 133–34; induction as mechanical method, 26–27, 28, 29; mechanical copying vs. organic imitation in Coleridge's aesthetic theory, 75–77, 81, 115, 182; "mechanical" repetition, 143–45; photography as new method of "mechanical" copying, 114–16; technology of universal management, 31–32
mediation: difference between observation and, 76
medium specificity: Greenberg's modernist notion of, xxi
Memoirs (Babbage), 31
Memories of the Analytical Society, 29

memory: Hume on imagination and,
19–20
metaphysical-design argument, 10, 12,
33, 43
methodological scientific publications,
xxii–xxiii, 4
Michasiw, Kim Ian, 102–3, 236n122
Michelet, Jules, 181
Milton, John, 77
Mirror and the Lamp, The (Abrams), 63
Mitchell, William J., 221n25
Modiano, Raimonda, 68, 232n52,
234n84, 236n117
monuments: Foucault on, 220n14,
244n12; for Talbot, 177, 189
Morrell, Jack, 226n64
motion, laws of: associationism mod-
eled after mechanical, 66–67
mute document: photograph in *Pencil
of Nature* as, xxv–xxvi, 177–78, 186–
98; muteness as structural effect of
historiographical discourse, 188–89

"Naked Truth, The" (Danto), 220n6
natural philosophy: belief in continuity
and consistency of nature, 36;
centrality of idea of the genius to,
230n26; end of, 40–42; the pictur-
esque and, 101; as scientific practice,
discursive specificity of, 21–22
natural theology: Talbot's understand-
ing of science and photography
and, 228n88; "true-to-nature"
representations supporting, 133;
Whewell's Bridgewater treatises
as mobilization of science to
defense of, 33–35; Whewell's moral
philosophy of science and, 43
nature: Coleridge's conception of,
68–69; developing sense of wonder
at, 21–24; Gilpin's picturesque
travel and, 84–86; Herschel's defini-
tion of laws of, 12–13, 17; historical
displacement in favor of "second

nature" of industrial capitalism,
149; historical shift in meaning of,
xv; irreducibility of being to repre-
sentation marked by, xvii, xix, 101,
129, 130, 143; Kant on, as synthetic
formal product of sensibility and
understanding, 62; legibility of, 102;
picturesque views of, 42, 82–108;
Priestley's monistic and materialistic
theory of, 64; productive "encoun-
ter" between image and, xxv; as
pure productivity, 65–66; repetition
in, 129–49; as representation and
representation as, photographic
image embodying condition of,
107–8, 137; resistance to fixed form
of identity, 126, 128–29, 172; in
romanticism, xvi–xvii, 53, 108;
self-agency of, xviii, 124–26, 164;
as temporal differentiating force
inseparable from continuous forma-
tion of photograph, 137–38. *See also*
"picture of nature," idea of
nature printing, 134–35
Naturphilosophie, xvi; Coleridge's
attempt to "Christianize," 68, 80;
polarity concepts in, 66, 232n51,
233n67; Schelling on, 65–66, 68
necessitarian materialism: Reid's
defense of Scottish Presbyterianism
against, 8
negative images, 89, 107, 117–18,
129, 140, 152, 175, 177, 223n2;
celænotype, 159; cyanotype, 156,
158–59; Hunt on, 167; productivity
of, 128. *See also* calotype; *Pencil of
Nature, The* (Talbot)
Nesbit, Molly, 222n26
Newhall, Beaumont, x, 219n3, 236n2,
243n1
Newton, Isaac, 9, 36, 48; dot notation,
227n72; dualistic ontology of matter
and force, 64; Goethe's challenge to
optical account of colors, 162–63;

Kant on, 50–51; projectile theories of light, 13, 15, 168, 224n27

Nickel, Douglas R., 228n88, 240n59, 240n66

Niebuhr, Barthold, 48

Niépce, Joseph Nicéphore, xii, 167

Ninth Bridgewater Treatise (Babbage), 34, 228n88

"Note on the Art of Photography: or, The Application of the Chemical Rays of Light to the Purposes of Pictorial Representation, A" (Herschel), 150

Novum Organum (Bacon), 7–8, 26, 179

Oak Tree, Carclew Park, Cornwall (Talbot), 91, 92

Oak Tree in Winter (Talbot), 92, 93

objectivity: mechanical, emergence in scientific practice of, 132, 133–34; modern notion of, 220n7

observation: difference between mediation and, 76; Foucault on, in classical paradigm, 78–79

Observations on the River Wye (Gilpin), 85–86

ocular spectra, concept of, 160–61, 164; Goethe's theory of colors and, 162–63

Ollman, Arthur, 220n10

Olson, Richard, 8–9, 224n16

"On Certain Improvements on Photographic Processes" (Herschel), 159

"On Sensorial Vision" (Herschel), 160

"On the Action of the Rays of the Solar Spectrum on Vegetable Colours, and on Some New Photographic Processes" (Herschel), 151

"On the Chemical Action of the Rays of the Solar Spectrum on Preparations of Silver and Other Substances, Both Metallic and Non-metallic, and on Some Photographic Processes" (Herschel), 150, 223n10, 238n17

On the Economy of Machinery and Manufactures (Babbage), 25–26, 32

"On the Nature of Light" (Talbot), 13–14

"Open Door, The" (Talbot), 51, 86–87, 176

optics, study of, 14, 224n24; wave theory of light and, 13–16

Order of Things, The (Foucault), xvi, 17–24, 234n82

paper photography: Hunt on, 167, 169, 171; Talbot and, xii–xiii, 36, 116, 122, 159, 177

"Part of Queens College, Oxford" (Talbot), 95, 96, 177, 244n13

patterning in photographs, sense of, 91–94, 139, 141; modification of, 143

Peacock, George, 29, 30

Peirce, C. S., 221n22

Pencil of Nature, The (Talbot), xiii, xix, xxiii–xxiv, 28, 29, 55, 117, 135, 175–98; "A Brief Historical Sketch of the Invention of the Art," 39–40, 49, 176; complex discursive identity of, 176, 244n10; Newhall's introduction to 1969 republication of, 243n1; photograph as mute document in, xxv–xxvi, 177–78, 186–98; photographic images as form of testimony, 190–92, 193, 197; picturesque representation simultaneously evoked and denied in, 98; plates in, 86–87, 88, 89, 94, 95, 96, 141–43, 175, 177, 187, 190–92, 194–96, 244n13; production of, 175, 243n3; record as valuable for historical understanding, emphasis on, 194–95; reenactment of the past through "evidence" of photographs in, 193–94; reviews of, 118–19; romantic ideas underlying, 63, 195–97; signification suggested by specific form of arrangement and delimitation in

images, 190, 193; vocabulary of the
picturesque in, 86–88
perception: of color, 162; exclusion
of time as inherent or qualitative
factor of, 120–21; Herschel's account
of, 10–11; in Hume's *Treatise,* as
copying process, 67; Knight on
improved, 106–7; picturesque eye as
ultimately a disembodied eye, 102;
primary imagination and, 69; as
relation of spatial synchronicity,
120–21
Philips, Mark, 245n27
*Philosophical Inquiry into the Origins
of Our Ideas of the Sublime and
Beautiful, A* (Burke), 85
Philosophical Magazine, 16
Philosophy of Manufactures, The (Ure),
25
Philosophy of the Inductive Sciences
(Whewell), xxii, 41, 42, 43, 44, 46;
criticism of Bacon in, 47
photogenic drawing, xii, xiii, 3–5, 83,
223n2; daguerreotype compared to,
116, 152; epistemological status of,
xix, xxii, 16, 108–9, 128; as "image
without a concept," xv–xvi, xxi, 108,
110, 165; model for "picture of
nature" translated from manual
drawing into, 88; nature printing
compared to, 135; as "new" proof
for value of inductive method,
xxiii, 3–4, 16, 24; Talbot's autogenic
concept of, 25–27, 114; Talbot's
conceptualization of, as copying
method, xii, xxiii, 5, 25, 32, 36,
114–16, 175–76, 220n6; Talbot's
definition of, as kind of "wonder"
or "natural magic," 20–24, 228n88;
Talbot's emphasis on "mechanical"
nature of, 26, 32, 114–16; Talbot's
first account (1839) of discovery of,
xii–xiii, xxiii, 3–6, 25, 30, 36, 39, 81,
115, 195; Talbot's second account

(1844) of discovery of, 28, 39–41, 42,
43, 49–50, 63, 73, 81, 82, 108, 113
photography: aims of science in, 10;
birth of, 109, 113; Brewster on art
of, 36–37; canonical histories of, x,
165, 172; discontinuity between
modern histories and early concep-
tualizations of, 166–73; early image
as "failed copy" or simulacrum,
xviii–xix, 116, 129, 146–49; essen-
tialist theories of, xvii–xviii; field of
photographic experimentation in
1830s and 1840s, xvi, 148, 165, 172;
historical division between modern
and postmodern discourses of, xx,
109, 222n31; idea of "history" as
underlying condition of modern
episteme embodied in image, xvi;
mode of production and forms of
intelligibility redefined in 1850s,
148–49; polarity concept underlying
early terminology of, 66, 232n51,
233n67; professionalization by
1850s, 170–72; scientific objectivity
and, 134; as specific epistemological
figure, ix, xi–xii, 4, 37; unpredict-
ability of process in early, 114–15
*Photography and Philosophy: Essays on
the Pencil of Nature* (Walden), x
*Photography: A Treatise of the Chemical
Changes Produced by Solar Radiation,
and the Production of Pictures from
Nature, by the Daguerreotype, Calo-
type, and Other Photographic Pro-
cesses* (Hunt), 168–70, 206–8
Photography Theory (Elkins), 221n22
photolithography, half-tone, 135
physics: conceptual changes within, 35;
wave theory of light and emergence
of modern, 14–15, 16, 35. *See also*
science
"picture of nature," idea of, 62, 109,
116; camera obscura's relation to,
52, 73, 77–79, 81–82, 108, 113;

photogenic drawing and, 50, 82, 88, 98; the picturesque and, 88, 98, 108

picturesque, the, xv, xxiv, 42, 82–108; ambivalence of romantic poets toward, 99–101; in associationist theories of taste, 108; diversions of Talbot's early photographs from conventions of, 90–95, 98; as form of unity, 85, 99–100, 103; Gilpin's writings on, 84–86, 101–4, 107, 108; Gilpin's writings on, paradox of, 101–2; as intermediary aesthetic category between the beautiful and the sublime, xxiv, 98–101; Knight's discussion of, 104–7; landscape in, notion of, 83–84, 101–2, 106–7, 235n94; popularity of, 84; reconsidered in light of postmodern theories of art, 101–2; Ruskin on "lower surface" vs. "noble," 99; shift from actual ownership to imaginative appropriation of, 84; time in, 95, 177

Plato and idea of "true copy," 136

Pneumatical Institute, 64, 72

poet: Coleridge's idea of philosophical genius as figure complementary to, 71–72

Poggi, Stefano, 230n26

polarity concepts in *Naturphilosophie*, 66, 232n51, 233n67

Popular Treatise on the Art of Photography, A (Hunt), 117–18, 152, 166–68, 169, 203–5, 237n8; on miscellaneous processes, 167–68; on paper processes, 167

positive images, 89, 90, 117–18, 135, 152, 155, 156–58, 159, 165, 170, 238n19

positivism, 246n45; evidentiary structure of, 188, 189, 190

postphotography, xix, 221n25

Potter, Richard, 15

Poussin, Gaspar, 101

prejudices: Bacon's theory of idols as, 7, 17

Preliminary Discourse on the Study of Natural Philosophy (Herschel), xxii, xxiii, 5–16, 17, 33, 35, 44; on accessibility of inductive method to general public, 27, 41; account of perception in, 10–11; as adaptation and elaboration of Bacon's *Novum Organum,* 7–8; application of principle of division of labor in, 27–29, 130; controversy surrounding wave theory of light and, 13–16; empiricism and, 7, 12, 43; Gilpin's essays on the picturesque and, 86; indebtedness to Scottish school of Common Sense philosophy, 8–10, 12–13; justification of science within culture, 6–7; on law of continuity, 11–13, 17; reviews of, 6; sense of methodological necessity in, 47; as "transitory" historical source, 16

Prelude, The (Wordsworth), 100

Price, Martin, 99, 105, 235n111

Price, Uvedale, 86, 98

Priestley, Joseph, 8, 48, 64

Principia (Newton), 9, 227n72

production: change as underlying condition of natural and material systems of, 53

professionalization in practice of photography by 1850s, 170–72

projectile theories of light, Newtonian, 13, 15, 168, 224n27

purposiveness: principle of, 59–60, 74

Pyle, Forest, 70, 231n45

Rajchman, John, 138

Ramalingam, Chitra, 221n17

Rancière, Jacques, xx, 222n27, 222n30; on aesthetics, xxi–xxii

rationalism, 48

reason: Enlightenment historiography and, 179

recognition: conceptual, synthesis of, 57; Deleuze on, 121

Reflections of the Decline of Science in England (Babbage), 6, 27, 31

Reid, Thomas, 8, 224n17; inductive principle of, 9–10, 17, 18–19

repetition, 129–49; Deleuze on, defined as "difference without concept," xix, 129–30, 136; levels of, analyzed by Deleuze in *Difference and Repetition*, 143–47; in primary imagination, 70; reintroduction of difference through, 147

representation, xvi, 17–24; Deleuze's philosophical criticism of, xvi, 120; failure of photographs to conform to pictorial conventions of, 90–95; Foucault on, 17–18, 36, 54, 78–79; as ground for knowledge, imagination as symptomatic of loss of, 56; Herschel's law of continuity and, 17–18, 20–21, 24, 35–36; limits of, simulacrum as failed copy manifesting, 146–47; nature as, and as nature, 107–8, 137; norms of, in classical paradigm, 132–33; photographic image as model of, 107–8, 137; picturesque, 85–86; picturesque, differences between Talbot's images and, 90–98; Reid's inductive principle and, 18–19

Researches on Light (Hunt), 168

resemblance: Coleridge's redefinition of, 76–77; exclusion from representation as form of knowledge, 17, 18–19, 62; imagination and dependency of knowledge on unaccounted, 19, 62, 129; laws of nature and, 12; photography in 1850s defined as transparent medium of, 149, 173; picturesque representation and, 85, 106; recognition and, 121; repetition as "difference without a concept" and,

129–30, 136; reviews of photogenic drawings in terms of, 118–19; as universal principle of association, 19–20, 127

Richards, I. A., 231n45

Richards, Joan L., 227n72

Rigney, Ann, 184, 192, 245n34

Ritter, Johann Wilhelm, 166

Roberts, Russell, 220n10

Robins, Kevin, 222n25

romantic historicism: Macaulay on, 178–79; as rebellion against Enlightenment historiography, 179–80

romanticism: aesthetic opposition between copying and imitation in, 75–77, 115; attacks on science, 43, 230n26; of Coleridge, 68, 77–78; Deleuze on foundation of, 56; emergence of romantic figure of genius, 42, 48–51; idea of life as act of differentiation in, 125; the mind as living organism or living plant in, 75; nature in framework of, xvi–xvii, 53, 108; picturesque as intermediary term marking shift from classic to romantic art, 99–101; role of historian in, xxv–xxvi, 178, 180; role of imagination in, xi, 197–98; Talbot's *Pencil of Nature* and, 63, 195–97; view of history, 48, 178–86; view of time, 180–81; vitalism defining central epistemological and aesthetic premises of, 75, 234n86; Whewell's attitude toward, 47–48

Rosa, Salvator, 101

Rosenblum, Naomi, 219n5

Rousseau, George, 234n86

Royal Institution, 117

Royal Photographic Society, 166, 243n109

Royal Society, 27, 30, 117, 122, 195

Ruskin, John, 99, 236n112

"Same," the: in Coleridge's philosophical project, privileged over difference, 80–81; in Foucault's concept of "life," 73; in Kant's transcendental philosophy, 121; as "Man," 80–81, 126; photographic image as image excluding form of, 127, 128, 148; repetition in the form of, 145–46; simulacrum as sign that interiorizes conditions of its difference from, 130

Saunders, Gill, 131–32, 239n48

"Scene in a Library, A" (Talbot), 190–92, 193, 194

Scene in a Wood (Talbot), 95–96

Scenes in a Library: Reading the Photograph in the Book, 1843–1875 (Armstrong), xvii

Schaaf, Larry, xii, xiii, 135, 220n8–12, 223n2, 223n10, 229n1, 241n78, 242n85, 243n2, 244n8, 246n50; on Herschel's photography, 241n80; on problems with photographic chemicals and papers, 237n6; on production of Pencil, 175, 243n3; on Talbot's botanical imagery, 139; on Talbot's familiarity with negative/positive process, 159, 238n19

Schaffer, Simon, 4, 47, 223n5, 225n44, 227n75, 229n4, 229n18, 230n26; on Babbage's mechanization of intelligence, 31, 228n88; on Brewster, 50; on natural philosophy, 21–22, 40–42; on technology of universal management, 31–32; on Whewell, 47, 49

Schelling, Friedrich, 65–66, 67, 68, 80, 232n49, 233n67

schema, Kant's transcendental, 58–59

science: amateur man of, 16, 30, 49, 84, 86; for Babbage, scientific knowledge as ultimate engine of technological progress, 32–33; chemistry as model for Coleridge's conception of, 71–72, 232n59; cultural view of, 26–27, 30; Deleuze on, of the sensible, 126, 147, 148, 239n29; emergence of concept of "mechanical objectivity" in scientific practice, 132, 133–34; as institutionally specialized activity, BAAS's presentation of, 27–28, 226n64; populist utilitarian view of, 49; rationalist histories of, 48; romanticism and, 43, 230n26; shift from the general to the specific in 1830s, 132, 133–34; Whewell's moral philosophy of, 43–52. See also botany, science of; chemistry

scientific method, 3–37; Babbage on moral value of, 33; Babbage's mechanization of intelligence and, 31–36, 53, 228n88; Bacon's formulation of, as mechanistic system regulating operations of mind and senses, 7–8, 12, 26, 31; engines of discovery, 25–37; as form of mental deskilling, xxiii, 25–37; representation and, 17–24; Victorian science and "law of continuity," 5–16, 24

scientist: coining of term, 49

Scott, Sir Walter, xxv, 22, 63, 245n27, 245n30; historical novels of, 182–84, 192; literary collections of, as new kind of antiquarianism, 184; Talbot's connection to, 185

Secord, Anne, 130, 134, 221n18, 239nn44–47; on popularization of botany, 130, 131

self-consciousness: Coleridge on, as highest principle of knowledge, 68; Schelling on unity and identity of, 65–66

Senebier, Jean, 154

Sepper, Dennis, 162, 242n91

Shaw, Harry E., 245n30

Sherington, Olive, 196

signs: as sensations, 17–18; as tools of
 analysis within knowledge, 17–18
Silliman, Robert H., 15, 225n31
silver: blackening of silver salts, 14;
 chloride of, 154; investigations of
 visible color effects of light on, 151–
 55; silver nitrate, 149, 150, 154
simulacrum: Deleuze on, as emblem
 of repetition as "difference without
 concept," xix, 129–30; early photo-
 graph as, 136, 137; as failed copy,
 xviii–xix, 116, 129, 146–49; mobiliz-
 ing concept of, xx–xxi
singular images, photographic images
 as, 116–29, 130; productivity of the
 calotype negative and, 128–29
skepticism, xi–xii, 24, 127; Hume and,
 45, 179; Reid's defense of Scottish
 Presbyterianism against, 8, 9, 19; in
 Talbot's Pencil of Nature, 196–97
skill: redefinition of, based on Smith's
 principle of division of labor, 29.
 See also deskilling, mental and
 manual
Slater, Don, 22, 226n47
Smith, Adam: Herschel's application
 of division of labor principle of,
 27–29
Smith, Crosbie, 33, 35, 228n80
Smith, Graham, 226n49, 226n58,
 240n59, 246n41
Snyder, Alice D., 233n66
Snyder, Joel, 42, 72, 82, 113–14,
 221n19, 229n11, 237n5, 237n12,
 238n16
Society for the Diffusion of Useful
 Knowledge, 27
solar microscope, 4, 25, 117
Solomon-Godeau, Abigail, 222n26,
 242n97
"Some Account of the Art of Photo-
 genic Drawing; or, The Process by
 Which Natural Objects May Be
 Made to Delineate Themselves

without the Aid of the Artists
 Pencil" (Talbot), xxv, 3
spectral analysis, 225n27
speculative tradition, 48
"spirit" (Geist): genius determined by,
 61–62
Sprig of Fennel (Talbot), 145–46
Sprig of Mimosa (Talbot), 143–45
Stewart, Dugald, 8
Stimson, Blake, 221n22, 222n31
subjective vision, 79
subjectivity: camera obscura as model
 of self-contained and "enclosed"
 passive, 78; Coleridge's criticism of
 empiricism and exclusion of, 67;
 corporeal subjectivity of observer,
 163–64; discovery models and
 awakening sense of, 40, 52, 63, 82;
 Foucault on, 54; irreducible, 47,
 52, 67, 73, 98, 163, 198; objectivity
 and, 132
sublime, the: Kant's concept of, 56, 60;
 picturesque as middle aesthetic
 term between the beautiful and,
 98–101
substantialism, 180
sun-pictures: photographic images as,
 25, 52, 116, 117, 118–19, 185
Sun Pictures of Scotland (Talbot), 185,
 246n41
Sutton, Damian, 221n23
Sutton, M. A., 225n27
Swing Riots (1830), 235n94
symbol: Coleridge's privileging of,
 over allegory, 79–80, 125; image of
 camera obscura as, 79–80
synthesis: forms in Kant's philosophy
 of, 57

Talbot, John, 196
Talbot, William Henry Fox, xii–xvi,
 xviii, xix, 13, 122, 167, 223n7,
 225n28, 229n2, 236n1, 237n11,
 238nn17–19, 238n27, 239n28,

245nn37–39, 246n49; as amateur botanist, 131; application of his copying method to solar microscope, 23–24; background of, xii–xiii; botanical imagery of, xxv, 123–26, 129–49, 172; conceptualization of photography as copying method, xii, xxiii, 5, 25, 32, 36, 175–76, 220n6; Davy and, 51, 64, 72, 232n59; definition of photogenic drawing as "natural magic," 20–24, 228n88; "developed-out process," xiii, 223n2, 228n1; discovery of photogenic drawing, first account of (1839), xii–xiii, xxiii, 3–6, 25, 30, 36, 39, 53, 81, 115, 195; discovery of photogenic drawing, second account of (1844), 28, 39–41, 42, 43, 49–50, 63, 73, 81, 82, 108, 113; education at Cambridge, 30; emphasis on value of experiments and primacy of experience, 14, 21, 222n1; Gilpin's popular writings informing, 86–87; Herschel's correspondence with, 152, 175–76, 238n19, 241n79; Herschel's photographic experiments and, 151, 152, 159, 223n10; Herschel's suggestion of terminology to, 5–6, 150, 223n10, 232n51, 238n17; Hunt's challenge of, for photographic patents, 166, 243n109; idea of the document, 185–86; as literary antiquarian, 185, 195; Macaulay and, 245n37; modes of arrangement and delimitation underlining compositional aspects of images of, 123–24, 139–43; new proof for validity of induction, xxiii, 3–4, 16, 24; photogenic drawing as image without a concept for, xv–xvi, xxi, 108, 110, 165; picturesque imaginings, 82–108; on productivity of calotype negative, 128–29; research sources on, xiii, 220n11; reviews of

images of, 88–90, 107, 118–19; Scott and, 185; studies on, xiii (see also Arnold, H. J. P.; Schaaf, Larry); on temporal and conceptual discontinuity between discovery and experiment, 72; temporality of photographic image for, 40, 95–98, 122–24, 137–38; wave theory of light and, 13–14, 16. See also Pencil of Nature, The (Talbot)

taste: democratization of, 84; Knight's program to outline a general theory of, 104–5. See also aesthetics

Techniques of the Observer (Crary), 73

technology of universal management, 31–32

Telescope of Sir William Herschel, The (Herschel), 153

temporality: difference of Talbot's images from "picturesque representation" in terms of, 95–98; in essentialist theories of photography, xviii; introduction of time into formations of knowledge, xvi, 35–36, 53, 116; Talbot's botanical images as temporal diagrams, 130, 137–38; Talbot's introduction of "latency" into paper photography, 122–24, 128, 172; Talbot's second account of discovery and awareness of, 40; two forms of, in Pencil of Nature, 188

Thackray, Arnold, 226n64

theory and law: Coleridge's differentiation between, 71

Theory of Colours (Goethe), 162

Theory of Life (Coleridge), 74–75, 233n69, 234n84

Thirlwall, Connop, 48

Thomas, Keith, 239n43

time: act of seeing embedded in, 163; as differentiating element between camera obscura and photographic

image, xxiv, 116, 120–22, 165;
Herschel's exploration of latency
and "dormant pictures," 152, 155,
156–61, 164; in Kant's philosophy,
57; nature as formed in, 53; as
"origin" in historicism, xxv, 186,
195–98; in the picturesque, 95, 177;
romantic historian's view of, 180–
81. *See also* temporality
"Tower of Lacock Abbey, The"
(Talbot), 118, 119, 196
Tractarians, 43
transcendental philosophy, Kant's,
54–62, 121
Treatise of Human Nature, A (Hume),
19–20, 67
Trinity: Coleridge's project to unify all
knowledge under idea of the, 68,
70–71, 234n84
Trinity College, Dublin, 16
"truth-to-nature," idea of: in Linnaean
botanical description, 132–33; in
review of "sun pictures," 118–19
Tucker, Abraham, 104
Turner, J. M. W., 99

understanding: free lawfulness of,
59–60; imagination and mediation
between sense and, 57–58
Unitarians, 64
unity: in Baumgarten's definition of
aesthetics, sensorial, 61; in
Coleridge's theory of life, 74, 75,
233n67; Coleridge's unified system
of knowledge, 68, 70–72, 234n84;
grounded on spirit, in idealism, 65;
between man and nature as goal in
romantic aesthetic theory, 56; of
nature, principle of purposiveness
and, 59–60; picturesque as form of,
85, 99–100, 103
universal management: technology of,
31–32
Ure, Andrew, xviii, 25

vegetable photography of Herschel,
xxv, 149–65, 172; color as main
subject of investigations in, 152, 154,
155, 162; decision to employ organic
substances in experiments, 151–52;
latency or "dormant pictures,"
exploration of, 152, 155, 156–61,
164; naming of, 155
Victorian science: collective effort to
define natural knowledge and to
legitimize its cultural status, 6–7;
law of continuity and, 5–16, 24;
validation of discoveries through
induction in early, 4
"View of the Boulevards at Paris"
(Talbot), 94–95
virtuality, xix, xx; end of natural
philosophy, 40–42
vision: camera obscura as disembodied
model of, 78, 120, 121; Foucault on
observation in classical paradigm,
78–79; Goethe's theory of colors
and, 162–63; Herschel on sensorial,
160–61, 163–64; subjective, 79
vitalism, 74–75, 234n86. *See also* life

Walden, Scott, x, 220n6
Ware, Mike, 242n84
Warnock, Mary, 225n37, 230n33
Watson, J. R., 100, 236n113
wave theory of light, xvi, 13–16, 24,
53, 168, 224n26; birth of modern
physics as specialized scientific
discipline and, 14–15, 16; debates
over, 13–16, 36
Weaver, Mike, 238n20
Wedgwood, Josiah, 64
Wedgwood, Thomas, 51, 63, 64, 167,
230n28
Wertz, S. K., 244n20
Whale, John, 236n117
Whewell, William, xxii–xxiii, 13, 15,
41–42, 228n82, 229n15, 229n16,
229n18; at Cambridge, 30, 41;

challenge to Babbage's project of
mechanization of intelligence,
33–34; Coleridge's epistemology and
politics and, 47–48, 49, 63, 67, 68,
229n18, 230n19; as "critic" of sci-
ence, 49; double role of books of,
50; on "Fundamental Antithesis of
Philosophy," 44–45; Herschel's
review of books of, 11, 43; moral
philosophy of science, 43–52; on
role of genius in scientific inquiry,
27–28, 46–50, 63; theory of induc-
tion, 46–47, 50; theory of knowl-
edge, 44–52
White, Hayden, 179, 180, 244n19
Wilder, Kelley, 223n10
Wild Fennel (Talbot), 146–47
Wilkinson, John Gardner, 191
Willis, Anne-Marie, 222n26

Winter Trees, Reflected in a Pond
(Talbot), 93–94, 98, 137; sense of
instability evoked in, 107–8, 137
Wise, M. Norton, 33, 35, 228n80
Wolf, Herta, 41, 229n6, 244n9
Wollen, Peter, 221n23
wonder: developing sense of, 21–22,
23–24
Wood, R. Derek, 242n98
Wordsworth, William, 48; on the
picturesque, 100
Worsley, Thomas, 42, 229n9

Yeo, Richard, 223n4, 223n9, 224n12,
225n35, 229n13, 229n18, 230n24; on
status of Victorian science, 4, 6, 14,
16, 27; on Whewell, 43–44, 47
Young, Thomas, 13